Rethinking Contemporary Art
and Multicultural Education

For over a decade, *Contemporary Art and Multicultural Education* has served as the guide to multicultural art education, connecting everyday experience, social critique, and creative expression with classroom learning. The much-anticipated *Rethinking Contemporary Art and Multicultural Education* continues to provide an accessible and practical tool for teachers, while offering new art, essays, and content to account for transitions and changes in both the fields of art and education. A beautifully-illustrated collaboration of over one hundred artists, writers, curators, and educators from in and around the contemporary art world, this volume offers thoughtful and innovative materials that challenge the normative practices of arts education and traditional art history. *Rethinking Contemporary Art and Multicultural Education* builds upon the pedagogy of the original to present new possibilities and modes of understanding art, culture, and their relationships to students and ourselves.

This fully revised second edition provides new theoretical and practical resources for educators and students everywhere, including:

- Educators' perspectives on contemporary art, multicultural education, and teaching in today's classroom
- Full-color reproductions and writings on over 50 contemporary artists and their works, plus an additional 150 black-and-white images throughout
- Lesson plans for using art to explore topical issues such as activism and democracy, conflict: local and global, and history and historicism
- A companion website offering over 250 color reproductions of artwork from the book, a glossary of terms, and links to the New Museum and G: Class websites www.routledge.com/textbooks/9780415960854

Rethinking Contemporary Art and Multicultural Education

New Museum of Contemporary Art

Edited by Eungie Joo and Joseph Keehn II
with Jenny Ham-Roberts

Routledge
Taylor & Francis Group

NEW YORK AND LONDON

NEW
235 BOWERY
NEW YORK NY
10002 USA
MUSEUM

Sponsored by

Deutsche Bank

Rethinking Contemporary Art and Multicultural Education is also made possible by a
generous grant from Agnes Gund.

Endowment support is provided by The Keith Haring Foundation School and Youth
Programs Fund, Rockefeller Brothers Fund, the Skadden, Arps Education Programs
Fund, and the William Randolph Hearst Endowed Fund for Education Programs at
the New Museum. Additional endowment support provided by the JPMorgan Chase
Professional Development Workshop Program for Teachers.

Additional program support is made possible by The Bloomingdale's Fund of the Macy's
Foundation, Con Edison, the May and Samuel Rudin Family Foundation, the New York
City Department of Cultural Affairs, and the New York State Council on the Arts.

First published 2011
by Routledge
270 Madison Avenue, New York, NY 10016

Simultaneously published in the UK
by Routledge
2 Park Square, Milton Park, Abingdon, Oxon OX14 4RN

Routledge is an imprint of the Taylor & Francis Group, an informa business

Designed and typeset by Alex Lazarou
Printed and bound in Canada by Transcontinental Interglobe

Library of Congress Cataloging in Publication Data
A catalog record has been requested for this book

ISBN 13: 978-0-415-88346-7 (hbk)
ISBN 13: 978-0-415-96085-4 (pbk)
ISBN 13: 978-0-203-84025-2 (ebk)

CONTENTS

PART II: On Artists

PART III: Artists' Works

PART IV: Integrating Curriculum

DIRECTOR'S FOREWORD

Rethinking Contemporary Art and Multicultural Education is the result of a collaboration of over 100 artists, writers, curators, and educators interested in contemporary art's power to affect learning in the classroom. The first edition, *Contemporary Art and Multicultural Education*, originally published in 1996, has served as an invaluable guide for high school teachers and students, providing insights and materials that challenge the normative practices of arts education and traditional art history. Featuring critical essays, artists' writings, and lesson plans in one book, it was an innovative tool for teaching art in schools. The second edition builds upon those efforts and incorporates current thinking on a topic of ever-expanding interest and furthers our understanding of and goals for art education.

The concept of "Rethinking" in this edition is a reexamination of the basic cornerstones: contemporary art and multicultural education—and the issues raised by the dialogue between them. Instead of presenting a new pedagogy, *Rethinking Contemporary Art and Multicultural Education* builds on the first edition to present new possibilities and modes of understanding art, culture, contemporaneity, and their relationships to our students and ourselves.

This project grew out of a conversation between New Museum and Routledge/Taylor & Francis Group that began in summer 2005 about a second edition to the highly acclaimed first edition, fondly referred to as the CAME guide. We would like to thank Susan Cahan and Zoya Kocur, the original creators of the CAME guide. We also acknowledge the Museum staff who initiated the second edition: Lisa Roumell, former Deputy Director and Chief Operating Officer; Anne Barlow, former Curator of Education and Media Programs; and Li Sumpter, former Manager of High School Programs, who saw the need and succeeded in getting this project off the ground. In 2007, Eungie Joo, Keith Haring Director and Curator of Education and Public Programs, took the helm and began to further define and conceptualize the project. Since that time, she has led her education team with a vision that has come to fruition in this publication. I thank Cathleen Lewis, former Manager of High School Programs, who was instrumental in the early stages, and the co-editors Jenny Ham-Roberts, former Manager of High School Programs, and Joseph Keehn II, Associate Educator, who have overseen the details of this book and its contents with deft precision.

Artists and professionals in the field across the country provided suggestions and feedback on the publication at various stages of its development. Sincere thanks go to the remarkable

contributing writers: Susan Cahan, Chitra Ganesh, Zoya Kocur, and Lan Tuazon, who, along with Kellie Jones, served as advisors to the publication, and brought the works of many of the included artists to our attention. I would also like to thank Lauren Cornell, Director of Rhizome and adjunct curator at the New Museum, Brian Sholis, Omar Wasow, and Ethan Zuckerman for their illuminating conversation on technology and access. Kara Walker graciously shared her manuscript from a seminar held here to be published in a context other than its original one. Walker's contribution reminds us that art can take many forms.

Rethinking Contemporary Art and Multicultural Education exemplifies collaboration at its best, with writings on artists and curriculum by a team of current and former New Museum interns, researchers, and staff including Travis Chamberlain, Sarah Demeuse, Jenna Dublin, Özge Ersoy, Benjamin Godsill, Jenny Ham-Roberts, Joseph Keehn II, Eungie Joo, Martha Kirszenbaum, Mathew Levy, Cathleen Lewis, Amy Mackie, Yvonne Olivas, Cris Scorza, Avril Sergeon, Ethan Swan, Jordana Swan, and Dina Weiss. G:Class partner teachers, particularly Martine Keisch, City-As-School; Bridget Malloy, Beacon High School; and Tiffany Vallo, Pace High School, welcomed our educators into their classrooms and provided valuable feedback on the curriculum. Additionally, interns Helen Melamed, Henry Mariscal, Shauna Skalitzy, and Anouk Soufer provided great assistance as this project came to completion. We thank Claire Barliant and Michelle Pirano for their editing expertise; the final manuscript stands as proof of their skills.

We greatly appreciate Routledge Publishing for their continued belief and commitment to this publication. For her dedication to seeing this project through its entirety, I am deeply grateful to Catherine Bernard, Senior Editor at Routledge/Taylor & Francis Group and her production staff: Georgette Enriquez, Editorial Assistant-Education; graphic designer Alex Lazarou; copyeditor Liz Jones; and Production Editor, Alf Symons.

Enough cannot be said of our many funders who made this publication possible. Most notably, we thank Deutsche Bank for their sponsorship of this publication and Agnus Gund for providing a generous grant to support the project. The Keith Haring Foundation; Rockefeller Brothers Fund; Skadden, Arps; and the William Randolph Hearst Foundation, have contributed major grants to ensure our education programs continue to reach new heights and engage an ever-expanding audience. We also thank the New York City Department of Cultural Affairs and the New York State Council on the Arts for their support of school and youth programs, and JPMorgan Chase for their support of professional development workshops for teachers. The Bloomingdale's Fund of the Macy's Foundation, Con Edison, and the May and Samuel Rudin Family Foundation have also contributed to this publication.

As always, special thanks go to our Board of Trustees for their continued support of educational programs at the New Museum.

Above all, we are enormously indebted to all the artists whose work appears in these pages; without them, this publication would not exist. Their creativity and commitment to art education will undoubtedly serve as valuable resources for future educators and practitioners of contemporary art. To this end, we dedicate this edition to all the teachers for whom this publication was created. Your desire and energy to teach; compassion for our youth; and hunger for knowledge have served as our foundation and continue to be an inspiration to us all.

LISA PHILLIPS

Toby Devan Lewis Director

New Museum

INTRODUCTION

In the years since the 1996 publication of *Contemporary Art and Multicultural Education*, both the New Museum and the field of contemporary art have evolved in profound ways. While this publication was originally conceived as a second edition to the original volume, it quickly became clear that *Rethinking Contemporary Art and Multicultural Education* would become more than an updated version of the first edition—that due to the influence of the first volume, as well as a critical mass of publications and art practices that challenge how art is traditionally viewed and interpreted, the terms of understanding contemporary art had changed.

Continuing the powerful history of education at the New Museum, this volume expands on the Museum's educational philosophy as well as its development of curricula through our high school education initiative, called the Global Classroom, or G:Class. Through G:Class, the New Museum has focused its efforts on how contemporary art might impact the intellectual growth of young people both inside and outside of the classroom. We have worked closely with partner teachers and principals from Beacon High School, City-As-School, New Design High School, and Pace High School, among others. Together, we investigate how the New Museum might be used as a tool in education—much like the Danish art collective SUPERFLEX's concept of the "SUPERTOOL," which they define as "a set of parameters that can be used in various forms, depending on the interest of the user. The parameters are defined and developed in relation to the needs or demands of the users." This has meant working with partner teachers to create new curricula and expanding our outreach to educators through professional development that focuses on contemporary art history as a course of study.

While the term "multicultural" has become contested, in large part due to its superficial application, Susan Cahan and Zoya Kocur remind us in their essay "Contemporary Art and Multicultural Education" that the original goals of multicultural education—curriculum reform through student-centered pedagogy, community involvement, and the equitable distribution of resources—of "transforming the very conditions that create social and economic inequalities" within education—are still as relevant and urgent as ever. Furthermore, they remind us of the need to continue to strive to incorporate art in education, that still "missing from multicultural art education is an approach that connects everyday experience, social critique, and creative expression." And while we respect the unfulfilled challenge of multicultural education, we also acknowledge the shifting terrain of discussions of pedagogy and equality, so that we offer the concept of "rethinking" to suggest that readers too should challenge the terms of these very discussions.

This volume employs a similar format to that of the original: essays on education, writings on artists, and suggested curricula. For the first section, "On Education," in addition to Cahan and Kocur, two artist-teachers discuss their ideas about the teaching of art based on their experiences in the classroom. Chitra Ganesh discusses the future of the American classroom, highlighting "key geographic, cultural, and technological shifts" that deserve careful consideration, while Lan Tuazon challenges the art-education enterprise to embrace student-driven outcomes and foster the development of active, critical thinkers.

In addition, this section presents material based in two public programs at the New Museum. Public programs have become a major part of the activities of the education department, allowing us to learn from leading practitioners of our time and explore alternative formats to engage with our public, such as the monthly seminar, Propositions, and the "New Silent Series" curated by our affiliate organization, Rhizome. In the conversation between Omar Wasow and Ethan Zuckerman titled "Network Equality: Technology and Access," we are reminded that "even as our world becomes more connected through the Web, cross-cultural engagement is something that needs to be actively and continually built around the new set of problems facing us today relating to how information is created, disseminated, and discovered." And in her manuscript, "A Proposition by Kara Walker," the artist provides a performative challenge to readings of representation by contemplating the autonomy of the artwork, the difference between the black subject and the black artist, and envisioning criticality through art.

The second section, "On Artists," provides brief introductions to the works of fifty-seven visual artists whose contributions to the field of art are undeniable. Artists presented here reflect a variety of practices that inform the New Museum in our exhibitions, programming, and teaching, and serve as an incomplete sampling of contemporary art in the twenty-first century. We hope these writings provide background for teachers to introduce such artists and their work in the classroom, as well as inspire further research. In addition to the images found in the color plates section of this publication, access to these and other images of works by the artists is available at www.routledge.com.

The final section, "Integrating Curriculum" provides thirty-six lesson plans that have been authored by New Museum educators with the assistance of our G:Class partner teachers. Divided into five chapters by thematic association—"Negotiating Space/Negotiating Self," "Activism and Democracy (Politics)," "Commodities, Exchange, Waste and Obsolescence," "Conflict: Local and Global," and "History and Historicism"—the lessons can be implemented directly with resources provided here, or easily adapted to introduce additional artists and support the objectives of your class.

For over thirty years, the New Museum has committed itself to contemporary art practices that expand our understanding of the time in which we live. Sharing that work with the public

through exhibitions, public programs, publications, and various educational resources remains a vital part of the Museum's mission. Through this publication the New Museum looks to support teachers and students of all ages to advance the role of contemporary art and ideas in the classroom and beyond.

EUNGIE JOO
Keith Haring Director and
Curator of Education and Public Programs

PART I
ON EDUCATION

CONTEMPORARY ART and MULTICULTURAL EDUCATION

Susan E. Cahan | Zoya Kocur

In 2008 the country elected its first president of African descent.[1] In recent years, several states have legalized marriage between same-gender couples. The speaker of the House of Representatives is a woman and a former first lady serves as secretary of state. A recent report found that the "Millennial Generation," those born between 1978 and 2000, are significantly more progressive than earlier generations were; they are more likely to support gay marriage, take race and gender equality for granted, be tolerant of religious and family diversity, have an open and positive attitude toward immigration, and display little interest in divisive social issues.[2] Are these signs that discrimination and oppression have come to an end in this country? Is racism a thing of the past?

We believe these developments are giant steps forward. They represent increasing recognition and acceptance of the diversity of human experiences, cultures, and choices. However, we also believe there is a need for continued understanding and action against systematic, institutionalized discrimination and oppression. In 2004, the bottom 50 percentile of African Americans in the United States possessed *none* of the country's net worth, while the wealthiest 1 percent of the overall population controlled 31.2 percent.[3] And the disparity between rich and poor has grown wider. According to a recent study, the wealth share of the least wealthy half of the population dropped from 3.6 percent in 1992 to 2.5 percent in 2004, while the share of the top 1 percent increased from 26.7 to 29.5 percent during the same period.[4]

Moreover, inequality, racism, and ethnocentrism have taken new forms. In the wake of the attacks of September 11, 2001, fear has been mobilized to demonize entire ethnic and religious groups. Therefore, as spectacular as some of our recent achievements have been, critical work still needs to be done to eradicate institutionalized imbalances of power and wealth and to understand and appreciate the many cultures that comprise our nation and our world.

Multicultural Education

Since the 1980s, the body of literature on multicultural education in the United States has grown. The range of perspectives reflected in this literature is broad, from the "heroes and holidays" approach and "celebrations of diversity" to radical critiques of institutionalized racism, sexism, and classism within the education system. Despite this scope, literature addressing the visual arts falls into a narrow range. While many promote the study of art from diverse cultures, they overlook the historical and political dimensions of cultural democracy. Conversely, within critical approaches to multicultural education, even interdisciplinary approaches, little attention has been paid to the substantive roles art can play.

Rethinking Contemporary Art and Multicultural Education aims to bridge this gap by highlighting the role of art within a critically based approach to multicultural education. Drawing from and expanding upon ideas in critical pedagogy, this book uses contemporary art as the focal point for an antiracist, antisexist, democratically based curriculum, providing both a theoretical foundation and practical resources for implementation.

What Is "Multicultural"?

The word "multicultural" evokes a wide range of meanings and implications.[5] At its worst, it has been taken to mean little more than a fad that captivated liberals in the late 1980s, launched a handful of careers by allowing a few people of color into the mainstream, and finally passed into oblivion in the 1990s. As early as 1989, performance artist Guillermo Gomez-Peña wrote that many had already grown leery of the word:

> [Multicultural] is an ambiguous term. It can mean a cultural pluralism in which the various ethnic groups collaborate and dialog with one another without having to sacrifice their particular identities and this is extremely desirable. But it can also mean a kind of Esperantic Disney World, a *tutti frutti* cocktail of cultures, languages and art forms in which "everything becomes everything else." This is a dangerous notion that strongly resembles the bankrupt concept of the melting pot with its familiar connotations of integration, homogenization and pasteurization. It is why so many Latino and black organizations are so distrustful of the term.[6]

Gomez-Peña's concerns are well founded since misunderstanding and misuse of the term abound. For example, in 2001 art critic Holland Cotter wrote, "Multiculturalism, more than an attitude but less than a theory, was a propelling force behind American art of the last two decades. It will define the 1990s in the history books as surely as Pop defined the 1960s."[7]

On the surface, this appears to be an affirmation of cultural equity. But a deeper reading reveals a problematic correlation between "Multiculturalism" and "Pop." Cotter presents the two terms as if they were parallel: Pop dominated art practice in the 1960s, multiculturalism reigned in the 1990s. The problem with this hypothesis is that the two terms are not equivalent. Pop was an art movement with an identifiable style and a particular aesthetic, which quickly emerged and entered into the canon of art history. The term "multicultural," as we use it, is an attempt to destabilize the very structures that elevate one style of art or one group of artists over another and create the linear succession of dominant art styles that make up the historical canon. It is precisely this hierarchical and linear notion of art history that has prevented work by artists of color from being considered part of the official story. "Multicultural" is not a style that came and went, but a condition of social existence.

What Is Multicultural Education?

Multicultural education emerged out of the context of social activism of the 1960s and 1970s, drawing energy and inspiration from the struggles against oppression by racial movements, feminism, and the movement for gay and lesbian rights. On college campuses, this activism took the form of demands for ethnic studies and women's studies courses and a greater sensitivity to cultural and gender biases. In primary and secondary education, it has concentrated primarily on curriculum reform, in its broadest application calling for a total school-reform effort using strategies such as student-centered pedagogy, community involvement in policy-making and governance, and equitable distribution of resources in order to increase parity for a range of cultural, ethnic, and economic groups.[8] As educational theorist Christine Sleeter has pointed out, "multicultural education has always been grounded in a vision of equality and has served as a mobilizing site for struggle within education."[9] Its purpose is to change the power structure in the wider society in order to foster social and political empowerment for all students.

Over the past three decades, educators have worked to develop curricula that are more pluralistic. While most attempts have moved beyond the "heroes and holidays" approach, few models of multicultural education are geared toward transforming the very conditions that create social and economic inequalities.

What Is the Role of Art in Multicultural Education?

Within the movement for multicultural education, curriculum development and instruction in art have been particularly slow to change. The models adopted in arts education are often the least likely to transform social and political conditions. Two of the most commonly used

introductory art textbooks, H.W. Janson's *History of Art* (first published in 1962) and Helen Gardner's *Art through the Ages* (first published in 1926), were initially written generations ago, and although they have been updated and revised several times, they still tend to distort or merely add on the history of black African art, the art of the African diaspora, and the art of many other cultures and groups. More recently, *Art History* (first edition 1995) by Marilyn Stokstad reflects social concerns by incorporating such topics as patronage and repatriation. Chapters on Asian, African, and Mesoamerican art are situated throughout the book, rather than being tacked on as afterthoughts. But the way in which contemporary artists are contextualized reflects the trouble art historians have had incorporating a diverse range of living artists into existing canonical narratives. For example, Julie Mehretu, an artist who was born in Ethiopia but grew up and currently lives in the United States, is discussed in the section on African art, while El Anatsui, an artist who has lived in Africa all his life—he was born in Ghana and currently lives in Nigeria—is included in the section on Modern Art in Europe and the Americas.[10] Such confusion results when artists are used instrumentally to support an author's narrative, rather than being addressed on their own terms. The following summary illustrates the narrow scope and pitfalls of the commonly used approaches.

The additive approach, one in which previously neglected movements or styles are added to the traditional list of European art movements, expands the curriculum without challenging the Eurocentric, patriarchal, and exclusionary biases of the overall framework. The glorification of token "masters" such as Georgia O'Keeffe, Romare Bearden, and Frida Kahlo merely reinforces the prevailing art narrative of the "gifted individual" who has been able to rise above his or her community in achievement. By definition, art created outside of these limited (and limiting) criteria lacks value.

In contrast, approaches that focus on signs of cross-cultural contact hold the potential to explore issues of biculturalism and cultural hybridization. However, they tend to emphasize a limited repertoire of historical events (such as the influence of African art on the development of cubism) and almost always stress the incorporation of Third World influences into European art. Occasionally, two-way flows of influence are recognized, such as the Portuguese influence on Benin sculpture in the sixteenth and seventeenth centuries, but rarely are artistic developments linked with historical and political events, such as colonialism, global imperialism, or the slave trade, which in many cases set the context for cross-cultural interaction. Furthermore, cross-cultural contacts between indigenous and diasporic groups are generally ignored, as "cultural diversity" is typically conceived as referring to "marginalized minorities" in relation to a white, European center.

Ethnically based approaches shift the center of inquiry to the culturally specific criteria that a particular society uses in creating and appreciating its art. The most effective approaches

integrate the study of art into a broader social, cultural, political, and historical framework. Yet in its usual emphasis, an ethnically based approach presents art in ways that make it seem distant and "other," keeping at arm's length questions pertaining to power relations in our own society.

Approaches to multicultural education that consider not only the art object and its function but also the culturally specific processes by which it was made and the sociopolitical dynamics shaping its reception are more complex; they take into account the cultural and social values and beliefs—including cultural biases—of teachers and students.[11] As Brian Bullivant points out, "culture" is not a set of artifacts or tangible objects, but the very way that the members of a particular group interpret, use, and perceive them.[12] "Use" includes intellectual uses by teachers and students within the educational process. Education thus becomes self-reflexive as students become more aware of their role as cultural interpreters and of the real ethical and social responsibilities accompanying that role.

The most common approaches for connecting the study of art with studio production are based on medium and form. (For example, students study African masks and then are assigned to make their own masks. Or, students examine the use of circular forms in art from a variety of cultures and periods and then create their own circular works of art.) Instead of enhancing cultural understanding, these methods reduce cultural artifacts to empty forms devoid of historical or social significance. The superficiality is apparent to students, who rightly question why they should care about issues that appear to be fabricated simply for the purpose of classroom study. Such approaches also tend to subsume art from every culture and context under narrow formal or technical concerns, which are themselves derived from European modernist aesthetic frameworks.

Generally missing from multicultural art education is an approach that connects everyday experience, social critique, and creative expression. When the focus is shifted to issues and ideas that students truly care about and that are relevant within a larger life-world context, art becomes a vital means of reflecting on the nature of society and social existence.

Contemporary Art Textbooks

Recently published textbooks on art of the post-World War II era include more women, artists of color, out gays and lesbians, and other previously excluded groups than ever before. The call for cultural equity has reached a point where most authors recognize the need to include at least some diversity in their selection of artists. However, inclusion alone does not eradicate the differential treatment of art. Many surveys of contemporary art contain a section that clusters artists of color, women, and other groups in a discrete chapter on identity or "alternative" art. The problem here is not only one of segregation in the guise of integration but also one of point

of view: who decides what is an "alternative" and what is considered the normative center? In other cases, gendered or racialized themes provide the pretext for such segregation, such as addressing the theme of domesticity exclusively with works by women. Often this approach wrenches artists and artworks out of their historical contexts in order to have them support a particular theme.

A second problem apparent in recent art history texts about art since 1960 is that they sometimes invoke the Civil Rights and Antiwar Movements as general backdrops to discussions of art of the era, without acknowledging the political challenge these movements posed to the very narratives of art history contained in these texts. Often authors use pictures of key moments in the Civil Rights Movement as background illustrations that reference historical developments in the 1950s and 1960s while excluding artists of color who were actually working at this time. In one text, a prominent author cites the Civil Rights Movement by stating that the "countless displays of extraordinary and anonymous courage on the part of black protestors with their handful of white allies" inspired the development of Happenings in the late 1950s and early 1960s. Yet this same author includes only one artwork by one artist of color among the 116 illustrations in this book.[13]

The second-rate treatment of works by artists of color was pointed out by art historian Richard Meyer in his insightful review of the year-by-year art history textbook *Art Since 1900* by Hal Foster, Rosalind Krauss, Yve-Alain Bois, and Benjamin Buchloh.[14] In the first of the book's two volumes, which covers 1900 to 1944, two entries address movements dominated by artists of color: the Mexican muralists and the Harlem Renaissance. These sections were written not by the primary authors, but by a writer who is not even credited. In sharp contrast to the crisp scholarship found in most of the book, these sections are written without rhetorical intensity or critical sophistication. Meyer writes, "While gesturing toward inclusion, *Art Since 1900* sets black and brown artists of the prewar period within a separate sphere of simplification."[15]

The final problem that has emerged is that the histories of works by artists of color are often reinvented for the convenience of the author. For example, *Art Since 1900* dramatically misrepresents the 1993 Whitney Biennial. In the authors' discussion of what they consider to be the exhibition's preoccupation with the use of African American stereotypes in art, they cite seven artists. Three of these artists were not in the show: Rotimi Fani-Kayode was born in Nigeria but lived in England; Yinka Shonibare is British; and Kara Walker, born and living in the United States, was actually included in the 1997 Whitney Biennial four years later.[16] Such distortions remove the artists from history and treat them as if they were game-board pieces that can be rearranged at will to suit an author's agenda.

Contemporary Art and Multicultural Education

Many teachers shy away from using contemporary art in their teaching because they do not feel comfortable with their own level of knowledge and are reluctant to introduce their students to anything they may not have mastered themselves. This response is not unique to educators. As art critic and historian Lucy Lippard has pointed out, the field of contemporary art "has become mystified to the point where many people doubt and are even embarrassed by their responses."[17] To make matters worse, teaching resources are scarce. The absence of curriculum materials about contemporary art reflects the attitude that the only valuable art is that which has "withstood the test of time." This attitude, in turn, reflects the belief that it is possible to establish universal cultural standards that remain fixed and permanent.

The relevance of contemporary art to multicultural education cannot be overstated. Over the past two decades, a significant shift has emerged in the sensibilities and outlooks of artists and critics, producing what philosopher, theologian, and activist Cornel West has referred to as the "politics of difference."[18] The features of this new cultural politics of difference include challenging monolithic and homogeneous views of history in the name of diverse, multiple, and heterogeneous perspectives; rejecting abstract, general, and universal pronouncements in light of concrete, specific, and particular realities; and acknowledging historical specificity and plurality. In this new art, issues of what constitutes difference and how it is determined have been given new weight and gravity.

The study of such art can enhance multicultural and socially activist education by helping to build students' understanding of their own place in history and emphasizing the capacity and ability of all human beings, including those who have been culturally degraded, politically oppressed, and economically exploited.[19] We advocate an approach that stresses the vital connections between students' lives inside and outside of school within a framework of social and historical analysis. This approach not only encourages students to speak from their own perspectives, but also encourages them to critique their environments and confront social issues in ways that are synthesized with the study of art.

A Social Reconstructionist Approach to Art and Education

The term "social reconstructionist" has been put forth by Carl Grant and Christine Sleeter to describe a type of education that prepares students to become active citizens who fully participate in society. According to Grant and Sleeter:

Education that is Multicultural and Social Reconstructionist … attempts to prepare students to be citizens able to actualize egalitarian ideology that is the cornerstone of our

democracy. It teaches students about issues of social equality, fosters an appreciation of America's diverse population and teaches them political action skills that they may use to deal vigorously with these issues.[20]

A social reconstructionist approach to art education requires a change in the content and organization of the curriculum, as well as a shift in instructional methods. Students are encouraged to bring their own existing knowledge and experiences into the learning process, lessening the privileging of one dominant "voice." This process of democratizing classroom discourse is of great importance, particularly given the increasing cultural diversity in schools.

At its best, multicultural education challenges and rejects racism, sexism, and other forms of discrimination in curricula and pedagogy, and fosters institutional practices that promote structural change. Multicultural education uses schools and cultural institutions as sites from which to critique larger social and political conditions that create injustices in the culture at large.

Museums and Arts Organizations: Into the Classroom

The role of museums and arts organizations in providing art education to public school students has increased dramatically over the past two decades. The impetus for much of this growth was the defunding of arts in public schools that began in the late 1970s. As illustrated in the timeline below (p. 14), public school funding for the arts has been in decline, if not in crisis, for nearly twenty-five years. During the 1980s, in response to the disastrous cuts to the arts that began in the prior decade, government agencies such as the National Endowment for the Arts (NEA) and state and local arts councils joined with private foundations, creating initiatives to bring arts back into the public schools, especially to the most underserved. Arts organizations responded by doing outreach, creating new programs, and partnering with schools in expanded ways. Museums, theater groups, dance companies, orchestras, and a wide range of other arts organizations all stepped in to fill the gap left by decreased school funding, often as the sole providers of art instruction in the schools they served.

The New Museum's High School Art Program (HSAP) was one such initiative. The program attracted federal, state, and private funding and was able to expand from serving three schools in 1980, when the program was founded, to more than a dozen the following decade. Government funding (with matching private funds) also supported the development and publication of the first edition of this book. Distinct from typical museum programs offered to schools (a museum visit and perhaps a follow-up with a museum educator), the HSAP was a multiweek program that introduced students and teachers to contemporary art, aesthetics, and social issues by integrating these into the schools' existing curricula. Though modest in size when it began,

the HSAP was the first program of its kind, both in its focus on serving inner-city public high school students and in its emphasis on contemporary art. By the early 1990s, the program had expanded to partner with a dozen New York City high schools serving "at-risk" students.

Efforts such as these brought innovative arts education to schools that had few resources. Eventually, broader efforts were organized to respond to the crisis in art education in schools in New York, such as the Annenberg-initiated Center for Arts Education (CAE) and the Chicago Arts Partnerships in Education (CAPE).

While the arts were being cut from the schools, the multicultural movement was gaining strength. The momentum of multicultural education as a viable and important means for educating a nation of students from diverse backgrounds was a key component of many arts programs implemented in schools by outside partners; the first edition of this book was a product of those efforts. The backlash against multiculturalism and the rise of conservatism in the late 1980s and 1990s, which was made manifest in the culture wars of the 1980s, eventually led to government censorship, elimination of funding at the NEA for individual artists, and attempts to eliminate the NEA itself, all of which created a negative impact on arts institutions that also reverberated in schools. (NEA funding for the first edition of this book was contingent upon the New Museum signing the NEA's "anti-obscenity clause.")

The struggle to keep arts in the schools has taken place against the backdrop of funding cuts at all levels of government and the political battles over the stakes of multiculturalism.

Painting by Numbers (or Not Painting at all): Standardized Testing

The period since the mid-1990s has seen a continuation of the ups and downs of art education in our schools. One of the largest factors influencing public arts education in the last decade (one that we would characterize as more negative than positive) has been the general trend in education toward standardized testing, which has led to an overwhelming emphasis on achieving quantifiable results in reading, writing, and math at the expense of learning in other subject areas, including not only art but also history, social studies, and science.

The centerpiece of the federal drive toward standardization, based in evaluation of academic success almost entirely through the standardized measurement of reading and math skills, is the 2002 No Child Left Behind (NCLB) Act, signed into law by President George W. Bush. NCLB identifies ten core subjects, art among them, but requires schools to measure and report only math and reading test scores. The push to improve test scores in these two areas has resulted in a decline in instruction in other subject areas, according to research from multiple sources.

A 2008 study from the Center on Education Policy found that among school districts that increased instruction time for English language or math (therefore reducing time spent on other

subjects), 72 percent of the schools reduced the classroom time for one or more of the nontested subjects by at least 75 minutes per week. Among districts reporting a decrease in instruction time since the passage of NCLB, 23 percent reported decreasing the total instructional time for arts and music by 50 percent or more compared to pre-NCLB levels—a greater reduction than felt in social studies, science, and physical education.[21]

A 2004 survey of 965 elementary and secondary principals from New York, New Mexico, Illinois, and Maryland published by the Council for Basic Education examined the curricular changes in schools effected by NCLB and found that 25 percent of schools had decreased their instructional time for the arts, while 75 percent had increased instructional time for math, writing, and reading.[22]

As quantitative analysis has become the preferred or required mode of evaluating the arts—displacing qualitative methods such as portfolio-based assessment—education and arts advocates have shifted their emphasis as well. In the past decade, organizations such as Americans for the Arts and other advocacy groups have turned to statistical analysis to communicate the severity of the crisis in arts education and to create awareness and support for restoring arts funding. Among the main areas of research are studies designed to demonstrate the positive impacts and value of art education for all learners and analyses of the impacts of NCLB on students' education.

What Now? What Next?

So what is the state of art education now? The results of the 2008 follow-up to the first national Arts Report Card were released in June 2009. The National Assessment of Educational Programs (NAEP) survey reported that 16 percent of students went on a school trip to an art museum, gallery, or exhibition in the last year, down from 22 percent in 1997.[23] In New York City, according to the Department of Education's (DOE's) *Arts in Schools Report* for the most recent completed school year, 2007–08, only 8 percent of elementary schools comply with the state law requiring that instruction be provided in all four art disciplines (visual arts, music, theater, and dance). Only 29 percent of middle school students are provided with the minimum required instruction in art mandated by New York state law. According to the DOE report, in 2006–07, 20 percent of schools did not have an art specialist in any area.[24]

Out of Tune: A Survey on NYC Students' Access to Arts Education, published by the Office of the Public Advocate for the City of New York, found that of the schools surveyed in its study, 75 percent of elementary schools offered only one period per week—an average of 45 minutes— of arts education to third graders, despite state regulations recommending that students in grades 1–3 receive the equivalent of five instructional hours of arts education per week.[25]

It concludes, "The DOE report shows that despite a decade-long effort to restore arts education in public schools, a large percentage of New York City public school children still do not receive any or receive only limited arts education."[26]

Data provided by the DOE also shows that schools with the most low-income students offer the least arts education. According to Richard Kessler, executive director of the Center for Arts Education,

> Of over one thousand public schools analyzed in 2006–2007, the higher the percentage of low-income students at a school the less likely it is to have an arts teacher and the less likely it is to have students visiting a museum or gallery, contributing work to an art exhibition, attending or participating in a dance, theater or concert performance."[27]

In the absence of arts funding in schools, parent associations have provided substantial funding for arts and other "extra" programs. Although school communities with enough resources to supplement or entirely fund arts programs clearly benefit, few low-income communities have the ability to raise hundreds of thousands of dollars to supplement the budgets of their local schools. Despite the efforts of advocates, it appears that the fight to include and support the arts in every school, without regard to the financial resources of parents, will remain an uphill battle. As reflected in these realities and the DOE data, the message seems to be that art is for the privileged.

Meanwhile, the trend toward provision of arts instruction in public schools by outside arts organizations is becoming a more permanent part of public school art instruction. The DOE's 2006–07 Arts in Schools report states that more than 430 arts and cultural organizations worked in NYC public schools in 2006–07. According to New York City's cultural affairs commissioner, 1,400 nonprofit cultural organizations were prepared to offer learning experiences in city classrooms in 2008.[28] As a result, programs like the New Museum's, and the thousands of other arts programs across the country that serve public schools, will continue to be a vital and essential component of art education in our schools going forward.

Selected Timeline: Art in Schools, 1975–2009

1975 Citywide arts curriculum is established in New York City public schools.

1975–76 NYC fiscal crisis; over 14,000 teachers, including a majority of art teachers, are laid off.

1978 California passes Proposition 13, cutting property taxes and resulting in dramatic cuts in school funding and arts education.

1984 Arts Partners is formed by several NYC agencies: Department of Cultural Affairs, Youth Services, Mayor's Office, and Board of Education; joins with arts organizations to provide arts in the schools.

1991 Board of Education data shows that two-thirds of NYC schools have no licensed art or music teacher.

1992 Eighteen arts organizations are working with twenty-two school districts through the Arts Partners program.

1992 Chicago Arts Partnerships in Education (CAPE) is founded in response to the lack of art teachers in that city's schools (where art teachers were teaching up to 1,400 students per week).

1994 National standards for core subjects, including the arts, are established by the US Department of Education.

1996 New York State implements a minimum set of requirements in each subject area, including art.

1996 NYC is awarded a 12 million dollar arts challenge grant from the Annenberg Foundation. In response, the NYC Board of Education, the Mayor's Office, and the teachers' union (UFT) create the nonprofit Center for Arts Education (CAE), awarding grants to thirty-seven partnerships in the first year.

1997 The National Center for Education Statistics releases its first comprehensive findings: "Eighth-Grade Findings from the National Assessment of Educational Progress."

1997 NYC hires 500 art and music teachers.

1998 In NYC, Mayor Rudolph Giuliani creates a dedicated funding stream for the arts, Project ARTS (Arts Restoration Throughout the Schools).

2001 *Arts in Focus: Los Angeles Countywide Arts Education Survey* is published in Los Angeles County, the largest in the country, with 1.7 million students. It finds that 37 percent of school districts have no defined sequential curriculum of arts education in any discipline, at any level, in any of their schools.

2002 President Bush signs the No Child Left Behind (NCLB) Act into law.

2002 NYC Department of Education reduces Project ARTS funding to $52 million (from a high of $75 million, or $63 per student, in 2000 and 2001) and eliminates dedicated purposes for the funds, resulting in a 50 percent reduction in arts education spending.

2007 Dedicated arts education funding (Project ARTS) is eliminated in New York City public schools.

Statistics for the timeline were gathered from the following sources

Americans for the Arts, www.americansforthearts.org

Annual Arts in Schools Report, 2007–2008, New York City Department of Education, available at http://schools.nyc.gov/offices/teachlearn/arts/Documents/AnnualArtsReport08.pdf

Arts in Focus: Los Angeles Countywide Arts Education Survey (Los Angeles: Los Angeles County Arts Commission, 2001).

Arts Partners Program Report, 1992–93 (New York: New York City Board of Education, Office of Educational Research, Brooklyn, 1993).

Burnaford, Gail, Arnold Aprill, and Cynthia Weiss, eds, *Renaissance in the Classroom: Arts Integration and Meaningful Learning, Chicago Arts Partnerships in Education* (Mahwah, NJ: L. Erlbaum Associates, 2001).

The Center for Arts Education: A Decade of Progress (New York: CAE, 2007).

Out of Tune: A Survey on NYC Students' Access to Arts Education (New York: Office of the Public Advocate for the City of New York, June 2008).

ENDNOTES

1 Barack Obama was the first US president of acknowledged African descent.

2 David Madland and Ruy Teixeira, *New Progressive America: The Millennial Generation* (Washington, DC: Center for American Progress, 2009).

3 Arthur B. Kennickell, "Currents and Undercurrents: Changes in the Distribution of Wealth, 1989–2004," Federal Reserve Board, Washington, DC, 2006, available online at http://www.federalreserve.gov/pubs/feds/2006/200613/200613pap.pdf

4 Ibid., 11. In simple terms, the wealthiest 1 percent of Americans control a third of the country's wealth, the next wealthiest 9 percent own another third, and the remaining 90 percent of Americans share the last third.

5 The term was borrowed from the field of educational theory, where it emerged in the 1970s and began to be applied in art contexts around 1980 with the exhibition "Multicultural Focus: A Photography Exhibition for the Los Angeles Bicentennial," curated by Sheila Pinkel. Planning for the exhibition began in 1979, and the show was presented at the Los Angeles Municipal Art Gallery, Barnsdall Park, during the 1980–81 season. Earlier, in the late 1960s and early 1970s, Dr Samella Lewis, an art history professor at Scripps College, ran an exhibition space in Los Angeles called Multi-Cul Gallery. The gallery focused on the work of black artists.

6 Guillermo Gomez-Peña, "The Multicultural Paradigm: An Open Letter to the National Arts Community," *High Performance* 12 (Fall 1989): 26.

7 Holland Cotter, "Beyond Multiculturalism, Freedom?" *New York Times*, July 29, 2001, Arts & Leisure section.

8 For three excellent references, see James Banks and Cherry A. McGee Banks, eds, *Multicultural Education: Issues and Perspectives* (Boston: Allyn and Bacon, 1989); Christine Sleeter, *Empowerment through Multicultural Education* (Albany: SUNY Press, 1991); and Sonia Nieto, *Affirming Diversity* (New York: Longman, 1992).

9 Sleeter, *Empowerment*, 10.

10 El Anatsui is also included in the section on contemporary African art.

11 See Robyn F. Wasson, Patricia L. Stuhr, and Lois Petrovich-Mwaniki, "Teaching Art in the Multicultural Classroom: Six Position Statements," *Studies in Art Education* 31, no. 4 (Summer 1990): 234–46.

12 Brian M. Bullivant, "Culture: Its Nature and Meaning for Educators," in Banks and Banks, *Multicultural Education*, 27–65.

13 Thomas Crow, *The Rise of the Sixties: American and European Art in the Era of Dissent* (New Haven: Yale University Press, 1996).

14 "Richard Meyer on Art Since 1900," *Artforum* 44, no. 1 (September 2005): 57; review of Hal Foster, Rosalind Krauss, Yve-Alain Bois, and Benjamin H.D. Buchloh, *Art Since 1900: Modernism, Antimodernism, Postmodernism* (New York: Thames and Hudson, 2004).

15 Ibid.

16 Foster *et al.*, *Art Since 1900*, 642–43.

17 Lucy Lippard, *Mixed Blessing: New Art in Multicultural America* (New York: Pantheon, 1990), 7–8.

18 Cornel West, "The New Cultural Politics of Difference," in Russell Ferguson, Martha Gever, Trinh T. Minh-ha, and Cornel West, eds, *Out There: Marginalization and Contemporary Cultures* (New York: New Museum of Contemporary Art; Cambridge, MA: MIT Press, 1990), 19.

19 See ibid., 34.

20 Carl Grant and Christine Sleeter, *Turning on Learning: Five Approaches to Multicultural Teaching Plans for Race, Class, Gender, and Disability* (New York: Macmillan, 1989), 212.

21 *Instructional Time in Elementary Schools: A Closer Look at Changes for Specific Subjects* (Washington, DC: Center on Education Policy, 2008). A copy of the report can be accessed through the website of Americans for the Arts, at http://www.americansforthearts.org/networks/arts_education/arts_education_015.asp#

22 Claus Von Zastrow and Helen Janc, *Academic Atrophy: The Conditions of the Liberal Arts in America's Public Schools* (Washington, DC: Council for Basic Education, 2004); available online at http://www.americansforthearts.org/information_services/arts_education_community/resource_center_016.asp

23 Results are available at http://nationsreportcard.gov/arts_2008/. In the survey, 7,900 eighth-grade students were tested. This is compared with assessments in other subjects, such as the 2007 assessment in which the department tested 700,000 students in reading and math, and 29,000 in history.

24 *Annual Arts in Schools Report, 2007–2008* (New York: Department of Education, 2008), available online at http://schools.nyc.gov/offices/teachlearn/arts/Documents/AnnualArtsReport08.pdf

25 *Out of Tune: A Survey on NYC Students' Access to Arts Education* (New York: Office of the Public Advocate for the City of New York, June 2008), 4.

26 Ibid., 13.

27 Richard Kessler, "Closing the Education Gap," *El Diario/La Prensa*, February 5, 2009.

28 *Out of Tune: A Survey on NYC Students' Access to Arts Education*, 11.

FUTURES FOR
THE AMERICAN CLASSROOM
Where Do We Go from Here?

Chitra Ganesh

The words kept repeating themselves in my head: "We are living in 'the future'—the future is now … We are living in 'the future'—the future is now …" From everything I can see, our present moment matches the imagined versions of "the future" that I glimpsed in science fiction movies and literature of the 1970s and 1980s, namely, a world dominated by technology and embedded with the kind of diversity promised by the likes of Sulu, Uhura, and Spock.

Here we are, arrived in *the future*—our world of incomprehensibly rapid and, most important, *uneven* technological, social, and political change. It is shaped by colliding realities: on the one hand, the unprecedented access some of us have to every type of information or material good through the technologies that flourish under our fingertips, and on the other, the struggle of many more who wonder how many days they will have to endure without clean water to drink. Such disparity is woven into the fabric of our visual culture. As we sift through these myriad changes, moment by moment, it is easy to feel we are at an impasse when considering how best to present the complexities of our world through the lens of contemporary art to an exceptionally diverse student body. So how do we proceed?

A number of key shifts in our social and cultural landscape over the past decade have resulted in a climate remarkably different from the one that produced the initial framework for multicultural art education more than twenty years ago. These include changing trends in immigration, the dominance of visual culture, now primarily mediated through the Internet, and the centrality of visual and discursive critique in the process of making, teaching, and viewing contemporary art. These shifts have also entailed changes in how we conceptualize identity—specifically, how we think about it, talk about it, and teach it. At the same time, emerging platforms of cultural production have been made possible by new technologies. Shifts in our social and cultural milieu and emerging platforms are far from being two distinct arenas of intellectual production. They equally affect ways of thinking about art as charted by contemporary artists and by those seeking to shape the future of American classrooms, and

create a dynamic relationship among contemporary art, cultural production, and progressive art education pedagogy. We can begin by taking cues from our recent experiences, as well as from our goals for the future, to sharpen our own analyses as art educators, teachers, and artists. These kinds of analyses, including that which I present in the remainder of this chapter, translate into tactical strategies that can be implemented in the classroom to substantively address the needs of today's and tomorrow's students, strategies that are flexible enough to accommodate the multiple directions in which our global cultures continue to evolve.

Immigration, Migration, Melting Pots, and Rainbow Underclasses

Many of our aspirations as practitioners of progressive pedagogy and cultural production have remained constant over time: fostering student-centered learning and open-ended questioning strategies, pushing for truly integrated and interdisciplinary models of learning, and illuminating multiple perspectives on cultural frameworks at the core of curriculum development. So what has changed, and how can we respond? The first step in crafting a thoughtful pedagogical response that is attuned to the current moment is to look at the ways technology and mass media now contribute to our understanding of cultural identity, and at the different terms that describe contemporary notions of culture and identity. Before our current age of technology and globalization, most people in the United States gained knowledge of non-American/"other"/"foreign" places through direct exposure to people who were from elsewhere, or had traveled there, and through printed material. Similarly, most of what the children of immigrants learned about their parents' country of origin came from partial, fragmented, and anecdotal information shared by members of their family and community.

Today, we can flit from screen to screen to access newspapers from any country online, double click on myriad websites, watch news shows, and listen to radio stations. More often than not, reports about South, East, and Central Asia will headline the day's news in the United States. The growing mainstream visibility of people and places outside the United States and Europe contrasts sharply with the rampant confusion among terms such as "American Indian," "Indian," and "Oriental" that was prevalent when I was growing up in New York in the 1970s and 1980s. Now movies like *Slumdog Millionaire* dominate the Oscars, while both hip-hop and reggaeton artists in the United States and abroad regularly sample Indian music and dance in top-forty videos. These are everyday examples of how the many populations that intersect in this country are growing, changing, and interacting on vastly complex social, cultural, and economic registers.

Language is also shifting as it attempts to describe today's uneven political and technological changes. For example, the terms "Global North" and "Global South" are replacing

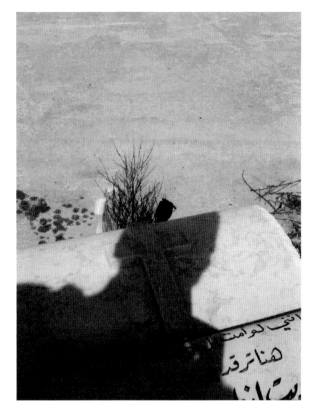

FIG. 1: EMILY JACIR, *Where We Come From*, 2001–03, detail (Munir). American passport, thirty texts, thirty-two chromogenic prints and video, text (Hana): 9½ x 11½ inches (24 x 29 cm), photo (Hana): 15 x 20 inches (38 x 50.8 cm). © Emily Jacir. Courtesy Alexander and Bonin, New York. Photo: Bill Orcutt. Also see artist entry for Emily Jacir in Part II (p. 131) for larger reproduction of this image

"First World" and "Third World," which were coined in the 1970s to describe the economic disparity between Western Europe and the United States on the one hand and the rest of the earth on the other. The term "Global South" is gaining currency and now includes "some 133 out of a total of 197" countries, which lie primarily (but not exclusively) in the Southern Hemisphere and have lower human development indices.[1] The term "Global South" understands the distinction between Euro-American nation-states and those in Latin America, Asia, and Africa as primarily geopolitical and economic—it is a political, rather than a geographical, term. Similarly, the concept of the "melting pot" once used to describe the racial diversification of, and eventual assimilation into, American culture has now given way to equally dangerous terms such as "rainbow underclass," used in a recent *New York Times* article to describe the growing swell of disaffected immigrant youth.[2] Becoming familiar with such terms is not simply a matter of updating our political correctness. The conception of a "rainbow underclass" reveals a shift—from seeing immigrant populations in America as people who want most of all to blend

happily into the fold, to acknowledge an overwhelmed and fearful response to the growing numbers of children of immigrants and migrant laborers into the suburbs of the United States. As problematic as it is, the term "rainbow underclass" also reveals an understanding of youth culture today that is much more diverse in terms of religion, culture, location, and class, as compared with the older notion of "inner city youth," which is applied almost exclusively to black and Latino populations in major urban centers. The shifts expressed in language are finding their way into the American classroom as well, as highlighted by another recent *Times* article that included the following line: "A record influx of immigrants has put classrooms on the front lines of America's battles over whether and how to assimilate the newcomers and their children."[3]

To Assimilate or Not? Anticipating Changes in Our Classrooms' Future

Today's American classroom bears witness to a greater influx of immigrant and migrant communities, from more diverse national origins, than ever before. This adds linguistic, cultural, and economic richness to the classroom, a major shift compared to the situation during my first year as an English as a Second Language (ESL) classroom teacher in a predominantly Dominican classroom in 1996, when ESL programs were primarily focused in Spanish-speaking communities.[4] Today, ESL programs have expanded well beyond Spanish and Chinese populations. The most recent immigrant English Language Learner populations I have taught included Polish, Haitian-Creole, Somali, and Bangladeshi students, in addition to Spanish and Chinese.

The need to diversify ESL programs in this country indicates changes in immigration patterns in the United States, which in turn indicate changes in global migration patterns more generally. The flux inherent to contemporary migration patterns yields very different negotiations around identity and location than did earlier patterns, even taking into account those that existed as recently as the 1980s and mid-1990s. Today's migration patterns generate populations that are no longer necessarily rooted or resettled within a singular national border. An increasing number of my own students over the past several years have regularly gone back and forth between Brooklyn and Pakistan or Trinidad, or between Mexico, Colombia, and the South Bronx, sometimes spending months or years at a time in each place. Students from such circumstances, while spending a significant part of their formative education here in the United States, confront being "American" in a very different manner compared to earlier generations of immigrant students, in that they are not as invested in assimilation or in prioritizing the question of their degrees of "American-ness" as they come of age.

Similarly, children of the first wave of immigrants from Third World countries also complicate our notion of what it means to be American, as do African American and Native

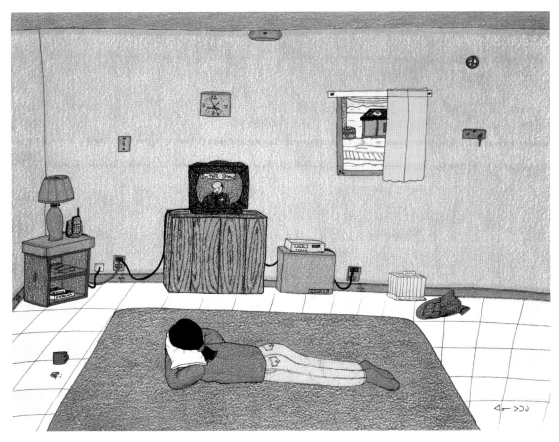

FIG. 2: ANNIE POOTOOGOOK, *Dr Phil* (Cape Dorset), 2006. Pencil crayon, 15½ x 20 inches (39.4 x 50.8 cm). Courtesy Feheley Fine Arts

American populations who have lived for centuries in this country with great economic hardship, segregation, and third-class citizenship. This includes people in their thirties, forties, and fifties of Asian, Latino, or Arab descent who have thick Southern accents, those who may never have been "back home" because home has always been Yorktown, Virginia, or St Louis, Missouri. The students of our future classrooms will continue to include Native Americans whose families have been rooted in this country for millennia but who are still the first in their community to attend college, as well as students who live in interracial families and may spend significant periods of their childhood outside the United States, only to return, live, and work here in their adulthood— students like the current president of the United States.

All of this is to say that the contexts shaping young people in the American classroom are increasingly defined by factors other than country of origin *per se*. These include religious affiliation, hierarchical or stratified class or ethnic positions within their homelands, and differences in educational opportunities between urban and rural schools. For example, the

rhetoric of the global community of Islam is emerging as a dominant aspect of contemporary social formations across the world, one that supersedes geographical or national boundaries in creating a sense of community and shaping immigrant students' identities and artistic interests. At the same time, Islam's historical and regional specificities are critical components in informing young immigrants' subjectivity in the United States. These coexisting factors are context-specific and complex. For example, students who have been previously educated in a one-room schoolhouse with more than forty students will have a completely different relationship to entitlement and power compared to their peers from the same country who were schooled in urban, middle-class environments and whose parents may have been scientists, doctors, or engineers but arrived in the United States seeking religious or political asylum.

Much of the available literature on multicultural education, including progressive pedagogical approaches to cultural diversity within the classroom that aim to move beyond mere "inclusion," still does not account for the growing complexity and geographic and class-based valences of what it means to be American. Attempts to move beyond a "heroes and holidays"[5] model continue to center a binary model in which students ostensibly struggle to negotiate two distinct cultures in the process of their inevitable assimilation into mainstream American culture. This model promotes an outdated framework that opposes two modes of culture: "ours" (i.e. American culture) and "theirs" (a stable set of practices from a country of origin). It also fails to understand that there can be only "partial, temporal understandings of a culture," never a "complete, homogenous" one.[6]

Using a student-centered model (which draws on lived experience and links the richness of that experience to curricular material) to engage teenagers in our future classrooms will require an ongoing examination of many categories we may take for granted—such as "American," "foreign," and "non-Western"—and thus use in our teaching without encouraging our students to question them. The new model demands that we leave behind the linear framework that proposes to connect identity, immigration, and assimilation, a framework that has implicitly constituted the core of many conversations around multicultural education in the last ten years. To truly move beyond additive models of inclusion, we need to let go of the twin notions that (1) "culture" describes a unitary set of practices, histories, and sociality bounded by a national border, and (2) identity and culture are organized primarily along national axes, over all other points of formation.

The ongoing upheaval of once stable categories such as identity, culture, and experience animates the contemporary artists whose work is featured in this book, including those who are making and showing their work outside the United States. Teaching about their work to high school students provides an ideal point of entry for thinking critically about today's economic, geopolitical, and technological concerns. These artists' works, which foreground institutional critique and move beyond the supremacy of a Eurocentric art canon, address

multiple and intersecting axes along which social formations operate. Teachers and artists may use this approach in order to stand together as the vanguard of the future, strategically framing conversations to illuminate how location, power, resources, gender, and race, among other categories of analysis, intersect with and produce one another, excavating disregarded histories and appropriating cultural material with a nuanced and critical understanding of context, social relations, and power.

Shifting Visual Cultures, Access, and Democracy

The American classroom's future trajectory parallels the conceptual, formal, and social strategies foregrounded in contemporary art today. We live in a visual culture whose ascendance is unparalleled. Dominated by multimillion-dollar advertising, commercial television, and film, with universally recognizable sign systems such as multinational logos, we are as familiar with the Nike swoosh or McDonald's arches as we are with the question mark or ampersand. The urgency of teaching art through the lens of visual culture has gained primacy in art education, interdisciplinary pedagogy, and curriculum development.[7]

Young people living in today's "future" are forced to negotiate emergent and shifting technologies that have become central to their experiences of both communication and visuality. These include cell phones, MP3 players, cameras, MySpace, Second Life, LiveJournal and the blogosphere, e-mail, and live chat rooms, not to mention other modes we have not yet imagined. As a recent study observed,

> Our students are not only extremely familiar with visual symbols and communication, but are often the target of this messaging. Visual imagery saturates their daily existence, and they are perhaps more likely to learn about history from television, film, video games, and photographs than from reading.[8]

The decline of the analog age and the emergence of the Internet as the primary purveyor of visual information have a number of critical implications that are worth careful consideration when thinking through the relationships among technology, visual culture, and teaching contemporary art in the diverse classroom.[9]

Three key factors in such a consideration are capitalism, access, and democratic address—as well as the generational and experiential gulf that separates our experience of visual technologies from that of our students. Technologically savvy adults Twittering on their iPhones don't even come close to participating in the kind of intimacy our students experience in relation to visual culture, which encompasses the seeming contradiction of both uneven access

FIG. 3: HASAN ELAHI, *Victory Mansions*, 2007, detail. Ink on paper, 153 x 96 inches (389 x 243 cm). Courtesy the artist

to and unparalleled facility with Internet-linked modes of visual address. It is vital to pause and expand upon the idea of access when considering how best to harness emergent forms of visual culture to critically engage with contemporary art. The Internet is frequently considered universally accessible—a ubiquitous, all at once, abundantly available tool for communicating

and disseminating information. Although the Web has permeated the vast majority of our world, and in many ways is seen to be creating a "global community" by bringing everyone closer to information, there is, in fact, an unevenness of access in our rapidly globalizing world that affects all aspects of our lives, including our ability to interface with technology.

Access is often coded in binary terms—either you have it or you don't—without accounting for gray areas that cover shifting relations to access. If we decide to implement strategies in our classrooms that utilize everyday acts of cultural expression, whether taking a picture for a project on a cell phone or using the Internet for visual research, we must also interrogate our own assumptions about access to such technologies. While most young people have some access to the Internet, be it at school or in libraries, not all students are able to use the computer in a private space. I have noticed that the proliferation and function of Internet cafés in the Global South is very similar to that in immigrant neighborhoods in New York, San Francisco, Philadelphia, and other urban centers, a phenomenon that may continue to spread with ever-changing demographics in the United States.

When I was working as first-year seventh- and eighth-grade teacher in 1996, we received a very substantial grant to help integrate technology into the classroom. As technology entered the classroom, it functioned not only as an educational tool but also as a distraction. Over the past five years, technology has been updated to include YouTube, instant messaging, live chatting, the occasional posting of provocative photos on the Internet, and now virtual-reality games such as Second Life.

These examples underscore the disjunction between total immersion in visual culture per se and a capacity to analyze or reconsider how images function in our historical and social contexts. Students' intimacy with popular media needs to be mined and developed to include critical thinking, and this can be applied to having them respond to performance, video, and participatory projects in contemporary art.

Finally, it is critical that we understand the Internet not simply as an inherently democratic, liberatory, or empowering medium that automatically guarantees student engagement and intellectual sophistication. Even among informed adult populations, the Internet colludes with the monumental advertising, television, and entertainment industries to reinforce materially based values (for example, consumption, gender conformity, stereotypes of race, beauty, fame, and wealth). The Web also presents a wealth of unreliable information, often cited these days as research, which one can easily misrepresent as truth. Recognizing the complex ways in which everyday technologies operate is crucial in order to diminish the knowledge gap between ourselves and our students when it comes to cell-phone photos, video streaming, and live chats, to name just a few of the avenues for researching and disseminating visual culture.

This essay aims to highlight key geographic, cultural, and technological shifts that bear careful consideration in building a coherent vision for our future's classrooms. I have spoken about trends in immigration and migration, how new technologies construct our visual culture, and the growing importance of social and institutional critique to today's contemporary artists. From this analysis, a few relevant areas of student inquiry emerge with great potential for developing critical understanding, and making, of contemporary art in the classroom. These include projects that foreground the archive and research, or move from an autobiographically based to a more socially contextualized analysis of personal experience and events. Implementing practical pedagogical strategies will ultimately give young citizens of the future an opportunity to explore artistic freedom—that is, the freedom to create and have access to those mind-expanding ideas and objects—that perhaps best illustrates democratic thought. At a time when democracy continues to be challenged even by our own policy-makers, the protection of art and art education in social institutions is becoming increasingly important.[10]

ENDNOTES

1 See Harold Damerow, "Global South," available online at http://faculty.ucc.edu/egh-damerow/global_south.htm (accessed May 31, 2010), and "Forging a Global South," United Nations Development Program, available at http://undp.org.cn/downloads/ssc/forgingaglobalsouth.pdf (accessed May 31, 2010).

2 Jason DeParle, "Struggling to Rise in Suburbs Where Failing Means Fitting In," *New York Times*, 18 April, 2009; available at http://www.nytimes.com/2009/04/19/us/19immig.html (accessed May 31, 2010).

3 Ginger Thompson, "Where Education and Assimilation Collide," *New York Times*, 14 March, 2009; available at http://www.nytimes.com/2009/03/15/us/15immig.html (accessed May 31, 2010).

4 Incidentally, ESL, or English as a Second Language, has been replaced by ELL, or English Language Learners, and this shift in terminology signals a waning of a linguistic hierarchy in identifying students' preferred language of communication.

5 "Heroes and holidays" is a shorthand way to discuss and critique the compartmentalization of cultural literacy by reducing the complexities of culture to a mere holiday such as Kwanzaa or the problem of teaching about "other" cultures by simply including one key figure from another culture into the fold of American history, literature, art, etc.

6 Christine Balangee Morris and Patricia L. Suthr, "Multicultural Art and Visual Cultural Education in Changing World," *Art Education*, July 2001, 10.

7 See Dipti Desai, Jessica Hamlin, and Rachel Mattson, *History as Art, Art as History: Contemporary Art and Social Studies Education* (New York: Routledge, 2009).

8 Ibid., 20.

9 There have been equally radical shifts in televisual culture in the form of reality shows and other modes of participatory, interactive television experiences, but I focus here on Internet and computer technology because of its central role in the classroom.

10 See Kerry Freedman, "Social Perspectives of Art Education in the US: Teaching Visual Culture in a Democracy," *Studies in Art Education* 41, no. 4 (2000): 314–29.

WHAT'S IN IT FOR ME?
Radical Common Sense in Art and Education

Lan Tuazon

The contradiction with education is that in order to teach, one must obscure. The typical classroom aims to create a neutral space of reflection, and to achieve this, other determinants—social, political, and economic—are set aside. To create the conditions for teaching, the classroom is severed from the exterior world to delay the realities of everyday life; but for those of us who stand in front of the classroom, it is clear that the realities of social injustices, market forces, and the stratification of daily life, far from being purged, are actually contained within it. Education is the field most vulnerable to the whims of political and economic reform, and in fact the reproduction of essentially the same reality that education aims to temporarily suppress is incarnated in the classroom and within each student. Every teacher has a tale to tell of the grievances he or she faces within a profession that forces teachers to make material and philosophical negotiations—to produce evidentiary results that often estrange them from their educational intentions and ideals.

The basic elements of education—material content, teachers, students, and the classroom—still constitute a rare structure in society. The classroom, despite its construct as neutral space, is in fact a social space for the last egalitarian efforts. It is the compensatory product to counteract all social, political, and economic imbalances that impede the ideology of democracy. For that matter, the classroom is a high-stakes place that demands emancipatory results—to restage and simulate a democratic world and its principles in practice. Teachers push students toward understanding and independence in preparation for their real and eventual encounter with socioeconomic forms of alienation. Students will judge their teachers based on how well they address these conditions. At least high school students are a hard group to lie to, and they "drop out" at the slightest hint of affirmative fiction. They have experienced alienation on many levels: in their relations with others, in their lack of representation as a social group in the public sphere, and in the personal consequences of their own socialization process. Students not only want teachers to understand where they

are coming from, but, more important, they want to know the source and symptoms of their alienation.

Museums create intelligible differences in fields of knowledge, and by preserving objects that have withstood the test of time, they establish the artistic and historical identity of a culture. The authority and legitimacy of the museum are always pending on the debate and contest of whether it does this successfully. With emancipation and education as its premises, the classroom looks a lot like a museum: classrooms are galleries; the teacher is the curator; and the students play the three-part role of artist, viewer, and critic. It is time to discard the model of the classroom as a place for the sluggish administration of conventions and dispel the notion that knowledge is produced elsewhere, to be imported and then mimed in the classroom. The classroom, like the museum, is a space where cultural identity and historical memory are not only represented but are actually produced. If one accepts the analogy of the classroom as museum, then the responsibility of the teacher as curator is to present uncensored and differentiated material content, to let such material permeate the classroom walls, and then allow students to experience and make of it what they will. Art teachers, before getting into the "how-to" of making art, need to help their students articulate why one would make art in the first place.

Contemporary art is a field of cultural production that is diverse in disciplines, content, and form. It is a field that investigates the social determinants of the past and reflects on those of the present, be they history, global media, politics, mass entertainment, or the personal. Art is the practice of existing as a human being in time, and the art object is merely a language that artists employ to negotiate/mediate a position against their subjective alienation. Consciously or not, teachers are susceptible to forms of institutionalized censorship: that is, selective ignorance of that which lies outside the classroom, which is seen as something beyond their educational scope.

A primary concern facing teachers who want to integrate contemporary art in the classroom is how to answer the inevitable, and difficult, question, "Why is *this* art?" Intelligent is the student/viewer who asks this question, and it is a question that cannot be ignored. Students must interrogate their encounter with dominant culture and its values. Such a question is an expression of doubt, which can only be the appearance and act of a personal will and determination to produce and challenge meaning. Certainly, students test their own preconceived notions of art in order to understand authorship, a concept that implicates them as active members of culture who can reformulate newer stakes in society in general. The dread teachers have in answering this crucial question comes from an honest acknowledgment that they themselves cannot be the sole arbiter of the explanation. I would add, in fact, that no single critic or artist could answer the question of what makes a thing an example of art. With contemporary art especially, there is a built-in uncertainty about its status. Even though articles, essays, and books abound that prescribe analysis of contemporary art, such works do not yet

have the necessary framing of experts and art historians to help deconstruct their meanings; not enough time has transpired to provide the critical distance required to accept them as verified truth. It seems at least that modern art is easy enough to revere and explain, since universities produce experts, who in turn produce explanations about its masters and masterpieces. Precisely because there is preexisting and institutionalized cultural reasoning surrounding modern art, students too readily accept abstract notions such as beauty as instant validations of art's value.

By contrast, contemporary art, lacking the element of time to speak on its behalf, has no definitive conventions other than being a field in which polarized ideas coexist: high/low art, mass-produced/original, beautiful/abject. In the words of art critic Boris Groys: *"The field of art is not a pluralistic field but a field strictly structured according to the logic of contradiction. It is a field where every thesis is supposed to be confronted with its antithesis."*[1] Thus, if we expect art to be an object, then contemporary art dematerializes it; for example, in an early precedent of relational art, Rirkrit Tiravanija hosted a dinner party, or more recently, Ginger Brooks Takahashi led a quilting session in the museum. If artists import life into the museum, they also lure art outside of its context, as in Dave McKenzie's proposal to museum audiences that they meet with him at designated times and places outside the museum. Contemporary art can involve everyday objects presented as artifacts of the personal (Susan Hefuna, Figure 4)

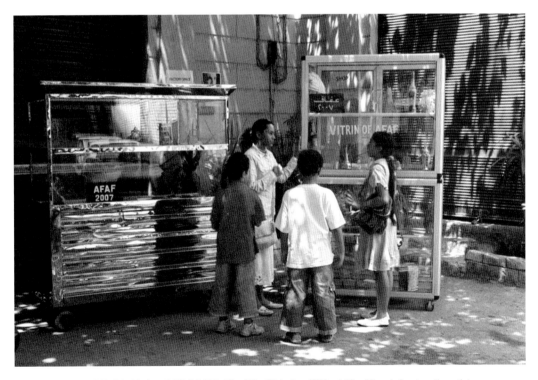

FIG. 4: SUSAN HEFUNA, *Vitrine of AFAF*, 2007. 79 x 55 x 20 inches (200 x 140 x 50 cm). Courtesy the artist

FIG. 5: DANH VO, *Untitled (Legionnaire)*, installation detail, 2007. Courtesy the artist

or consist of historical artifacts shown as formal sculptures (Dahn Vo, Figure 5). At times it relies heavily on the documentary impulse to produce research for neglected fields (Center for Land Use Interpretation, CLUI) or, inversely, may consist of a fictional research team that poeticizes journalistic issues (Walid Raad, Figure 6). Contemporary art awakens the inner cynic in us all with its incessant processes of negation and inversion. To answer the question of why something is art requires a discursive practice—even if analysis amounts to a synthesis of meaning that will quickly be overturned to breed nothing more than paradox and contradictions.

The process of art interpretation is an exercise in intelligence that requires only the most basic human critical faculties of observation, emotion, and speech. Art and its discourse can be a simple process of having students ascribe language to their senses, form meaning, and then collect proof to support their thinking. Students belong to a culture of their own, with values specifically determined by their personal identity and history. Because contemporary art is itself in a state of becoming, it turns students into witnesses of their own cultural historical present. What is at stake then for students is the will to take a position—to make or break out of this cultural moment. This is the foundation of the "universal teaching" system of the French teacher and philosopher Joseph Jacotot (1770–1840):

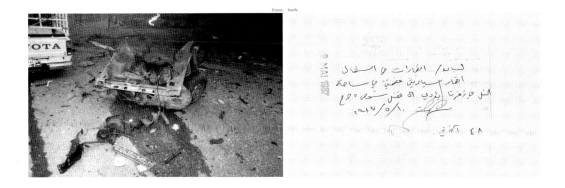

FIG. 6: THE ATLAS GROUP, *My neck is thinner than a hair: Engines*, 2004. © Walid Raad. Courtesy the Paula Cooper Gallery, New York

Meaning is the work of the will. This is the secret of universal teaching. It is also the secret of those we call geniuses: the relentless work to bend the body to necessary habits, to compel the intelligence to new ideas, to new ways of expressing them; to redo on purpose what chance once produced, and to reverse unhappy circumstance into occasions for success.[2]

Furthermore, as interpreters of art's meaning, teacher and student, artist and viewer, curator and pedestrian stand on equal ground; the truth of their human equality rests on knowing that the faculty of one's common sense and language are all that one needs. Here the teacher can set aside all educational science and take comfort in the realization that when it comes to finding meaning in art, there is no master language to learn and reproduce.

The (In)Equality of Objects

All objects are essentially the same. Time will be indifferent to them all, aging and destroying them equally. However, certain objects achieve a special status—bestowed by artists, curators, museums—that distinguishes them in historical time and grants them the special treatment of being preserved in museum collections. This is more problematic with contemporary art, which has a tendency to be immaterial, at times forcing viewers to go to lengths even to find it, and at other times consisting of nothing more than a document of events passed. When it does take a material form, it is often an all-too-familiar object that one encounters every day in the real world. Which raises the questions: what does it mean to reframe a familiar object for artistic reflection, and what is the logic that places such an object in the museum?

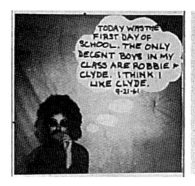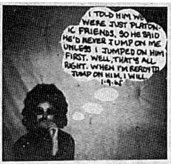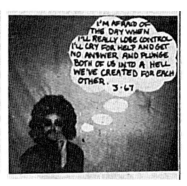

FIG. 7: ADRIAN PIPER, (LEFT) *The Mythic Being, Cycle I: 9/21/61*, 1973. Village Voice newspaper ad of September 27, 1973, #1 of 17 from the "Mythic Being Village Voice" series, 14⅞ x 11½ inches (37.7 x 29.2 cm). (MIDDLE) *The Mythic Being, Cycle I: 1/9/65*, 1974. Village Voice newspaper ad of January 31, 1974, #5 of 17 from the "Mythic Being Village Voice" series, 14⅞ x 11½ inches (37.7 x 29.2 cm). (RIGHT) *The Mythic Being, Cycle I: 3/67*, 1974. Village Voice newspaper ad of March 28, 1974, #7 of 17 from the "Mythic Being Village Voice" series, 14⅞ x 11½ inches (37.7 x 29.2 cm). Collection of the Museum of Modern Art, New York. Purchased with funds provided by Donald L. Bryant, Jr, Agnes Gund, Marlene Hess and James D. Zirin, Marie-Josée and Henry R. Kravis, Donald B. Marron, The Edward John Noble Foundation, Jerry I. Speyer and Katherine Farley, and Committee on Drawings Funds in honor of Kathy Fuld

The reification process is so great that anything placed in a museum and maintaining its place there marinates into art. This is, at the very least, precisely what Marcel Duchamp demonstrated with his readymades: for example, the 1915 snow shovel he titled *In Advance of the Broken Arm*. The contradiction, of course, is that it remains a shovel both outside and inside the museum, and both before and after the mediation of the artist. The object is a constant, and so it is the context of the museum and artistic authorship that are the variables determining differences. It is not that everything under the sun, of life outside the museum, is art—after all, there is not enough room to move the entire hardware store there. Rather, artists continue to find new considerations of what can be perceived as art and what types of things can enter the museum. Seeking out these new formulations for art is not only an exercise of artistic will but also a test of the humanitarian project of the museum as a constructed social space that contains and produces cultural meaning. Once we arrive at this understanding and then take it one step further, the entire project of humanity can similarly be expanded beyond the spatial confines of the museum.

The functional space of the museum is precisely why contemporary art, in addition to the duality of form and content, prioritizes context as its primary source of meaning. The inclusion of context—relevant situations, events, people, and relationships—constitutes an attempt to step outside the bounds of the museum, to recover art in life. Artists import other contexts into the museum and, vice versa, walk out of the cultural context of the museum and into the expansive sphere of social life. In 1973 Adrian Piper created a series of works around a fictitious

FIG. 8: ANDREA FRASER, *Official Welcome*, 2001. Video still of performance at Kunstverein in Hamburg, 2003. Courtesy the artist

male *Mythic Being* whereby each month she wrote a narrative, stepping into the thoughts and personality of her mythic male alter ego (Figure 7). Performing in a body conceived as different from her own gender and personal history, she encountered the world through that body, uttered thoughts generated from that body, and extended the limits of her own identity into that of another. As Piper described it, "The *Mythic Being* is an alternative of myself. One of the many possible products of my experiences and history, though I myself am the only one."[3] Decades later, in 2001, in a work titled *Official Welcome*, Andrea Fraser, playing herself as an artist giving an acceptance speech for a commission, disrobed in front of her audiences claiming that she herself wanted to be an artwork (Figure 8). Manifested in these two works are potential answers to the question of what it means to make art, which is one and the same as the question of what it means to be human:

> Human beings can only be truly dignified if they can be conceived as works of art—or better, as works of art that they themselves produce as artist. This concept of the human being is the basis of all humanistic utopias, all of which understand individual human beings, and ultimately the community, the state, as works of art. So the question arises: what are we ready to accept as art, and what criteria do we have for accepting certain things as such? For it would seem that only answering that art is the site of becoming human will permit us to see what human beings really are—that is, those human beings who are granted human rights and can be considered the subjects of democracy.[4]

Teaching

According to conventional thinking about education, learning is achieved through the teacher's technical proficiency in producing and disclosing explanations. The instructor's role is to track the development of students as they close the gap between ignorance and knowledge. In such a view, the more competent and intelligent the teacher, the greater the distance between his or her own expertise and the students' inexperience. According to this logic, then, teaching imposes an imbalance of intelligence between the expert teacher and the novice student. Teachers will adapt and manipulate explanations to close this gap, and lessons are commonly staggered and sequenced to encourage a slow acceptance of palatable portions of learning—a process, I would argue, that potentially delays students' intellectual satisfaction until a much later stage. This is what Rancière called *enforced stultification*. Not only does it train students to accept that their achievement of understanding is dependent on others' explanations, it also is based on assumptions about what students are capable of at a given moment of their development. Students are classified and tested according to their intellectual capacity; the resulting "specialization" of their education serves to actualize the fiction that differentiates their intelligence in the first place, thereby creating real limitations to their capacity to learn. To clarify, I am not being indifferent to real socioeconomic imbalances. Rather, I argue that students facing these injustices are not served by a tailorization of their education that misinterprets social imbalance as an imbalance of intelligence. Certainly, there have been attempts to mitigate socioeconomic imbalances in the classroom through institutionalized educational mandates, but that can unfortunately lead to unequal treatment in the classroom.[5] It is important to remember that all students are independently intelligent, capable of learning through their own senses. Dominant and normative explanations of society and culture effectively reproduce only ideology. Even the Socratic method, with its leading questions, allows for a readymade form of understanding that is not wholly the student's own. Students naturally withdraw when asked to forfeit their own ideas to another's, and who would not eventually retaliate against the submission of their will to the dominant and the norm?

Given the heterogeneity within the classroom, where students are at various levels of development biologically, socially, and economically, it is clear that each student will produce a form of understanding based on how much attention is given to their will. A teacher's role is to fortify the will of a student's intelligence toward understanding, which is not about the reception of fact and explanation, but rather, the presentation of oneself to another; understanding is the desire to speak to and face the will of another with one's own will. Because there is inherently room to question and formulate the legitimacy of contemporary art, it is a prime subject for the type of learning that evades the possibility of *enforced stultification*.

There is no need to stall the culture of intelligence. Perhaps the simple truth in art and education is that both are public acts. At one time or another, students will have to present themselves to the world. It seems to me that the only conditions necessary for the creation of an environment of learning are access to an equal space of learning and teachers who persistently fuel students with the confidence to speak. When asked to recall a favorite teacher, people often cite that teacher who empowered them by insisting on the equality of his or her ability and intelligence. Students may at first challenge this assumption of equality with a straightforward question of what it is exactly that you want them to do. "Take a position," I say, "step into your role in history." How might students react to the affirmation of life as the work of art? These are the newfound stakes in art education. The aim of art education is not solely to create new artists, but to foster an understanding of art as a determinant of what it means to be human.

ENDNOTES

1 Boris Groys, *Art Power* (Cambridge, MA: MIT Press, 2008), 2. The italics are his.

2 Jacques Rancière, *The Ignorant Schoolmaster: Five Lessons in Intellectual Emancipation*, trans. Kristin Ross (Stanford, CA: Stanford University Press, 1991), 56.

3 Adrian Piper, *Out of Order, Out of Sight* (Cambridge, MA: MIT Press, 1996), 109.

4 Groys, *Art Power*, 175.

5 An example of this imposed inequality can be seen among bilingual learners who are segregated from other students. For the school system to truly help non-native speakers, it needs to offer English as a language within the overall educational plan rather than offering a separate education for non-native speakers.

MANUSCRIPT FOR

A Proposition by Kara Walker: The object of Painting is the subjugated Body. The Painter is the colonizing entity. How do Paintings understand the concept of liberty? And who will teach them?

With an introduction by Eungie Joo

When we teach and discuss art, the emphasis is often on art as it is resolved as an object, an installation, or the representation of these forms. There are, of course, practical reasons for this—often ideas about a discrete work of art are, by necessity, being communicated away from the work itself, using a reproduction as a reference. At the same time, we have been taught to think of art as painting, sculpture, photography, or more recently, video.

But contemporary art is in many ways less tidy than that. Many contemporary artists explore art practices that involve writing, pedagogical theory, collaboration, performance, actions, and other activities that may never yield the type of object that we could effectively represent as an image. These activities, too, can be considered art, or at least a vital part of art and the ideas that generate and sustain it.

To educate a new generation of young people *with* contemporary art, educators need to pay attention to such activities and perhaps use them when considering how best to utilize the structure of works of art, art practices, and the concepts around art to guide us in our teaching.

At the New Museum, we recognize that contemporary art takes many forms, and in an effort to support a variety of practices and experimentation in art, the Museum hosts and develops seminars with artists and cultural thinkers for our local audiences. One such series is called "Propositions." For this two-day seminar, the New Museum invites a distinguished artist, cultural thinker, or curator to present a hypothesis or an idea in progress. The seminar leader in turn invites a guest artist, scholar, performer, or cultural critic, or presents a screening or activity, as a kind of counterpoint or research session. Finally, the seminar leader and guest conduct an intimate discussion with the public to expand upon the ideas introduced.

Based loosely on a model of scientific investigation, "Propositions" aims to share with Museum audiences the complex, interdisciplinary, even unusual ways in which artists and arts professionals research and develop concepts in their work while attempting to advance these same ideas through the use of the public forum as a kind of working session or open workshop.

The following manuscript and selection of supporting images are from the first "Proposition" lecture, given by artist Kara Walker on September 25, 2009, in the New Museum Theater. The "lecture" was an incredibly precise PowerPoint performance, replete with a collection of images, pauses, text, self-reflexivity, and affect. The following day, activist and sociologist Soniya Munshi gave a lecture about her own area of research: the relationship between domestic violence and state violence in South Asian communities since the Homeland Security Act was enacted in the United States. That afternoon, some thirty-five people (artists, writers, students, and at least one retired state administrator) probed the ideas Walker and Munshi had presented from a wide range of perspectives.

Kara Walker's writing is a discrete component within an art practice that is deeply and uniquely rooted in philosophical, political, personal, and fantastical investigation. As a performance, the manuscript occupied space and time in an indescribable way, and yet its ability to inspire idea production seems certain. Walker's writing is included in this publication to demonstrate one way that the New Museum attempts to nourish, study, and present contemporary art and ideas through new models of education and activity.

EUNGIE JOO

Keith Haring Director and

Curator of Education and Public Programs

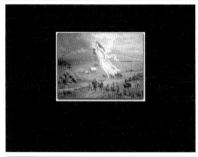

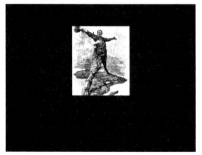

Presentation New Museum [playlist]

Section 1: I am the perpetrator

The Nigger is akin to the painter's canvas
an inert ahistorical, expedient lie

The Nigger is an image made out of black bodies dying

Made to be a receptacle for Hubris

The Painter contains multitudes

The viewer is a Mob
(The painter manipulates mob mentality)

The Painter controls the outcome of the narrative

The Painter creates the canvas over which ideals of dominance are drawn.

The Modern Painter's ideal stems from Manifest Destiny—the Land is a vast, unpeopled canvas.

Modern Painting could not exist without the invention of the Primitive.

The Nigger is one version of the pre-Enlightenment body. A hollow, to be filled with the by-products of European philosophy.

The Nigger is a Primitive body which Painters covet, collect, and put to work.

But then there are Niggers, and there are Blacks—
and Some are Paintings and some are human. Don't confuse the two.

Paintings don't demand their human rights. Or participate in

liberation struggles.

Paintings cannot speak for themselves. Their voices have been stripped from them. Painters are cruel masters.

Black men and women, however, do resist conscription into the site of fictions. They abhor the stage and mask. They Frighten mobs from their preternatural attack by refusing to perform the role.

And should not be painted by anyone purporting to respect human rights.

Every stroke of the painters brush soils the perfection of the black even as it dignifies that nigger called a canvas. (blank slide)

And exalts that mob.

Every stroke of the painters brush strips the canvas of meaning and makes it moan.

And every painter derives pleasure from this stroke.

—Displacing—the psychic pain of Liberty—onto a body who can take it.

And every painter activates history and tradition in this stroke. The touch of genius. The Imperialist imperative. Power over powerless.

The Mob is activated by the spectacle of this touch.

The touch contains the spectacular innovation of liberty—

lust—plus death and resurrection—

awakens in the mob a sense of higher purpose.

Religious, esthetic, Nationalistic purpose.

The mob thrusts itself future-forward as the Primitive object dutifully perishes.

In other words, the painting must die, and keep dying—in order for the "artist" to live

blank

6

action

7

spectacle

8

9

10

A Great Injustice Has
Occurred

Section 2

The spectacular touch, the stroke of genius, disabuses the mob of any culpability—

But what if, oxymoronically, there appears on the scene a canvas which paints? What to make of the anti-spectacle—this implosion of the avant-garde?
Can this canvas, sub- subaltern that it is [yes, and worse, inanimate object], give voice to its own needs? Where do paintings locate themselves in a universe of objects and ideas?

Do all Paintings contain within them the damaging history of their captivity or can they,
like victims of state-sponsored suppression and violence,
resist the systemic damage that's been done to them?

Paintings will need allies, they will need influence.

Imagine a painting using the raw flesh of itself as a savage instrument for change.

Section 2: A great injustice has occurred

As the observer of the so-called "creation" of a painting, the viewer is in fact being subjected to a great disintegration of the social fabric. Witnessing but not objecting to the narcissistic force artists regularly mete out at the supposed blank space of the picture plane.

Reality frightens painters—and they strip fictions from the skin of it. As audiences we are trained to condone this brutality as representative of creative power.

Audiences should forgo this construction and turn their attentions to undoing the power structure that makes art a viable activity. Audiences should reject the "awe-inspiring wonder" of the creative act as yet another opiate that has held them captive. Artists demand that audiences stare helplessly, like frightened children watching father beat mother.

Audiences must resist the temptation to side with patriarchal power. Even if they must yank the brush from the artist's hand!

Images, like enslaved child brides, should be carefully removed from their white, rectangular, two-dimensional compounds, loaded into unmarked vehicles, taken to an undisclosed location, and undergo psychological evaluation. Many will be unfit to live normal lives.

16

List of Demands:
Painters should be banished
Artists should take anger management courses
Artists need to retrain themselves that they may contribute morally to society
Canvases should be returned to their natural state
Objects should be given proper burials
Materials should be free to govern themselves
Sculptures should be granted amnesty
Art collectors should be rehabilitated
Galleries should be turned into schools
Philosophers, architects and children, however, those members of society with time on their hands, may be allowed to beautify our surroundings.

Section 3: I am the victim

history lesson:

In 1992 it occurred to me that making paintings was an activity linked with the question of my body. It was as though all at once feminism finally reached my noggin soon followed by black feminist writings that effectively told white feminists to go to hell.
so I got it that:
I was born into a world consisting of a white male-dominant power structure.
That women, and particularly black women in America, had been silent sexual slaves, the object of the male gaze and subjected to political and social injustices that make the blood run cold. But also, that there is a long tradition of resistance and protest against cultural

17

18

19

20

21

hegemony. And that it was imperative that I, an African American Woman Artist, take a closer look at this:

(Picasso's Negro period—the ladies here, famously, considered it an "assault on European traditions of representation and taste" [cite] made space for the artist as anti hero, alternately toying with European racist conquest Africa, and exposed fascination with dirty "africanized" whores.)

and question its relationship to

My identity as "Black" as "Female" as "sexual" and as "artistic."

Perpetually optimistic, and apparently oblivious to the concept of fear—I could never quite reconcile my rich and growing interior artistic life with my encounters with cruelty, the continual assaults on my person from childhood on up. From my older brother's violence to my mother's silent complicity with it—to overtly racist encounters outside the family—in fact, by 1992 I was making my art in complete and willful ignorance of the very racist and sexist attitudes that were coming at me in almost comically demeaning ways.

Cut to—montage of Klan rally at Stone Mountain Park, confederate flags waving in the breeze, white kids shouting "Nigger" at me, "Nigger Lover" at my friends, being slapped backhanded for the offense of my gender, receiving a 10-yard stare for being uppity, white men confessing they had never fucked a black woman before— the cry of ecstasy—"you hot little whore." Cut to—more confessions from white men at work—their disgust at the L.A. rebellion, disgust at Rodney King, quizzical musings on the sex life of Anita Hill. Cut cut cut cut to the ease with which my quiet independence and agency became the stuff of conjecture, stereotyping, and legend.

It is important for me to acknowledge the protection from all of the above afforded me by my father (a successful educator and painter) and more precisely, the activity of Painting, which became my most

promising means of escape. (See Picasso.)

Reacting to the identity politics within art discourse in the early 90s, I found myself testing a liberation theory on paintings. Recognizing that my relationship to patriarchal structures was more compliant than resistant, and struck dumb by the preponderance of self-important artists, who invariably would regard my paintings and my experience as not black enough, not fully representative (this an attitude from both white and black viewers),

I turned my attention to the question of how to make a black artwork. Essentially, thinking of this very talk-

At an early 90s forum on the black male image—I determined the following.
Artists—
imagined their art and identities as fixed
viewed the art object as a site for education rather than fantasy
spoke about their art from the vantage point of fear. [in particular fear of reprisals]
And to me, the artworks on display were made to suffer under the weight of so much anxiety over the symbiosis of looking and being seen—That singular, and possibly disruptive, structure artists are expected to engage in.

It has been the tradition in Black arts and letters for artists to engage in a kind of collective protectionism from the hostile (but necessary) gaze of White viewers. It is a protectionism that goes way beyond the art object—straight to a history of subjugation—the "slave mentality" to be blunt. Art is, to begin with, a decadent path to follow—but once there, a plethora of social taboos and restrictions are on hand to shake fists and wag fingers.

So a decadent modern painter may want to have an objective relationship to her art, but black audiences will activate the work above and beyond any postmodern theory of signs and signifiers.

What for you may be a sign, others call their grandmother—so goes the logic.

~~Back then I wanted there to be a visual space to interrogate the mediated image of a black female subject, her relationship to having been "made" so many times—by a white culture in need of an Other—an awesome undesirable—to better understand and maybe dismantle the mechanisms that suspend that object—Negro Woman—in time, memory, art, space, history, folklore etc.~~

~~hoping that she might at least figuratively tell me what she is made of and ask why the hell I am making her?~~

Section 4: Scapegoat

In "What Do Pictures Want?" W.J.T. Mitchell speculates on the lives of images. Material objects, paintings, films, photos—circulating, mobile, animated mediums whose existence is determined by the desire to look, or be seen.

In the essay "Living Color: Race, Stereotype, and Animation in Spike Lee's *Bamboozled*," Mitchell examines the fluidity of the racist image, flowing, as it does through all forms of media, into the psyche and outward again to influence and damage interpersonal connections.

"For it is the pictures—the stereotypes, the caricatures, the peremptory, prejudicial images that mediate between persons and social groups—that seem to take on a life of their own—a deadly, dangerous life at that—in the rituals of the racist (or sexist) encounter." (Mitchell, p. 297)

The Minstrel and Blackface stereotype has been an object of controversy "throughout the history of black culture" and all attempts to either eradicate or legislate (OR SHOUT DOWN) the image/language of these stereotypes have kind of backfired. Mitchell suggests that our "stereotype of the Stereotype ... is of a *sterile type*, not of a living or lively image" that slips past our sensors like a virus that resists immunization.

I don't want to talk about this much, because there is a lot of

22

23

24

scholarship already about the history and complexity of the Racial Stereotype, and I have contributed mightily to the effort of activating and moving these same tropes to suit my own needs.

My responsibility as an artist is to the integrity of my thought process, my experience, my interests and desires—Right? and to locating a means by which I can make this apparatus visible. So here's my question, again: Do I have a social responsibility to my images? I mean Specifically to the materials and subjects that are in my employ?

Or—Do I, by choosing to engage in a postmodernist dialectic, reactivate that European, white, hetero-sexist, patriarchal, Imperialist, Colonizing, value system in which

1 the artist is master of all (he) touches, and
2 the canvas and image are merely reactive substrates? and
3 must the viewer be relegated to passive, disempowered witness to this injustice?

~~Can I, as an artist, attest to any allegiance with feminist, anti-colonial, resisting politics from within this structure?~~

Can the performative act of cutting a figure out at least allude to the transient nature of the stereotypical image and can the use of narrative and figuration indicate my ambivalence about the act of making art? And is that enough if it works?

It was my hope that these images [and my practice] would never sit still, and for them to resist conforming to the limited expectations viewers might have for them. ~~The figures that I, artist, slash from the blank page are in flux during the act of cutting and remain mutable when fixed to the wall~~

However, my work has become fixed, so what was once a deeply intertwined mix of the private, personal, historical, psychosexual, and esthetic has now a recognizable Master.

In her text "Kara Walker No / Kara Walker Yes / Kara Walker?" Howardena Pindell and twenty-eight other writers have taken to task several interrelated issues: this artist's responsibility to her images, the psychic pain transmitted by the act of looking at the art of Kara Walker, the Contradictory perspectives on racism posited within the work of Kara Walker, the hegemonic dominance in the art market of "the art of Kara Walker," and the need for resistance to the Dominating power structure—a sketchy "negress" called Kara Walker —who works in cahoots with white supremacy.

The texts, some of them poetic, some not, are one form of creative resistance, the resistance of the viewer against the abusive nature of the art, the art market, and the conditions of its making.

[I will quote, but will try to resist editorializing]

To quote contributor Rashidi Ishmali in her essay "A Voice from the Other Side of the Canvas":

> Investors, critics and art patrons who support this work use pseudo-crit language to obscure both context and content. While Kara Walker can, should and must be able to do, say and perform her artistic themes and images in any manner she wishes, we, the onlookers have the right and responsibility to not be amused, provoked or titillated.

Camille Ann Brewer's essay "Time to Bring about Change":

> Ms. Walker has learned well to entertain her audiences with a long legacy of eschewed perceptions of American History and subconscious thoughts of the perceived "other" by the majority. If the vile and volatile images, which she has a right to produce, are her point of departure, then where do we go from here conceptually? If Ms. Walker decided to express her "Negress" narrative in an abstract framework, would she still be the celebrated art world wonder and "genius" who

has been groomed to become the standard to which all other visual artists are measured?

Najjar Abdul-Musawwir more or less gets to the heart of the question:

> I am not interested in celebrating the stereotypical aesthetics of Denzel Washington, Halle Berry or Kara Walker. I am not willing to sacrifice the empowerment of African Americans, or any people, at the price of celebrating stereotypes that empower Whites in American society. I am not interested in exploiting the serious history of African Americans for selfish gain. I cannot respect any artist who is willing to do so. I believe we must direct a warning to our society about the psychological damage done by empowering white supremacy through African-American art. I am interested in how our generation, and those to follow, are empowered beyond the Willie Lynch mentality of Art Making.

Camille Billops writes in a short paragraph "Kara Walker's Message":

> ~~Kara Walker's work has its roots in minstrelsy. At one time the Germans, the Irish, the Jews, the Italians and the Blacks were all mocked by Americans and the British. Gradually, over time all the minorities except the African Americans were able to suppress the racists' jokes and mockery.~~
>
> To gain perspective on Walker's art, ask yourself this question: Can you imagine a Jew exhibiting a Jew in Auschwitz fucking a dog? Or an Italian in silhouette sucking on a Nazi's dick?
>
> The question is not whether it happened, but rather why should we publicly remind the world of minstrel mockery of our own people, even if we're well paid to do it. While our black leaders demand of us to stop using the "N" word, Walker's art tells the world:
>
> "See, we were and are Niggers, and we're not ashamed of it." Our struggle has been too hard and long to get Obama elected to the Presidency to denigrate our images now.

So now it is 2009 and I can speak at least for now, for my art.

If you ask me to imagine something, Camille, I will—because I am cursed with an active imagination, and I'm not afraid to use it. Just now, in your essay you conflated a fantasy "Jew" artist exhibiting "a Jew" without once suggesting some kind of mediation: Is the Jew in a film? a painting? In what context might this bestial image be occurring—gallery? porno?

Whether we should be Public with our imaginations seems to be the issue, and isn't that the nature of art?

I am going to Take a closer look at this "Willie Lynch mentality of Art making," ~~Najjar,~~ because it is part of the black existential, and art is a pretty good means for articulating intangibles like that.

But honestly Howardena, I want to thank you for this book. You know by now that I am the great devourer, and a prolific image maker—if you feed me the stereotype of myself, you'll not like what comes out the other side …

Section 5: The Trade off
Escape from perpetuation. Denial of the gaze. Reduction of pleasure

"Mommy makes Mean Art."—Octavia at age 4

I found myself turning back to this long running critique of the Artist Kara Walker, noting that her methods of image construction feature a reliance on having the "viewer" complete the violence of the acts she depicts. By hiding sexual and violent acts behind a veil of the solid black cutout she sometimes evades responsibility, positing the interpretation of the image squarely in the mind's eye of the viewer. The viewer is so preoccupied with "figuring it out" that she sometimes loses sight of the artist's ulterior motive—That this artist wants the whole process, from historical pain to mediated image to conflicted imagination to physical sensation to art object to its "read," to be alive—to move and rattle the nerves of its author.

30

31

and as rattled nerves go, and as Ms. Pindell, et al. attest, the
work—its reification of the dynamic of imperialism,
and the attendant fame and fortune showered on me (Not Matthew
Barney or Damien Hirst wealth, mind you)

this work that displays and flays the figurative (whether
representational or not),

my work, which conflates historical fact with its fictions

is making black people sick.

Section 5.2: Thirteen ways of looking at a Black Girl (and then some)

Around the time of my Whitney Museum survey, I made an effort to
speak truth to power—the power in question was my own,

If my work spoke back and said "don't hurt me anymore," as some
might attest, I would

first be pissed off. Angrily recalling my libidinal drive from the effort
to speak about pain and suffering. I would yell at my work and say,
"You wouldn't even BE here if it weren't for me!"

And if my work said: "Take your hands off my body," I would reply,
"Your Body is My body."

And if my work threatens to leave, I will threaten to throw her out,
and keep the money.

And my work will then sleep quietly on the sofa, silent and afraid for
many months.

Eventually I would ask, with false humility, if I might win her back by
addressing the subject of power. Would that make her happy?

And if my work agreed to this constraint, because she loves me, and

BOYS WILL BE BOYS, ELECTRIC
IMPULSES TO THE NIPPLES, FLAYED
SKIN AT BACK, BEACH BALL, SKINNED
AND LICKED CLEAN, SAND MIXED WITH
SEMEN. SEA SALT IN WOUNDS. SCAR
TISSUE LOVELY. LIGHTER FLUID, MATCH.
SKIN BUBBLES/ BOILS. HOT BODIES WRITHING
IN LUST. ROPES SINGE, MUSCLE SINEW
TAUT THEN SLACK. LIPS CURLED,
EYES BUGGIN', TEETH SINK TO
NEW DEPTHS, BONE SUCKING.

32

SKIN PULLED TIGHT OVER MUSCULATURE
MADE WEAK BY STARVATION. IT IS
ALL your fault that i am here
Doing this to you. You could Have prevented
this outcome if you just Kept your pants
up. you dirty minded ape. I don't believe
in thoughts like that. See what you
have forced me to do. Pull your SKIN
BACK IN

33

an imaginary Black man forced
to invent 'The White Woman' to
Scream him into Being.
Every canvas is a space
Begging to be maimed
The Paper calls the Brush
to break its neck

34

A WHITE ARTIST WOULD BE
LYNCHED FOR SUCH REMARKS
IF BLACK ARTISTS WERE
THE LYNCHING SORT BUT
WE ARE TIMID IN SOCIAL CIRCLES
AND UNUSED TO CASTING
A GLANCE ASKEW AT WHITE
ART DESPITE ITS RACIST
UNDERTONE

35

PICTURES YOU Neither
COMPREHEND NOR RESPECT.
LAUGH YOUR HEARTY LAUGH
AT THE LITTLE RAPED
DRAWING OF NEITHER/NOR.
WE WILL SIT IN STRADDLE
POSITION ETERNALLY AROUSED
By THE IMPOSSIBILITY OF
CLOSURE

36

Leave this place to find work 'up North'
NOTHING BUT THE SHIRT ON MY
BACK. NOT EATEN IN DAYS
A KIND FACE IN A NEW COUNTY BY
NIGHTFALL I HEAR SOME VOICES.
By day break I am a head on a
Post a body in a cold Stream
let that be a warning to others

37

DOCILE AND SWEET COMPANION
Broken at the Neck and
Hog-tied. Hands all Shaky
and Great With Child. Kindness
found in a glimmer of her killers
eye. To change me you will
have to bust me up. I never
learn.

38

blank

39

Thirteen ways of Looking
at a Black Girl

(and then some)

section 6

40

41

wants to rehabilitate me—I would ask, "May I cut out a figure?" and my work might reply, NO, because this is just how it starts—"once you start cutting, you lose all self-consciousness, you act like you own us, you think you're big."

Next my work will deny me the usual moves—visual pleasure—a surface to rest on—a particular touch that dazzles an audience accustomed to gazing with wry ambivalence at my uncensored images.

Next my work will demand some kind of restorative space to gather itself and then ask that I provide it. With all the restrictions intact.

And if I am a good artist, I will comply with the demands of my art, because it has put up with me long enough.

So, without resorting to my usual narratives and figuration—denying, most of all, the sensual pleasure of visuality and composition, I sat down to this brutalist group of posters on an existential theme of reconstruction.

I think of them as drawings about that moment when the voice of the perpetrator uses the language of the victim—and I also think about them as the moment a painting is created, perpetrator/victim. The bare-knuckle obliteration of an iconic empty field. The direct translation of passion to surface.

And my art thought it was an effective step toward repairing our unique bond. My art wanted truth and reconciliation.

However I, the artist, still want to believe she is a fiction whose rights must be denied, that my drive toward the spectacular may survive.

[Search for ideas supporting the Black Man as a work of Modern Art,

Contemporary Painting. A death without end.]

Conclusion

Perhaps artworks have drawn other conclusions about the nature of their confinement?

and Artists, perhaps your relationship to your work is less confrontational?

less fraught with anthropomorphizing gestures,

or reactions against colonization or issues stemming from enslavement.

What solutions can we find to reconcile the satisfying, self-aggrandizing, or ambivalent process of Making

The owning and touching, moving and shaping of space—without exacerbating the tortured cry from within the frame?

KARA WALKER

September 25, 2009

SLIDE CAPTIONS

1 (Slide 2), *I am the Perpetrator: section 1*. Courtesy the artist.

2 (Slide 4), *"nigger"* (Corpse of Black Man – lynched – face painted white, shirt stained with human blood (his own) seated in a chair, propped up with stick held by an unseen perpetrator and perpetrator's shadow, circa 1900). Source: *Without Sanctuary: Lynching Photography in America*, http://www.withoutsanctuary.org/main.html (accessed April 14, 2010).

3 (Slide 6), *black*. Courtesy the artist

4 (Slide 7), *untitled* (JOHN GAST, *American Progress*, 1872. Oil on canvas). Source: "American and New England Studies," University of Southern Maine, http://www.usm.maine.edu/anes/news/image-gallery.html (accessed April 14, 2010).

5 (Slide 9), EDWARD LINLEY SAMBOURNE, *The Rhodes Colossus Striding from Cape Town to Cairo*, cartoon for *Punch*, December 10, 1892. Source: "The Rhodes Colossus," Wikipedia, http://en.wikipedia.org/wiki/The_Rhodes_Colossus (accessed April 14, 2010).

6 (Slide 10), *blank*. Courtesy the artist.

7 (Slide 11), *action* (HANS NAMUTH, *Jackson Pollock at work,* 1950). Source: "Beauty," Library of Congress, http://www.loc.gov/exhibitis/eames/beauty.html (accessed April 14, 2010).

8 (Slide 12), *untitled* (The body of 17-year-old Jesse Washington after he was beaten with shovels and bricks, castrated, had his ears and fingers cut off, and finally burned alive. His body is here hanging on display in Robinson, Texas, seven miles from Waco, where the lynching took place. Postcard, May 16, 1916). Source: *Without Sanctuary: Lynching Photography in America*, http://www.withoutsanctuary.org/main.html (accessed April 14, 2010).

9 (Slide 14), *(action painting)*. . . (CHRISTIAEN VAN COUWENBERGH, *Three Young White Men and a Black Woman*, 1632. Oil on canvas). Source: Web Gallery of Art, http://www.wga.hu/frames-e.html?/art/ (accessed April 14, 2010).

10 (Slide 15), . . . Courtesy the artist.

11 (Slide 16), Courtesy the artist.

12 (Slide 17), Courtesy the artist.

13 (Slide 19), *untitled* (JOHN T. BLEDSOE, *Little Rock, 1959, Rally at State Capitol/JTB*, August 20, 1959, film negative). Source: Library of Congress, "Prints and Photographs Online Catalogue," http://loc.gov/pictures/item/2003654354/ (accessed April 14, 2010).

14 (Slide 23), *A Great Injustice Has Occurred: Section 2*. Courtesy the artist.

15 (Slide 24), *untitled* (Red Guards burning books). Retrieved from http://mike-serverthepeople.blogspot.com/2008/08/battle-for-chinas-present-mao-and.html (accessed April 14, 2010).

16 (Slide 25), . . Courtesy the artist.

17 (Slide 26), *I am the Victim . . . : Section 3 sigh* (Image of Kara Walker). Courtesy the artist.

18 (Slide 27), *untitled* ("Some Class Eh?," circa 1900. Postcard). Source: http://www.cardcow.com/148782/some-class-eh-ethnic-black-americana/#img (accessed April 14, 2010).

19 (Slide 28), **sigh**. Courtesy the artist.

20 (Slide 29), **sigh** (Chimpanzee painting). Courtesy the artist.

21 (Slide 30), *OMG!* (PABLO PICASSO, *Les Demoiselles d'Avignon*, 1907). Courtesy the Museum of Modern Art.

22 (Slide 34), *Scapegoat: Section 4*. Courtesy the artist.

23 (Slide 35), *untitled*. Courtesy the artist.

24 (Slide 36), *Slavery! Slavery!*, 1997. Cut paper on wall. Collections of Peter Norton and Eileen Norton, Santa Monica, California. Source: "The Art of Kara Walker," Walker Art Center, http://learn.walkerart.org/karawalker/ Main/Humor (accessed April 14, 2010). Courtesy the artist.

25 (Slide 37), *Slavery! Slavery!*, 1997. Cut paper on wall. Collections of Peter Norton and Eileen Norton, Santa Monica, California. Source: "My Complement, My Enemy, My Oppressor, My Love," Whitney Museum of American Art, http://whitney.org/Search?query=Kara+Walker (accessed April 14, 2010). Courtesy the artist.

26 (Slide 39), *Song of the South*, 2005. Installation. Courtesy the artist.

27 (Slide 40), *untitled* (LEFT: HOWARDENA PINDELL, *Free, White and 21*, 1980. Film still. RIGHT: Image of Kara Walker). Courtesy the artist.

28 (Slide 41), *untitled* (Cover of Howardena Pindell et al., *Kara Walker – No/Kara Walker – Yes/Kara Walker – ?* (New York: Midmarch Arts Press, 2009)). Courtesy the artist.

29 (Slide 42), Courtesy the artist.

30 (Slide 43), *The Trade off: section 5 "mommy makes mean art" – O at age 4*. Courtesy the artist.

31 (Slide 44), *Search for ideas supporting the Black Man as a work of Modern Art/Contemporary Painting. A death without end: an appreciation of the Creative Spirit of Lynch Mobs –*. Fifty-two works, installation view, Sikkema Jenkins & Co., New York. Courtesy the artist.

32–38
(Slides 45–52), *Search for ideas supporting the Black Man as a work of Modern Art/Contemporary Painting. A death without end: an appreciation of the Creative Spirit of Lynch Mobs –*, installation of fifty-two works, 2007. Ink on paper. Courtesy the artist.

39 (Slide 53), *blank*. Courtesy the artist.

40 (Slide 54), *Thirteen ways of Looking at a Black Girl (and then some): section 6*. Courtesy the artist.

41 (Slide 55), *10 Years Massacre (and its Retelling) #2*, 2009. Cut paper and acrylic on gessoed panel. Courtesy the artist.

42 (Slide 56), *black*. Courtesy the artist.

43 (Slide 57), *conclusion of sorts: should art objects be treated as entities with civil rights?; do artists owe audiences the right to reject art on the grounds of human rights offenses?; should artists curtail the notion of "freedom of expression"*. Courtesy the artist.

44 (Slide 58), *conclusion of sorts: Must Black artists carry a special burden relative to western art and objects, specifically because of European usurpation/cooptation of bodies, resources and images from Africa?*. Courtesy the artist.

45 (Slide 59), *conclusion of sorts: what steps to move beyond a Master/slave, perpetrator/victim, dialectic of Artist/ Object; is it possible (or even desirable) to apply real world negotiation strategies to the "fictive" world practice?*. Courtesy the artist.

46 (Slide 60), *untitled* (Image of Kara Walker). Courtesy the artist.

NETWORKED EQUALITY: TECHNOLOGY AND ACCESS

A discussion between Omar Wasow and Ethan Zuckerman moderated by Brian Sholis

With an introduction by Lauren Cornell

One of the greatest promises of the Internet is its ability to connect people across geographically distant locales and incongruous cultures; one of the most fatuous myths associated with it is that its technology, alone, will be able to usher in a globalized world. Like anything else, the Web is what people make of it. Tim Berners-Lee, the British engineer and scientist credited with its founding, said recently: "We don't look at [the Web] anymore as connected computers or as connected Web pages. We look at the Web now as humanity connected. Humanity connected by technology."[1] The "wow" factor of the Web is gone; what we have now is a vibrant, complex new public realm that reflects international society, in all its varied wisdom and possibility, and its bad behavior as well.

In spring 2009, my co-curators on the New Museum exhibition "The Generational: Younger Than Jesus" and I invited the critic Brian Sholis to organize a series of public programs that would consider the show's themes, which were generationality and emergent directions in contemporary art. An edited excerpt from one of these fascinating panels follows. It captures a conversation between two leading technology theorists: Ethan Zuckerman, senior researcher at the Berkman Center for Internet and Society at Harvard Law School and a co-creator of GlobalVoices, and Omar Wasow, a doctoral candidate in African American Studies and Government at Harvard and co-founder of Blackplanet.com. They discussed the notion of "networked equality"—a concept of technological access crucial for international education and society, and one underlined by a serious contradiction: currently, there is no networked equality; rather, a dramatically uneven relationship to the Web is pervasive around the world, as is a shifting concomitant set of problems and possibilities. In broad terms, issues of access remain urgent in many places, whereas in areas where connectivity is more widespread, the pressing question becomes how best to harness it.

Wasow and Zuckerman elucidate some of the challenges affecting these two extremes of equality in regard to youth and education. First, where there is access, there is a tendency, in

Zuckerman's words, toward "homophily," or the pursuit of sameness. In other words, contrary to popular hopes, youth are not seeking out *new* social universes through the Web or social media, but rather increased connection with the peers they already know; their social worlds are merely replicated and reinforced online, not elaborated. Second, in areas where connection to the Web is harder to obtain, the salient strategy has been to supply hardware, as in the project One Laptop per Child. The question raised in both cases is: what happens exactly when that connection is supplied, and is it enough? While having a computer or cell phone is essential to communication today, what is needed for a multicultural Web is the promotion of an intelligent and creative citizenry that uses it well. In terms of strategies, Wasow argues for the importance of education that fosters curiosity and confidence (instead of "computer literacy") as building blocks for understanding and innovating with technology; Zuckerman points to websites, including his own luminary GlobalVoices project, that translate international news and provide deeper context for current events. What emerges from their suggestions and analyses is that, even as our world becomes more connected through the Web, cross-cultural engagement is something that needs to be actively and continually built around the new set of problems facing us today relating to how information is created, disseminated, and discovered.

Questions about networked equality are of the utmost importance for art, in regard to how work is discovered, discussed, and historicized. Contemporary art—itself a paradigm often based in a critique of modernism's innate Western bias—needs more initiatives that recognize the Web's promise, and limitations, and that strive to push past them toward greater international engagement. Wasow and Zuckerman don't directly address contemporary art, but their conversation—as well as their larger bodies of critical work—illuminates the reality of how people engage the Web and suggests powerful methods of improvement.

LAUREN CORNELL
Executive Director, Rhizome
Adjunct Curator, New Museum

BRIAN SHOLIS: Most people are very happy to move in the world they live in. And so my first questions have to do with how to make incentives that encourage people to get around the borders that we've wrapped ourselves in. Do you need government to step in and somehow encourage people to seek connections with and knowledge about people with whom they might not otherwise have contact or to consider information that the market might not otherwise provide them? Can you speak a little to that?

ETHAN ZUCKERMAN: So the analogy I usually use when I talk about this stuff is to talk about information from the same perspective as nutrition. You may notice that I'm sort of a thick guy. There are people out there who would suggest and mandate that people need to eat in certain ways. I'm sure there is a strain of thought that wants to constrain me from going out for a beer after this talk.

Generally speaking, the way the US government has handled this is by making information available, through things like nutritional information labeling. When we're talking about that sort of information, the more the information the better. So we don't mandate that people stop eating Cheetos or whatever other personal temptations are out there, but we do warn people that they may need certain things in their diet and we show them how to get them.

That's probably what I would suggest around diversifying information online. First of all, we do a terrible, terrible job of having a sense of what news we're actually getting. A lot of us pat ourselves on the back for reading *The New York Times*, for watching whatever news is on television. You may well be consuming crap—particularly if you're looking at newscasts. During the average nightly newscast on local television, something like less than 10 percent is given to international news. By the way, that has fallen by almost 300 percent from the 1970s.

So in a world that is getting more and more global, the economy gets more global, and there are more global threats, whether from disease or terrorism or anything like that. And yet, what you've got is a world where you're getting less and less information about those things. So having some good information about what we're seeing and what we're experiencing would be a really nice first step.

Second, when you look on the back of your package of Cheetos, it gives you some basic nutritional information. It essentially says that having eaten this, you don't need any more calories today. You can choose to do what you like with that information. It would be interesting to think about what "nutritional" information is needed to be an informed citizen and live in a democracy, which is more or less what we live in.

So no, I don't think anyone is going to mandate these things. As much as I would love to mandate that 10 percent of the time be given to African news on television every night, it's just

not going to fly. But in truth, most of us are fooling ourselves. I think most of us believe we're getting more diversity than we actually do.

I hang out in a couple of well-known online communities, places like Reddit and Metafilter, where people pride themselves on not being creatures of the mainstream media, on getting their own news. But if you do an analysis of what shows up on these sites, it's far worse than what you would get out of a good newspaper. It's way more centered on certain issues. If you look at the community you're hanging out with, within a group like Reddit, it's 90 percent male and 87 percent English as a first language. It's a very limited piece of it. So let's get the information about what we're encountering first, and then let's figure out how to make other changes from there.

OMAR WASOW: So I have two quick reactions. First, you're clearly right. I worked in local news for a while, and I worked for MSNBC when it was first starting up and trying to figure out what it was in the mid-1990s and late 1990s. When Princess Diana died, the slogan that never made it on the air, but that reflected the gallows humor of the staff, was "If they're dead, we're live—MSNBC." "If it bleeds, it leads" is the classic story of local news. So that's absolutely true. The funniest example of that to me was how Fox at one point had their "international minute" and they literally had a stopwatch in the corner of the screen so you knew you only had to suffer through another twenty-five seconds. And of course the last ten seconds were something like "Look, it's an elephant on a bicycle!"

So, yes, fundamentally you're right. The riddle though is how to deal with the motivation. I think about this with nutrition too, right? What is it that gets people to change behavior? For the most part, I don't know that nutritional information changes people's behavior much. I mean people know smoking isn't good. They know that eating at McDonald's every day is probably not a path to longevity, and yet that doesn't seem to change things. And so I come back again to championing the idea that we need to think of this more in terms of building a foundation and education. I'm often surprised at how newspapers like *The New York Times* will decry all sorts of broad trends related to declining literacy or the way people aren't reading as much as they used to. But then they are one of the most cautious organizations when it comes to talking about school reform. So, in my mind, they are really conservative in a kind of anti-reform way, and I have to ask, do you not see that there's a tension there? That if we do not produce more deeply literate, engaged, passionate readers and writers out of our K–12 school system, then your newspaper's audience is not going to grow?

It's a very long-term and in some ways almost clichéd argument, but maybe the last point would be to frame it around who are the good guys and who are the bad guys. In our public education system, we have a bureaucracy that is the bad guy, and we have a lot of people who

are champions of the status quo, and I put them in the camp with the bad guys. The insurgents, which I mean in a positive sense, are the folks who are really pushing to break the monopoly that exists. So what gets us to a more literate America and a perpetually more engaged America is first that people get a quality education so that they maybe read the *Financial Times* rather than *The Wall Street Journal* and they read *The Economist,* which is a little better than, say, *Newsweek.* But also that people have access to sources like *The European*, a newspaper/ magazine that is now defunct, so they have a deeper connection to the world at large. Those sorts of experiences might produce individuals who have an internal motivation to do it rather than a sense of "oh, I know it's good for me, but I don't want to."

ETHAN ZUCKERMAN: The "it's good for me" approach never works, right? You and I were both part of the generation whose parents were told to get their kids a computer, that this would be a good, aspirational thing to do. "Your kid will learn how to program in Basic. He'll be smart. He'll go on to great success." It happened to be true in both of our cases, but not quite the way they expected.

What actually happened was we really wanted to have a video arcade. You run out of quarters after a while. It turns out that you can type in programs that are not nearly as much fun as Donkey Kong, but once you start fooling around with them, they can actually become as much fun, and at a certain point typing in the game and then modifying it, programming it, is actually more fun. So what happens is that you get seduced into all of this.

The truth is that when you're talking about getting people to be cosmopolitans, getting people to be globalists, you need to seduce them into it. In some cases, I mean that literally. The people who do cross the line tend to be people who already have reason to cross lines in other aspects of their lives—they are bilingual, they are bicultural, they have some sort of deep interest that's already taken them out of their cultural reality. I actually think the way a lot of people end up becoming globalists in one fashion or another is by falling in love with someone from another culture, another place. Once you're dating someone from Ghana, it actually kind of forces you to learn the culture.

The other thing you said, which I think is absolutely right on, has to do with the nature of education. We may differ on the individual questions of how we would set up different schools, but one of the things that is becoming incredibly important to the world media and media reform is this idea of how educated your audience is. CBC/Radio-Canada is starting to do an experiment during their international news. First, they give you this minute-long story—"here's the breaking story out of Sri Lanka"—and then they back it up with four minutes of context: by the way, there's been a civil war here for thirty years; here's why the Tamil and the Sinhalese are different people; here's what they both want out of this. You would assume that this sort of spoon-feeding

would build resistance. Instead, what they're finding out through user surveys is that people love it, and once they're getting more and more of this background information, what they want now is to find out the resolution of these stories.

So I would say that on the issues I care about, I'm with you: you've got to start in school, and you've got to start by reforming a geography curriculum, which has essentially fallen off the mountain. You need to start by having classrooms where people are reading the newspaper every day. I don't care whether they read it on screen or read it on paper, but having some sort of global engagement.

BRIAN SHOLIS: I couldn't agree more. If we're going to parse "good" people and "bad" people in these larger questions, to what extent are such lines divided generationally? I'm thinking of social issues like the acceptance of gay marriage, for example. Increasingly, it seems that it will resolve itself.

OMAR WASOW: This is why technology access doesn't matter, and let me limit my comments here to the United States. I think it matters enormously in other parts of the world. But there is a technology equivalent of junk food, which is a kind of "pure consumption" model. If all you do is play video games and you don't ever get to a place where you're building something and engaging yourself in a different way, then it may be fun, but it's not necessarily allowing you to do more in the world. Again, I want to be careful, as I'm indicting video games here. Anything can be really powerful. But it's absurd to think that we need to worry about young people [in the United States] getting access to technology. The people who need to worry about getting access to technology are old people, right? Young people in this country have a relatively high access to technology and are going to Wikipedia, but a lot of what they're doing is playing and listening to music and watching videos and that's great. But it's not making them more critical thinkers necessarily. The Internet is not necessarily a tool for civic engagement. It can happen. I'm not saying it's exclusively junk food. But in the same way that given the choice between a chocolate chip cookie and broccoli, you'll more often than not pick the chocolate chip cookie, more often than not kids would rather download music or movies or play games.

The generational divide that does exist speaks almost to a curse of abundance, right? The person who grew up in the pretechnology era, who had an education that forced them to learn to write in longhand, may have some advantages over the person who learns to write on a word processor. The skill is not fundamentally about manipulating words easily. It's about communicating effectively, being able to construct words elegantly. Just because young people have more access to technology doesn't mean they have more of the skills that would allow them to succeed in a network economy. I think a lot of the skills that allow you to succeed in the

network economy are old liberal arts kinds of skills, such as learning to tell truth from falsehood. How do you pick color A versus color B, pixel A versus pixel B, stock A versus stock B? That's about cultivating wisdom, and that's not fundamentally about technology.

BRIAN SHOLIS: As you respond to that, I just want to throw in the idea of some sort of cultural inertia that becomes lessened over time by virtue of the fact that globalization becomes substantiated in a more real, rather than imaginary, globalization or cosmopolitan manner.

ETHAN ZUCKERMAN: I have a bunch of colleagues at the Berkman Center who are maybe twenty years older than we are. These are folks who generally encountered the Internet once their brains were already fully shaped. They were working scholars who had theories about how people interact with one another, and these guys were blown away by it. They thought it was the coolest thing out there. Governments were going to fall, national boundaries were going to be wiped away, and we were going to head toward some sort of postnational utopia by virtue of the fact that we were all connected by networks of love and grace.

You get to our generation, the people who actually did a lot of the early development with this, and there is a really mixed picture, right? I mean, part of my experience of the Internet has been deeply international, a deeply connected space. I've met amazing people from all over the world in part because when I got online in the late 1980s, there were only a couple hundred thousand geeks in the world that you could talk to and it didn't matter so much whether they were in Japan or in Turkey. They all spoke marginal English and they all understood Monty Python jokes. That has changed over time.

A colleague of mine at the Berkman Center, danah boyd, who studies youth culture by hanging out with kids at shopping malls, came back to me the other day and said these kids don't talk to anyone online they don't already talk to at school. And what's happened is that these networks, which are now ubiquitous within American culture, have simply replicated a lot of existing social infrastructure.

As social media comes into play, I'm actually watching people turn from globalists into localists. Essentially, what happens is that when a network comes online and very, very few of your neighbors are on that network, you have a great incentive to connect internationally. As soon as your neighbors pick this up, you've got so much more social capital with people who are your countrymen, people who are in your city, people who are already in your social circle.

So people are hanging out on sites like Facebook, which turn out to be amazingly powerful diversifying tools if used in the right way, and they're simply reinforcing certain circles that people are already in. The great thing about technology is that it makes possible all sorts of different connections that just weren't possible at an earlier time. The bad thing is that it doesn't

change human nature and particularly as it becomes more pervasive, it actually sort of forces us back into relationships we were already in. Once you can now go and hang out online with all the folks in your neighborhood or all the folks at your school, there are really strong social incentives to go ahead and do that.

So I think what you're finding with our generation is this odd sense of disappointment. Actually no, the Internet hasn't revolutionized education. It certainly hasn't internationalized the world to the extent we would want. My guess is that the generation of kids who are growing up in it right now as digital natives are thinking, "duh." I mean, why did we ever think this stuff was transformative? I don't ask my mobile phone to be transformative. I don't ask my car to be transformative and bring about utopia. Those are old enough technologies for which we know the downsides as well as the upsides.

OMAR WASOW: I couldn't agree more. We can't just fetishize technology. But I do think there are opportunities to deliver … so we spend $60 billion in our schools deploying computers and Internet access and have very little to show for it in K–12 education. I think we are actually on the verge of something much more … where we're going to start seeing some return on the confluence of technology in education, and that has me very excited. I genuinely think that it's going to be possible—I don't know if it will be in ten or forty years—for a poor child anywhere in the world without access to a high-quality teacher to get more or less a very high-quality education that's entirely self-paced using some cheap device. And you know, that's not going to be true for all disciplines. It's probably hard to teach yourself musical theater, but reading, writing, math—you could build self-paced modules that would sit on a cheap computer and take a child from kindergarten through the twelfth grade. I'm not arguing against children playing with other children and being in school, but if they don't have access to a good school, then the computer alternative may be radically better.

ETHAN ZUCKERMAN: So interestingly enough, that's the logic behind OLPC [One Laptop per Child], right?

OMAR WASOW: No, because I think for the OLPC it's the hardware that matters, and my argument is that the software matters. That what's really important is producing high-quality educational software, and as best as I can tell, that's not been a core part of the story yet with One Laptop per Child. And that's been my frustration. There is a lot of innovation to admire in what they've done, but I think we need to focus much more on how to produce high-quality educational software.

ETHAN ZUCKERMAN: So who leads that movement? You're a pioneer in changing education within this country. Whether or not it's the One Laptop per Child device or something else, computers are coming into the classroom in this country. And they're coming into the classrooms with exactly the same problems that One Laptop per Child has had, which is that students love them and teachers hate them.

OMAR WASOW: Right.

ETHAN ZUCKERMAN: I think that changes a little bit as teachers are getting younger and younger. But where is that effort going to come from? Who's going to build that software?

OMAR WASOW: Well, I'm literally thinking about, with other people, ways to develop a nonprofit to do more of that. So, one answer is that I am trying to think about it. And there is the PlayPower group that I mentioned, who have this incredibly exciting story about millions of cheap $9.00 computers. What I came away with from talking to them was wondering, okay, how do we open source the manuals and the computer magazines and take all of that infrastructure that was so critical to my kind of self-paced education and make it available to some kid who has this $9.00 computer that is hooked up to a TV but who doesn't have any of the instructional materials? And then how do we take it even one step further and give them something more than just PDFs?

At the Games for Change gathering [New York, 2009], there was a woman from Sri Lanka who was talking about these programmers she works with there who were all basically self-taught. They learned to program in Basic, and one person would go and download a chapter [of the manual] and print it out and then they would all share it. That's how these guys learned to become programmers. As one person put it, if you know how to type you go from earning $1.00 a week to $1.00 a day, and if you learn to program you're going to be a middle-class person pretty much anywhere in the world.

So how can we push it so we're not just distributing a manual, but instead achieving something where the computer actually functions like a tutor? There are good examples of this now where computers are serving as tutors to help kids learn. But it means not just saying "here's the text, type it in yourself." Rather, the computer is prompting you and taking you step by step through something.

BRIAN SHOLIS: I want to ask about the graduated deployment, so to speak, of all these technologies, all this software. With your international experience and in light of what you've said about those of us who have come to learn about the downsides of networked technology, do you feel it's incumbent upon people who have already gone through that experience to let those

coming to networked technology for the first time learn at their own pace? Or should we impart the lessons learned from previous experience? And also, have you noticed—in other countries that are now dealing with social networks and social media—the same kind of replication of existing face-to-face networks that danah boyd has identified? Is that necessarily the case in other cultures, and if so, does it happen more quickly, less quickly?

ETHAN ZUCKERMAN: The NGO that I previously founded—Geekcorps—was based on this idea. The way I learned to program, *really* program—not just fool around, but make cool websites that made real money program—was through apprenticeship. Particularly in learning Unix, which is the core of the Internet, it's the operating system we all speak. It's kind of how the online world is actually written. The books just won't help you … you almost have to be initiated into it. You almost have to go through a hazing ritual with it and preferably find someone to sit next to you as you go through it.

So one of the things that I was really worried about after spending a lot of time in Ghana was that technology was getting stalled at the level of what you could do with Windows. My feeling was that if we could get some Unix hackers on the ground, then we had the possibility of people getting to the next level. Keep in mind, I'm not talking about teaching Basic to high school students. The sort of projects we were working on had to do with trying to get a Rwandan company up to speed so they could manage the database that handled the court scheduling for the Gacaca trials in the wake of the genocide. If the choice was between going to a US contractor for several million dollars or going to a Rwandan contractor for several million dollars, wouldn't it be great to go to a Rwandan contractor?

So I think there are targeted interventions, whether it's thinking about ways to essentially walk people through a programming curriculum or to try to coach and mentor some folks within a technical ecosystem. I don't think this is like *Star Trek* "first contact," where you let people figure this all out on their own. I think we can intelligently figure out ways to work through this with them.

ENDNOTE

1 Tim Berners-Lee, "IGF 2009 Opening Keynotes" (keynote address, Internet Governance Forum (IGF), Sharm El Sheikh, Egypt, November 15, 2009). Audio of the keynote address entitled "Berners-Lee talks about today's Web" can be accessed through Elon University/Pew Intern Project: http://www.elon.edu/e-web/predictions/igf_egypt/keynote.xhtml (accessed March 24, 2010).

PART II
ON ARTISTS

SHAINA ANAND

BORN 1975, BOMBAY/MUMBAI, INDIA
LIVES AND WORKS IN MUMBAI

Shaina Anand cites underground nuclear testing in 1998 in India as prompting her involvement in activism. The event galvanized many fellow activists in Mumbai who were also increasingly concerned with India's role in international trade agreements.[1] As economic globalization was being heralded, few were scrutinizing the effects of this shift on a local level. Anand, whose background is in documentary film, decided to explore the possibility of using broadcast media as a way to draw attention to socio-economic problems.

In 2004, a crew of student videographers, under Anand's direction, turned Shivaji Nagar's Russel Market in Bangalore into its own television channel, *Rustle TV*. The pace of the project was very fast, lasting about two weeks. Students ran about the market gathering footage. They then learned to edit this onsite so that it could be quickly looped back to the market—which constituted not only the channel's primary audience, but also its featured performers. This meant that programming was being aired as new material was being cut or filmed. The simultaneity of this productive loop was deliberate: The purpose was to encourage immediate, active engagement.

Building upon the infrastructure of *Rustle TV*, Anand organized a media event that was to run parallel to the 2005 World Information City Conference, which focused on promoting information technologies, distribution, and access. To realize her project, Anand arranged for pirated programming to be provided to about 3,000 local homes via an illegal but free television cable channel provided by a local cableman named Lokesh. As an intervention, *WI City TV* (2005) manifested the conference's themes on the local level, contrasting the abstractions of conference talk with the reality of what true "access" might mean. Content for *WI City TV* was gathered by several artists, video- and filmmakers, and editors who interviewed local residents and took shots of the neighborhood surrounding the conference. Among other subjects featured were sellers of bootleg films, a century-old cinema, and the shopkeepers of a bazaar and a market, both of which were being torn down to build malls in Shivaji Nagar, Bangalore.

Critical Art and Media Practices (CAMP) was founded in 2007 as an umbrella of sorts for projects by Anand and fellow artist-activists Sanjay Bhangar and Ashok Sukumaran. Influenced by open-source software, CAMP interrogates modes of ownership, investigates physical infrastructures, and seeks new modes of distribution. It is also a studio space that is collaborative and open, supporting a variety of artist- and media-based projects. CAMP has given

FIG. 9 (TOP): *Motornama Roshanara*, 2008. Cycle-rickshaw tours of the Roshanara road, transport and industrial area. Twenty rickshaws, 90 minutes each, eleven locations, accompanying soundtrack, New Delhi. Courtesy the artist

FIG. 10 (LEFT): *Khirkeeyaan*, 2006. Video, CCTV cameras, cable TV, television sets, microphones and other surveillance technology. Courtesy the artist

FIG. 11 (RIGHT): *Recurrencies-sharing_01*, 2007. Wireless electronic system, switchboard with two dimmers, 60-watt bulb, standing fan. Courtesy the artist

rise to a number of works, including the online archive of transcribed video footage called Public Access Digital Media Archive (pad.ma), and *Wharfage* (2008), which produced a book on radio transmissions documenting non-WTO-liable "free trade" between Sharjah and Somalia.

As Anand's projects often focus on local networks of exchange that are already in place, she frequently takes on the role of producer, setting the stage for media interventions. A series of projects under the title "Recurrencies" (2005–)[2] focuses on how electricity functions formally, symbolically, and semiotically as currency. One incarnation of this project, called *Everything is Contestable* (2006), took place in Singapore at the Church of St. Gregory the Illuminator. Switches controlling the lights of the church façade were posted at two locations: one, just outside the gate, worked 24 percent of the time, while the other, which was farther away, worked 76 percent of the time. The incongruency is equal to the percentage of electricity provided by the state versus electricity provided more reliably by the private market. Confusingly, some private providers are actually owned by the state, raising doubts about the possibility of true economic competition. This dilemma hones in on contradictions that Anand highlights again and again in her work as she works to redefine prevailing notions of culture, democracy, and access.

YO

NOTES

1. Alessandra Renzi and Megan Boler, "Chitrakarkhana: Picture Factory-Artist Food. Interview with Shaina Anand, Media Activist, with Alessandra Renzi and Megan Boler," in *Digital Media and Democracy: Tactics in Hard Times*, edited by Megan Boler (Cambridge, MA: MIT Press, 2008), 2.

2. Other projects include *Changes of State* (in which the façade of the 110-year-old Elgin Talkies Theater in Bangalore became animated with sound, smoke effects, and light via the manipulation of four electric switches posted outside near to the theater; Elgin Talkies, Bangalore. World Information City, 2005) and *Khirkeeyaan* (a closed-circuit video that produced seven episodes from content gathered at four locations within a 200-meter radius; Khirkee Extension, New Delhi, 2006).

SELECTED BIBLIOGRAPHY

Anand, Shaina, "WIC TV," in *In the Shade of the Commons: Towards a Culture of Open Networks*, edited by Lipika Bansal, Paul Keller, and Geert Lovink (Amsterdam: Waag Society, 2006).

—— "Notes on Micromedia Ecologies," presentation on Global Media for Culture Industries, Cultural Diversity and Cultural Policy in the Time of Globalisation at a two-day consultation on the UNESCO Universal Declaration of Cultural Diversity, Centre for the Study of Culture and Society and Alternative Law Forum, Bangalore, India, September 27–28, 2007.

—— Artist's website: http://www.chitrakarkhana.net/

"Chitrakarkhana: Picture Factory-Artist Food. Interview with Shaina Anand, Media Activist, with Alessandra Renzi and Megan Boler," in *Digital Media and Democracy: Tactics in Hard Times*, edited by Megan Boler (Cambridge, MA: MIT Press, 2008).

EDGAR ARCENEAUX

BORN 1972, LOS ANGELES
LIVES AND WORKS IN LOS ANGELES

Acting as both witness and participant, Edgar Arceneaux reveals unlikely parallels between historic events, aesthetic gestures, and schools of thought. He describes his work as "epistemological in nature," and in his installations he "investigates not just what we know, but how we come to know it."[1] Arceneaux's approach combines rigorous scholarship with free association. His methods suggest a gifted detective who has a sharp eye, arcane knowledge, an affinity for deductive leaps, and a sympathetic understanding of human behavior.

Arceneaux employs a range of different artistic practices to realize his conceptually based projects. The exhibition "Correlations and Isomorphisms" (2008) combines painting, drawing, sculpture, and video projection. The display asserts a relationship between very different systems used to make sense of the world, such as the Zodiac, Christianity, cosmology, and phenomenology. Yet Arceneaux is able to isolate the secret, nearly invisible strands that connect these philosophies, gradually shaping a harmony rather than a hierarchy. In *Constellation Drawings (Last Supper Room)* (2008), the twelve signs in the Zodiac are aligned with the number of Christ's disciples present at the Last Supper, thereby providing the groundwork for a series of drawings. Rolled up and positioned upright behind a cloth-draped table, twelve drawings flank a thirteenth, in reference to Leonardo da Vinci's painting of the Last Supper. Visitors may unroll the drawings to reveal lush and inviting depictions of the heavens, each charting a different constellation. In this way, the visitor is invited to join Arceneaux's investigations and to consider the ways that meaning is often arbitrarily ascribed to different objects or events.

The Alchemy of Comedy ... Stupid (2006), another example of Arceneaux's large-scale projects, similarly unites very different topics under a single premise, and illuminates the bonds between comedy and sympathy, performer and audience, and perception and reality. The work comprises a grid of video monitors surrounded by unfinished sketches and the artist's handwritten notes. The monitors are arranged to reference ancient alchemical structures, and the videos are tinted to reflect the four elements: yellow for air, red for fire, blue for water, and green for earth. Each channel presents heavily fractured edits of a routine by comedian David Alan Grier, whose jokes, when discernable, seem designed largely to keep sadness at bay. Over the course of the performance, Grier confronts his difficult relationship with his father, failed relationships, and his own terror at being tested for cancer. Arceneaux's video-editing relies on the same strategies of misdirection, surprise, and contradiction on which Grier's jokes depend,

FIG. 12 (TOP): *Alchemy of Comedy ... Stupid*,
2006. Nine-channel video (four projections, five
32-inch flat screen monitors, five DVD players),
cardboard, and wood. Dimensions variable.
Courtesy the artist and Susanne Vielmetter
Los Angeles Projects. Photo: Gene Ogami

FIG. 13 (BOTTOM): Watts House Project,
September 27–28, 2009. Courtesy Watts House
Project and Susanne Vielmetter Los Angeles Projects.
Photo: Aimee Chang

and essentially drain the comedy from the routine, thereby unraveling the emotional complexities that underlie the humor.

In 2008, Arceneaux assumed directorship of the Watts House Project, "an artist-driven urban revitalization project centered on the historic Watts Towers in the Watts neighborhood of Los Angeles."[2] Existing in the shadows of Simon Rodia's Watts Towers, the project is designed to right an unfairness that has long troubled the neighborhood: the lack of social or economic benefits that the neighborhood should have received as a result of being home to one of LA's main tourist attractions. Every year, thousands of visitors come to see the towers, and the city invests no small amount of money to maintain Rodia's work, although Watts, a historically black neighborhood, has long been neglected by municipal agencies. Since its inception in 1996, the Watts House Project has added murals to some of the houses under its umbrella, designed custom fencing for others, and installed at least one new driveway. In 2008, the program expanded its activities, recruiting designers and artists to enact even more ambitious overhauls, such as landscaping and architectural renovations.

Rather than treating the neighborhood's houses as a blank canvas for artistic creation, Arceneaux is emphatic about the necessity of having the residents determine the project's direction. He describes his role as a facilitator who oversees this "open studio" and locates specialists who can realize the homeowners' ideas for improving their homes and neighborhood. In this way, the Watts House Project is a continuation of a studio-driven practice exemplified by "Correlations and Isomorphisms," in that the core strength of the artist lies in identifying unlikely affinities and building on these connections. In Arceneaux's own words, "rather than just arbitrarily building/constructing relationships, I am recognizing that which exists before us."[3]

ES

NOTES

1. Alma Ruiz, "Interview with Edgar Arceneaux," *From and About Place: Art from Los Angeles* (Tel Aviv: The Center for Contemporary Art, 2008).

2. Ibid.

3. Ibid., 78.

SELECTED BIBLIOGRAPHY

Arceneaux, Edgar, *Lost Library* (Ulm, Germany: Kunstverein Ulm, 2003).

—— *The Alchemy of Comedy … Stupid* (Chicago: WhiteWalls, 2006).

Gaines, Charles, "Edgar Arceneaux's Search for Meaning Among Infinite Variations," *Afterall* 10 (Autumn/Winter 2004): 64–71.

Lorch, Catrin, "Drawings of Removal," *Afterall* 10 (Autumn/Winter 2004): 76–80.

Mizota, Sharon, "Public Equity: Edgar Arceneaux and Watts House Project," *Artforum* 47, no. 3 (November 2008): 155–56.

Ruiz, Alma, "Interview with Edgar Arceneaux," *From and About Place: Art from Los Angeles*, exhibition catalogue (Tel Aviv: The Center for Contemporary Art, 2008).

ANDREA BOWERS

BORN 1965, WILMINGTON, OHIO
LIVES AND WORKS IN LOS ANGELES

Of the famous Black Panthers Party credo, "Do something, even if you only spit," Andrea Bowers says, "It was a proletariat call to action. I'm an artist so I use my art as spit."[1] Approaching art's conflicted relationship to activism as a problem that needs solving, Bowers often combines interviews, videos, drawings, and archival materials to make projects that respond to feminist and political ideas—particularly the various forms of civil disobedience and activism in which women have participated or played a prominent role. She has adopted a conceptual practice influenced by Michael Asher, Charles Gaines, Hans Haacke, Suzanne Lacy, Adrian Piper, and Martha Rosler, artists whose steadfast commitment to their political beliefs has significantly impacted Bowers and helped shape her understanding that the personal is political, and thus all art is inherently political.[2] Her methodology begins with a close examination of a community's response to an event or issue that often divides people (abortion, the US invasion of Iraq, AIDS, and immigration). Bowers then uses aesthetics as an entry point for viewers to "sit with"[3] issues to which they may have strong reactions, and through her work she hopes to find ways of changing belief systems that unfairly malign marginalized populations.

In *The Weight of Relevance* (2007), Bowers documents the maintenance and storage of the 1987 AIDS Memorial Quilt in a three-channel video. Interviews with the people, mostly women, who care for and display what is known as the largest piece of folk art in the world, are juxtaposed with close-ups of the vibrant quilt in its storage facility. This project was developed in response to the article "AIDS Quilt Old and Fading: Once a Mighty Symbol of Love and Loss, the Patchwork Tribute to the Dead Has Gone from Large to Largely Forgotten," in the *Los Angeles Times*.[4] Bowers examines the current status and meaning of this "once mighty symbol," and asks why this National Treasure does not carry the same "weight" it once did. Bowers proposes that its diminished importance could be attributed to demographic shifts in those being infected (in the twenty-first century, the disease is primarily contracted by women and people of color) and the quilt's relocation from San Francisco, which has a large gay population, to Atlanta's mostly black community. The slow-motion camera work and the documentary footage in *The Weight of Relevance* allow viewers to sit with the quilt and consider their own politics and role in re-silencing histories.

Bowers also engages in a labored, intensive process of realistically drawing archival materials, documents, and photographs—a practice influenced by the draftsmanship of Vija

FIG. 14 (TOP): Stills from *The Weight of Relevance*, 2007. Three-channel video (color, sound, 26:15 minutes, looped), three DVDs, three DVD players, three video projectors, speakers. 80½ x 435 inches (204.5 x 1104 cm). Courtesy the artist and Susanne Vielmetter Los Angeles Projects

FIG. 15 (BOTTOM): *Still Life of The AIDS Memorial Quilt in Storage (Blocks 4336–4340)*, 2007 (detail). Colored pencil on paper. 72 x 36 inches (183.5 cm x 92 cm). Courtesy the artist and Susanne Vielmetter Los Angeles Projects. Private collection. Photo: Gene Ogami

Clemins and Sylvia Plimack Mangold. In the series "Eulogies to One and Another" (2006), Bowers drew reproductions of articles found on the Internet that concerned the deaths of American aid worker Marla Ruzicka and her translator Faiz Ali Salim in Baghdad. Rendered with great detail, including pixilation, the thirty-two drawings show Bowers's commitment to the medium as a way to honor the subject and give her an intimate understanding of it. In *Nonviolent Civil Disobedience Drawing (Elvira Arellano in Sanctuary at Adalberto United Methodist Church in Chicago as Protest against Deportation, 2007)* (2007), Bowers demonstrates her attuned sense for detail in her depiction of Elvira Arellano, a Mexican activist who entered into sanctuary in a Chicago church in 2006 to avoid being separated from her eight-year-old son, Saul, a US citizen. In this and other works, the act of dissent has tremendously affected Bowers and her understanding of artistic practice. As she has stated, "To bear witness is not only to observe but also to provide proof and testify … dissent is patriotic and essential to maintaining democracy. These positions allowed me to consider the relationships between art and politics in much more fluid ways."[5]

By telling Arellano's story with empathy and speaking to the injustice of American immigration and border policies, Bowers addresses the ways in which US politics are often entangled with religious belief by asking, "Who would Jesus deport?" In challenging us to consider our own political position on the contentious topic of immigration, such a question is typical of Bowers's compelling, powerful work.

JKII

NOTES

1. Correspondence with artist on January 23, 2009.
2. Ibid.
3. *Between Artists*, "Andrea Bowers in conversation with Catherine Opie," (New York: A.R.T. Press, 2008), 45.
4. Correspondence with artist on January 23, 2009.
5. Andrea Bowers as cited in Eungie Joo, "DIY School: Andrea Bowers and Eungie Joo in Conversation," in *Nothing is Neutral: Andrea Bowers* (California Institute of the Arts and REDCAT, 2006), 51.

SELECTED BIBLIOGRAPHY

Bowers, Andrea, "Guest Lecture by Andrea Bowers," *Artillery 1*, no. 5 (May 2007): 24.

Joo, Eungie, *Nothing is Neutral: Andrea Bowers*, exhibition catalogue (Los Angeles: California Institute of the Arts and REDCAT, 2006).

Cesarco, Alejandro, ed., *Between Artists: Andrea Bowers in Conversation with Catherine Opie* (New York: A.R.T. Press, 2008).

Dawsey, Jill, "Andrea Bowers' History Lessons," *Afterall* 14 (Autumn/Winter 2006): 18–26.

MARK BRADFORD

BORN 1961, LOS ANGELES
LIVES AND WORKS IN LOS ANGELES

Mark Bradford deems his work "paintings," but instead of pigment, his materials consist of posters and glue, and sometimes string and silver leaf, and his paintbrush is a commercial sander. His process is akin to collage or, to be more precise, decollage, the traditionally Surrealist practice of revealing images by removing material from a collaged surface, rather than adding to it. The materials Bradford considers his "paint" are torn and distressed posters that were ripped from the fences of the South Central Los Angeles neighborhood where he has a studio. Upon closer examination, viewers will notice that words and images begin to emerge,[1] resulting in a vivid composite of urban life.[2]

In *Mississippi Gottdam* (2006) Bradford layered silver leaf on top of community posters and pieces of string that had been glued to the canvas. The string is applied in flowing, wave-like patterns. Paraphrasing the artist, curator Carter Foster states that these waveforms, which appear frequently throughout the work, "evoke the form and subject of Leonardo da Vinci's celebrated drawings of current patterns and deluges in which cities are destroyed by inundations of biblical scale."[3] Using a sander and various other tools, Bradford recovers portions of the color and content from the posters hidden beneath the silver leaf. The final work shows a vast silver tsunami of spiraling waves that obscures the community messages conveyed through the posters.

Bradford's titles suggest that there is something more than abstraction at work in his compositions.[4] For example, *Mississippi Gottdam* references the Nina Simone song "Mississippi Goddam" (1964), in which she sings out against those who advise her to "go slow" in her pursuit of African American civil rights: "To do things gradually would bring more tragedy."[5] Bradford turns the title into a tragically ironic pun: Mississippi supposedly has "got a dam," but the dam is broken and waves of water consume the community underneath. Bradford, who created this work in 2006, is clearly referencing the aftermath of Hurricane Katrina in 2005. The work vividly illustrates the effect of the hurricane on African American communities in Mississippi, and takes up Nina Simone's refrain in his frustration against those who say, "slow down."

Bradford occasionally ventures into performance art, video art, sculpture, and site-specific installations, as illustrated in two other works that directly reference the devastation of Hurricane Katrina: *HELP US* (2008) and *Mithra* (2008). The rooftop installation *HELP US* (2008) is a sign made from white stones that simply spells out the words "HELP US." The message recalls the pleas written by many New Orleans residents on the roofs of their homes as they waited for

FIG. 16 (TOP): *Mississippi Gottdam*, 2007. Mixed media collage on canvas. 102 x 144 inches (259.1 x 365.8 cm). Courtesy the artist. Photo: Luciano Fileti

FIG. 17 (BOTTOM): *Mithra*, 2008. Wood and found materials. Dimensions variable. Installation view, *Prospect 1*, New Orleans. Courtesy the artist

assistance. The installation of this artwork at Steve Turner Contemporary in Los Angeles, which was only visible from the air, underscores the artist's concerns about the lack of civic urgency in response to the crisis despite the many people who were still in dire need.[6]

Mithra (2008), a site-specific sculpture erected in the Lower 9th Ward of New Orleans, is meant to evoke Noah's ark, and is composed almost entirely of plywood fencing. Bradford deliberately placed the work in the neighborhood that was most devastated by the hurricane. Mithra is a Zoroastrian deity who is supposed to aid in the destruction of evil and the administration of the world. This work is further evidence of Bradford's astute understanding of the symbolic power of different materials—the plywood fencing calls attention to the need to rebuild the neighborhood. Noah's ark promised the salvation of all God's creatures on Earth. By naming his ark "Mithra," after a non-Christian divinity, Bradford conflates myths across religious boundaries and demands that everyone consider the difference between mere salvation and reconstruction.[7]

TC

NOTES

1. The geographic source and exact nature of his primary material occasionally varies.

2. "Art:21 Access '07: Mark Bradford at the Studio Museum in Harlem," Public Program, Studio Museum in Harlem, October 4, 2007.

3. "The inspiration is direct, according to the artist," in Carter E. Foster, *Neither New nor Correct: New Work by Mark Bradford*, exhibition catalogue (New York: The Whitney Museum of American Art, 2007).

4. Consider, for example, these Mark Bradford titles: *Black Venus* (2005); *Black Wall Street* (2006); *Noah's Third Day* (2007); *A Scaled Down Atlas for a Scaled Down Monarchy* (2007); *James Brown is Dead* (2009).

5. "Mississippi Goddam" was written by Simone in response to the murder of Medgar Evers and the bombing of the 16th Street Baptist Church in Birmingham, Alabama, in which four African American girls were killed. Nina Simone and Stephen Cleary, *I Put a Spell On You* (Cambridge, MA: Da Capo Press), 1991.

6. Shana Nys Dambrot, "Mark Bradford: *Help Us*," March 29, 2008, http://flavorpill.com/losangeles/events/2008/3/29/mark-bradford-help-us (accessed September 12, 2009).

7. Doug MacCash, "A Three-story Surrealistic Ark Aground in the Lower 9th Ward," *The Times-Picayune*, November 2, 2008.

SELECTED BIBLIOGRAPHY

Bedford, Christopher and Hamza Walker, *Mark Bradford*, exhibition catalogue (Yale University Press: Wexner Center for the Arts, 2010).

Foster, Carter E., *Neither New nor Correct: New Work by Mark Bradford*, exhibition catalogue (New York: The Whitney Museum of American Art, 2007.

Gaines, Malik, Ernest Hardy, and Philippe Vergne, *Mark Bradford: Merchant Posters* (Aspen, CO: Gregory R. Miller & Co./Aspen Art Press, 2010).

Joo, Eungie, *Bounce: Mark Bradford & Glenn Kaino*, exhibition catalogue (Los Angeles: California Institute of the Arts/REDCAT, 2004).

Mack, Joshua, "Mark Bradford, 'Nobody Jones'," *Time Out New York*, February 13, 2008.

Pesanti, Heather, "Mark Bradford," in *Life On Mars: 55th Carnegie International*, exhibition catalogue (Pittsburgh, PA: Carnegie Museum of Art, 2008).

GINGER BROOKS TAKAHASHI

BORN 1977, HUNTINGTON, WEST VIRGINIA
LIVES AND WORKS IN BROOKLYN, NEW YORK

A belief in the power of collective action to overcome seemingly insurmountable obstacles is central to the work of Ginger Brooks Takahashi. Inspired by her early encounters with DIY punk culture and its relatively small-scale, self-sustaining lifestyle, Brooks Takahashi organizes new, self-sustaining communities that question cultural conventions.[1] Group art-making is central to her activities as a way to unite individuals so they can work together to liberate and redefine attitudes toward such key issues as gender, feminism, homosexual identity, sex, and social history. The resulting work of art is a collective gesture of defiance, and therefore all the more meaningful and important to the community that created it.

Brooks Takahashi's interest in community and collaborative processes perhaps most directly evolved from her participation in the collaborative project *LTTR*.[2] Created in 2001 as an annual independent "gender queer feminist art journal," *LTTR* was published by a group of artists (also calling themselves LTTR) who worked together without hierarchy and were driven by a shared ambition to address their own contemporary "gender queer feminist" community.[3] The art and writing in *LTTR* was generated from submissions solicited via the Internet and various other modes of outreach, and edited by LTTR members. The journal was then distributed to potential members and supporters of that community in order to bring them into the fold. The journal thus represents a group of people who are in the process of identifying and expanding their own cultural identity, an aspect that figures prominently into Brooks Takahashi's later work.

In *How did she find herself here?* (2007) Brooks Takahashi develops a dialogue between her own practice and that of Nancy Holt, namely Holt's seminal earthwork *Sun Tunnels* (1973–76). This is one of a series of works in which Brooks Takahashi references underrepresented aspects of 1970s queer and feminist culture and embarks on imaginary collaborations between herself and a past that she is only able to experience through art objects and artifacts. In *How did she find herself here?* Brooks Takahashi takes photos of Holt's earthwork, turns these photos into slides, and incorporates the slides into a new installation, suggesting evocative analogies between acts of collaboration, appropriation, copulation, and procreation, while earnestly attempting to transcend boundaries of space, time, and logic in order to connect more profoundly with another artist and her work.[4]

Brooks Takahashi's efforts to generate and explore new communities through collaborative art-making experiences have culminated in her ongoing work *an army of lovers*

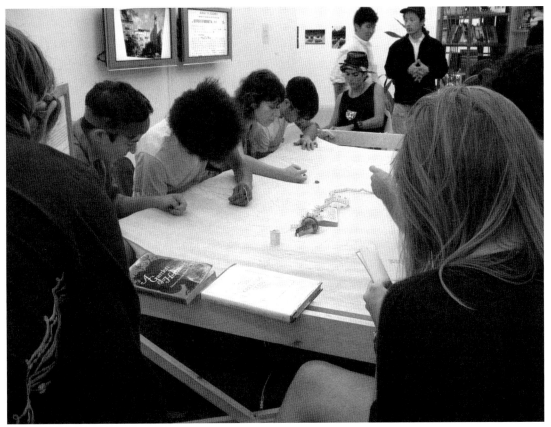

FIGS 18 + 19 (TOP): Excerpt from *How did she find herself here? Nancy Holt, 1973–76*, 2007. Slide projection installation: forty text and image slides on auto-replay. Dimensions variable. Courtesy the artist

FIG. 20 (BOTTOM): *an army of lovers cannot fail*, 2006. Powerstitch event, "Museum as Hub: Six Degrees," New Museum, 2008. Courtesy the artist and New Museum, New York

cannot fail (2004–), whose title could be taken as the thesis of the artist's practice. In this participatory work, friends and strangers are invited to join the artist in a series of quilting forums called "Powerstitches." Each forum lasts several hours as participants are encouraged to contribute their own stitches to an all-white quilt designed by the artist, while sharing readings and reflections on the subjects of privilege, sex, and society. The quilt, which has yet to be completed, documents the presence of those who have previously participated in its creation while offering itself to new hands, generating its own unique, perpetually self defining community across barriers of time and place. Linking back to the artist's own queer identity, the quilt playfully incorporates white-on-white stitched images of large bunnies posed in various homosexual acts with women. These seemingly harmless yet explicit images encourage even non-queer individuals to join in an open-ended (but still decidedly *queer*) dialogue without inhibition, emphasizing once again the idea that love, inclusivity, and togetherness are the ultimate weapons against apparently insurmountable forces such as fear and ignorance, which are perpetuated by some facets of mainstream American society.[5]

TO

NOTES

1. Correspondence with artist on December 28, 2008.
2. Holland Cotter, "Explosion LTTR," *New York Times*, August 6, 2004, sec. E32. LTTR is an acronym with many meanings, including "Lesbians To The Rescue" and "Listen Translate Translate Record," which are the titles of the first and second issues of the journal. A definitive meaning of LTTR remains intentionally elusive, further underscoring the idea of a community in the process of expanding the definition of itself.
3. LTTR and contributing artists, *LTTR V: Positively Nasty* (2006).
4. Ginger Brooks Takahashi, "How Did She Find Herself Here?" May 22, 2007, http://brookstakahashi.com/holt (accessed March 18, 2009).
5. "Ginger Brooks Takahashi, Dave McKenzie, and Lisa Sigal in conversation with curator Eungie Joo," New Museum Public Program, October 18, 2008.

SELECTED BIBLIOGRAPHY

Brooks Takahashi, Ginger *et al.*, "About *LTTR*," *LTTR*, 2007, available at http://www.lttr.org/about-lttr (accessed March 18, 2009).

Carpenter, Susan, "Whirl of the Words," *Los Angeles Times*, August 21, 2002, available at http://articles.latimes.com/2002/aug/21/news/lv-bookmobile21 (accessed February 9, 2010).

Chun, Kimberly, "Interview with Ginger Brooks Takahashi," *San Francisco Bay Guardian*, February 8, 2006, available at http://www.sfbg.com/40/19/art_art_ginger.html (accessed February 9, 2010).

Cotter, Holland, "Explosion LTTR," *New York Times*, August 6, 2004, sec. E32.

CENTER FOR LAND USE INTERPRETATION

FOUNDED 1994

BASED IN CULVER CITY, CALIFORNIA, AND WENDOVER, UTAH

As stated on its website, the Center for Land Use Interpretation (CLUI) is an organization "dedicated to the increase and diffusion of information about how the nation's lands are apportioned, utilized, and perceived."[1] It executes this mission through a staggering range of media outlets, including books, exhibitions, information kiosks, bus and boat tours, educational outreach programs, videos, and a quarterly newsletter, among others. Founded in 1994 by the artist Matthew Coolidge and a small group of collaborators, it has rapidly grown into its institutional ambitions, expanding to encompass field sites, outposts, and residencies across the country. Since its inception, CLUI has deployed an interdisciplinary methodology that draws on a variety of organizational models.

CLUI defines its field of inquiry as "anthropogeomorphology"—Coolidge's neologism for the study of the landscape as altered by humans.[2] It archives the raw material for these investigations in its Land Use Database, a repository of "unusual and exemplary land use in the United States."[3] These seemingly contradictory criteria of the "unusual and exemplary" guide CLUI's data selection, giving equal weight to the exceptional and the banal. The Land Use Database composes a portrait of America that is at once familiar and utterly foreign, highlighting both our everyday geography and less frequented locales ("landfills, utility corridors, airports, shipping terminals, power plants"[4]) that quietly define the contours of our way of life. When a location brought to CLUI's attention meets these benchmarks, an independent field researcher will visit and photograph the site to identify its defining characteristics. This emphasis on "ground truth"— empirical, descriptive observation—is essential to the organization's methodology. While preexisting narratives about a site can reflect the interests of property or government, CLUI strives to articulate an unbiased, politically neutral account of land use.

In commemoration of the sesquicentennial anniversary of the discovery of oil in the United States in 2009, CLUI embarked on a three-part project mapping the centers of the American oil industry: Alaska, California, and Texas.[5] Given the critical nexus oil occupies in the broader matrix of economic, environmental, and security policy, CLUI hypothesized that the industry's footprint would in some measure reflect America's character as a nation.[6] The Alaska portion of this project resulted in *The Trans-Alaska Pipeline* (2008), a slide show of captioned photographs documenting the 800-mile-long artery that conducts oil from the nation's largest oil field to domestic markets. Aerial photographs capture massive industrial pumping stations nestled in yawning valleys, while ground-level views show the pipeline's surreal, snaking path through

FIG. 21: *The Trans-Alaska Pipeline: A CLUI Photoscape Presentation*, 2008.
Courtesy the Center for Land Use Interpretation photo archive

tundra. CLUI's extensive text covers everything from the structure's corporate stakeholders to acts of sabotage by rural Alaskans. Through this evenhanded, non-polemical presentation, a picture of the pipeline emerges as the circulatory system of a hybrid ecosystem that, while remote, remains intimately connected to our daily lives.

A similar view of the land emerges in *Up River: Points of Interest on the Hudson from the Battery to Troy* (2007). Tracing the river's banks, CLUI identifies and describes the military bases, historic mansions, abandoned quarries, repurposed factories, and other structures that preserve the region's densely layered history. The Hudson's role as a conduit between New York City and rural upstate has shaped the state's economic and cultural character for generations. As Coolidge writes, the "sculpted landscape" of the river's shores "tell[s] what we have done with our past to get to the present and about the journey to this point and beyond."[7] *Up River* calls these sites to our attention not to cast judgment, but rather to raise awareness. This effort towards an expanded consciousness of the environment lies at the heart of CLUI's practice, because as Coolidge cautions, "[W]e are bound to forget what we choose not to see."[8]

ML

NOTES

1. The Center for Land Use Interpretation, 2009, at http://www.clui.org/ (accessed May 22, 2009).

2. Jeffrey Kastner and Matthew Coolidge, "True Beauty: Jeffrey Kastner Talks with Matthew Coolidge about the Center for Land Use Interpretation," *Artforum* 43, no. 10 (Summer 2005): 286.

3. The Center for Land Use Interpretation, 2009, at http://www.clui.org/ (accessed May 22, 2009).

4. Matthew Coolidge, "Introduction," in *Overlook: Exploring the Internal Fringes of America with the Center for Land Use Interpretation*, Matthew Coolidge and Sarah Simons, eds, (Los Angeles: Metropolis Books, 2006), 16.

5. *The Lay of the Land* (The Center for Land Use Interpretation Newsletter), "Focus on Oil," edited by Matthew Coolidge and Sarah Simons (Spring 2009): 1.

6. "The places of oil production, conveyance, storage, and processing are the physical landmarks of the petroleum age. Understanding how this system works, on a national level, creates a picture of who we are as a nation," Matthew Coolidge, from Tom Vanderbilt and Matthew Coolidge, "1000 Words: The Center for Land Use Interpretation," *Artforum* 47, no. 3 (November 2008): 299.

7. Matthew Coolidge, *Up River: Man-Made Sites of Interest on the Hudson from the Battery to Troy* (New York: Blast Books, 2008), 5.

8. Ibid.

SELECTED BIBLIOGRAPHY

Coolidge, Matthew and Sarah Simons, eds, *Up River: Man-Made Sites of Interest on the Hudson from the Battery to Troy* (New York: Blast Books, 2008).

Hooper, Rachel and Nancy Zastudil, eds, *On the Banks of Bayou City: the Center for Land Use Interpretation in Houston*, exhibition catalogue (Houston: Blaffer Gallery, the Art Museum of the University of Houston, 2009).

Kastner, Jeffrey and Matthew Coolidge, "True Beauty: Jeffrey Kastner Talks with Matthew Coolidge about the Center for Land Use Interpretation," *Artforum* 43, no. 10 (Summer 2005): 286–87.

Vanderbilt, Tom and Matthew Coolidge, "1000 Words: The Center for Land Use Interpretation," *Artforum* 47, no. 3 (November 2008): 298–305.

NIKHIL CHOPRA

BORN 1974, CALCUTTA, INDIA
LIVES AND WORKS IN MUMBAI, INDIA

Nikhil Chopra's artistic production encompasses drawing, installation, performance, photography, video, and theater. His semi-autobiographical performances react to and capture a particular place and moment in history, yet are distinctly situated in the "now." By layering the past onto the present, Chopra's work offers key insights into how the past influences our current situation. His performances employ various strategies of separating himself from others, the most extreme being a vow of silence. He also sheds any remaining traits from his own personality.

In the performance *The Death of Sir Raja III* (2005), Chopra takes on the character Sir Raja, whom the artist was inspired to create after researching late-nineteenth-century to early-twentieth-century British photography of Indian aristocracy. Adorned with British regalia and demonstrating the utmost proper British etiquette, Sir Raja epitomizes the proverbial English Sahib. During the performance, Sir Raja lies silently still on rugs flanked by elaborate drapes, as if he were posing for Caravaggio, Rembrandt, Vermeer, or Velasquez in an effort to depict his own death. The performance took place on the fourth floor of Kitab Mahal, a British neo-gothic building in the heart of Bombay's Fort District, and there was no clear demarcation between the viewing space and the performance, enabling viewers to come within inches of the action.

But Chopra's main alter ego, Yog Raj Chitrakar, came about as a result of the artist mining his own personal history—"Yog Raj" references his grandfather, Yog Raj Chopra (a hobbyist landscape painter), and "Chitrakar" translates to "picture maker." While at the Khoj International Artist Association performance-art residency in Delhi, Chopra developed his Victorian era[1] draftsman persona and set out on his first expedition as an explorer in search of the perfect vista.[2] In *Yog Raj Chitrakar visits Lal Chowk, Srinagar* (2007), Chopra performed as Yog Raj Chitrakar, complete with knickerbockers, argyle knee stockings, patent-leather lace-ups, necktie, and scally cap. As if transported from the past, Yog Raj Chitrakar walked to the center of the capital of Jammu and Kashmir and began to execute a portrait of Lal Chowk clock tower directly onto the street in charcoal and chalk. Because of boundary disputes between China, Pakistan, and India, the colonial law forbidding Indians to congregate in groups of five or more is enforced in Kashmir, and when onlookers began to form a crowd, a military squadron ordered the spectators to line up to be frisked. Once searched, the curious returned to watch Yog Raj Chitrakar finish the drawing. Perhaps unwittingly, the audience became part of the work through an unspoken agreement to bear the consequences of their viewership.

FIGS 22, 23 + 24: *Yog Raj Chitrakar visits Lal Chowk, Srinagar*, 2007.
Khoj Kasheer, Khoj International Artists' Association, November 2007.
Courtesy the artist. Photo: Sujan Chitrakar

As part of his "Memory Drawing" series, Chopra has performed as Yog Raj Chitrakar in cities such as London, New York, and Mumbai, with little to no direct interaction with the audience. Yog Raj Chitrakar has undergone several transformations (artist, cartographer, dandy, draftsman, empress, explorer, painter, soldier), as the character has evolved over a number of performances, some lasting over two weeks. Approaching each performance with a list of tasks to carry out, Chopra adopts Yog Raj Chitrakar's various traits and performs his daily rituals— dressing, washing, shaving, eating, drinking, and sleeping. Often the process culminates with Yog Raj Chitrakar crowning himself as an empress figure (a transformation of a gender that destabilizes masculine narratives of exploration and conquest while interrogating the extant empire). In exhibitions such as "Yog Raj Chitrakar: Memory Drawing IX" at New Museum, the artist displays remnants of his performance such as half-eaten food, cut hair, articles of clothing, partially used charcoal sticks, and a huge drawing of New York City as seen from Ellis Island to "represent" the performance as a kind of historical event.

Affected by location, time, climate, and general unpredictability, the performances vary widely and their outcomes (and resulting drawings) are impossible to anticipate. The durational aspect of the work prohibits the artist from ever really escaping the character. Yet for Chopra, the amount of time he spends as Yog Raj Chitrakar allows him to answer the question, "What is that character and how blurry can those lines become between what is real and what is fantasy, what is dramatized and what is truly experienced?"[3] The audience is then left to determine ways in which to experience the work and what ultimately happens during the narrative of the ephemeral performance and to its tangible aftermaths.

JKII

NOTES

1. In Yog Raj Chitrakar, *Memory Drawing IX* (2009), Yog Raj Chitrakar's personas shifted from the Victorian era to the 1920s in New York City.
2. Correspondence with artist on November 18, 2009.
3. Interview with Nikhil Chopra by Tom Dodson in *Champs Not Chump*, available at www.champsnotchumps.org/episode_3/transcript (accessed October 12, 2009).

SELECTED BIBLIOGRAPHY

Citron, Beth, "Nikhil Chopra. As Told by Nikhil Chopra to Beth Citron," *Artforum* 48, no. 3 (November 2009).

Jumabhoy, Zehra, "Nikhil Chopra," *Frieze Magazine* 127 (November/December 2009).

Van Lindt, Barbara, "Nikhil Chopra: Yog Raj Chitrakar: Memory Drawing VI," interview between Nikhil Chopra and Barbara Van Lindt, in *Performance— Mumbai*, Brussels Festival brochure, April 30—May 23, 2009.

ABRAHAM CRUZVILLEGAS

BORN 1968, MEXICO CITY
LIVES AND WORKS IN MEXICO CITY

Abraham Cruzvillegas assembles sculptural installations from an unexpected array of materials. The artist studied pedagogy at the National Autonomous University (UNAM) in his native Mexico City and started exhibiting his work in the early 1990s. Together with his peers, he participated in the artist-run space "Temistocles 44," as well as informal workshops organized by the artist Gabriel Orozco. These environments provided an alternative to traditional ways of teaching art and raised concerns that continue to resonate and influence Cruzvillegas's practice, namely labor, exchange of value, and the industrial readymade versus hand-made craftsmanship, specifically as these issues affect or are affected by the sociocultural makeup of Mexico City.

In *Autoconstrucción* (2008), for instance, Cruzvillegas combined wool, wood, iron, tin, painted papers, hemp cord, plywood, plaster, cardboard, plastic rope, a buoy, a pipe, aluminum, chicken wire, ceramics, a broom, coins, sheep feces, and his own hair. The work is entirely composed of materials found around the artist's studio in Cove Park, Scotland, where he was an artist in residence in 2008. While Cruzvillegas used materials that were immediately on hand, *Autoconstrucción* as a whole references the artist's past, namely the settlements in the hills around Mexico City where he spent the greatest part of his childhood. The work, which translates as "self-construction," refers as much to the artist's process of making sculpture in Cove Park as it does to the informal architecture in the outskirts of Mexico City. The houses in Mexico City are built over time and do not follow a preconceived master plan; Cruzvillegas's work echoes this principle by rejecting production and perfection. Instead he brings unstable matter and contrasting materials into the gallery to echo the changing reality outside and to challenge an understanding of sculpture as the ultimate expression of permanence, uniformity, or balance. Cruzvillegas states that he transforms the materials he encounters, but that he does not aim to freeze them into a permanent state: "After transforming something, I want it to be ready to be transformed again, by interpretation, by physical decay, by its own weight, by time. It happens anyway. That is why I don't like the idea of production, because it means arriving at the end, not the beginning."[1]

Cruzvillegas's work frequently focuses on craftsmanship. In an untitled piece from 1993, he presented a bicycle wheel that he filled with a circular wooden panel. While Cruzvillegas's wheel clearly references Marcel Duchamp's 1913 readymade, a bicycle wheel on a stool, the panel featured a painted motif of red carnations created by his own father, who is a professional craftsman. This work exemplifies how Cruzvillegas juxtaposes the found object (made and

FIG. 25 (TOP): *Autoconstrucción*, 2008.
Wood, wool, artist's hair, iron, tin, painted papers,
hemp cord, plywood, plaster, cardboard, plastic
rope, buoy, pipe, aluminum, chicken wire, ceramics,
broom, coins and sheep shit. Variable dimensions.
Courtesy the artist and kurimanzutto, Mexico City

FIG. 26 (LEFT): *Pending Sculpture*, 2008.
Buoys and rope. 106³/10 x 66⁹/10 x 66⁹/10 inches
(270 x 170 x 170 cm). Courtesy the artist and
kurimanzutto, Mexico City

produced elsewhere) with an example of handmade, local craftsmanship. In so doing, he brings up questions of labor and exchange value.

Many of Cruzvillegas's pieces also profit from the artist's astute use and understanding of color. *Cánon Enigmático a 108 voces* (2005), made from discarded buoys, fine wire, and steel wire, is a work that is suspended from the ceiling. The artist salvaged these floating devices from a Yucatán water passage and brought them into the gallery space. This unexpected change of context brings the color scheme and diverse spherical shapes of the floating devices to the foreground. At the same time, Cruzvillegas has also worked in a monochrome palette. *Autorretrato Ciego* (2007–08) echoes the rigidity of early twentieth-century painting and sculpture that reduced the use of color to emphasize geometric shapes. In *Autorretrato Ciego*, however, Cruzvillegas does not attempt such extreme reduction. Instead, he applies a coat of black acrylic paint to one side of found papers, wrappings, postcards, and clippings, and leaves the other side untouched. He then pins these 563 different shapes to the wall, calling attention to geometry and the irregularity of the material that is visible underneath the black layer.

Autorretrato Ciego translates to a paradox: "blind self-portrait." Cruzvillegas's practice stands out for combining opposing elements, both in formal and conceptual terms. *Handrail Ramp* (2007), a fragment from *Autoconstrucción*, uses construction materials (iron bars, pieces of wood) to create an almost delicate, seemingly floating structure. The two inverted wooden canes that support the white-painted wood panel appear to defy gravity and add an unexpected lightness to the geometrically defined construction. Whereas one might expect the solid components of *Handrail Ramp* to result in a sturdy, gravity-bound structure, Cruzvillegas turns the tables on such expectations and brings out an unforeseen lightness and elegance from the ostensibly heavy material.

SD

NOTE

1. Quoted in Tom Morton, "Found and Lost," *Frieze* 102 (October 2006): 214.

SELECTED BIBLIOGRAPHY

Cruzvillegas, Abraham and Francis McKee. *Autoconstrucción: Abraham Cruzvillegas*, exhibition catalogue (Glasgow: The Centre for Contemporary Arts, 2008).

Cruzvillegas, Abraham, Jimmie Durham, Mark Godfrey, Ryan Inouye, and Clara Kim. *Abraham Cruzvillegas Autoconstrucción: The Book*, exhibition catalogue (Los Angeles: REDCAT, 2009).

Cotter, Holland, "Art in Review: Abraham Cruzvillegas," *New York Times*, May 16, 2003.

López-Cuenca, Alberto, "Shells, Sharks, and Boxing Gloves," *Artnews* 102, no. 8 (September 2003).

Rodrigues Widholm, Julie, ed., *Escultura Social: A New Generation of Art from Mexico City*, exhibition catalogue (Chicago: Museum of Contemporary Art, 2007).

HASAN ELAHI

BORN 1972, RANGPUR, BANGLADESH
LIVES AND WORKS IN OAKLAND, CALIFORNIA

On September 12, 2002, Hasan Elahi went to a U-Store It in Tampa, Florida, to pay for a
storage unit. The manager then reported to law enforcement officials that he had seen a Middle
Eastern man carrying explosives and fleeing the area. Upon arriving in Detroit, Michigan on
June 19, 2002, from an overseas trip, the Bangladesh-born Elahi was stopped by immigration
authorities and led to an Immigration and Naturalization Service detention room for questioning
by the Federal Bureau of Investigation (FBI). Elahi has since been repeatedly interrogated by the
FBI as a terrorist suspect, and although he has passed nine lie-detector tests and was verbally
"cleared," he was asked to check in with the FBI prior to each of his departures until further
notice. The first interrogation changed the artist's life. Since his art practice was already focused
on technology and the tinkering of its mechanics, Elahi shifted his attention to his role as
subject, and began to develop his own self-surveillance technology in order to both question the
government's overzealous scrutiny in the name of protecting American democracy, and to address
issues of race, ethnicity, immigration, and citizenship.

In contrast to the maxim, "Innocent until proven guilty," Elahi's practice suggests
that presumption of innocence is only applicable to those whose personal liberties are not
compromised by government regulations, such as the Homeland Security Act and the PATRIOT
Act, passed shortly after the September 11 terrorist attacks. Elahi states, "As a citizen of the
United States, I feel a moral obligation to question my government when I feel it does not
accurately reflect the will of the people."[1] Self-surveillance is an approach that has been used
in conceptual works by Sophie Calle, Chris Burden, and Vito Acconci. By adopting a similar
strategy, Elahi is able to highlight the prejudices surrounding recent events and their political
ramifications.

Tracking Transience (2002–) is an ongoing project that documents, catalogues, and
archives Elahi's whereabouts and purchases. Including images of the airports he has slept in,
toilets used, meals eaten, and a Google map that tracks the artist's exact location via a GPS
device, the online archive, housed on the interactive website trackingtransience.net was initiated
in reaction to the FBI's 2002 investigation. The site is a comprehensive resource providing
quantitative information on the artist's life, such as travels and expenses viewed as data entry
records that read like financial bank statements: 06/18/08 7-ELEVEN 290 GEORGE STREET
NEW BRUNSWICK NJ $9.58. The extensive image bank contains over 20,000 pictures often

FIG. 27 (TOP AND DETAIL BELOW): *Victory Mansions*, 2007.
Ink on paper. 153 x 96 inches (389 x 243 cm). Courtesy the artist

captured with a simple camera phone. All images are immediately uploaded, categorized, and linked to the main archive. Each image, complete with label copy, can be retrieved through different portals, and they have on occasion been installed as photographic montages, such as *Victory Mansion*, a grid of shots of terminals, bathrooms, control towers, and aerial landscapes/cityscapes taken in 2008, and *Altitude v2*.0, a selection of meals eaten in the air during 2005 and 2006. The project provides proof of Elahi's activities, a record that, if need be, could act as evidence in his defense. Referring to this as "aggressive compliance," Elahi takes control of his surveillance through self-regulation.[2] Who could possibly track you better than yourself? Obsessively and somewhat absurdly, Elahi "hides nothing" and "reveals all" through publicly displaying the cache on the Internet.

The project's light-hearted compulsory documentation of every detail belies a sense of psychological discomfort. Addressing privacy issues and racial profiling, *Tracking Transience* questions normative usages and meanings of surveillance. Elahi realizes every viewer's worst nightmare, the fear that someday they may be asked to provide similar information.[3] In positioning the viewers as the subject rather than the investigator (the traditional role of a viewer), the website acts as a self-reflection: "What reasonable cause would the FBI need in order to investigate me?" Using equipment and technology that is readily accessible (and even purchased at a local Wal-Mart, as numerous transactions suggest), Elahi shows the civilian how to be his or her own witness. Will Elahi's self-documentation ever cease? Until the government again respects the privacy of its people, expect a daily upload on trackingtransience.net.

JKII

NOTES

1. Correspondence with artist on April 7, 2009.
2. Michael Connor, "The New Normal," in *The New Normal*, exhibition catalogue (New York: Independent Curators International and Artists Space, 2008), 35.
3. Correspondence with artist on April 7, 2009.

SELECTED BIBLIOGRAPHY

"Artist Takes FBI Surveillance a Step Further," Michel Martin in conversation with Hasan Elahi, National Public Radio, May 30, 2007, available at http://www.npr.org/templates/story/story.php?storyId=10540966 (accessed January 26, 2010).

Connor, Michael, "The New Normal," in *The New Normal*, exhibition catalogue (New York: Independent Curators International and Artists Space, 2008).

Elahi, Hasan, artist's websites, 2009, http://elahi.sjsu.edu/ and http://www.trackingtransience.net/ (accessed February 3, 2010).

Mihm, Stephen, "The 24/7 Alibi," *New York Times Magazine*, December 9, 2007, available at http://www.nytimes.com/2007/12/09/magazine/09247alibi.html?_r=1 (accessed January 21, 2010).

CAO FEI

BORN 1978, GUANGZHOU, CHINA
LIVES AND WORKS IN BEIJING, CHINA

In her work, Cao Fei complicates the relationship between the real and the virtual. Her practice might be considered "postmedium," as it attempts to chart new pathways in a cyberspace populated by both fake individuals and real characters. Her interest in the virtual stems from a certain discontent shared by many who are part of a younger generation growing up in an insecure world:

> My country is growing at high speed and the development of the new cities in pace with the global economy is confusing. On many levels, all of us, young and old, lose our way. Costume players juxtapose the fantasy world of video games with the reality of our lives. It is an expression of our alienation from traditional values. This is my generation.[1]

Cao's work suggests a quest for a new relationship between art and society and embraces its dramatic evolution: "We grew up with pop culture, new technologies, electronic entertainment, computer games, American rap … The Chinese contemporary art scene is now entering a completely new phase that is both individualized and globalized."[2]

Engaging technologies that allow users to interact with computer-simulated environments found in virtual games such as Second Life, Cao challenges notions of self and identity. The artist was among the first members to join Second Life.[3] In this virtual world, the players or "residents" interact with each other through the characters they have created. In 2006, Cao Fei invented an avatar named China Tracy, using her virtual experience as the basis for an ongoing artwork. For the Venice Biennale in 2007, for instance, China Tracy was shown building her Pavilion over the Piazza San Marco, and the avatar invited her Second Life virtual friends to join her for the premiere of the projection of the three-part video, *i.Mirror*. The video is described by the artist as a "virtual documentary,"[4] where we follow the adventures of China Tracy dating a young Chinese hipster, traveling to the beach, or visiting a museum in a dislocated urban environment. China Tracy's virtual experiences often express melancholy, as seen in the message that scrolls down the screen: "To go virtual is the only way to forget the real darkness." Cao's "Second Life" project has extended into a new project, "RMB City," a fictional city that is "a rough hybrid of communism, socialism, and capitalism,"[5] being built by China Tracy and involves virtual real estate deals. It also claims

FIG. 28 (LEFT): *Hip Hop Fukuoka, 2005*. Single-channel video. 7 minutes. Courtesy the artist and Vitamin Creative Space, Guangzhou, China

FIG. 29 (BELOW): *My Future is Not a Dream 05*, 2006. Digital chromogenic print. 47¼ x 59 inches (120 x 150 cm). Courtesy the artist and Vitamin Creative Space, Guangzhou, China

to combine "overabundant symbols of Chinese reality with cursory imaginings of the country's future."[6]

The urban environment has been an important factor to Cao's production. In 2004, Cao produced "COSPlayers," a series of photographs and videos depicting young individuals dressed up as their favorite Japanese anime characters and posing among a set of recently constructed buildings. Cao used her native Guangzhou as a backdrop, leading curator Hans-Ulrich Obrist to describe the rapidly growing industrial city as a "nexus" that helps steer and shape the artist's interdisciplinary activities.[7]

As Massimiliano Gioni stated in *Younger Than Jesus: The Generation Book* in 2009, Cao, rather than "discussing the status of the image … seem[s] to be interested in amplifying the symptoms of [a] cultural mutation."[8] The thin line that Cao Fei draws between reality and virtual reality echoes French philosopher Jean Baudrillard's thoughts on simulacra in his essay "Simulacra and Simulation," where he states that the copy supersedes the original and the real dissolves into symbols and signs.[9]

MK

NOTES

1. "Cao Fei/China Tracy," interview with Cao Fei by Carolee Thea, in *Everyday Miracles*, 52nd Venice Biennale (Chinese Pavilion, Venice, Italy, 2007), 122.
2. Ibid., 123.
3. In early 2010, over 17,000,000 Second Life accounts were registered. Linden Lab, "Second Life," 2010, available at www.secondlife.com (accessed January 27, 2010).
4. Eleanor Heartney, "Like Life," *Art in America* 96 (May 1, 2008), 164.
5. http://rmbcity.com
6. Ibid.
7. Hans-Ulrich Obrist, "First Take," *Artforum*, no. 5 (January 2006), 180–181.
8. Lauren Cornell, Massimiliano Gioni, and Laura Hoptman, eds, *Younger Than Jesus: The Generation Book*, exhibition catalogue (New York: New Museum and Steidl, 2009), 39.
9. Jean Baudrillard, "Simulacra and Simulation," in *Selected Writings*, ed. Mark Poster (Stanford, CA : Stanford University Press, 1988), 166–84.

SELECTED BIBLIOGRAPHY

Baudrillard, Jean. "Simulacra and Simulation," in *Selected Writings*, edited by Mark Poster (Stanford, CA: Stanford University Press, 1988).

Cao Fei and Vitamin Creative Space, *RMB City*, 2009.

"Cao Fei/China Tracy," interview with Cao Fei by Carolee Thea, in *Everyday Miracles*, 52nd Venice Biennale (Chinese Pavilion, Venice, Italy, 2007).

Cornell, Lauren, Massimiliano Gioni, and Laura Hoptman, eds, *Younger Than Jesus: The Generation Book*, exhibition catalogue (New York: New Museum and Steidl, 2009).

Heartney, Eleanor, "Like Life." *Art in America* 96 (May 1, 2008).

Obrist, Hans-Ulrich, "First Take," *Artforum* 44, no. 5 (January 2006).

URS FISCHER

BORN 1973, ZURICH, SWITZERLAND
LIVES AND WORKS IN NEW YORK

Urs Fischer's artworks fuse the seeming polarities of logic/nonsense, simple/complex, and reality/fantasy in forming his own theater of the absurd. Often working with traditional media such as drawing, painting, photography, and sculpture, Fischer creates work in which the medium is central to the work's message. For Fischer, "[t]he medium always influences the message. The medium is a medium for the message, after all … [T]he chicken and the egg both come first. I don't believe this is the case for all art-making, but for me it is."[1] While Fischer's work challenges connoisseurship, his use of various styles, techniques, and mediums places the imagination—both his and ours—center-stage in his play on scale, space, materiality, and perception.

Fischer creates hybrids from extreme opposites. Beginning with a small piece of squished clay that is then scanned and enlarged into a cast aluminum sculpture titled *Marguerite de Ponty* (2006–08) that is more than 13 feet high, the artist magnifies a tiny gesture to a larger than life archetype that combines traditional techniques with new technologies. His manipulation of scale is often playful, as seen in *Untitled (Lamp/Bear)* (2006). The nearly 25-foot-high cast bronze sculpture of a teddy bear coated in yellow completely dwarfed its upstate New York surroundings, creating the illusion of being in a giant playroom where mansions were reduced to doll houses and SUVs were miniaturized to Matchbox® cars. The whimsicality is offset by the bear's slump posture and the bisection of its crown by a desk lamp. And yet the lamp is essential, since it illuminates a comforting toy when a child might need it most, in the middle of the night.

Touching on the architectural interventions of Gordon Matta-Clark and earthworks by Michael Heiser, Fischer merged themes of destruction, transformation, and transparency with a 38-by-30-foot crater, 8 feet deep, dug into the floor of New York gallery, Gavin Brown's Enterprise. The 2007 project was titled *you*. The curious ventured into the space, entering as though through a door in *Alice's Adventures in Wonderland*, and inched their way around and into the giant hole. But just as Lewis Carroll had the ability to make nonsense sound logical and vice versa, Fischer had not simply excavated the gallery floor as a deconstructive gesture or an anti-art stunt, but has conceived of a space where the below is still above and the above is not too far from below. That is, what appears to be floor level is actually halfway up the gallery walls.

Works such as *Cumpadre* (2009) and *Noisette* (2009) humorously tweak everyday objects, encouraging comparisons of Fischer's practice to that of an illusionist or magician. Involving the

FIG. 30 (LEFT): *you*, 2007. Mixed media. Dimensions variable. Installation view, Gavin Brown's Enterprise, New York. Courtesy the artist and Gavin Brown's Enterprise

FIG. 31 (RIGHT): *Marguerite de Ponty*, 2006–08. Cast aluminum in five parts. 157½ x 110¼ x 102⅜ inches (400 x 280 x 260 cm) (approximately). Courtesy the artist and Gavin Brown's Enterprise, New York

FIG. 32: *Noisette*, 2009.
Mixed mediums. Dimensions
variable. Courtesy the artist and
Gavin Brown's Enterprise, New York

attachment of a once-living butterfly to an actual croissant, *Cumpadre* forces viewers to consider the "truth" of the materials. The multimedia *Noisette* consists of a latex tongue that pops out of a rough, punched-out hole in the gallery's wall. Since the tongue is motion-activated, viewers can only experience it if they approach and examine the wall's imperfection.

The work *Last Call Lascaux* (2009) consisted of one-to-one scale photographs of the walls, ceiling, and beams of the New Museum's third-floor gallery just after the previous exhibition was deinstalled. The meticulously rendered reproductions of scarred empty walls were then printed as wallpaper and pasted back on the wall, subtly exposing what had previously existed there. The title is a homophone that juxtaposes the site of the Paleolithic cave paintings in France with a bartender's late night announcement often ignored by customers. This layering of the remnants of a past with a seemingly inconsequential present further compounds the confusion between what is remembered and forgotten; concrete and illusory; reality and fantasy.

JKII

NOTE
1. Correspondence with artist on January 5, 2009.

SELECTED BIBLIOGRAPHY

Brown, Gavin. "Interview with Urs Fischer," *Interview* (December/January 2008): 186–91.

Fischer, Urs, ed., *Urs Fischer: Paris 1919*, exhibition catalogue, Whitney Biennial, 2006 (New York: JRP|Ringier, 2007).

Gioni, Massimilliano, ed., *Urs Fischer: Shovel in a Hole*, exhibition catalogue (New York: New Museum and JRP|Ringier, 2009).

Neil, Jonathan T.D., "The Fischer King," *Art Review* 6 (December 2006): 70–74.

CARLOS GARAICOA

BORN 1967, HAVANA, CUBA
LIVES AND WORKS IN HAVANA

Since the early 1990s, conceptual artist Carlos Garaicoa has made work about the urban landscape, particularly focusing on fragile structures subject to decay.[1] Garaicoa approaches the city as a contemporary flâneur, searching for the histories, politics, and ideologies visible from the street. Through architecture, drawing, installation, photography, video, and public intervention, Garaicoa is able to recover and reimagine the fabric of the city, revealing hidden meanings and proposing new structures.

Garaicoa's urban-related themes appear in an important early work from 1998, *City View From the Table of My House*, in which crystal glasses, cutlery, and other small household objects are arranged on a coffee table to form a miniature city. He later began examining the demarcation of public and private space more closely, as evidenced in a more recent work, *Yo no quiero ver mas a mis vecinos (II)* (I Don't Want to See My Neighbor Anymore (II)) (2006), consisting of several scaled-down versions of major walls, such as Hadrian's Wall, the Great Wall of China, and the Berlin Wall. The work suggests that walls prevent not only physical transit, but the transmission of ideas as well. But when viewers climb over the knee-high structures, the imposing restrictions and boundaries are surmounted. Influenced by Frank Gehry and Santiago Calatrava, Garaicoa created the smaller-scale walls to address architectural issues of impracticality and waste and to offer new ways of thinking about structures, especially the restrictive nature of both physical and imaginary barriers. Dealing with boundaries is also a theme in another interactive work *Damas chinas* (Chinese Checkers) (2008), in which viewers play checkers with ample-size marbles on a larger-than-life board.

The site-specific installation *Pérdida* (Loss) (2006) was the result of Garaicoa's investigation of the depopulation of the Echigo-Tsumari area in Japan. Focusing on the disappearance of the urban space, Garaicoa created two monumental installations: an outdoor miniature ghost town of stone houses crafted from the blueprints and photographs of homes in the region, and an indoor piece composed of funerary lanterns that match the number of exterior stone houses. Using Japanese lamps, a recurring element first seen in his work *New Architecture* (2000), Garaicoa illuminates a potential imaginary city. Influenced by the public interventions and installations of Felix Gonzalez-Torres and Krzysztof Wodiczko, Garaicoa is sensitive to the individuals who live in Echigo-Tsumari and the emotional responses they may have to seeing a work that addresses their specific situation.

FIG. 33 (TOP): *Yo no quiero ver más a mis vecinos (II) (I don't want to see my neighbors anymore (II))*, 2006. Permanent installation: brick, concrete, foam and metal. Collection of Castello di Ama Collection, Gaiole in Chianti, Italia. Courtesy the artist

FIG. 34 (BOTTOM): *Pérdida* (Loss), 2006. Installation: rice paper lamps, wire, and stone sculptures. Dimensions variable. Courtesy the artist and Galleria Continua (San Gimignano–Beijing–Le Moulin)

FIG. 35: *Untitled (RCA Victor)*, 2006. Pins and threads on lambda photograph mounted and laminated in Gator Board. 59⅘ x 48 inches (151.8 x 121.8 cm). Private collection, USA. Image courtesy the artist

As in the practices of 1970s conceptual artists Bruce Nauman and John Baldessari, Garaicoa's photography–sculpture–text hybrids juxtapose imaginary with the real to create new readings of his native Cuba. In *Untitled (RCA Victor)* (2006) and *Untitled (La Internacional)* (2006), Garaicoa pins threads onto photographs that delineate the outline of buildings in an attempt to establish a link between fiction (the drawing) and reality (the photograph). The combination of sculpture and photography is seen in an earlier untitled series (2003–04) about deteriorating architecture in Havana, where the threads are pinned over areas of absence. Similarly, in *Untitled (RCA Victor)*, the threads are systematically placed in the voids. A storefront sign, such as "RCA Victor," became the departure point to create new meaning: "PUERCA Victoria que nos honra INDECIBLE Vida la que honramos" (Filthy victory that honors us/ unspeakable life/the one that we honor). Influenced by the writings of Jorge Luis Borges and Italo Calvino (in particular their texts on the ephemeral nature of cities), this poetic play on the signage that adorns retail shops, restaurants, and hotels in varying states of dilapidation results in a narrative of the city in crisis.

JKII

NOTE
1. Correspondence with artist on March 17, 2009.

SELECTED BIBLIOGRAPHY

Block, Holly, "Carlos Garaicoa," *Bomb Magazine* 82 (Winter 2002–03).

Enwezor, Okwui, Sean Kissane, Enrique Juncosa, and Sofia Hernandez, *Carlos Garaicoa: Overlapping* (Dublin: Charta and Irish Museum of Modern Art, 2010).

Hernandez, Erena, "Carlos Garaicoa: From Ruins to Desire," *Art Nexus* 44 (2002): 44–49.

Lovelace, Carey, "Carlos Garaicoa at Lombard-Freid," *Art in America* 95 (March 2007): 176–77.

Spiegler, Marc, "City Lights," *ARTnews* 104, no. 3 (March 2005): 96–99.

SHILPA GUPTA

BORN 1976, MUMBAI, INDIA
LIVES AND WORKS IN MUMBAI

Shilpa Gupta uses a broad range of media including photography, video, performance, installation, and the Internet. The form and content of her artworks are closely related. Gupta's earlier work from the late 1990s often probed and questioned the formation of identity through her use of menstrual blood stains, birth marks, and other physical traits or elements. Her focus on the female body paved the way for a practice that questions how identities are created, molded, or suppressed by nationality, ethnicity, race, and gender. Gupta's work probes cultural and historical violence, not only to suggest an alternate historiography, but to encourage a greater awareness of the self and the ways in which the self is constructed.

Gupta's installation *Half Widows* (2006) is emblematic of the artist's symbolic language. The work addresses the concerns of women in Kashmir whose husbands have disappeared and cannot be declared dead by the state, leaving the wives to deal with an agonizing uncertainty. Viewers are encouraged to discover the different layers of the installation step by step: one has to make one's way to the video projection by walking through a set of clothes hung from clotheslines. The video depicts a woman dressed in white, carrying a flag made of the same fabric. While her movements and gestures evoke military rigidity, her positioning against a sky-blue backdrop disrupts any sense of a location for the work. The looped video seems to refer to a feeling of paralysis in the face of authority, nation-building, and cross-border militancy.

A recurring theme in the artist's work is the violence inherent to the construction of Pakistan, which was established in 1947 at the same time India gained independence from British rule. In *Untitled* (2008), the artist uses a series of large-scale photographs printed on flex (a polythene sheet used for high-quality digital prints) to interpret the famous saying, "See no evil, hear no evil, speak no evil," which is often associated with the values of positivism and peace upheld by Mahatma Gandhi, who kept a statue of the three wise monkeys often used to illustrate the ancient saying. Gupta photographs a group of children standing in a line, covering each other's eyes, mouths, and ears, as if to form a never-ending chain that is both fragile and seemingly permanent. Although the image may refer to the three monkeys, it also implies the almost internalized violence embedded in the daily life of India and many other countries.

The work *In Our Times* (2008) reflects a similar concern. It consists of two mobile microphones on two ends of a metal bar mounted on a stand, from which one hears two strikingly similar declarations or promises for peace, happiness, and progress: Pakistan's first

FIG. 36 (TOP): *Half Widows*, 2008. Video installation and photographs. Dimensions variable. Courtesy the artist

FIG. 37 (BOTTOM): *In Our Times*, 2008. Singing mobile microphones. 76 x 57 x 24 inches (193 x 144.8 x 61 cm). Courtesy the artist

FIG. 38: *There is No Explosive in This*, 2007. Interactive installation and photos. Dimensions variable. Courtesy the artist

president Muhammad Ali Jinnah's speech from August 11, 1947, and India's first prime minister Jawaharlal Nehru's inaugural address from August 15, 1947. These seesawing microphones reflect the intense violence that surged after these speeches were delivered. The euphoric tone celebrating the independence of the respective countries is ultimately replaced by a sense of disillusionment.

Gupta's practice continuously seeks the active participation of the audience. The words "There is no explosive in this" are printed on bags that Gupta invites audience members to take out onto the street in the eponymous 2007 work of the same name. As viewers exit the gallery, they become participants in the work. The work acquires its meaning once it enters the public realm, where perceptions of one's self in relation to others are much heightened.

ÖE

SELECTED BIBLIOGRAPHY

Huber-Sigwart, Ann, "Bridging the Gap: The Work of Shilpa Gupta. Ann Huber Sigwart interviews Shilpa Gupta," *n. paradoxa 'violence'* 21 (2008): 16–24.

Merali, Shaheen, "Stars and strikes ... The Imagination of an Artist," *Affair* 1 (2008): 196–221.

Sardesai, Abhay, "I Support Piracy: Interview with Shilpa Gupta," *Art India* 13, no. 3/4 (2008–09): 36–38.

DANIEL GUZMÁN

BORN 1964, MEXICO CITY
LIVES AND WORKS IN MEXICO CITY

Daniel Guzmán is known for dramatic, politically charged, and ironic drawings that often include text. Aside from these drawings, which revel in the grotesque and the obscene, his restless and wide-ranging oeuvre also includes painting, installation, video, and sculpture composed of found objects. Guzmán's artistic influences are primarily Mexican, and range from the ancient, such as Aztec art and sculpture, to the modern and contemporary, including nineteenth-century caricaturist José Guadalupe Posada, muralist José Clemente Orozco (whom he once referred to as his favorite artist), and Modernist painter José Luis Cuevas. Guzmán also gleans inspiration from the later figurative work of American Modernist Philip Guston, German Expressionist Otto Dix, as well as writing by Charles Bukowski and William S. Burroughs, and US and Mexican rock music from the 1970s and 1980s. Although his work may be graphic and even shocking, it is more than a crude depiction of violence. Guzmán's ultimate goal is to increase awareness of Mexico's contemporary cultural and social issues.

In his first video, *Remake* (1994), Guzmán collaborated with his peer Luis Felipe Ortega to re-enact iconic performances by American artists Vito Acconci, Bruce Nauman, and Paul McCarthy. Guzmán restaged these works in order to become more familiar with the practices of these artists; in the process he closed the gap between artistic developments in the US and Mexico.

The four drawings in the series "El Gráfico" (2008), include distorted images, cartoons, and typography informed by images that have appeared recently in Mexican tabloids such as *El Sol de México*, *Alarma*, and *El Gráfico*, the last for which the work is aptly titled. These rough and violent images are similar to the depictions of battle and sacrifices in Aztec imagery, such as the dismembered body of the Coyolxauqui in the Aztec solar calendar. Guzmán's images are also reminiscent of photos of "las muertas de Juárez," the term for the female homicides that started more than a decade ago in Ciudad Juárez, Chihuahua, Mexico, but have been overlooked by many. In addition, we see stencil-like forms resembling "papel picado," a form of folk art that consists of cut tissue-paper images relating to death, which are often used to decorate altars during Mexican celebrations of the Day of the Dead. (The skulls and other Aztec symbols, such as pyramids, that are associated with this type of art, appeared in Guzmán's earlier series "La búsqueda del ombligo" [The Search of the Navel] [2005–07].) "El Gráfico" also features text, both to emphasize the tabloid designs and to highlight the ironic and political commentary inherent in the work.

FIG. 39 (TOP): *How to Make a Monster? I*, 2008. Chinese ink and pencil on cotton paper. Triptych 39⅜ x 27½ inches (100 x 70 cm) each. Courtesy the artist and kurimanzutto, Mexico City. Photo: Michel Zabé and Enrique Macías

FIG. 40 (BOTTOM): *How to Make a Monster? II*, 2008. Chinese ink and pencil on cotton paper. Triptych 39⅜ x 27½ inches (100 x 70 cm) each. Courtesy of the artist and kurimanzutto, Mexico City. Photo: Michel Zabé and Enrique Macías

In *How to Make a Monster? II* (2008), Guzmán continues his development of narratives that combine fiction and reality. The central image of this black-and-white triptych presents a horrific scene—buildings on fire, children and adults in disguise—while the two flanking portraits depict former Mexican president Lazaro Cardenas (president from 1934 to 1940) and his son Cuauhtémoc Cardenas Solórzano, a contender in the 1988 presidential election that resulted in the ousting of the Partido Revolucionario Institutional (Institutional Revolutionary Party, also known as PRI), which had ruled for fifty-nine years. This work is more than an analysis of the state of politics in Mexico. It also represents Cardenas Solórzano's disillusionment after failing in his attempts to follow in the footsteps of his father, a trial faced by many adolescents, albeit often on a less public scale.

Assemblage is an integral part of Guzmán's sculptural process. In *Brutal Youth*, from the sculpture series "Everything is Temporary" (2008), Guzmán juxtaposes discarded furniture, a wood door, plastic bones, record covers, engraved Plexiglas, and a text panel that reads:

ALL WEAKNESSES SHOULD BE ELIMINATED. A YOUTH WILL BE FORMED IN MY CAMPS THAT WILL MAKE THE WORLD TREMBLE. I WISH IT TO BE BRUTAL, ARROGANT, HEROIC AND CRUEL. YOUTH SHOULD BE THIS; IT WILL OVERCOME ALL SORTS OF HARDSHIPS AND WILL BE EXEMPT OF ALL SENTIMENTALISMS.

The sculpture resembles an altar made to honor restless adolescents, although the text's ironically fascist tone illustrates how youth often becomes synonymous with anarchy and destruction. Yet despite the ambiguous message, a central element of the sculpture is DEVO's 1981 *New Traditionalists* album, which includes the anthem "Through Being Cool." The album's presence hints at the artist's wistful longing for his own youth.

CS

SELECTED BIBLIOGRAPHY

Flood, Richard, ed., *Double Album: Daniel Guzmán and Steven Shearer*, exhibition catalogue (New York: New Museum, 2008).

Fogle, Douglas, ed., "Daniel Guzmán," in *Life on Mars. 55th Carnegie International*, exhibition catalogue (Pennsylvania: Carnegie Museum of Art, 2008).

Kino, Carol, "Confronting His Culture and Himself," *New York Times*, December 7, 2008.

Widholm, Julie Rodrigues, "Daniel Guzmán," in *Escultura Social: A New Generation of Art from Mexico City*, exhibition catalogue (Chicago: Museum of Contemporary Art, 2007).

RACHEL HARRISON

BORN 1966, NEW YORK
LIVES AND WORKS IN NEW YORK

Rachel Harrison's sculptures are composed of a wide range of materials, including thrift-store miscellanea, repurposed art pedestals, makeshift walls, cheap paint, Styrofoam, plaster, chicken wire, costume accessories, and photographs ripped from tabloids and teen magazines. Sometimes profound and sly, other times obvious and crude, Harrison's humor is the glue that holds her precarious, seemingly slapdash assemblages together.[1]

In her 2007 work *Trees for the Forest*, Harrison confronts the viewer with an assortment of brightly painted pedestals, all of varying heights and widths, assembled as a small forest of rectangular trees. Paintings of different subjects in varying styles are hung on the pedestals at eye level. Closer inspection reveals that the paintings are not by Harrison, but by many different artists. The paintings were collected—"salvaged" might be a more accurate word—by Harrison during trips to thrift stores over the years, and are then presented in the makeshift gallery constructed from the pedestals, which were found in storage at Harrison's own gallery. Are viewers meant to look at and appreciate these paintings on their own merits (as one might appreciate a collection of paintings in a group show), or to view the piece as a whole in which the paintings are only one component? The title *Trees for the Forest* suggests that the context in which a work is displayed manipulates our expectations of cultural value.[2]

As *Trees for the Forest* illustrates, the artist is interested in upending Western traditions of statuary form. The pedestals have an anthropomorphic quality; the paintings become faces.[3] This is perhaps more literally apparent in works like *American Idol* (2008), in which the artist places an unplugged microphone on a stand in front of a Styrofoam obelisk. The obelisk takes on the appearance of a singer stepping into the spotlight for her one stab at fame and fortune, about to pour her heart into a fiery ballad, but completely unaware that the microphone is unplugged.

Pop culture references appear constantly throughout Harrison's work. Portraits of celebrities like Leonardo Dicaprio, Johnny Depp, Kevin Bacon, and Prince are incorporated into Harrison's critique of the way art is displayed and contextualized. A promotional still of Mel Gibson taken for the 1995 movie *Braveheart* (which was written and directed by Gibson, who also stars in it) is featured prominently in *Huffy Howler* (2004). The actor gazes down at the viewer from a piece of fur dangling from a pipe that, in turn, appears to have been rammed into a bicycle. Purses filled with rocks hang from the bicycle's handlebars, serving as counterweights that allow it to balance on Styrofoam blocks. The pole stuck into the rear of the bicycle recalls

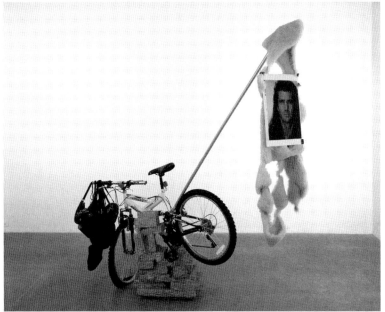

FIG. 41 (TOP): *American Idol*, 2008. Wood, polystyrene, cement, Parex, acrylic, microphone with stand. 62 x 24 x 89 inches (157 x 61 x 226 cm). Courtesy Greene Naftali Gallery, New York. Photo: André Morin

FIG. 42 (BOTTOM): *Huffy Howler*, 2004. Wood, polystyrene, cement, Parex, acrylic, Huffy Howler bicycle, handbags, rocks, brick, sheep skin fur, pole, wire, digital inkjet print, and binder clips. 84 x 84 x 30 inches (213.4 x 213.4 x 76.2 cm). Courtesy Greene Naftali Gallery, New York Photo: Oren Slor

the disemboweling of Gibson's martyred hero at the end of the movie. It is worth remembering that Gibson is a devout Catholic who has been criticized for his anti-Semitic comments and the portrayal of Jews in the other movie he wrote and directed, *The Passion of the Christ* (2004).[4] It is difficult not to interpret the piece as mocking Gibson's self-righteous, abnegating views.

Continuing Harrison's satirical critique of Western sculptural forms, *Huffy Howler* also borrows from the tradition of equestrian statuary,[5] which typically presents powerful and heroic men astride equally powerful and heroic steeds. In *Huffy Howler*, Gibson's steed is an awkwardly balanced bicycle, and Gibson, the actor-hero, is riding his "horse" backwards, seemingly quite pleased with himself. What he does not seem to realize, however, is that when you look at his face, you are also looking at the "horse's ass"—and that ass happens to have a pole sticking out of it. By casting a skeptical eye at pop culture and the art world, Harrison creates an ambiguous reality where the contents of this week's *Tiger Beat* and the permanent collection at the Metropolitan Museum of Art are both subverted—and at the same time praised, since her ecstatic use of color and materials communicate a goofy and wondrous kind of love for it all.

TC

NOTES

1. Richard Hawkins, "Enigmarelle the Statuesque," *Parkett* 82 (May 2008): 120–29.
2. Ina Blom, "All Dressed Up," *Parkett* 82 (May 2008): 130–42.
3. Hawkins, "Enigmarelle."

4. The fact that it is unclear whether or not the artist intends for us to take into account her Jewish heritage when viewing *Huffy Howler* is, most likely, an awkward ambiguity that Harrison appreciates. Rachel Harrison, "Public Art Fund Talks at the New School with Rachel Harrison," Public Program, New School, March 25, 2009.
5. Hawkins, "Enigmarelle."

SELECTED BIBLIOGRAPHY

Baker, George, "Mind the Gap," *Parkett* 82 (May 2008): 143–55.

Blom, Ina, "All Dressed Up," *Parkett* 82 (May 2008): 130–42.

Gingeras, Alison M., "(Un)Natural Selection," *Parkett* 82 (May 2008): 156–63.

Harrison, Rachel, "Public Art Fund Talks at the New School with Rachel Harrison," Public Program, New School, March 25, 2009.

Hawkins, Richard, "Enigmarelle the Statuesque," *Parkett* 82 (May 2008): 120–29.

Kelsey, John, and Rachel Harrison, *Rachel Harrison: if i did it*, exhibition catalogue, edited by Heike Munder and Ellen Seifermann (Zurich: Migros Museum für Gegenwartskunst, 2007).

SHARON HAYES

BORN 1970, BALTIMORE, MARYLAND
LIVES AND WORKS IN NEW YORK

More and more I think my work has become something like an enactment of a series of performatives rather than performance. This perhaps reveals that although I was greatly relieved to abandon (by moving out of the performance and theatrical venue) the demand to be entertaining, I nevertheless have a bit of discomfort that most of the work I do in front of an audience now involves just standing in front of them and speaking.[1]

Sharon Hayes creates moments of engagement with her audience in which she explores everything from her American lesbian feminist identity to the politics of love and war, alternative forums for public opinion, and most importantly the speech act itself. By defining her practice as a "series of performatives rather than performance" she carefully delineates the parameters in which she operates. Over the years, Hayes has utilized found speeches and recordings—often by well-known political figures such as Ronald Reagan or Patty Hearst—to call attention to the slippery power of language and its potential to construct or suppress meaning. More recently she has combined found texts and snippets of language from songs, newscasts, and letters with her own writing.

In *Revolutionary Love 1 & 2* (2008), which took place outside of both the Democratic National Convention in Denver, CO, and the Republican National Convention in St. Paul, MN, Hayes asked roughly 100 queer participants to publicly recite—in unison—a text she had written for the occasion about gay power and liberation. Subtitling them *I Am Your Worst Fear* for the DNC and *I Am Your Best Fantasy* for the RNC, Hayes used these very charged political moments to address queer culture head on. The volunteers recited the ten- to twenty-minute texts three times over the course of two hours. As Hayes has expressed, these performances were intended as personal addresses to the power structure, or a group of people speaking their hearts as one.

In *Everything Else Has Failed! Don't You Think It's Time for Love?* (2007), presented in front of the UBS Building in midtown Manhattan, Hayes entered the sidewalk from the front doors of the building armed with a microphone and amp and began reciting a text that combined her own words with those of others from memory. As an actor might rehearse their lines, she repeated the text over and over with varying degrees of emotion and physicality. The speeches were recorded and then presented in the lobby of the building via a large speaker installed in the space, accompanied by a series of silk-screened works reminiscent of protest posters of the 1960s and 1970s. Hayes also employed recitation and repetition in *I March In The Parade of*

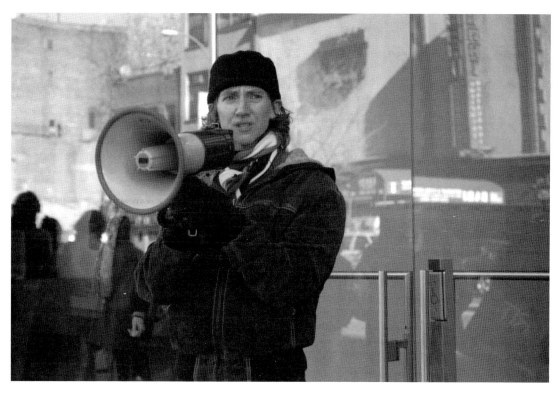

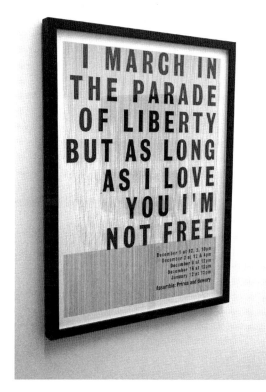

FIG. 43 (TOP): *I March In The Parade Of Liberty, But As Long As I Love You I'm Not Free*, 2008. Documentation of performance, New Museum, New York, NY. Courtesy the artist and Tanya Leighton Gallery, Berlin. Photo: Andrea Geyer

FIG. 44 (LEFT): *I March In The Parade Of Liberty, But As Long As I Love You I'm Not Free*, 2007–08. Audio installation (one PA system), Xerox. 24 x 20 inches (61 x 50.8 cm). Courtesy the artist and Tanya Leighton Gallery, Berlin. Photo: James Wagner

Liberty, But As Long As I Love You I'm Not Free, a series of performances commissioned by the New Museum in 2008. Over the course of a month and a half, Hayes walked from the museum to various locations in downtown Manhattan with a bullhorn; speaking, shouting, and professing her thoughts, feelings, and frustrations about love, politics, and life. These sessions could be heard in real time over a large speaker installed in the museum's Shaft Project Space and continuously throughout the exhibition.

Presentations of Hayes's work have often consisted of multi-channel video, slide, and/or audio installations, or selections of both found and hand-made signs, posters, and banners. Often her work is first experienced live and later reworked into a format that suits the particular environment in which it is presented. Recently, Hayes installed a plethora of signs—as an extension of the speech act—in the group exhibition "Ecstatic Resistance," echoing her use of written language for *In the Near Future* (2005), which utilized slogans from protest signs of past political movements. For *I Didn't Know I Loved You*, included in the 2009 Istanbul Biennial, Hayes invited individuals from a queer Turkish community to read several texts on the city's bustling Istiklal Street. The readings were recorded and were presented in the exhibition as a single-channel video projection.

Hayes's archival approach to the production and presentation of her work compliments her obsession with collective memory and the politics of forgetting. By deftly navigating the contingent terrain between false sincerity in the form of public rhetoric and the powerful emotionally driven content of personal love letters, Hayes melds these two distinct approaches to language into an entangled prophetic amalgamation. The phrase "Why can't you be my country?" a question Hayes has often posed, simultaneously summarizes and underscores her interest in the juncture between political agency and personal action.

AM

NOTE

1. Sharon Hayes and Yvonne Rainer, "Familiarity, Irony, Ambivalence (and Love, Hate, Envy, Attraction, Revulsions, Hubris as Byproducts of the 'Performative' Act): An Email Conversation between Sharon Hayes and Yvonne Rainer," in *Work the Room: A Handbook of Performance Strategies*, edited by Ulrike Müller (Berlin: B_Books, 2006), 34.

SELECTED BIBLIOGRAPHY

Bryan-Wilson, Julia, "Julia Bryan-Wilson on Sharon Hayes," *Artforum* 44, no. 8 (May 2006), 278–79.

Thompson, Nato, *A Guide to Democracy in America* (New York: Creative Time Books, 2008).

SUSAN HEFUNA

BORN 1962, GERMANY
LIVES AND WORKS IN EGYPT AND GERMANY

Susan Hefuna often uses the Arabic word *Ana*, which means "I," in her work, emphasizing the metaphorical meaning of the palindrome—a word that can read forwards and backwards—in relation to her own identity as someone who lives in both Cairo, Egypt, and Frankfurt, Germany. In her installation *Ana* (2006), Hefuna engraved the word "Ana" and its German equivalent "Ich" on a plate of bronze. She used the two words to great effect in her video *Ana/Ich* (2006), by turning them into a spoken-word piece: the video shows a quick edit of different Egyptians saying "Ana," which is interspersed with shots of Hefuna as she says either "Ana" or "Ich".

Hefuna is deeply inspired by the cities she lives in, and says that being based in different places is like being between "different layers of interpretation of reality."[1] She made a series of photographs of everyday scenes from Cairo, such as baskets of vegetables, for "Still Life Cairo" (2007), while another series, "Life in the Delta 1423/2002" (2002), depicted rural Egyptian life scenes around the great river. For the public art piece *Vitrines of AFAF* (2007), she placed objects that she had collected from women in Cairo in vitrines on the street, to explore her interest in everyday life and personal memorabilia.

Another dichotomy central to Hefuna's artistic practice is the tension between interior and exterior; the private sphere and public space. This concept is particularly evident in her use of Mashrabiyas—traditional Arabic windows constructed to allow air to circulate and light to filter in, yet whose decorative elements help maintain the privacy of those inside. A key element in Arabic architecture, Mashrabiyas symbolize seclusion and retreat. In an interview with curator Hans-Ulrich Obrist, Hefuna says: "The nice thing about these rooms is that you're isolated and protected from the world around you, but at the same time, you can see it all."[2] Whether Hefuna's installations are large rectangles made of cast bronze (*ANA*, *Dream*, and *Drawing* [2009]), or imposing wooden plates (*10 x ANA* [2007]), they recall the latticework of these traditional windows. Hefuna also made a series of photographs of women hidden behind Mashrabiyas and therefore barely visible, thereby addressing the traditional reflective function of the Mashrabiya, to conceal the highly protected domestic lives of women throughout the Muslim world.

More recently, Hefuna has started developing some large-scale architectural projects, such as *Mirage 07*, a billboard-size freestanding wall made of mirrored glass that turned transparent depending on the angle of light hitting it. Created for the Sharjah Biennial in 2007, this

FIG. 45: *ANAgram*, 2008. Pen on tracing paper.
11.4 x 8.3 inches (29 x 21 cm). Courtesy the artist

FIG. 46: *Patience is Beautiful*, 2008. Wood and ink.
94 1/10 x 68 1/2 inches (239 cm x 174 cm). Courtesy the artist

mysterious wall reflected the city on its exterior, preventing viewers from seeing beyond it during the daytime, but allowing them to see through it as soon as dusk arrived. In *Mirage 07*, Hefuna again engages visibility and invisibility, the private and the public.

MK

NOTES

1. Correspondence with artist on January 5, 2009.

2. Hans-Ulrich Obrist, ed., and Susan Hefuna, *Pars Pro Toto* (Heidelberg: Kehrer Verlag, 2009), 13.

SELECTED BIBLIOGRAPHY

Eltorie, Aida, "Creating the Dream Space," *Contemporary Practices: Visual Arts from the Middle East* IV (2008).

Fox, Fiona, "Studio Practices: Susan Hefuna," *Contemporary Practices: Visual Arts from the Middle East* I (2008).

Kristeva, Julia, *Stranger to Ourselves* (New York: Columbia University Press, 1994).

Obrist, Hans-Ulrich, ed., and Susan Hefuna, *Pars Pro Toto* (Heidelberg: Kehrer Verlag, 2009).

JONATHAN HERNÁNDEZ

BORN 1972, MEXICO CITY
LIVES AND WORKS IN MEXICO CITY

At the core of Jonathan Hernández's practice is a system of collecting and organizing images that is rooted in the processes of observation and thought.[1] Hernández sources these images from a vast field of media—newspapers, advertising, postcards, even the artist's own camera. He describes this collection as a project of "many years,"[2] a massive archive necessitating a definite taxonomy. But instead of structuring these thousands of images as a hierarchy, grouped perhaps by beauty or truthfulness or use value, Hernández creates a system of relations, carefully arranging and juxtaposing the images. Tellingly, Hernández does not refer to these compositions as "collages" or "assemblages," preferring to label his works "detonations."[3] The designation makes it clear that these are not inert bundles of images, but carefully timed deployments intent on causing a reaction.

One of the earliest examples of detonation in Hernández's work is "Vulnerabilia," a series begun in 2002 comprised entirely of newspaper photos with their captions removed. Without this textual reference, the possible interpretation of each photograph becomes infinite. This potential is further magnified by the context created by the surrounding photos, illuminating both similarities and differences. In the iteration *Vulnerabilia (Simetrias y multiplicaciones)* (2006–08), a row of beached whales mirrors a squadron of jets flying in formation, the glossy-wet skin of the one recalling the mechanized gleam of the other. It is not possible to determine whether the jets are performing in an air show or about to bomb a village. It is an ambiguity that explores ideology without being overtly ideological. Hernández is upfront about this distinction: "I believe more in a political way of making art than in political art."[4] Beyond the compositional rhyme between the whales and the airplanes, countless oppositions and correspondences emerge; however, the specific nature of these relations is determined by each viewer's response to the images.

Hernández forces us to reconsider our familiarity with the steady stream of pictures that surround us. From the spectacular (celebrities and landmarks), to the mundane (animals and asphalt); the images he selects are always discernable, and fit neatly into classification systems. There's no mystery in individual images of soccer players, full moons, or parades, however, brought together in works like "Vulnerabilia", the echoes and relationships between these images guide viewers to a deeper process of observation. Hernández described this process as a "kind of ping-pong game between events, context, and circumstances that heightens the power and meaning of things."[5]

FIG. 47 (TOP): *Rongwrong XV*, 2007. Newspaper collage on cardboard. 22⁷⁄₁₀ x 24⅕ inches (57.7 x 61.4 cm). Courtesy the artist and kurimanzutto, Mexico City. Photo: Michel Zabé and Enrique Macías

FIG. 48 (BOTTOM): *Rongwrong XXI*, 2008. Newspaper collage on cardboard. 32½ x 37 x 1⅖ inches (82.5 x 94 x 3.5 cm). Courtesy the artist and kurimanzutto, Mexico City. Photo: Michel Zabé and Enrique Macías

119

A second series, "Rongwrong," also begins with newspaper photos, but these images have undergone sharp interventions: objects and individuals were meticulously excised from their surroundings, which are often bound together by delicate, ribbon-like frames. Laid out onto stark, black or white backgrounds, the carefully composed relationships between these characters become the primary feature of each piece. In *Rongwrong XXI* (2008), an image of Vladimir Putin clutching a toy rocket mirrors a smaller image of two children armed with toy guns, recalling the subtle humor and provocation of the "Vulnerabilia" series. The two images are juxtaposed with a third image of the production of a film, showing a myriad of cameras, lights, and workers without showing what the camera is capturing, and thus demanding the viewer to consider the difference between fiction, reality, and spectacle.

This process of expanding his compositions beyond simple binary oppositions and symmetries is intertwined with Hernández's interpretation of contemporary culture: "what we today understand as culture is very complex and encompasses a whole new dimension."[6] For Hernández, this new dimension is closely related to the torrent of images and media available to us, which has sufficiently destabilized the usual hierarchy so that an art exhibition "can be as much a cultural event as a soccer game or watching videos on YouTube."[7] Hernández views the artist as an ideal candidate for following these shifts: "an artist has the great advantage of being a kind of outsider who goes in and out of the structures of society."[8] By selecting images as the most tangible location of these structures and their networks, Hernández is able to create deliberate, thoughtful works that demand deliberate, thoughtful observation from their viewers.

ES

NOTES

1. "This is exactly what I like to set off with my work: observation and thought." Correspondence with artist, January 2009. Translated from Spanish by Fernando Feliu-Moggi.

2. Interview by Gilane Tawadros, in "Jonathan Hernández: Rongwrong," *Photoworks*, UK (May–October 2007).

3. Ibid.

4. Correspondence with artist, January 2009.

5. Ibid.

6. Ibid.

7. Ibid.

8. Ibid.

SELECTED BIBLIOGRAPHY

Bedford, Christopher, "Jonathan Hernández at MC," *Art in America* 96 (May 2008): 203–04.

Demos, T.J., ed., *Vitamin Ph: New Perspectives in Photography* (New York: Phaidon Press, 2006).

Hernández, Jonathan, *Vulnerabilia* (Madrid, Spain: La Caja Negra Ediciones, 2005).

—— *Diario japonés* (Madrid, Spain: La Caja Negra Ediciones, 2006).

LESLIE HEWITT

BORN 1977, NEW YORK
LIVES AND WORKS IN NEW YORK

Leslie Hewitt examines the past in unconventional ways, accessing overlooked knowledge and experience embedded in everyday images and familiar situations. Consider, for example, photographs from the past packed away in albums and stored in closets. Recall once-revolutionary books and magazines now collecting dust in second-hand shops. But when this material is assembled by Hewitt for her photographs, she activates a waning consciousness of social transformation and resistance embedded in "unconventional archives."[1] Her primary source materials are documents of the Civil Rights and Black Consciousness Movements of the 1960s and 1970s—a period of turmoil in the US that ended around the time of the artist's birth date.

In her extended photography project "Riffs on Real Time" (2002–08), Hewitt compresses time and history into flat optical space. Her photographs layer found snapshots of family life, printed pop-culture media from the 1960s and 1970s, as well as casual doodles, monochrome book covers, and tear sheets from manuals. There is both concordance and dissonance between personal and public pasts of the snapshots and mass-circulated materials, and a decisive break in the tangible, accessible present represented by the worn floorboards and shag carpet backgrounds. Her approach to photography responds to the medium as a social instrument. Personal photography turns into an archive of collective memory.

In *Riffs on Real Time (3 of 10)*, a snapshot of an outdoor family gathering is centered on a page torn from a school textbook. The textbook lesson discusses mobility, communication, and the influence of the media on public opinion. Hewitt's choice alludes to the reform in education that catalyzed in the 1960s. The nostalgia and familiarity of the snapshot and the authority of the textbook feel at odds with one another. Hand-drawn doodles overlap with the text, suggesting the presence of an uninterested student, while introducing into the frame yet another visual language—that of graffiti and the urban culture with which it is associated. Hewitt bends the associative "riffs"—or disjunctions—in language and form between these objects layered in real time, forging new relationships between systems of knowledge that actively challenge one another.[2] Compared with a news journalist's "official" account of events conveyed in flash-blasted photographs of street-level confrontations, Hewitt explores how personal photographs and vernacular imagery by anonymous photographers, artists, and residents contribute previously unheard perspectives to our understanding of the way history played out.

FIG. 49 (TOP): *Riffs on Real Time (3 of 10)* and *Riffs on Real Time (10 of 10)*, 2008. Chromogenic prints. 40 x 30 inches (101.6 x 76.2 cm). Courtesy the artist

FIG. 50 (BOTTOM): *Make It Plain*, 2008. Mixed media. Dimensions variable. Installation view, Whitney Museum of American Art, New York. Courtesy the artist

"Riffs on Real Time" also suggests a contemporary reassessment of the way the Civil Rights Movement raised public awareness and encouraged social agency. Photography is a process of concealing, as well as revealing, making the world beyond the frame part of its political dimension. An image's discursive possibilities are either expressed or limited by its context of display. What becomes important is the viewer's participation with the work rather than passive spectatorship, the "activation" of associations for the viewer because of the diverse material objects within Hewitt's photographs. This is a central component to her project "Make It Plain" (2006–08)—a series of large photographs that take on a sculptural presence and build upon the themes of "Riffs on Real Time"—working instead with time-worn household objects and printed materials, arranged in subdued daylight. The objects are composed in a balancing act. They are balanced not only literally, in terms of their arrangement, but also in the equal weight given to mundane objects and those that reverberate with pointed political references, such as the partially visible book titles *Black Protest: History, Documents, and Analyses: 1619 to the Present* (1968), by Joanne Grant, and *The Kerner Report: Report of the National Advisory Commission on Civil Disorders*, which was commissioned by the United States Federal Government in 1967 and released in 1968. The spines of these books support the composition of *Make It Plain, (5 of 5)*. Again, Hewitt relies on the viewer to make her own associations; the objects operate like words in a sentence, each building upon the other to arrange new meaning out of everyday materials.

Hewitt's body of work continually returns to the social and political dimensions of the camera, exploring how photography can give voice to new types of consciousness and subjectivity. Shifting between mediums and decades, she "riffs" on established systems of knowledge, upsetting the stability of histories and memories that are often accepted as truth.

JD

NOTES

1. Correspondence with artist on May 11, 2009.

2. Leslie Hewitt in conversation with Kate Menconeri, *The Everyday: A Master's Thesis Exhibition*, exhibition catalogue (Annandale-on-Hudson: Bard Center for Curatorial Studies, 2009).

SELECTED BIBLIOGRAPHY

Lax, Thomas J., "Toward an Ethics of the Double Entendre," *New Intuitions: Artists in Residence 2007–2008*, exhibition catalogue (Harlem: The Studio Museum in Harlem, 2008).

Lovell, Whitefield, "Artists on Artists," *Bomb Magazine* 104 (Summer 2008): 64–65.

Martin, Courtney J., "Leslie Hewitt," *Frequency*, exhibition catalogue (Harlem: The Studio Museum in Harlem, 2005–06).

—— "Wishes Are Where Desires and Aspirations Live," *I Wish It Were True*, exhibition catalogue (New York: Jamaica Center for Arts and Learning, 2007).

Speers, Emily Mears, "Leslie Hewitt," *Modern Painters* (December 2006/January 2007): 94–95.

HUANG YONG PING

BORN 1954, XIAMEN, CHINA
LIVES AND WORKS IN PARIS

Huang Yong Ping's career has been forged in a crucible of cross-cultural exchange. In the 1980s, he was instrumental in introducing Dada and Neo-Dada tactics to China's frenzied early encounters with modern art. While his contemporaries were practicing various forms of expressionistic painting, Huang was absorbing the influences of Marcel Duchamp, John Cage, and Joseph Beuys. Since that time he has developed a hybrid artistic practice, in which East and West pointedly interact so as to throw into relief the ever shifting currents of globalization. In Huang's work, Chan Buddhist theology joins forces with Duchampian provocations, or the divinations of the *I Ching* are applied to contemporary political events. He uses this strategic heterogeneity to illuminate the latent power structures that emerge when one culture comes into contact with another.

As a founding member of Xiamen Dada—a group of five upstart artists bent on aesthetic transgression—Huang was an early provocateur in China's nascent contemporary art world. The most significant development in his work from this period was his embrace of divination and chance procedures. Beginning with a series of abstract paintings, he created work by following the chance determinations of roulette wheels, dice, turntables, and other aleatory mechanisms. By privileging the laws of chance over his personal preferences, Huang subverted the expressionistic rhetoric of his contemporaries and asserted an alternative model to the then-dominant creative process. He could cite Eastern and Western precedents for this philosophical turn, namely Chan Buddhism and Dada, since both promote self-abnegation and a dispassionate acceptance of nature's ebb and flow. Huang would later rely primarily on the oracular diagrams of the *I Ching*, an ancient Taoist text which he consults regularly on projects to this day.

The cross-cultural subtext of Huang's early work was made explicit in *The History of Chinese Painting and the History of Modern Western Art Washed in the Washing Machine for Two Minutes* (1987). As its title blatantly states, the artist washed two art history books—Wang Bomin's *History of Chinese Painting* and Herbert Read's *A Concise History of Modern Painting*—in his home laundry machine for two minutes and then displayed the resultant amorphous mound of pulp on top of a wooden tea box. *Two Minutes* staged a collision of two grand cultural traditions, and the illegible remains captured the ambiguities and complexities of all intercultural discourse.

Huang was in Paris for an exhibition in 1989 during the outbreak of the Tiananmen Square massacre, an event that led him to decide to reside in France permanently. Working

FIG. 51 (LEFT): *The History of Chinese Painting and the History of Modern Western Art Washed in the Washing Machine for Two Minutes*, 1987/1993. Chinese tea box, paper pulp, and glass. 30⅕ x 19 x 27½ inches (76.8 x 48.3 x 69.9 cm). Courtesy the artist

FIG. 52 (TOP RIGHT): *Four Paintings Created According to Random Instructions*, 1985. Installation: oil on four canvases, four shadow boxes with wooden frame, and ink and felt-tip pen on paper. 84 x 60 inches (213.4 x 152.4 cm). Installation view Walker Art Center. Courtesy Walker Art Center, Minneapolis

FIG. 53 (BOTTOM RIGHT): *Colosseum*, 2007. Installation: ceramic, soil, and plants. 218⁹⁄₁₀ x 298²⁄₅ x 89 inches (556 x 758 x 226 cm). Installation view, "C to P," Barbara Gladstone Gallery, New York. Courtesy the artist and Barbara Gladstone Gallery

in the West has only heightened his sensitivity to the inherent politics of cultural identity. In *Passage* (1993), he foregrounds the thinly veiled structures of political exclusion we encounter in our daily lives:

> Nowadays when we travel, especially as we pass through customs in airports, we are often confronted with the question of "identity." The two signs that we see at passport control, "EU Nationals" and "Others," symbolize in a certain way contemporary concepts of nation. All countries try to distinguish "us" from "them."[1]

Huang recreated these two customs gates, placing in the middle of each a lion's cage that housed the animal's feces and chewed remains of its prey. Passing through either gate thus became a charged moment of reflection, in which viewers faced the specter of predation.

In recent years, Huang has taken symbols of national identity as the subject of work that is global and transhistorical in scope. *Pentagon* and *Colosseum*, from 2007, are large-scale ceramic models of these landmark buildings, both of which are militaristic products of imperial ambitions marked by a large central courtyard. By fabricating these structures in ceramic, a material signifier of ancient Chinese ingenuity, Huang instills them with a host of new symbolic associations. For example, they could evoke the terracotta army of Xi'an—China's own ceramic expression of military dominance. By filling the gaps in these structures with soil and a wide variety of seeds, Huang gradually neutralizes their symbolic potential, as they slowly become overgrown by the vegetation they host. In these works and many others, Huang convokes disparate cultures and histories to produce statements that speak poignantly to our global contemporary moment.

ML

NOTE

1. Huang Yong Ping, "Passage," in *House of Oracles: A Huang Yong Ping Retrospective*, exhibition catalogue (Minneapolis: Walker Art Center, 2005), 37.

SELECTED BIBLIOGRAPHY

Andrews, Julia F., *Fragment Memory, the Chinese Avant-garde in Exile*, exhibition catalogue (Columbus, Ohio: Wexner Center for the Arts, Ohio State University, 1993).

Huang Yong Ping, "Painting with Industrial Technology: Looking for New Substitutions," *Leonardo* 18, no. 2 (1985): 91–92.

Vergne, Phillippe and Doryun Chong, *House of Oracles: A Huang Yong Ping Retrospective*, exhibition catalogue (Minneapolis: Walker Art Center, 2005).

RUNA ISLAM

BORN 1970, DHAKA, BANGLADESH
LIVES AND WORKS IN LONDON

Runa Islam offers new twists on old formal rules, disrupting traditional stylistic and filmic devices in order to create new cinematographic languages. Coming from a broad understanding of different kinds of filmmaking (avant-garde, documentary, mainstream, expanded cinema), Islam questions and reconsiders various forms of representation and tackles the mechanics of the medium and its power to affect our conception, perception, and reception of ideas and images. The structural and technical elements of Islam's work are thereby inextricably linked to their conceptual framework. Islam's technique critically engages the formal apparatus of the moving image. Her methods include loose—sometimes fragmented—plot structures, unusual framing and camera angles, discontinuities, or slow-motion, all ways of affirming that film is not merely a medium of representation, but, to quote Jean-Luc Godard, a "form that thinks."[1]

One of Islam's earlier works, *Tuin* (1998), is an "intertextual" work that employs film, video, and sound. For *Tuin*, Islam restages a scene devised by cinematographer Michael Ballhaus for Rainer Werner Fassbinder's *Martha* (1973), in which the male character's gaze on the female character is portrayed by an unprecedented 360-degree camera tracking shot. Presented as a three-screen installation, *Tuin* introduces a multitude of shifting perspectives, rendering a dense, layered reconsideration of the characters and, via the 360-degree movement, revealing the perspectives of not only the actors, but also the film crew and the camera itself.

The work *Scale (1/16 inch = 1 foot)* (2003) combines Islam's interest in architecture with her understanding of how spatial constraints affect human psychology. The film depicts a Brutalist building, the Gateshead multi-story car park designed by Owen Luder in 1965, which gained relative fame when it was used in Mike Hodges's 1972 cult gangster film, *Get Carter.* The double video projection positions a smaller screen in front of a larger one and therefore prevents a complete view of either. The film includes mundane interactions in what is later revealed to be a stage set of the architect's unrealized restaurant in the never-used top story of the building. The artist does not aim to remake Hodges's scenes, nor does she celebrate the infamous failure of modernist architecture. Instead, she presents a montage of perspectives, albeit discontinuously, by juxtaposing different angles and scales, changing the roles of the waiters and the customers, as well as by introducing an unsettling transition from the shots of the building's exterior to its architectural model, which includes little figurines of characters from the film. Along with sounds that signal disruptions in time and narrative, the camera's

FIG. 54 (TOP): *Scale 1/16 inch = 1 foot*, 2003.
Two-screen projection. Duration: 16 minutes
51 seconds. © Runa Islam. Courtesy the artist and
White Cube, London. Photo: Gerry Johansson

FIG. 55 (BOTTOM): *The Restless Subject*, 2008.
Installation shot, Shugo Arts, Tokyo. 5 April—17 May
2008. © Runa Islam. Courtesy the artist and White
Cube, London. Photo: Runa Islam

motion provides the spectator with almost alienating aesthetics, further confusing the difference between fiction and reality.

Movement is an important aspect of *The Restless Subject* (2008), in which a 16 mm film projector projects a film of a thaumatrope, an optical toy dating from the nineteenth century. The toy consists of a card whose surfaces are painted with different pictures: In this case one side shows a bird next to an insect, and the other a cage. These images appear to merge together as the thaumatrope rapidly rotates on a fixed axis, resulting in a third image wherein the bird appears to be trapped in the cage. This can also be seen as an analogy for the recorded image being trapped within the filmed frame. Islam drives the point home by placing the projector face to face with the screen.

In *The house belongs to those who inhabit it* (2008), Islam pushes her inquiry further, and creates a gestural work, using a relatively free-hand method to spell out a text in one continuously filmed sequence. The artist breaks away from the automated movement deliberately used in *Cinematography* (2007) and *Empty the Pond to Get the Fish* (2008)—two earlier films where she also employed the idea of writing with the camera. The work, *The house belongs to those who inhabit it*, depicts interior shots of a forsaken industrial building, and exterior shots showing the ruins of houses and architecture as well as an untamed landscape in a decommissioned industrial area of Trentino, Italy. The title is an English translation of the slogan that is commonly used by squatters' movements in the region. The immediacy of the image is central to understanding the film—it is this that encourages viewers to consider who defines the terms of ownership and belonging. As is true of all of Islam's work, the formal aspects of filmmaking are employed to powerful effect.

ÖE

NOTE

1. Jean-Luc Godard, "Histoire(s) du cinema," TV series/video essay made for Canal+, ARTE and Gaumont, 1988–98.

SELECTED BIBLIOGRAPHY

Farronato, Milovan, "Interview with Runa Islam,"*ART iT* 16 (Summer/Fall 2007).

Fischer, Tine, "In Conversation with Runa Islam," *Runa Islam, Moving Pictures* (Copenhagen: Pork Salad Press, 2002).

Herbert, Martin, "Cinematic Effects: The Art of Runa Islam," *Artforum* 44, no. 5 (January 2006).

Kerr, Carolyn, Helen Little, and Sophie O'Brien, eds, *Turner Prize 08* (London: Tate Publishing, 2008).

Michalka, Matthias, and Susanne Koppensteiner, eds, *Runa Islam: Empty the Pond to Get the Fish*, exhibition catalogue (Cologne: Verlag der Buchhandlung Walther König; Vienna: Museum Moderner Kunst Stiftung Ludwig, Wein/White Cube, 2008).

Varadinis, Mirjam, and Sabine Maria Schmidt, eds, *Runa Islam: Restless Subject*, exhibition catalogue (Heidelberg: Kehrer Verlag; Zurich: Kunsthaus; Essen: Museum Folkwang, 2008).

EMILY JACIR

BORN 1970, BAGHDAD, IRAQ
LIVES AND WORKS IN RAMALLAH, PALESTINE, AND NEW YORK

Emily Jacir deploys the aesthetics of Conceptual art to explore issues of movement, resistance, and citizenship. Though her methods—which include photo-text displays and museological vitrines—appear cerebral, she imbues them with unexpected emotion, poetry, and human drama. In highlighting the ways in which individual subjectivities are a function of political and historical forces, Jacir has used her own experience as a Palestinian to create works that engage in conversations about racism, ethnicity, nationality, religion, and politics. Her art often introduces viewers to lives that have been irrevocably altered by the shifting dynamics of global power. Rather than commenting didactically on such developments, Jacir brings to life the passions, routines, and private tragedies of individuals who seldom have a voice in the dominant historical narratives. This intimately personal quality of her art reveals how the political can shape the deepest reaches of human consciousness, including its desires, frustrations, and sense of home.

In her 2003 project, *Where We Come From*, Jacir asked a number of Palestinians, "If I could do anything for you, anywhere in Palestine, what would it be?" With her American passport, Jacir could move relatively freely throughout Israel and could thus fulfill the wishes of the men and women to whom she posed this simple yet fraught question.[1] She presented the work as a juxtaposition of text and photograph: the former stating the respondent's wish, name, city of birth, citizenship, and the restrictions imposed on his or her mobility by Israeli authorities, the latter depicting the wish's realization. The responses Jacir received ranged from the humorous to the heartrending. Rami from Bayt Jalla asked, "Go on a date with a Palestinian girl from East Jerusalem that I have only spoken to on the phone." The accompanying photograph, shot from Jacir's perspective, shows the girl in question sitting on the opposite side of a café table, evidently nonplussed. Another reads, "Go to my mother's grave in Jerusalem and put flowers and pray," and hangs next to an image of the tombstone, partially shaded by the artist's silhouette. Each photo-text unit represents a request fulfilled, but only vicariously—a reminder of the impossibility of fully consummating the dreams of the people living under occupation.

Jacir's recent ongoing work *Material for a film* (2004–) intensifies the empathic qualities of *Where We Come From.* In this project, she materially re-creates the life of one the Palestinian diaspora's high-profile victims, the intellectual Wael Zuaiter. He was the first Palestinian murdered on European soil. Through a display of postcards, photographs of his library, and other personal effects, as well as diary entries from the artist herself documenting her discovery of

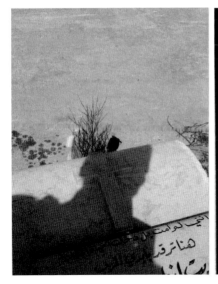

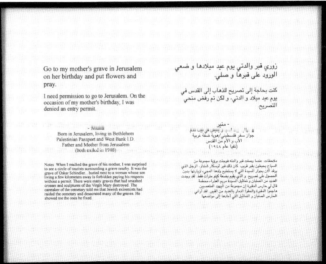

Go to my mother's grave in Jerusalem on her birthday and put flowers and pray.

I need permission to go to Jerusalem. On the occasion of my mother's birthday, I was denied an entry permit.

— Munir
Born in Jerusalem, living in Bethlehem
Palestinian Passport and West Bank I.D.
Father and Mother from Jerusalem
(both exiled in 1948)

Notes: When I reached the grave of his mother, I was surprised to see a circle of tourists surrounding a grave nearby. It was the grave of Oskar Schindler... buried next to a woman whose son living a few kilometers away is forbidden paying his respects without a permit. There were many graves that had smashed crosses and sculptures of the Virgin Mary destroyed. The caretakers of the cemetery told me that Jewish extremists had raided the cemetery and desecrated many of the graves. He showed me the ones he fixed.

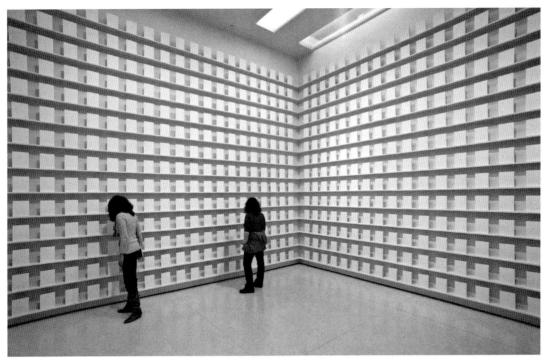

FIG. 56 (TOP): *Where We Come From (Munir)*, 2001–03 (detail). American passport, thirty texts, thirty-two chromogenic prints, and video. Text (Hana) 9½ x 11½ inches (24 x 29 cm). Photo (Hana): 15 x 20 inches (38 x 50.8 cm). Image © Emily Jacir. Courtesy Alexander and Bonin, New York. Photo: Bill Orcutt

FIG. 57 (BOTTOM): *Material for a film (performance)*, 2006. Installation and performance. Dimensions variable. Installation view, Solomon R. Guggenheim Museum, New York. Image © The Solomon R. Guggenheim Foundation, New York. Courtesy Alexander and Bonin, New York. Photo: David Heald

Wael in the traces he left behind, Jacir creates a portrait of Zuaiter as a compassionate pacifist. While dominant historical narratives have confined his legacy to the atrocities of the 1972 Olympic Games, *Material for a film* breathes life into this forgotten figure. Its title alludes to the embodied, cinematic qualities to which Jacir aspires: "I wanted *actual* material for a film—the colors, the streets, the places and spaces that were a part of his life, sound recordings, feelings, where was his apartment? What did it look like? What streets did he walk on?"[2]

In the course of her research, Jacir learned that one of the thirteen bullets fired at Zuaiter lodged itself in the spine of his personal copy of *The Thousand and One Nights*, which he was in the process of translating into Italian. Struck by this haunting fact, she created an entire installation based on this one aspect of the story, *Material for a film (performance)* (2006). To realize this piece she successively fired a single bullet into 1,000 thin, blank white books, which were then shelved on white bookcases lining the gallery. The work memorialized the untimely death of a man dedicated to a life of the mind. As Jacir commented, "It's a memorial to untold stories. To that which has not been translated. To stories that will never be written."[3] The two-part structure of *Material for a film* produces a gripping emotional trajectory, in which viewers first come to know a man through his communications, habits, and passions, only to then be confronted by the chilling silence of his death.

ML

NOTES

1. Today Jacir might not be able to realize the work, as Palestinians who hold American or European passports are regularly denied entry by the Israeli authorities and are no longer granted freedom of movement once inside.

2. Murtaza Vali, "All That Remains: Emily Jacir," *Art AsiaPacific* 54 (July–August 2007): 101.

3. Ibid., 103.

SELECTED BIBLIOGRAPHY

Bell, Kirsty, "Another Country," *Frieze* 114 (April 2008): 158–61.

Demos, T.J., "Desire in Diaspora: Emily Jacir," *Art Journal* 62, no. 4 (Winter 2003): 69–78.

Johnson, Ken, "Material for a Palestinian's Life and Death," *New York Times*, February 13, 2009, C29.

Kravagna, Christian, John Menick, Stella Rollig, Edward Said, *et al.*, *Emily Jacir: Belongings: Arbeiten/ Works 1998-2003*, exhibition catalogue (Linz: O.K. Centrum für Gegenwartskunst Oberösterreich; Vienna: Folio Verlag, 2003).

Vali, Murtaza, "All That Remains: Emily Jacir," *Art AsiaPacific* 54 (July–August 2007): 98–103.

MICHAEL JOO

BORN 1966, ITHACA, NEW YORK
LIVES AND WORKS IN NEW YORK

Michael Joo is an artist occupied primarily with examining the interrelated nature between antithetical forces: science and art; natural and artificial; real and imaginary. Rather than view these pairs as irrevocably opposed, Joo has carefully exposed the arteries running between them, shifting the focus from conflict to coexistence. Using what independent curator Bruce W. Ferguson succinctly described as "braided research modes,"[1] Joo creates work that integrates disparate systems. As is often true of the real-life outcomes of such encounters—nature and civilization, technology and humanity, fiction and fact—the result is not always harmonious. Rather than force these separate streams into an artificial unity, Joo prefers to demonstrate that, regardless of differences, these forces are obliged to coexist, sometimes clashing, sometimes overlapping, and sometimes mutating into an entirely new form. Joo describes this intersection as "a complex network of non-hierarchic information."[2]

Early in his career, Joo adopted a scientist's objectivity and distance to carefully excise human presence from his work. Joo has described science as a system that allows him to definitively relay ideas without invoking the biases involved in other forms of communication: "Science for me involves a language that is authoritative yet coded."[3] He sees this need for a less biased language as a result of his upbringing: "with Korean parents in the Midwestern United States, language was a precious commodity. Science was a more universal language that bridged a cultural gap."[4]

This cultural gap, or more accurately the acknowledgement of cultural differences, comes to the forefront of many of Joo's works. For example, *Stripped (Instinctual)* (2005) is a life-size sculpture of a skinned zebra in which the animal's musculature is a pattern that suggests the removal of its white stripes. This pattern, although rendered in a neutral color, is often mistakenly read as the zebra's white stripes, rather than the black skin that remains when the white is removed. A review of the work reverses the scientific fact that zebras are black with white stripes,[5] and describes *Stripped* as "a life-size sculpture of a standing zebra ... apparently unconcerned that its black stripes had been flayed, revealing muscle and fat underneath."[6] The misunderstanding about the nature of the zebra's stripes engenders a larger discussion about color, and the internalized cultural biases that lead to such incorrect assumptions.

This discussion-provoking ambiguity is the result of operating at the intersections of presumably unrelated issues—in this case, cultural biases and animal physiology. For Joo, this provocation is located in the work itself, in the examination of a tangible object and the

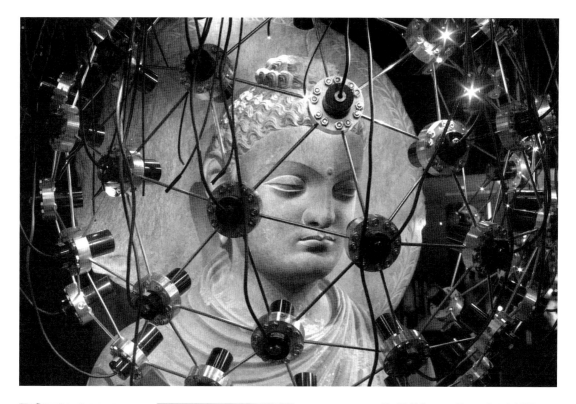

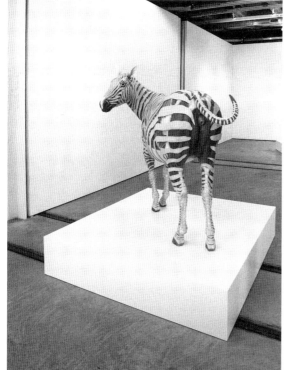

FIG. 58 (TOP): *Bodhi Obfuscatus (Space-Baby)*, 2005 (detail). Mixed mediums. Dimensions variable. Courtesy the artist and Anton Kern Gallery, New York

FIG. 59 (LEFT): *Stripped (Instinctual)*, 2005. Urethane foam, epoxy resin, enamel paint, hand-built epoxy, glass, and wood. Dimensions variable. Courtesy the artist and Anton Kern Gallery, New York

subsequent push to identify it. Joo has explained, "I am interested in playing with notions of physicality and the slippery nature of the identity of an object (or person, place, thing)."[7] Joo is aware that he is unable to control the context in which his work is viewed. What he can control, however, is his own point of view. In his words, "the artist has a unique opportunity to take a framework that's static and imbue it with a slight vibration."[8]

"Bodhi Obfuscatus" (2005–) is a recent series by Joo that exists in between science and religion, representation and reality, and history and progress. Utilizing a halo fitted with multiple surveillance cameras (as many as fifty-four), Joo is able to capture an incredibly detailed portrait of an object or person. The first iteration, *Bodhi Obfuscatus (Space-Baby)* (2005), surrounded the head of a third-century Pakistani Buddha sculpture with this array of cameras, feeding the resultant footage into a matrix of mirrors, forming hundreds of images of both the sculpture and the viewers. Author Paul Black noted that the work "demonstrated that [Joo] is more interested in the way we perceive than in what it is we are looking at."[9] Joo himself compares the work to the effect of twenty-first-century media overload: "A more media-saturated, information-based society means a heightened sense of context as the core of establishing meaning."[10] In "Bodhi Obfuscatus," perhaps his most focused scrutiny of a static framework, Joo reaffirms his dedication to examining context, and allowing this overlap of meanings to push forth new realizations.

ES

NOTES

1. Bruce W. Ferguson, "Where There Is (Artificial) Smoke There Is Fervor," in *Joo*, exhibition catalogue (London: Other Criteria, 2007), 28.

2. Quoted in the press release for Michael Joo, *Joo* (London: Other Criteria, 2007), available at https://www.othercriteria.com/browse/all/books/michael_joo/ (accessed February 1, 2010).

3. Hans-Ulrich Obrist, "Interview with Michael Joo," in *Joo*, 6.

4. Ibid.

5. See Donald R. Prothero and Robert M. Schoch, *Horns, Tusks, and Flippers: The Evolution of Hoofed Mammals* (Baltimore: Johns Hopkins University Press, 2003), 221.

6. Brian Boucher, "Michael Joo at the Bohen Foundation," *Art in America* 94, no. 3 (March 2006): 147.

7. Quoted in Daniel Birnbaum, "Michael Joo and the Doctrine of Cycles," in *Michael Joo*, exhibition catalogue (Seoul: Leeum, Samsung Museum of Art, 2006), 62.

8. Correspondence with artist on January 18, 2010.

9. Paul Black, "The Real and the Imagined: A Conversation," in *Joo*, 30.

10. Ibid.

SELECTED BIBLIOGRAPHY

Joo, Michael, Hans-Ulrich Obrist, Bruce W. Ferguson, Paul Black and Hyunsun Tae, *Joo*, exhibition catalogue (London: Other Criteria, 2007).

Joo, Michael, Jane Farver, Daniel Birnbaum, and Charles Gaines, *Michael Joo*, exhibition catalogue (Cambridge, MA: MIT List Visual Arts Center, 2004).

LAUREN KELLEY

BORN 1975, BALTIMORE, MARYLAND
LIVES AND WORKS IN HOUSTON, TEXAS

On Lauren Kelley's stop-motion animation videos, curators Massimiliano Gioni and Jarrett Gregory wrote that they are "visually and stylistically reminiscent of children's television programs of the '70s and '80s, such as *Sesame Street* and *Reading Rainbow*."[1] And yet the stories they tell could not be less appropriate for children: whether bemoaning an unplanned pregnancy or exploring the world of flight attendants, Kelley's work introduces viewers to a world in which dolls and puppets are the chief players in a bizarre theater that merges the absurd with cinéma vérité. By using a "unique a cast of black dolls and puppets that have undergone low-tech—and often hilarious—modifications,"[2] Kelley breathes life into the plastic characters while poignantly and humorously addressing issues such as gender, feminism, and the human condition.

Big Gurl (2006) is a twelve-minute video featuring Black Barbie® dolls filmed in a combination of clay and stop-motion animations. With the use of clay, Kelley transforms Barbie®'s model frame by molding full lips and big noses to her delicate face, and giving her voluptuous hips, thighs, and bosoms. These additions simultaneously highlight stereotypes about the female African American body and Barbie®'s unrealistic proportions. Kelley's filming technique is sometimes deliberately awkward, such as in a scene in which a large woman wearing white underwear starts jumping on a small makeshift trampoline, and close-ups of her bouncing breast take over the frame. The haphazard visuals are offset by the voiceover, which is consistent and clear. *Big Gurl* tells the story of three women: Minnie, a secretary who takes a pregnancy test in the bathroom at work and, after finding out the result is positive, decides to have an abortion; Sheila, an employee at Queens Chicken and Biscuits, who works in the kitchen and spends her day sweating and dodging sexual advances from the male employees and costumers; and Violet, a soon-to-be bride, who is introduced on her wedding day while she is trying to fit into her dress. As the ceremony is delayed, she reflects on how she has arrived at this point in her life. Violet's story ends happily, with the narrator saying that she "finally she got it together and two hours later she was wed to a brother who best fit her."[3]

On September 4, 2008, Hurricane Ike hit Galveston, Texas, leaving millions throughout Texas without power, food, water, and gasoline.[4] Kelley spent fourteen days without electricity. During that time, the artist recalls that she used a battery-powered radio to listen to everything from the news to Serge Gainsbourg.[5] In response to this experience she created *Wild Seed* (2008), a single-channel video that combines found audio of a banal poem about the four

FIG. 60 (TOP): *Wild Seed*, 2008. Single-channel video. 1:28 minutes. Courtesy the artist

FIG. 61 (BOTTOM): *Prototypical Oppression/ Obsession*, 2009. Single-channel video. 14 minutes. Courtesy the artist

seasons from a French tutorial with English subtitles. The camera pans through a topiary garden with bushes shaped like elephants, gorillas, French poodles, and cows. Kelley carved the garden out of Styrofoam and decorated it with green ground cover, underbrush, and foliage used for architectural models. As the French audio describes sudden rain or snow, the English subtitles appear to voice the thoughts of the topiary giraffe, who describes the environmental changes as if they were a bad dream. The video recalls the 1920s surrealistic cinema pioneered by Luis Buñuel, Man Ray, and Marcel Duchamp, in that it is more dreamlike than real, and yet raises poignant and timely questions about the human condition and the impact of our actions on the world.

CS

NOTES

1. "2008 Altoids Award", exhibition brochure (June 25–October 12, 2008); Massimiliano Gioni and Jarrett Gregory, New Museum, New York.

2. "Rapture in Rapture", exhibition brochure (November 15, 2008–January 11, 2009), curated by Elizabeth Dunbar; Arthouse at the Jones Center, Austin, TX.

3. Narrator, *Big Gurl*, 2008.

4. James C. McKinley, Jr, and Anahad O'Connor, "Rescues Continue in Texas; Millions Without Power," *New York Times*, September 15, 2008, available at http://www.nytimes.com/2008/09/16/us/16Ike.html (accessed March 8, 2010).

5. Ibid.

SELECTED BIBLIOGRAPHY

Gray, Lisa, "Heartbreak in the Dollhouse," *Houston Chronicle*, April 29, 2008.

McKinley, James C., Jr, and Anahad O'Connor, "Rescues Continue in Texas; Millions Without Power," *New York Times*, September 15, 2008, available at http://www.nytimes.com/2008/09/16/us/16Ike.html (accessed March 8, 2010).

MARGARET KILGALLEN

BORN 1967, WASHINGTON, DC
DIED 2001, SAN FRANCISCO

The installations, paintings, and drawings of Margaret Kilgallen deliberately embrace spontaneous gestures and the hand-made. Her easy approach to painting is perhaps a result of her background as a graffiti artist in the Bay Area, where she made line drawings on freight trains using the tag Matokie Slaughter. Kilgallen, who died in 2001, always felt a strong tie to San Francisco: "On any day in the Mission in San Francisco, you can see a hand-painted sign that is kind of funky, and maybe that person, if they had money, would prefer to have had a neon sign. But I don't prefer that. I think it's beautiful, what they did and that they did it themselves."[1] The two-story-high installation *Half Past* (1999) combines images of animals, objects, and people. There are both tender moments such as kissing couples and surfing ladies, for example, and grim scenes—a bickering, clenched-fist couple, or a woman reluctantly taking a spoonful of medicine. The piece is emblematic of the artist's understanding that life is full of both joyful moments and disappointments.

While her work is emotional and visually raucous, her methods were staunchly self-reliant and resourceful. Kilgallen always worked by hand, rejecting aids such as projectors for even her large-scale works. In the installation *Main Drag* (2001), the artist drew fifteen-foot letters (the title of the piece covered an entire wall), merging the notched serifs of hand-painted signs with the three-dimensional shading of graffiti. An adjacent wall described an actual main drag—a stretch of pavement lined with nondescript businesses, a liquor store and a crumbling motel. Pedestrians lingered and trees withered as they reached towards the sky, emphasizing the burdened title. These panoramas frame a freestanding tower, a hodgepodge of reclaimed wood resembling a lighthouse or a rural outpost. Flanked by the spare rectangles of the town's stores and the straight posture of the lettering, the tower swarmed with signs of life. Open panels revealed collections of small dowels with finely-painted human faces and cactuses potted in rusty cans. Letters adorning these cans suggest personal, coded messages. Imperfections were part of her aesthetic. As Kilgallen explained in an interview from the same year:

> I do spend a lot of time trying to perfect my line work and my hand, but my hand will always be imperfect because I'm human ... If I'm doing really big letters and I spend a lot of time going over the line ... I'll never be able to make it straight. From a distance it might look straight, but when you get close up, you can always see the line waver. And that's where the beauty is.[2]

FIG. 62 (TOP): *Half Past*, 1999 (detail). Mixed mediums. Dimensions variable. Installation view, The Institute of Contemporary Art, Boston. Courtesy the artist and The Institute of Contemporary Art, Boston. Photo: Charles Mayer

FIG. 63 (BOTTOM): *Half Past*, 1999. Mixed mediums. Dimensions variable. Installation view, The Institute of Contemporary Art, Boston. Courtesy the artist and The Institute of Contemporary Art, Boston. Photo: Charles Mayer

Kilgallen's reverence for the hand-made signals one of her primary influences—folk art. However, her definition of what qualified as "folk" was quite broad, and she variously cited the colors of Indian miniatures, the flatness of sixteenth-century manuscript lettering, and the coded drawings of freight-train graffiti as being among her aesthetic inspirations and ideals of beauty. "Most of the things that inspire my artwork are 'folk' art of some kind," she once said.[3]

Kilgallen was against uniformity in people as well as objects: In 2000, during an interview for the PBS series *Art:21*, a nationally televised series, Kilgallen took some time to comment on how women are perceived: "I feel like so much emphasis is put on how beautiful you are and how thin you are, and not a lot of emphasis is put on what you can do and how smart you are."[4] Kilgallen explained that her art is intended to inspire young women to make their own.

Indeed, the figures in Kilgallen's work are overwhelmingly female, and often portray her heroines. These women are surfers, banjo players, and adventurers, but also mothers and wives. She painted them smoking, eating, and fighting. With a minimum of narrative detail, her women demonstrate their aspirations and obligations. As she explained, "There need to be women in our everyday visual landscape, working hard and doing their own thing, whether you like it or not, whether it's acceptable or not."[5]

ES

NOTES

1. Margaret Kilgallen, quoted in "INTERVIEW: Influences and Train Marking," *Art21*, 2007, available at http://pbs.org/art21 (accessed February 10, 2010).
2. Quoted in Susan Sollins, "Excerpts from an Interview with Margaret Kilgallen for *Art:21*," in *Margaret Kilgallen: In the Sweet Bye & Bye*, exhibition catalogue (Los Angeles: REDCAT, 2005), 123.
3. Ibid., 121.
4. Ibid., 126.
5. Ibid.

SELECTED BIBLIOGRAPHY

"INTERVIEW: Influences and Train Marking," *Art21*, 2007, available at http://pbs.org/art21 (accessed February 10, 2010).

Joo, Eungie, "Margaret Kilgallen: A Lost Interview with the Artist," *Giant Robot Magazine* 37 (Summer 2005): 38–43.

Kilgallen, Margaret, *Margaret Kilgallen: In the Sweet Bye & Bye*, exhibition catalogue (Los Angeles: REDCAT, 2005).

AN-MY LÊ

BORN 1960, SAIGON, VIETNAM
LIVES AND WORKS IN NEW YORK

An-My Lê orchestrates lush, seductive photographs of imaginary scenes from wars. Taken with a large-format-view camera, Lê's photographs blend elements of journalistic reportage, vintage war photography, and photo-based conceptualism in order to question, or deconstruct, how we as a culture represent violent, political conflict. Lê's photography focuses on adults "playing" war— reenacting historical battles or staging battles as preparation for future attacks—highlighting the thin membrane separating truth from fiction, and the camera's inability to distinguish one from the other.

War has been a constant artistic preoccupation for An-My Lê, who lived in Saigon for fifteen years until her family's evacuation to the United States. In response to this traumatic personal history, in 1999 Lê began to research and correspond with Americans who re-enact specific battles from the Vietnam War, with an eye towards total historical verisimilitude. Out of this research, a collaboration of sorts between the artist and the re-enactors began; Li traveled to Virginia and North Carolina to photograph staged battles from the war that had defined much of her childhood. The resulting series of photographs, collectively titled "Small Wars" (1999– 2002), consists of gelatin silver prints of uniformed men at rest, seemingly weary from battle. In one photograph, two young men sit beneath the shade of trees, their legs splayed out, machine guns in their laps, smoking cigarettes—the scene is both one of war and one of play. While the uniforms and guns transmit the aura of early 1970s Southeast Asia, the evergreens and the carpet of pine needles upon which the two soldiers rest mark the scene as wholly North American in setting. Incongruities like this are the hallmark of Lê's work; they alert viewers that things are not what we assume them to be.

In 2003 Lê refocused her attention on recent conflicts with the series "29 Palms." After being denied a request to be "imbedded" with US soldiers in war zones, Lê instead attached herself to regiments of troops at a combat training zone in the Mojave Desert for Marines about to head to Iraq and Afghanistan. The resulting images are, and at the same time are not, about the US military's recent involvement in the Middle East. Like the images of troops re-enacting Vietnam battles, these troops are "playing" war—practicing for a war they will soon join. Shot with a bulky, large-format camera, each print possesses a careful composition and an all-encompassing depth of field, belying the analog technology with which they were taken. While the images are themselves representations of a simulacrum of war, they seem more "real" and

FIG. 64 (TOP): *F.O.D. Walk, USS Peleliu, California*, 2005. Archival pigment print. 40 x 56½ inches (101.6 x 143.5 cm). Courtesy Murray Guy, New York

FIG. 65 (BOTTOM): *Target Practice, USS Peleliu*, 2005. Archival pigment print. 40 x 56½ inches (101.6 x 143.5 cm). Courtesy Murray Guy, New York

143

permanent than the sanitized, military-approved CNN videos from the early days of the invasion of Iraq.

In her most recent work, Lê continues to examine American forays into foreign lands and waters, be they imperialistic, militaristic, or scientific. Recent subjects include Antarctica, aircraft carriers at sea, Australian jungles, and oil derricks. *Target Practice, USS Peleliu* (2005) consists of five figures on the edge of an aircraft carrier, checking the targets perched on the edge of the ship's deck, which they have just shot through with bullets from their pistols. The absurdity of the image is only outweighed by the violent surge of clouds that dominates the sky above them. Moving away from strictly military pursuits, *C-17, Pegasus Ice Runway, Antarctica* (2008), presents a large aircraft transporting scientific explorers to their barren, icy landscape. The huge plane seems dwarfed by nature; the sky and ground seem to merge in the image, the background is nonexistent. These images all have the same effect—the guns, planes, and ships are insignificant when seen from this scale. In short, Lê seems to want not just to deconstruct images of war and power, but to suggest alternative ways of seeing the world.

BG

SELECTED BIBLIOGRAPHY

"An-My Lê," in *Ecotopia—the 2nd ICP Triennial of Photography and Video* (New York/Göttingen: ICP/Steidel, 2006), 154–59.

Churner, Rachel, "An-My Lê—San Francisco Museum of Modern Art," *Artforum* 46, no. 8 (April 2008), 377.

Godfrey, Mark, "An-My Lê," in *Vitamin PH—New Perspectives in Photography* (London: Phaidon Press, 2006), 154–57.

Gopnik, Blake, "An-My Lê," *Artforum* 46, no. 9 (May 2008).

Gregory, Stamatina, "The Presence of Absence: Art and Media Critique," *Image War: Contesting Images of Political Conflict*, exhibition catalogue (New York: Whitney Museum of American Art Independent Studies Program, 2006).

GLENN LIGON

BORN 1960, BRONX, NEW YORK
LIVES AND WORKS IN NEW YORK

Glenn Ligon is internationally recognized for his works in various media that explore issues surrounding race, sexuality, identity, representation, and language. Ligon frequently incorporates text, language, and imagery from a range of sources, including stand-up comedy, children's coloring books, slave narratives, and the literary works of James Baldwin, Ralph Ellison, Zora Neale Hurston, and Gertrude Stein—transforming these materials into paintings, works on paper, neon sculptures, and installations. Ligon's work often blurs the lines between seeing and not seeing, transparency and abstraction, commenting on the socially and politically loaded territory of representation.

In the series "Stranger" (2006), comprised of the coal-dust paintings for which the artist is perhaps best known, Ligon stencils black text across the surface of white, door-size canvases. The text references many sources: "Stranger in the village" refers to the 1953 essay by James Baldwin;[1] "I am an invisible man," references the Ralph Ellison novel;[2] and Zora Neale Hurston's text is referenced in "I feel most colored when thrown against a sharp white background."[3] The repetition of the text, and its visibility and erasure, occurs in the application of thick encrustation of oilstick and coal dust, adding to the reductive and seductive quality of the paintings. The text appears to float on the canvas, sometimes at center, other times hovering closer to the top or bottom. However, the readability of the words is obscured by the overlaying paint, rendering the text almost illegible. Bordering on notions of abstraction, Ligon's practice employs formal strategies as a way to engage the viewer. It is precisely this type of engagement that gives Ligon's work a sense of complexity, of operating on multiple layers. As Richard Meyer has written, "For all the seeming dispassion of Ligon's formal method (monochrome palette, stenciled letters, repeated words), his text paintings are supercharged with affect. They speak a first-person voice of black subjectivity while registering the denial and relentless silencing of that same voice."[4]

Ligon reveals what it feels like to be an outsider, and he challenges assumptions about race with powerful wit. Continuing his appropriation of text, in the neon work, *Untitled (I Sell the Shadow to Support the Substance)* (2006), Ligon borrows text from Sojourner Truth's *carte de visite* to draw comparisons between Truth's relationship to public discourse as a nineteenth-century black female, and his own as a black male artist living in the twenty-first century. By blacking out the front of the neon instead of the back of the neon, the works glow from behind, giving the simultaneous sense of illumination and darkness, while elegantly touching on the issues of opacity, repression, and invisibility.

145

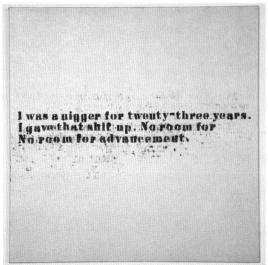

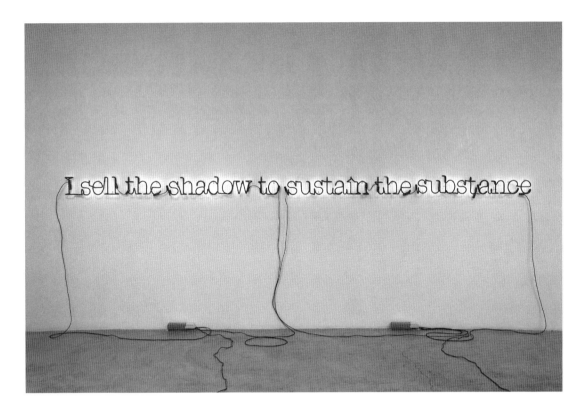

FIGS 66 + 67 (TOP): *No Room (Gold) #7 and No Room (Gold) #46*, 2007. Oil and acrylic on canvas. 32 x 32 inches (81.3 x 81.3 cm). Courtesy the artist and Regen Projects, Los Angeles

FIG. 68 (BOTTOM): *Untitled (I Sell the Shadow to Support the Substance)*, 2006. Neon light and black paint. 8½ x 185 inches (21.6 x 469.9 cm). Courtesy the artist and Regen Projects, Los Angeles

In the paintings *No Room (Gold) #7* and *No Room (Gold) #46* (2007), Ligon moves away from the somber palette of his early work, as indicated by the title. Turning his attention to Richard Pryor's stand-up comedy routines from the 1970s, Ligon paints Pryor's joke, "I was a nigger for twenty-three years. I gave that shit up. No room for advancement," on a gold background. The text is legible on *Gold #46* while revealing the messiness of the paint transfer from stencil to canvas; however, in *Gold #7*, the text becomes virtually invisible. In rewriting Pryor's jokes as text paintings, Ligon forces us to consider the intensity of their stereotypes and uncovers the rage hidden beneath their humor. Ligon's painted fragments of Pryor's joke against a gold monochromatic background suggest his own visual punchline to a joke rooted in the past, yet still resonant in the present. The racially charged jokes Ligon depicts speak in the vernacular language of the street and reveal a complex and nuanced vision of American culture.

From his earliest text paintings to his most recent installations, Ligon has challenged the apparent transparency of language by changing the intended meaning and display. These changes have resulted in language that is difficult, and sometimes impossible to see. As Ligon himself observes, "I've always taken text to the point of disappearance in my work."[7] The artist uses disappearance to address the limits and absences that lie at the heart of identity, and to suggest that individual subjects never align neatly with the overarching terms of race or sexuality. Ligon teaches us that the material force of language and the legacy of the borrowed voice may register most strongly at the very moment of its disappearance.

CL/JH

NOTES

1. "Stranger in the Village," a 1953 essay by James Baldwin, a gay black American man, that scrutinizes the image he conjured for the inhabitants of a tiny Swiss village.

2. Ralph Ellison's *The Invisible Man* (1952) is a discussion on race in America and what it is like to be an outsider, outcast, to be human, and to be ignored.

3. "How It Feels To Be Colored Me," a 1928 essay by Zora Neale Hurston, bears witness to what it was like growing up in a small country town in Eatonsville, Florida.

4. Meyer, Richard, "Borrowed Voices: Glenn Ligon and the Force of Language," *Queer Cultural Center* 1 (2009).

5. Stein uses overly simplistic and embarrassing racial stereotypes to describe her African American subjects.

6. Tyler Coburn, "Glenn Ligon, How It Feels to Be Me," *ArtReview* (January/February 2009): 65.

7. Cited in "An Interview with Glenn Ligon and Gary Garrels, March 15, 1996," in *Glenn Ligon New Work*, exhibition brochure (San Francisco: Museum of Modern Art, 1996).

SELECTED BIBLIOGRAPHY

English, Darby, "Glenn Ligon: Committed to Difficulty," in *Glenn Ligon—Some Changes*, exhibition catalogue, Toronto: The Power Plant, 2005.

Meyer, Richard, "Borrowed Voices: Glenn Ligon and the Force of Language," *Queer Cultural Center* 1 (2009), available at http://www.queerculturalcenter.org/Pages/Ligon/LigonEssay.html (accessed May 15, 2009).

DANIEL JOSEPH MARTINEZ

BORN 1957, LOS ANGELES
LIVES AND WORKS IN LOS ANGELES

Daniel Joseph Martinez's conceptually driven projects have variously combined text, image, video, electronics, and performance to address power, resistance, conventional norms, and history. With no small amount of irony, his art probes uncomfortable issues of personal and collective identity and disturbs viewers' potential complicity in maintaining cultural or socio-political biases.

Graduating from CalArts in the mid-1970s, along with other Conceptual artists such as Michael Asher, John Baldessari, and Robert Cummings, Daniel Joseph Martinez gained national prominence in 1993, when he produced works for the Whitney Biennial, the Venice Biennale, two projects at Cornell University, and the city-wide Chicago public-art project "Culture in Action," which was curated by Mary Jane Jacobs. Martinez says, "That year became a type of model for working, inside and outside of traditional spaces, with and against the canonical vocabulary, while allowing for the simultaneity of radical politics, in terms of content, and radical aesthetics, as forms, to coexist."[1]

The practice Martinez describes is best exemplified by the 1993 work *Museum Tags: Second Movement (Overture) or, Overture con Claque (Overture with Hired Audience Members)*, which involved the use of the Whitney Museum's tags to proclaim, "I Can't Imagine Ever Wanting to be White." Such an action automatically implicates the audience, turning them into performers whose participation is essential to—even demanded by—the piece. The artist continues to be fascinated by the power of language to manipulate, as illustrated by the ongoing project "Divine Violence"[2] (2003–). In the 2007 installation of this work, the "ever-growing rhizome of political terror"[3] is collected and hand-recorded on gold-painted panels that name "the groups in the world currently attempting to enforce politics through violence."[4] Reminiscent of crypt faceplates and historic plaques, the 128 individually rendered panels are evenly spaced in a grid formation, and represent the battlegrounds that result from tension caused by language and its various interpretations. "Divine Violence" also questions the justification of violence "in the name of" a cause or a person, and the way words are employed to perpetrate and excuse violent acts.

Considering Martinez's work as an exploration of dualities, his practice can be understood as operating via different pairings—politics and aesthetics; the traditional and the radical; the object and the subject. This can be seen in *the west bank is missing, i am not dead, am i* (2008), which makes transparent the political aftereffects of modernist architecture on contemporary communities through a comparison of two housing developments: a planned suburban community

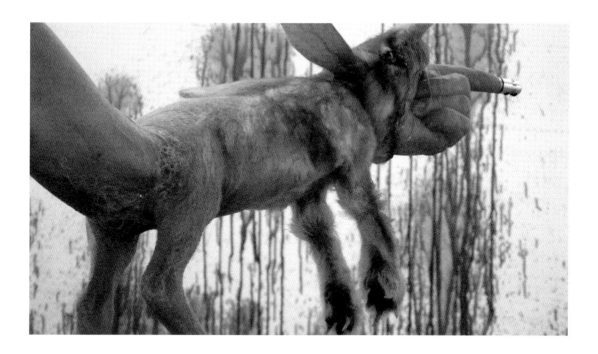

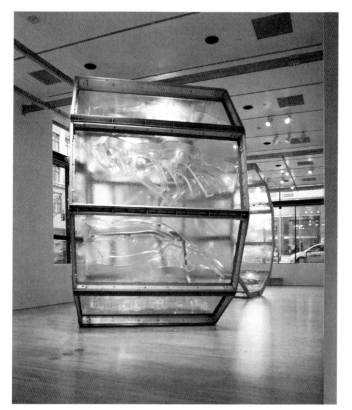

FIG. 69 (LEFT): *the west bank is missing: i am not dead, am i*, 2008. Clear Vacuform and aluminum. 15 ft x 10 inches (457.2 x 25.4 cm). Installation view, Amie and Tony James Gallery, Graduate Center, City University of New York. Courtesy the artist and Simon Preston Gallery, New York

FIG. 70 (TOP): *Redemption of the Flesh: It's just a little headache, it's just a little bruise; the politics of the future as urgent as the blue sky*, 2008 (detail). Animatronic sculpture of fiberglass, electronics, pneumatics, blood, and animal hair. Dimensions variable. Courtesy the artist and the Simon Preston Gallery, New York

in California, and the settlement housing that is part of Israel's West Bank initiative. In *the west bank is missing, i am not dead, am i*, architectural models of the different housing blocks rendered in clear vacuform plastic are placed on two enormous helix-shaped aluminum tracks, magnifying the similarities of the architectural developments. Through the work's physical transparency, Martinez suggests a correlation between modernist architecture and class formation in the United States, and posits a comparison with the Israeli settlements.

The work, *Redemption of the Flesh: It's just a little headache, it's just a little bruise; the politics of the future as urgent as the blue sky* (2008), is a continuation of Martinez's investigation of the body as a site of struggle. An offshoot of a trilogy of animatronic figures, built to look like the artist, that were created between 2002 and 2007, *Redemption of the flesh* is an animatronic sculpture made up of three distinct parts representing the animal, the human, and the machine. Fusing a taxidermic hare (recalling artist Joseph Beuys, who used the same object to challenge the prehistory of art); a fiberglass cast of his right arm; and a computer-driven machine that transverses on a XYZ axis, the sculpture flails around on the floor while spraying fake blood from its "life-source" (a refillable barrel)[5] onto the gallery's walls, creating an abstraction reminiscent of Jackson Pollock's action paintings. Influenced variously by Rudolf Schwarzkogler's 1960s performances involving pain and mutilation, Ray Kurzweil's speculation about artificial intelligence, and Sandy Stone's writings on technology and sexuality,[6] the sculpture parodies violence as portrayed by the media, and criticizes viewers who romanticize and unknowingly encourage such travesties through passive spectatorship.

Considered together, Martinez's works offer a number of different and challenging ideas about identity and politics, and engage viewers in a variety of ways. His is a diverse and eclectic practice linked by a single common thread: the desire to provoke and assert new ways of thinking about the world.

JKII

NOTES

1. Phong Bui, "Daniel Joseph Martinez with Phong Bui," *The Brooklyn Rail: Critical Perspectives on Arts, Politics, and Culture* (March 2008): 26.
2. Title taken from Walter Benjamin's 1927 essay "Critique of Violence."
3. Press release, "Daniel Joseph Martinez: Divine Violence," The Project, New York, 2007.
4. Ibid.
5. Correspondence with artist on February 18, 2009.
6. Ibid.

SELECTED BIBLIOGRAPHY

Baum, Rachel Leah, Harper Montgomery and Eric C. Wilson, "Daniel Joseph Martinez," *interReview* (2008): 38–50.

Martinez, Daniel, *Daniel Joseph Martinez: A Life of Disobedience* (Ostfildern: Hatje Cantz, 2009).

BARRY MCGEE

BORN 1966, SAN FRANCISCO
LIVES AND WORKS IN SAN FRANCISCO

Since the 1979 gallery debut of street art pioneers Lee Quinones and Fab Five Freddy, curators and artists alike have attempted to bring the vitality and lawlessness of graffiti into a fine arts context. These attempts have largely been regarded as failures, with the work's "grit and defiance drained away by institutional approval."[1] Through an ever-expanding practice that currently incorporates formal pattern paintings, aerosol spray paint, found objects, photography, animatronic mannequins, and ballpoint pen drawings, Barry McGee has spent the last two decades successfully engaging audiences by mounting his graffiti-centered art in galleries and museums.

In the late 1980s, while pursuing a BFA in painting and printmaking in San Francisco, McGee began painting on the street, executing his tag name, "TWIST," in small stylized letters, and creating massive, wall-spanning murals punctuated with frowning faces and giant, cartoon-like screws. Many of his trademark strategies developed naturally as a result of the demands of unsanctioned public art. The recurring problem of how to access the train cars and building rooftops that were ideal surfaces for graffiti often required McGee to come up with creative and dangerous solutions. As his studio practice developed, McGee brought this same daring ingenuity to his installations, leaving museum-goers as impressed with the artist's wherewithal as they might have been on seeing a TWIST mural on the roof of a ten-story building.

The installation *One More Thing* (2005) is an excellent example of how McGee translated this daring. Over a dozen overturned vehicles covered in graffiti occupied the gallery at Deitch Projects in New York. Towers of televisions flickered, their screens mimicking the patterns on the hundreds of paintings that engulfed the gallery walls. Overlapping one another, the brightly colored, unmistakably hand-made paintings created a sense of movement. In sections of the installation, the pattern paintings were interrupted by portraits of weary, heavy-browed men. A closer look at these men reveals them to be a diverse crowd, but always showing the same rough edges and signs of fatigue. McGee described the importance of his motif of the male figure as

> kind of like this everyman, and it's very specific to San Francisco, where there's a huge homeless population that everyone wants to be free of, a bit like graffiti … things that the city is trying to get rid of, or pretending doesn't exist. With my work, I'm trying to reveal this.[2]

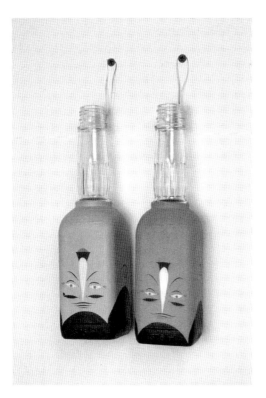

FIG. 71 (LEFT): *Untitled (2 bottle installation)*, 2005.
Acrylic on glass bottles and wire. 10 x 5 x 3 inches
(25.4 x 12.7 x 7.6 cm). Courtesy the artist and Deitch Projects,
New York

FIG. 72 (BOTTOM): *Untitled*, 2008. Ink on paper.
Thirty framed drawings, Dimensions variable. Courtesy the artist
and Deitch Projects

This "everyman" appears strategically throughout McGee's work, popping up erratically but persistently. The artist's best-known representations of the character appear painted onto empty bottles of cheap liquor, as in the work *Untitled (68 Bottle Installation)* (2005). With this work, McGee creates a totemic connection to these forsaken men and at the same time articulates a brutal metaphor for their dispensability.

In a 2001 interview McGee defended graffiti, stating: "There's a lot of talk of how damaging graffiti is … but there's actually no damage. It all can be removed or painted over."[3] He went on to contrast it against the effect of advertising: "If there's commercial jingles from the '70s or '80s that I remember and that are stuck in my head, that's damage to me."[4] McGee's attitude toward commercialization is embedded in his aesthetic decisions. The hand-made quality of his work is intended as a rebuttal to the slick, dominant forces of the advertising industry. By continuing to evoke the unregulated declarations of graffiti, McGee affirms his support of a form of expression that, albeit illegal, is available to everyone regardless of their race or economic status. As the foundation of his practice, street art sets the political tone of his work, particularly in its capacity to assert someone's right to be heard. "I'm not comfortable with the idea that someone who has money can put up a billboard in your neighborhood telling you how to live your life," McGee explained in 2005. "A community should have its own voice."[5]

ES

NOTES

1. Tessa DeCarlo, "The Latest Tagger to Be Tagged for Success," *New York Times*, July 11, 2004, 230.
2. Barry McGee, artist statement, in *WATARI-UM* (Tokyo: Watari Museum of Contemporary Art, 2007), available at http://www.watarium.co.jp/exhibition/0706_mcgee_en.html (accessed September 10, 2009).
3. "Public and Private Space: Interview with Barry McGee," *Art:21*, available at http://www.pbs.org/art21/artists/mcgee/clip2.html (accessed September 10, 2009).
4. Ibid.
5. Jessica Lack, "Riot on an Empty Street," *i-D Magazine* 258 (September 2005).

SELECTED BIBLIOGRAPHY

Celant, Germano and Barry McGee, eds., *Barry McGee* (Milan: Fondazione Prada, 2002).

DeCarlo, Tessa, "The Latest Tagger to Be Tagged for Success," *New York Times*, July 11, 2004, 230.

Joo, Eungie, "Regards, Barry McGee," exhibition brochure (Minneapolis: Walker Art Center, 1998).

Lack, Jessica, "Riot on an Empty Street," *i-D Magazine* 258 (September 2005).

McGee, Barry, *The Buddy System* (New York: Deitch Projects, 2002).

—— *Things Are Really Getting Better,* exhibition catalogue (Amsterdam: Stedelijk Museum, 2007).

DAVE MCKENZIE

BORN 1977, KINGSTON, JAMAICA
LIVES AND WORKS IN NEW YORK

Perhaps best known for his performances that transform everyday interactions into art, Dave McKenzie has talked to passersby while sitting on a park bench, gone on dates through a lottery system, and even danced in a gallery with no music for six hours. His performances illustrate experimental theater director Richard Schechner's theory that there are three forms of time: set, event, and symbolic. In *Private Dancer* (2007), McKenzie uses a "set" time of six hours to dance with or without visitors. There is an important element of spontaneity to this piece, as visitors are invited to participate. McKenzie also welcomes the unknown with the amusing work *It's a Date* (2005), in which visitors to the Savage Gallery in Portland, Oregon, entered their names into a drawing to have a date with the artist. Here time is marked in terms of "event" time, from the moment the lottery starts to the end of the date. The duration of this event marks the time the artist is committed to carrying out the work, yet is framed within the symbolic time of the date itself—comprising a greeting, a program such as dinner and a movie, conversation, and a farewell.

For the project *On Location* (2008), McKenzie scouted locations around the Lower East Side of New York City for potential sites for a movie that would never be made. McKenzie references film notices that inform residents there will be filming on their block for a designated period of time. McKenzie placed his own "Dear Neighbor" letters on businesses, residences, and signposts, emphasizing that residents' lives will not be impacted with the bold text: PLEASE NOTE: CARS LEFT ON THESE STREETS WILL NOT BE AFFECTED BY FILMING.[1] The posting continues by stating, "At times you may see me with video and still photography equipment," but maintains that residents "are not the focus of these instruments. I will not portray you or describe you and this place." The project preys on human vanity—and paranoia.

One of the many projects centered on McKenzie's willingness to commit to being somewhere at a certain place and time is *I'll Be There* (2007–). Originally carried out at the Whitney Biennial in 2008, *I'll Be There* begins with McKenzie's pledge to show up. These proposed encounters could unfold any number of ways: with a conversation, a random happenstance, or even with the artist being stood up.[2]

Communication and its various pitfalls are not the only theme in the artist's work. *Bing* (2008), a white canvas painting leaning against the gallery wall with the text "BING" written in graffiti along its base, was inspired by a photograph of a derelict building with "STOP THE

FIG. 73: *On Location*, 2008. Photocopies. 11 x 8½ inches (27.94 x 21.59 cm).
View: The Lower East Side during the exhibition Museum as Hub: Six Degrees,
New York, NY. Courtesy the artist and Susanne Vielmetter
Los Angeles Projects. Photo: New Museum

FIG. 74: *BING*, 2008. Acrylic paint, spray paint, wood, and fake brick.
Dimensions variable. Courtesy the artist and REDCAT, Los Angeles. Photo: Scott Groller

BOMBING" spray painted on it. Wanting to work with texts and objects that are relevant to the moment, McKenzie anticipates a future in which "many of them [texts] will read like STOP THE BOMBING."[3]

JKII

NOTES

1. "New Museum Global Classroom (G:Class)," website available at www.gclass.org (retrieved from "Artist" section, http://gclass.org/artists/dave-mckenzie, February 26, 2010).

2. Eungie Joo, *Museum as Hub: Six Degrees*, Exhibition Paper 4 (New York: New Museum, 2009), 6.

3. "Screen Doors on Submarines: Dave McKenzie in Conversation with Ryan Inouye," exhibition brochure (California: REDCAT, 2008).

SELECTED BIBLIOGRAPHY

Boucher, Brian, "Dave McKenzie, 'All Together Now', At or Near the Studio Museum in Harlem," *Art in America* 96 (March 2008).

Foumberg, Jason, "Slightly Unbalanced," *Frieze* 115 (May 2008): 171.

Museum as Hub: Six Degrees, Exhibition Paper 4 (New York: New Museum, 2009).

Just Kick It Till It Breaks, exhibition catalogue (New York: The Kitchen. 2008).

Malone, Micah, "Dave McKenzie Portland, OR," *Art Papers* (May/June 2007).

JULIE MEHRETU

BORN 1970, ADDIS ABABA, ETHIOPIA
LIVES AND WORKS IN NEW YORK

Julie Mehretu takes cities and urban environments as a point of departure for her large-scale paintings. Based on blueprints and architectural drawings of stadiums, fortifications, shopping malls, airports, and, more recently, housing projects, Mehretu's paintings are engaged not only with formal concerns of line, color, and form, but also social issues of power and globalism. Curator Douglas Fogle wrote of her work, "By using elements extrapolated from recognizable references in our built environment, the artist has created paintings that provocatively blur the line between both figuration and abstraction and history and fiction while constantly referencing the world around us."[1]

Mehretu cites hip-hop "sampling" as one of her influences. Just as hip-hop music is composed of parts of prerecorded songs to produce a "new" audio track,[2] Mehretu takes samples from maps, architectural plans, and art-historical references to create her own visual language, a lexicon that integrates lines, arcs, dots, vectors, hatch marks, and dashes. Mehretu explains, "My aim is to have a picture that appears one way from a distance—almost like looking at a cosmology, city, or universe from afar—but then when you approach the work, the overall image shatters into numerous other pictures, stories, and events."[3]

In Mehretu's practice, architectural plans or blueprints are first applied to the canvas as an under-drawing. The paintings are then layered in acrylic resin. Mehretu builds up surfaces continually, drawing and painting overlapping lines, forms, and color, and collaging symbols onto each successive surface, creating a deep and densely populated space.

The triptych *Stadia I, II, and III* (2004) was painted at the beginning of and during the Iraq War. When exhibited and hung together these canvases resemble a massive arena, the activity revolving around a circular field seething with raw energy and chaos. Lines move in and out of space, characters move across the surface of the painting, and flag pendants and commercial icons from the global economy emerge from the surface. With this work, Mehretu compares the aggression in stadium games to the competition between nations in a global marketplace:

> The coliseum, the amphitheater, and the stadium are perfect metaphoric constructed spaces clearly meant to situate large numbers of people in a highly democratic, organized, and functioning manner. However, it is in these same spaces that you can feel the undercurrents of complete chaos, violence, and disorder. Like going to see fireworks—you feel the crowd at the same time as you feel the explosions.[4]

FIG. 75: *Stadia I*, 2003. Ink and acrylic on canvas. 108 x 144 inches (274.32 x 365.76 cm). Image © Julie Mehretu. San Francisco MoMA Collection. Courtesy The Project, New York. Photo: Richard Stoner

FIG. 76: *Stadia II*, 2004. Ink and acrylic on canvas. 108 x 144 inches (274.32 x 365.76 cm). Image © Julie Mehretu. Carnegie Museum of Art Collection, Pennsylvania, Gift of Jeanne Greenberg Rohatyn and Nicolas Rohatyn and A.W. Mellon Acquisition Endowment Fund. Courtesy The Project, New York. Photo: Richard Stoner

These constructed spaces are designed to celebrate pageantry and competition. They are also sites for the expression of conflict and hostilities. Ironically, a year after Mehretu completed these paintings, the New Orleans Superdome, which housed Hurricane Katrina evacuees in August 2005, became a nesting ground where safety and violence, order and chaos, community and revolt, churned in the same space.[5]

The title *Black City*, which Mehrutu used for two different paintings made in 2005 and 2007, refers to the increased militarization of American cities after September 11, 2001 and the subsequent "War on Terror." In these works, Mehretu cites a mixture of different systems of militarized space, including many different plans of fortified cities, from American Civil War fortifications to Hitler's Atlantic wall bunker to ideas about spatial organization that can be found in virtual systems. Interested in how stadiums and military architecture have affected contemporary social space, Mehretu examines what it means to live in American border cities. "How do borders and walled-in cities operate when you're trying to build a free open society that represents ideals like liberty, justice and prosperity? What determines why one individual belongs in one place and not another?" the artist once asked rhetorically in an interview.[6] These are the sort of questions she raises, however obliquely, in works like *Black City* and others.

CL

FIG. 77: *Stadia III*, 2004. Ink and acrylic on canvas. 108 x 144 inches (274.32 x 365.76 cm). Image © Julie Mehretu. Virginia Museum of Art Collection. Courtesy The Project, New York. Photo: Richard Stoner

NOTES

1. Douglas Fogle, "Putting the World into the World," in *Julie Mehretu: Drawing Into Painting*, exhibition catalogue (Minneapolis: Walker Art Center, 2003), 6.
2. Richard Shusterman, "The Fine Art of Rap," *Pragmatist Aesthetics Living Beauty, Rethinking Art*, second edition (New York: Rowman & Littlefield, 2000), 202.
3. Olukemi Ilesanmi, "Looking Back: E-mail interview between Julie Mehretu and Olukemi Ilesanmi, April 2003," in *Julie Mehretu: Drawing Into Painting*, exhibition catalogue (Minneapolis: Walker Art Center, 2003) 13.
4. Ibid., 14.
5. Swarupa Anila and Rebecca R. Hart, Wall Text, "City Sitings," exhibition (Detroit Institute of the Arts, 2007).
6. Swarupa Anila and Rebecca R. Hart, interview with Julie Mehretu, Detroit Institute of the Arts, 2007.

SELECTED BIBLIOGRAPHY

Allen, Siemon, *Julie Mehretu: City Sitings* (Detroit: Detroit Institute of Arts, 2009).

Chua, Lawrence, "Julie Mehretu," *Bomb Magazine* (Spring 2005): 24–31.

de Zegher, Catherine, *Julie Mehretu: The Drawings* (New York: Rizzoli, 2007).

"Julie Mehretu, Yang Fudong, and Lucy McKenzie," *Parkett* 76 (Zurich: Parkett-Verlag, 2006), 24–63.

Mehretu, Julie, *Julie Mehretu: Grey Area* (New York: Guggenheim Museum, 2010).

O'Reilly, Sally, *Collage: Assembling Contemporary Art* (London: Black Dog Publishing, 2008).

WANGECHI MUTU

BORN 1972, KENYA
LIVES AND WORKS IN NEW YORK

Early in Wangechi Mutu's career, collage served as the medium in which the artist sketched out ideas for her sculptures and performance. Now they have become distinct works in their own right, ranging in scale from postcard to life-size. The collages are on paper or Mylar, and incorporate a variety of materials—packing tape, paint, ink, glitter, cutouts from porn and fashion magazines, African ethnographies, and medical illustrations. Mutu often adds cutout lips, faces, eyes, legs, masks, and hair, to female bodies painted in a washed-out, mottled style. Because several of her collages, such as *Pin-Up* (2001), *Immigrant Nightmares* (2001), *Forensics Forms* (2004), and *Ark Collection* (2006), consider the female form, her work has been linked to artists Kara Walker, Cindy Sherman, Shirin Neshat, Michal Rovner, and Marina Ambrovic, who investigate culture and history as it is sited on the female body. Like Walker and Sherman, Mutu also explicitly references sexuality, violence, and beauty. She extends this allusion by grafting animal patterns and limbs onto her female characters. In Mutu's words, these elements refer to the "need to extend, perforate, change, or shapeshift [the] body in order to exist."[1] This need to move and shift actively resists the notion of fixed identity, and simultaneously acknowledges the pressure and expectations to "perform" certain aspects of one's identity (such as gender).

One might interpret the bodies in Mutu's works as having undergone a serious trauma: evidence of the price paid for having to conform to cultural standards. This is especially true of the large-scale collage *Try dismantling the little empire inside of you* (2007) which depicts a running or leaping figure on the right whose chest has exploded its contents to the left of the composition, filling it with sticks and body parts, including severed heads, both black and white. The body on the right is presumably permanently altered and has motorcycle wheels for feet, hands, and joints. The work conveys the difficulty of exorcising cultural stereotypes that prevent individuals from living a free, unobstructed life.

Exploring similar themes, *Perhaps the Moon Will Save Us* (2008) was a site-specific installation that was included in the New Museum's exhibition, "Unmonumental." It depicted a mountain landscape at night. The sky was painted a rich matte brown and perforated with holes for stars; and the mountains were made of strips of shiny brown packing tape that stretched out from the wall onto the floor. A whitish full moon, pieced together from animal furs, hung in the center of the sky. Bare trees stood on the right, their branches twisting and bending to reach

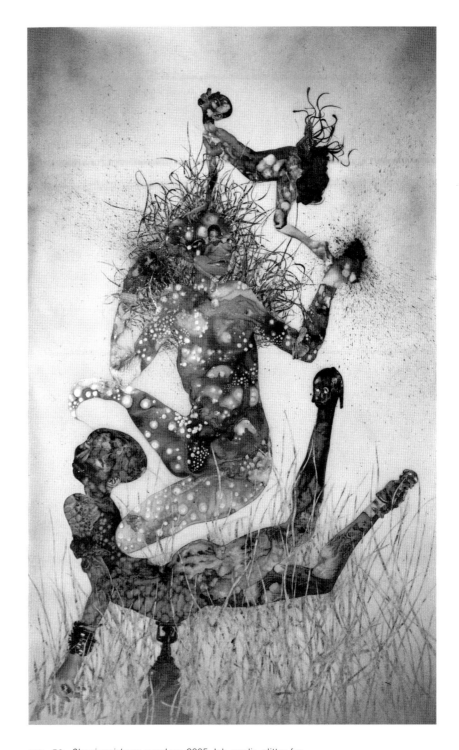

FIG. 78: *Sleeping sickness saved me*, 2005. Ink, acrylic, glitter, fur,
contact paper, and collage on Mylar. 86⅕ x 51⅕ inches (219 x 130 cm).
Courtesy of Susanne Vielmetter Los Angeles Projects. Photo: Mariano Peuser

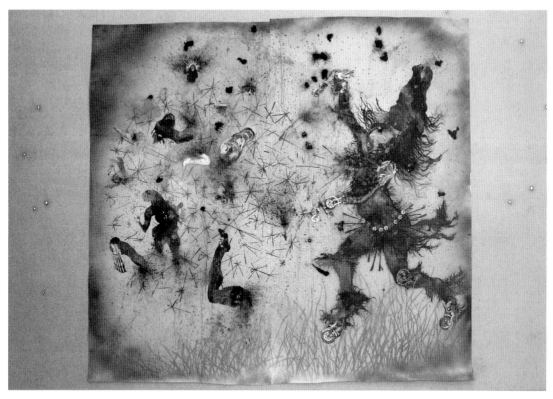

FIG. 79: *Try dismantling the little empire inside of you*, 2007. Ink, pigment, photo collage with mixed media on Mylar and wall. 95³∕₁₀ x 103⁹∕₁₀ inches (242 x 264 cm) (Mylar only). Courtesy the artist, Susanne Vielmetter Los Angeles Projects, and the Sikkema Jenkins Gallery, New York. Photo: Becket Logan

to the left. Migrating between the trees and the moon were dozens of pink pig carcasses flying through the air with fur wings. The not overly optimistic title suggests that we are all prey to the prejudices that contribute to a distorted and often false perception of others.

YO

NOTE

1. Barbara Kruger, "Interview with Wangechi Mutu," *Interview* (April 2007).

SELECTED BIBLIOGRAPHY

Enright, Robert, "Resonant Surgeries: The Collaged World of Wangechi Mutu," *Border Crossings* 27, no. 1 (2008): 28–46.

Eshun, Ekow, *Y.on.I: Wangechi Mutu*, exhibition catalogue (London: Victoria Miro Gallery, 2007).

Kruger, Barbara, "Interview with Wangechi Mutu," *Interview* (April 2007).

Singleton, Douglas, ed., *Wangechi Mutu: A Shady Promise* (Bologna: Damiani, 2008).

Stief, Angela, *Wangechi Mutu: In Whose Image?* exhibition catalogue (Nürnberg: Verlag für moderne Kunst Nürnberg, 2009).

RIVANE NEUENSCHWANDER

BORN 1967, BELO HORIZONTE, BRAZIL
LIVES AND WORKS IN BELO HORIZONTE

Rivane Neuenschwander's interest in chance takes center-stage in her videos, works on paper, photographs, and installations. Influenced by the Neo-Concrete movement of the late 1950s and early 1960s in her native Brazil, Neuenschwander challenges art's formal and conceptual limits through the use of many different mediums. In the ongoing project *Eu Desejo o seu Desejo* (I Wish Your Wish) (2003–), visitors are invited to take fabric ribbons printed with the desires of people from different locations. According to the tradition at the church Nosso Senhor do Bonfim in São Salvador, Bahia, Brazil, where the idea for making the wish ribbons originated, the ribbon is tied around the wrist, and once it falls off or breaks away, the wish comes true. The work has several layers of meaning, addressing the passage of time, the dissolution of physical boundaries, and the notion of reciprocity, since viewers who wear the ribbons theoretically help a stranger's wish come true.

Metaphors are embedded in Neuenschwander's works and are often connected to politics.[1] Taking its title from the supercontinent of the Paleozoic and Mesozoic eras 250 million years ago, the video *Pangaea's Diaries* (2008) employed a stop-frame animation technique to record hundreds of carnivorous ants as they crawled over a dish of carpaccio. Through their eating and shifting of the raw meat, the ants appeared to map and chart a plausible terrain. Meanwhile, notions of assimilation, consumption, corruption, destruction, distribution, and transformation are suggested by the process of ingestion.

The unpredictability of nature as metaphor for human rights was the underlying motif to the 2007 work *Continente-Nuvem* (Continent-Cloud). Consisting of tiny white Styrofoam balls hovering within a translucent ceiling and pushed around by air currents, *Continente-Nuvem* forever changes its shape. By alluding to the movements of clouds and their lack of physical boundaries, the work subtly points to those whose movements are more restricted, such as illegal immigrants.

For the artist, "The exhibition space becomes the studio, as it is there that experimentation, observation, and the process happens, all of which are essential for the work to exist."[2] Monumental in scale, *Suspension Point* (2008) bisected the South London Gallery: a temporary wooden floor structure transformed the gallery into two distinct environments: one of darkness, one of lightness. From below, one could see the beams, struts, posts, and flooring that supported the gallery above. The only light source emanated from two films projected on the

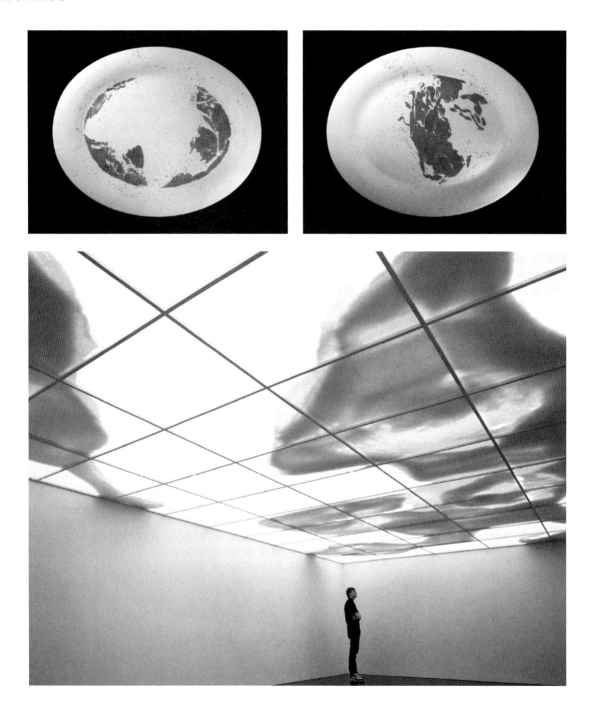

FIGS 80 + 81 (TOP): *Pangaea's Diaries*, 2008. Digital photographs transferred to 16 mm film, loop. 1 minute. Courtesy Stephen Friedman Gallery, London; Galeria Fortes Vilaça, São Paulo; and Tanya Bonakdar Gallery, New York. Photo: Rivane Neuenschwander

FIG. 82 (BOTTOM): *Continente-Nuvem* (Continent-Cloud), 2007. Correx, aluminum, Styrofoam balls, fluorescent lighting, electric fans, and timers. Dimensions variable. Installation view, Stephen Friedman Gallery, London. Courtesy Galeria Fortes Vilaça, São Paulo; Stephen Friedman Gallery, London; and Tanya Bonakdar Gallery, New York. Photo: Steve White

walls, a bulb, and the natural light that came from a staircase leading to the upper space. Within the environment there were also many sounds, some more subtle than others. Water dripping into a metal basin amped by a microphone from the work *It's raining out there* (2008) created in collaboration with the Brazilian native musicians O Grivo, is overshadowed by the creaks of viewers' footsteps above. The evocative noises and their meanings are uncertain, serving mainly to magnify a sense of foreign surroundings and a feeling of displacement. The upper airy space was a complete contrast. Flooded by light from the glass roof, viewers walked up the stairs, blinded by the rays, to find the aforementioned basin, a series of holes drilled halfway up the wall, a small mountainous landscape of dust (residue from the drilled holes), and a series of perforations along the ceiling borders.[3] As an experiential environment, *Suspension Point* exemplified the artist's unique aesthetic, which she has termed "ethereal materialism."

JKII

NOTES

1. Correspondence with artist on January 26, 2009.
2. Ibid.
3. Ibid.

SELECTED BIBLIOGRAPHY

Andrews, Max, "Rivane Neuenschwander," in *Life on Mars: 55th Carnegie International* (Pittsburg, PA: Carnegie Museum of Art, Pittsburg, 2008), 246–47.

Comic Abstraction: Image-Breaking, Image-Making, exhibition catalogue (New York: Museum of Modern Art, 2008), 25–26, 96–101.

Flood, Richard, *Rivane Neuenschwander: A Day Like Any Other*, exhibition catalogue (New York: New Museum, 2010).

Jones, Kristin M., "Rivane Neuenschwander," *Frieze Magazine* 104 (January–February 2007).

—— Rivane Neuenschwander, *to/from*, exhibition catalogue (Minneapolis: Walker Art Center, 2003).

NOGUCHI RIKA

BORN 1971, SAITAMA, JAPAN
LIVES AND WORKS IN BERLIN, GERMANY

Noguchi Rika has used a basic pinhole camera to photograph the sun and a waterproof digital camera to capture the mountainous terrain beneath the ocean near Yonaguni Island—the westernmost island of Japan. Whatever device she uses to take her pictures, Noguchi never manipulates her images in the darkroom or digitally. Her images are simultaneously recognizable and ambiguous; familiar and mysterious; banal and fantasy. It is through such dichotomies that Noguchi's works become explorations of the world.

Noguchi travels far and wide to photograph a wide variety of subjects. "In the Desert"(2007), shot in the United Arab Emirates, is a series of landscapes sparsely populated by men tending racing camels, in which both man and beast are fully cloaked to protect themselves from the harsh desert winds. A pale blue sky dwarfs the cloaked camels and men, who appear as shadowy figures, seemingly blending with the sand and the grains of the photographic prints. The figures are in focus, yet their identities are anonymous, blurring the distinctions between animal and man in their shared barren environment.

Mostly the human figure is absent from Noguchi's photographs. In "Marabu" (2005) the large stork became the subject of a series that was shot in Germany. Normally living in flocks in Africa, the marabou is unmistakable due to its size, bare head and neck, black back, and white underbelly. Noguchi photographed the bird at the Berlin Zoo and used a pinhole camera for the series, which produced a hazy halo that surrounds the exotic bird in the images. The camera produces a circle of confusion (CoC)—the part of an image that is acceptably sharp—resulting in an ambiguous two-legged form constrained to an unmarked moment in an unknown place.

In the aptly titled series "The Sun" (2005–), Noguchi explores Earth's closest and most familiar star. Asked to make a book about color, Noguchi looked towards the celestial body responsible for nature's palette.[1] Armed with the most basic camera—the pinhole—Noguchi captured images of the sun by shooting directly into the ball of light. Since the camera has no viewfinder, Noguchi left the composition of the images to chance. Perhaps best described as unaltered seeing, each photograph in the series presents a direct or indirect view of the sun— captured through windows, over buildings, and between clouds. The subject is very familiar, yet the images seem otherworldly.

Noguchi installs her images in exhibitions with great care, using the gallery's white box more like a theater's black box. In the 2009 installation of "The Sun" at D'Amelio Terras Gallery

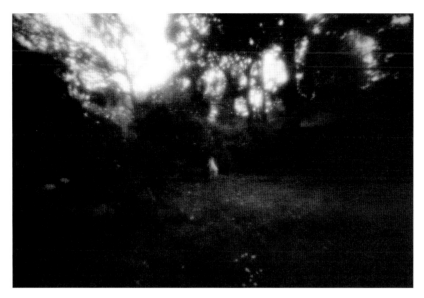

FIG. 83 (TOP): *Marabu #1*, 2005. Chromogenic print. 19⁷/₁₀ x 29½ inches (50 x 75 cm). Courtesy the artist; D'Amelio Terras, New York; and Gallery Koyanagi, Tokyo

FIG. 84 (BOTTOM): *In the Desert #2*, 2007. Chromogenic print. 35²/₅ x 35²/₅ inches (90 x 90 cm). Courtesy the artist; D'Amelio Terras, New York; and Gallery Koyanagi, Tokyo

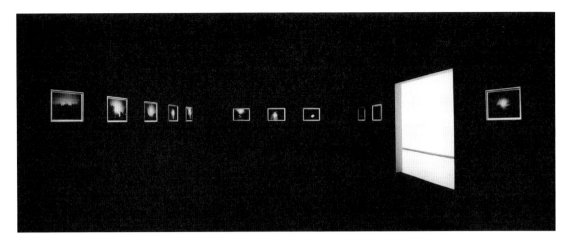

FIG. 85: *"The Sun" series*, 2005–. Installation view, "Life on Mars,"
55th Carnegie International, Pittsburgh (2008). Courtesy the artist

in New York City, Noguchi trained a spotlight on each soft-focused image, hung on black walls. Mirroring the mechanics of photography, Noguchi guides the viewer's eye. As always, she ensures that nothing is missed.

JKII

NOTE

1. Max Andrews, "Noguchi Rika," *Life on Mars: 55th Carnegie International* (Pittsburg: Carnegie Museum of Art, 2008).

SELECTED BIBLIOGRAPHY

Andrews, Max, "Noguchi Rika," in *Life on Mars: 55th Carnegie International* (Pittsburg: Carnegie Museum of Art, 2008).

Chong, Doryun, "The Quiet Awe of Noguchi Rika," in *Brave New Worlds*, exhibition catalogue (Minneapolis: Walker Art Center, 2007).

Noguchi Rika, *The Sun* (Tokyo: Izu Photo Museum, 2009).

—— *Seeing Birds* (Tokyo: P3 Art and Environment, 2001).

—— *The Planets* (Tokyo: Hara Museum of Contemporary Art; and Birmingham: Ikon Gallery, 2004).

Ozaki, Tetsuya, "Noguchi Rika," in *Vitamin Ph: New Perspectives in Photography* (New York: Phaidon, 2006).

CATHERINE OPIE

BORN 1961, SANDUSKY, OHIO
LIVES AND WORKS IN LOS ANGELES

Catherine Opie became well known in the early 1990s for her gender-bending portraits of Daddys—leather men and women—and sadomasochism dykes in California, but her interest in community is equally apparent in several of her photographic series from the last decade. As she has stated: "The s/m community ... was thought of—and still is thought of, to an extent—as predatory or perverted. S/m was often framed in the language of the abnormal, which stripped it of its humanity. I wanted people to have a humble moment with my friends."[1]

Her first solo exhibition in New York, "Being and Having" (1991) at 494 Gallery, brought together photographs of women, set against bright yellow studio backgrounds, who directly addressed the camera. They posed in moustaches, creating an illusion of hyper-masculinity that confronted prior conceptions about lesbian identity. Produced just one year after Judith Butler's groundbreaking theoretical text, *Gender Trouble*, and following the pinnacle of the culture wars of the 1980s, Opie's overwhelmingly honest photography hit a nerve in the art world by forcefully challenging the status quo.

Though much of Opie's work undeniably references the autobiographical, she has also captured the built and natural settings of the United States by documenting Southern California mini-malls and freeways, the Great Lakes, mansions in Bel-Air and Beverly Hills, and the landscape of Juneau, Alaska. She continues to add cities—Chicago, Minneapolis, New York, and St. Louis—to her ongoing black-and-white "American Series," which she began in 1997. Having cited influences such as Walker Evans, Dorothea Lange, and Robert Frank, Opie is clearly interested in various methods of constructing individual and communal identity, seamlessly shifting back and forth from portraiture to photographs of architecture and landscape.

Her work has been the subject of two solo exhibitions in recent years that represent significant milestones in Opie's career: "1999 & In and Around Home," at The Aldrich Contemporary Art Museum in 2006, which traveled to three additional venues, and "Catherine Opie: American Photographer" at the Solomon R. Guggenheim Museum, in 2008. The Aldrich exhibition brought together two disparate bodies of work: "1999," a meditation on the American landscape at the end of the millennium and "In and Around Home," which drifts between her personal life and current events. The exhibition at the Guggenheim, which is the most extensive presentation of Opie's work to date, also brought together two unique series for the first time. Her photographs of ice fishing houses in Minnesota (produced during a residency at the Walker Art

FIG. 86 (TOP LEFT): *Marqeil*, 2007. Chromogenic print. 29½ x 22 inches (74.9 x 55.9 cm). Image © Catherine Opie. Courtesy Regen Projects, Los Angeles

FIG. 87 (TOP RIGHT): *Oliver in a Tutu*, 2004. Chromogenic print. 24 x 20 inches (61 x 50.8 cm). Image © Catherine Opie. Courtesy Regen Projects, Los Angeles

FIG. 88 (BOTTOM): *Mendenhall Glacier & Waterfall*, 2007. Chromogenic print. 48 x 64 inches (121.9 x 162.6 cm). Image © Catherine Opie. Courtesy Regen Projects, Los Angeles

Center) were paired with those of a community of surfers in Malibu, California, and were hung in rows directly across from each other in a narrow gallery. Though the two bodies of work reveal starkly different landscapes, both present temporary communities that exist for a season, then disappear, only to re-emerge a year later. Two of her best-known (and more controversial) works, *Self Portrait/Cutting* (1993) and *Self-Portrait/Pervert* (1994), were also included in the exhibition at the Guggenheim, as well as her series from 2000 of large-format Polaroids of her close friend, performance artist Ron Athey, who has been HIV-positive for over a decade.

One of Opie's ongoing series, "Football Landscapes," which she began in 2007, portrays American high school football players, teenage boys whose liminal state between childhood and adulthood is reminiscent of Opie's photographs some twenty years ago of butch dykes striking their most manly pose. As with her series of surfers and ice houses, "Football Landscapes" traces the individual and group dynamics of American popular culture.

From her photographs of unfamiliar newscasters to portraits of her son, such as *Oliver in a Tutu* (2005), Opie's work ultimately reveals the underpinnings and nuances of a world constantly in flux. In capturing evidence of fleeting moments, such as a presidential election, the construction of a freeway, or a barren landscape, Opie's work is a poignant reminder of the fragile beauty of the human experience.

AM

NOTE

1. Catherine Opie as told to David Velasco. *Artforum* 47, no. 1 (September 2008).

SELECTED BIBLIOGRAPHY

"Andrea Bowers and Catherine Opie," in *Between Artists*, ed. Alejandro Cesarco (New York: A.R.T. Press, 2008).

Blessing, Jennifer, *Catherine Opie: American Photographer*, exhibition catalogue (New York: The Solomon R. Guggenheim Museum, 2008).

Fogle, Douglas, *Catherine Opie: Skyways + Icehouses*, exhibition catalogue (Minneapolis: Walker Art Center, 2002).

Hammond, Harmony, ed., *Lesbian Art in America* (New York: Rizzoli, 2000).

Hough, Jessica, *Catherine Opie: 1999 & In and Around Home*, exhibition catalogue (Ridgefield, CT: Aldrich Contemporary Art Museum, 2006).

Smith, Elizabeth, *Catherine Opie: Chicago (American Cities)*, exhibition catalogue (Chicago: Museum of Contemporary Art, 2006).

CLIFFORD OWENS

BORN 1971, BALTIMORE, MARYLAND
LIVES AND WORKS IN QUEENS, NEW YORK

In his writing, Clifford Owens has referred to a crisis of meaning that affects black performance artists, including the notion that blackness is not as readily identified with performance as much as it is with other mediums.[1] Photography, which Owens uses to document his performances, is a medium that can be seen as an intervention in this crisis, increasing both visibility of black performance and its history.

During a residency at the Skowhegan School of Art in Maine in 2004, Owens turned scheduled studio visits with visiting artists into opportunities for performance. In one instance, performance artist William Pope.L. joined him in slinging mud against the white wall of the studio. Thirty-six black-and-white stills show the two artists in action, as the studio walls become increasingly covered with splotchy mud. In a later iteration of the piece, Owens asked the performance and video artist Joan Jonas to make a drawing using his body. The photographs of the performance *Studio Visits: Studio Museum in Harlem (Joan Jonas)* (2005) show her dragging his body around a shallow platform upon which six large pieces of drawing paper have been taped.

Collaboration with established artists, as in the "Studio Visits" series, or his staging of *Lick Piece 1964*, a performance by the African American Fluxus artist Benjamin Patterson taken from *Four Fluxus Scores by Benjamin Patterson* (2006), are ways of revising the dominant white narrative of performance art. To insert oneself into history is to give it a new context or twist—a subtle gesture with radical implications. New contexts offer new understandings not only of Owens's work, but the larger constellation of artists and art histories he invokes.

Owens is also interested in how audience members engage him as part of the "social contract"[2] implicating both audience and performer. Several of his works touch upon this theme. For *Tell Me What to Do with Myself* (2005), Owens enclosed himself in a space equipped with video cameras from which he could be seen via monitors or through a peephole. Owens followed instructions given to him by audience members outside. These included undressing, masturbating, drinking his urine, and being silent. An even stronger comment on the relationship between the artist and the audience is *Photographs with an Audience* (2008). In this work, the audience responded to instructions called out by Owens, and he responded to their instructions in turn. A camera documented the events of the performance as they unfolded, which was a distinct contrast from the one-way vision of *Tell Me What to Do with Myself*, since the presence

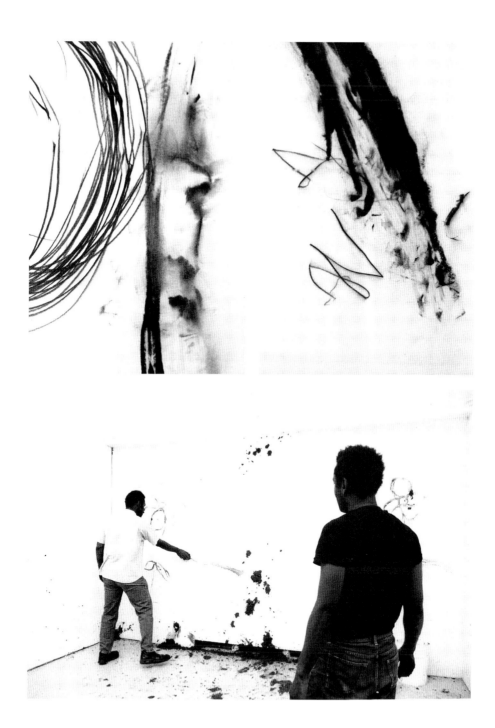

FIGS 89 + 90 (TOP): Drawings from *"Studio Visits: Studio Museum in Harlem (Joan Jonas),"* 2005. Graphite and charcoal on paper. 30 x 22 inches (76.2 x 55.9 cm). Courtesy On Stellar Rays, New York

FIG. 91 (BOTTOM): *Studio Visits: Skowhegan (William Pope.L)*, 2004–08 (detail). Installation: thirty-six black and white photographs, mounted on aluminum. 5 x 7 inches (12.7 x 17.8 cm) (each). Courtesy On Stellar Rays, New York

of a camera caused audience members to reflect on their role in tacitly accepting the "social contract" of performance.

Owens pushed the contractual idea further after he was invited by artist Shaun Leonardo to participate in a series of artist talks titled "On Friendship." The two spoke intimately about how they knew each other, but these details were never to leave the room because the audience had to sign legally binding nondisclosure contracts prior to being admitted to the talk. A similar tactic was employed for *Some Things We Do Together* (2008), a series of collaborative performances for which Owens and Leonardo built a private space inside a gallery. The performances were invitation only, and nondisclosure contracts were used again, giving the event an air of exclusivity.

Photography and nondisclosure contracts provide concrete evidence that a more ephemeral exchange between performer and audience took place. The substance of Owens's work, it seems, is not so much about producing an artifact or document, but perhaps what such documents represent: a heavily structured social interaction.

YO

NOTES

1. Clifford Owens, "Notes on Critical Black US Performance Art and Artists," *Fylkingen Electronic Journal* (October 2003), available at http://www.hz-journal.org/n3/owens.html (accessed December 2, 2009).

2. Clifford Owens, "Discharging the Anxiety of Influence," *NYFA Current*, 2007, available at http://www.nyfa.org/level3.asp?id=586&fid=6&sid=17 (accessed March 3, 2010).

SELECTED BIBLIOGRAPHY

Owens, Clifford, "Discharging the Anxiety of Influence," *NYFA Current*, 2007.
—— "Notes on Critical Black US Performance Art and Artists," *Fylkingen Electronic Journal* (October 2003).

Woods, Bryon, "The Process Series and Clifford Owens," *Independent Weekly*, November 4, 2009.

ELIZABETH PEYTON

BORN 1965, DANBURY, CT
LIVES AND WORKS IN NEW YORK

Elizabeth Peyton has been a celebrated portraitist since the mid 1990s—a time when figurative painting was not central to art discourse.[1] Her subjects have included film idols, rock stars, and historical figures (John Lennon, Marie Antoinette, and Susan Sontag), as well as friends and fellow artists (Rirkrit Tiravanija, Angus Cook, and Nick Mauss). Peyton's oeuvre is marked by a striking intimacy, even in her depictions of the historical.

Using a variety of source materials, including photographs (either taken by the artist or clipped from printed matter such as magazines), film, and video stills, Peyton makes paintings, drawings, or prints of what she refers to as "pictures of people." Peyton never aims to make a photographically real reproduction. In *Frida (Frida Kahlo)* (2005), which is based on Julien Levy's 1938 photograph of Kahlo taken the same year as her first solo exhibition in the United States, Peyton creates a new way of looking at the late artist. Peyton renders Kahlo in soft, smooth brushstrokes as a beautiful, nude, young woman.

Peyton has stated that she uses paint "the way some artists use composition: it holds each portrait together in all its formal energies and psychic vicissitudes."[2] Whether it is the actor Leonardo DiCaprio or a studio assistant, Peyton's treatment is seemingly consistent. Her choices of color, line, and scale are simultaneously bold and modest. Often smaller than a standard sheet of paper on gessoed board, the paintings feature precise yet gestural brushwork in translucent and jewel-like tones that vibrate against one another. For Peyton, "Making art is making something live forever. Human beings especially—we can't hold on to them in any way. Painting and art is a way of holding onto things and making things go on through time."

Peyton's subjects have varied from Napoleon Bonaparte to Kurt Cobain to her ex-husband, and there is no system to how she chooses subjects. For Peyton, "There is no separation for me between people I know through their music or photos and someone I know personally. The way I perceived them is very similar, in that there's no difference between certain qualities that I find inspiring in them."[3]

The works *Liz and Diana, Susan Sontag (after H.C. Bresson's Susan Sontag, Paris, 1972), Georgia O'Keefe (after Stieglitz 1917)*, and *Jonathan (Jonathan Horowitz)*—all completed in 2006—give a sense of the artist's range of subjects. "I don't really choose [who to paint]," she says. "It just sort of has to happen. I start listening to something or I'm seeing somebody a lot or seeing their art. And then I just really want to make a picture of them."[4]

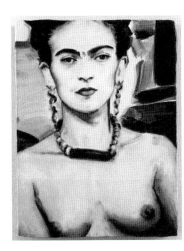

FIG. 92 (LEFT): *Frida (Frida Kahlo)*, 2005. Oil on board. 9 x 7 inches (22.9 x 17.8 cm). Courtesy the artist and Gavin Brown's Enterprise, New York

FIG. 93 (BOTTOM): *Angus and Jonathan (Angus Cook and Jonathan Caplan)*, 2006–07. Oil on medium-density fibreboard. 10 x 8 inches (25.4 x 20.3 cm). Courtesy the artist and Gavin Brown's Enterprise, New York

Peyton's "pictures of people" place her in a long lineage of painters who make figurative portraits, a genre that resists the passage of time by capturing a person at a particular moment in their life.

JKII

NOTES

1 Laura Hoptman, "Fin de Siècle," in *Live Forever: Elizabeth Peyton*, exhibition catalogue, New Museum (New York: Phaidon Press, 2008), 225.

2. Jarvis Cocker, "Elizabeth Peyton," interview between Jarvis Cocker and Elizabeth Peyton, *Interview* (October 2008).

3. Elizabeth Peyton quoted in *Whitney Biennial 2004*, exhibition catalogue (New York: Whitney Museum of American Art, 2004), 224.

4. Cocker, "Elizabeth Peyton."

SELECTED BIBLIOGRAPHY

Cocker, Jarvis, "Elizabeth Peyton," interview between Jarvis Cocker and Elizabeth Peyton, *Interview* (October 2008).

Elizabeth Peyton: Portrait of an Artist, exhibition catalogue (Bologna: Damiani, and Connecticut: Aldrich Contemporary Art Museum, 2008).

Higgs, Matthew, Steve LaFreniere, Dave Hickey, Douglas Blau, Meicost Ettal, Linda Pilgrim, Jerry Saltz, Roberta Smith, and Giorgio Verzotti, *Elizabeth Peyton* (New York: Rizzoli, 2005).

Live Forever: Elizabeth Peyton, exhibition catalogue (London: Phaidon, and New York: New Museum, 2008).

Peyton, Elizabeth, Rachael Thomas, and Enrique Juncosa, *Elizabeth Peyton: Reading & Writing*, exhibition catalogue (Milan: Charta, and Dublin: Irish Museum of Modern Art, 2009).

Whitney Biennial 2004, exhibition catalogue (New York: Whitney Museum of American Art, 2004).

ANNIE POOTOOGOOK

BORN 1969, CAPE DORSET, NUNAVUT TERRITORY, CANADA
LIVES AND WORKS IN OTTAWA, CANADA

Annie Pootoogook comes from a long lineage of artists from Cape Dorset in Canada and has been influenced by their practices, in particular those of her grandmother, Pitseolak Ashoona.[1] Like her grandmother, who is acclaimed for her timeless, traditional scenes of Inuit daily life, Pootoogook bases her drawings on her own life. References to Nintendo, Coleman grills, and clothing tags that say "Made in China," are scattered throughout carefully rendered episodes of people eating, engaging in games of tug-of-war, or going on hunting expeditions. Unlike her grandmother, however, Pootoogook departs from "traditional" Inuit art by addressing social issues of alcoholism and mental health, and incorporating images of technology and consumerism.

In fact, Pootoogook's drawings are a much-needed corrective to naïve perceptions of an "untouched" North. For example, the drawing *A True Story* (2006) features figures in synthetic parkas and boots floating in a body of water along with a red gas can. Pootoogook describes the event as "really happen[ing] in Cape Dorset … in 1981 or 1982. The men were hunting for walrus. They put too many walrus in the boat so it was too heavy and the boat sunk. They all died."

Pootoogook's drawings are systematic: she begins with a graphite under-drawing that is outlined in black, and then filled in with color. Formally, her style recalls Inuit drawing techniques and aesthetics where an object, figure, or scene is centered on the paper and realistically rendered. The use of toning and shading is replaced with hard-edged lines to indicate depth and space. The drawings are not naturalistic or based on photographs, but are constructed from memory.[2]

Pootoogook's attention to detail is extraordinary, and her drawings often read like short stories. In *Dr. Phil* (2006) a reclining girl in a red sweater, off-white pants, and matching red socks is shown watching the "Dr. Phil" show in a room filled with banal items: a purple lamp, cordless phone, a sewing machine case, a VCR complete with buttons and the time in red digital numbers, a clock whose hands are positioned to 1:25 p.m., and a faux wood TV stand are among the many objects on view. A neighbor's home on the other side of a snow-covered street can be seen through a window hung with a yellow curtain. The room's clutter is offset by vast swaths of monochromatic hues: aqua-green walls, a Kelly green rug, and a white tiled floor.

Similar vignettes of everyday life abound in Pootoogook's drawings, which have simple, descriptive titles that help viewers understand exactly what they are looking at: a man kneels

FIG. 94: *Family in Tent (Cape Dorset)*, 2006. Pencil crayon.
16¼ x 20 inches (41.3 x 50.8 cm). Private collection.
Courtesy Feheley Fine Arts, Toronto

◁ ᓲ ⟩ᑐᒧ

FIG. 95: *Composition (Bad Thoughts) (Cape Dorset)*, 2003.
Ink and pencil crayon. 20 x 26 inches (50.8 x 66 cm).
Courtesy Feheley Fine Arts, Toronto

beside a table in *Drinking Beer in Montreal* (2006); children sit in front of a television broadcasting a local program in *Watching Seal Hunting on Television* (2003–04); red lingerie replete with a size tag, hook fastener, and a flower appliqué constitutes *Bra* (2006); and a woman's head (perhaps a self-portrait), surrounded by signs and symbols referencing Inuit mythology, sticks her tongue out in *Composition (Bad Thoughts)* (2003). "What is most important to me is to put things from my heart and my mind onto the paper," says Pootoogook. "So it is what I draw, not how I draw and what I draw with—it is the things that are important."[3]

JKII

NOTES

1. Correspondence with artist on February 16, 2010.
2. "Annie Pootoogook," from *3 Cousins*, exhibition brochure (Toronto: Feheley Fine Arts, 2007).
3. Correspondence with artist on February 16, 2010.

SELECTED BIBLIOGRAPHY

Annie Pootoogook, exhibition catalogue (Toronto: The Power Plant Contemporary Art Gallery, 2006).
"Annie Pootoogook," *3 Cousins*, exhibition brochure (Toronto: Feheley Fine Arts, 2007).

Baerwaldt, Wayne, Nancy Campbell, and Deborah Root, *Annie Pootoogook* (Calgary: Alberta College of Art and Design, 2007).
Moving Forward: Works on Paper by Annie Pootoogook, exhibition brochure (Toronto: Feheley Fine Arts, 2003).

WALID RAAD

BORN 1967, CHBANIEH, LEBANON
LIVES AND WORKS IN NEW YORK AND BEIRUT

Walid Raad is the founding member of the Atlas Group, an imaginary foundation whose stated mission is to archive the history and visual culture of contemporary Lebanon. Under this institutional banner and in association with a cast of real and fictional collaborators, he produces documents in a variety of media that address his nation's recent past at oblique angles to traditional historical narratives. Eschewing the conventions of political history, which tracks an oscillating trajectory of victors and vanquished, Raad's archive focuses on the banal details of people's lives in a state at war. The fact that these fabricated documents hew closer to "real life" than officially sanctioned histories is just one of the many ironies that permeate Raad's work:

> The geopolitical history of contemporary Lebanon that was being written [in the years since the wars ended] was leaving out so much of what I considered to be my experiences of these events. The mere ability to be able to walk freely from West to East Beirut unhindered by checkpoints is not an experience one would have had 15 years ago. I wanted to make documents that were conscious of that.[1]

His project's institutional and documentary strategies raise broader questions about the accretion of authority to historical accounts. The photograph and the archive are revealed to be malleable constructs whose claims to truth are always partial and motivated.

Most of the Atlas Group's documents are attributed to anonymous or fictitious sources, though some are credited to Raad himself. One such example, "Let's Be Honest, the Weather Helped" (1984–2007), consists of a series of photographs of bullet-pocked, Beirut street scenes, blanketed by brightly colored dots of varying sizes. In an accompanying text, Raad explains:

> Like many around me in Beirut in the late 1970's, I collected bullets and shrapnel. I would run out to the streets after a night or day of shelling to remove them from walls, cars, and trees. I kept detailed notes of where I found every bullet and photographed the sites of my findings, covering the holes with dots that corresponded to the bullet's diameter and mesmerizing hues I found on the bullets' tips. It took me another 10 years to realize that ammunition manufacturers follow distinct color codes to mark and identify their cartridges and shells. It took me another 10 years to realize that my notebooks in

FIG. 96 (TOP): *Scratching on Things I Could Disavow_plate 1 (2, 3, 4)*, 1989. Four archival inkjet prints. 44 x 60 inches (111.8 x 152.4 cm) (each). Image © Walid Raad. Courtesy of the Paula Cooper Gallery, New York

FIG. 97 (BOTTOM): *My neck is thinner than a hair: Engines*, 2001. Installation: photographs and ink on paper. Dimensions variable. Image © Walid Raad. Courtesy of the Paula Cooper Gallery, New York

part catalogue 17 countries that continue to supply various militias and armies fighting in Lebanon.[2]

Viewing these pictures, one is initially drawn to the attractive colors and tension between the aesthetics of abstraction and photography. The text, however, reveals the dots to be a code signifying the geopolitics of violence in Lebanon. The work "Let's Be Honest ..." simultaneously summons to mind both a child's fascination with his surroundings and the distribution networks of terror. That these documents are, perhaps, fabricated makes them no less unsettling.

Recently, Raad's focus has shifted to the Arab world's burgeoning engagements with contemporary art and his own relationship to this phenomenon. He has observed the emergence of an Arab contemporary art infrastructure (i.e. art fairs, museums, galleries, schools, symposia, etc.) that has grown in complicity with regional strategies for economic development. His understanding of these events is informed by the artist and writer Jalal Toufic's notion of "the withdrawal of tradition past a surpassing disaster," a phrase that serves as the title of an essay in Toufic's book *Forthcoming*.[3] Toufic describes how trauma can create a rift between a culture and its traditions, going so far as to suggest that the objects of these traditions can be rendered inaccessible to vision. In *Scratching on Things I Could Disavow: A History of Modern and Contemporary Art in the Arab World Part I_Volume 1_Chapter 1 (Beirut: 1992–2005): A Project by Walid Raad*, a recent multi-part work, Raad applies Toufic's formulation to the Arab contemporary art efflorescence. He subjects his own work to this interrogation by presenting the Atlas Group's documents in miniature, hung in an architectural model of museum galleries. Echoing the self-reflexivity of Marcel Duchamp's *Boîte-en-Valise*, Raad exposes his own complicity in the contemporary art world's systems of distribution and display. The work questions the critical efficacy of the Atlas Group in this perilously fraught moment in his nation's history.

ML

NOTES

1. Walid Raad, as cited in Janet A. Kaplan, "Flirtations with Evidence: The Factual and the Spurious Consort in the Works of The Atlas Group/Walid Raad," *Art in America* 92 (October 2004): 134.

2. Walid Raad, "Let's Be Honest, the Weather Helped," The Atlas Group Archive, 2010, available at http://www.theatlasgroup.org/data/TypeA.html (accessed March 3, 2010).

3. Jalal Toufic, *Forthcoming* (Berkeley: Atelos, 2000).

SELECTED BIBLIOGRAPHY

Gilbert, Alan, "Walid Raad," *Bomb Magazine* 81 (Fall 2002): 38–45.

Jones, Caroline A., "Doubt Fear," *Art Papers* 29, no. 1 (January–February 2005): 24–35.

Nakas, Kassandra and Britta Schmitz, *The Atlas Group (1984–2004): A Project by Walid Raad* (Cologne: Verlag der Buchhandlung Walther König, 2007).

MICHAEL RAKOWITZ

BORN 1973, GREAT NECK, NEW YORK
LIVES AND WORKS IN CHICAGO

Michael Rakowitz combines various forms of sculpture, performance, and design in his highly aesthetic works. Interested in architecture and urban space, Rakowitz employs "efficacy as a medium and as a tactic."[1] He looks for solutions to urban problems on the ground, taking advantage of the existing infrastructure. For example, Rakowitz turned to building exhaust ducts as a departure point for the site-specific project, *paraSITE* (1998–2000). *paraSITE* is a series of plastic shelters for the homeless that are inflated and heated by the exhaust of the buildings to which they are attached. A variation on Japanese architect Shigeru Ban's refugee shelters created for the homeless after the Kobe earthquake in 1995,[2] the project demonstrates Rakowitz's effectiveness in addressing an "invisible" population, the homeless, via exhaust ducts, an engineering system that is considered an eyesore at best. *paraSITE* explores ways of using public space in order to help underserved groups.

With an open-ended approach, Rakowitz constantly revises and evaluates outcomes before his work takes its final form. In the project *Return* (2006), Rakowitz reworked his initial concept, a drop box for Iraqis living in the US to send things back home, into a shipping center staffed by those already working in the exhibition space. The project later evolved into Davisons & Co., a reincarnation of his family's import–export business that once operated in Baghdad, now reopened in Brooklyn "to illuminate the logistical difficulties and roundabout methods of sending and receiving shipments from a country under foreign occupation and facing an uncertain future" and to address "the absence of anything bearing the label 'Product of Iraq' on store shelves in the United States."[3] With Davisons & Co., Rakowitz became the first storeowner in nearly thirty years to sign a contract to import Iraqi dates to the US. But his initial success was short-lived. After several attempts to locate the dates, his 200 boxes were found rotting in Damascus. Finding value in what some might deem a failure, Rakowitz says, "the overall transaction served as a surrogate for a larger tragedy, in that the narrative of the dates' ill-fated journey to the US mirrored the plight of hundreds of thousands of Iraqi refugees."[4]

Continuing his investigation of the relationship between the US and Iraq, the ongoing project *the invisible enemy should not exist* (2007–) considers the US invasion of Iraq and its aftermath through the display of a series of reconstructed artifacts looted from the Iraq Museum in 2003. The project's title is a direct translation of *Aj-ibur-shapu,* the ancient Babylonian street that ran through the Ishtar Gates, which were excavated from 1902 to 1914 and put on permanent

FIG. 98 (TOP): *Joe Heywood's paraSITE shelter*, 2000. Plastic bags, polyethylene tubing, hooks, and tape. Dimensions variable. Site-specific installation at Battery Park City, Manhattan, New York. Courtesy the artist and Lombard–Freid Projects, New York

FIG. 99 (MIDDLE): *Return* (Brooklyn), October–December 2006. Site-specific work at Davisons & Co., import/export company 529 Atlantic Avenue Brooklyn, New York. Courtesy the artist and Lombard–Freid Projects, New York

FIG. 100 (BOTTOM): *The invisible enemy should not exist (Recovered, Missing, Stolen Series)*, 2007. Middle Eastern packaging and newspapers, and glue. Dimensions variable. Installation view, Lombard–Freid Projects, New York. Courtesy the artist and Lombard–Freid Projects, New York

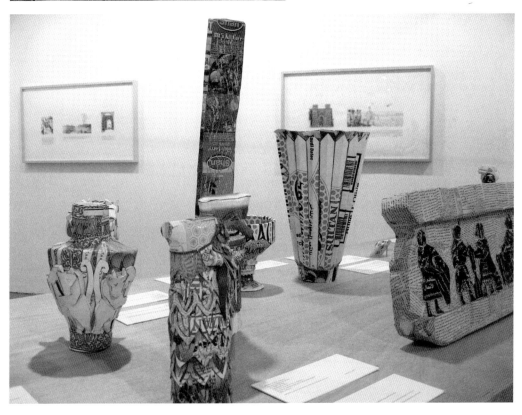

display at Berlin's Pergamon Museum in the 1930s. The Iraqi government rebuilt the gates in the 1950s. To create the replicas of artifacts for *the invisible enemy should not exist*, Rakowitz uses recycled Arabic newspapers and food wrappers. A label with the National Museum registrar's data, quotations from relevant sources, and the status of the artifact's whereabouts accompanies each replica. For artifact IM65359—a 5.5 cm by 7.3 cm replica of an ivory bull from ca. 800 B.C. sculpted from local Arabic newspapers—the extended label text contains the mission statement of the Iraq Museum published in the Museum's catalogue in 1976:

> The relics of the past serve as reminders of what has been before, and as links in the chain of communication between past, present and future. The society which possesses many and fine museums has a correspondingly stronger historical memory than the society without them.[5]

Recasting the question "Who is the invisible enemy that should not exist?" in terms of the destruction of culture and history, Rakowitz encourages viewers to reflect on society's apathy toward cultural values and ethics.

JKII

NOTES

1. Michael Rakowitz, *Harrell Fletcher/Michael Rakowitz (Between Artists)*, edited by Alejandro Cesarco (New York: A.R.T. Press, 2008), 50.
2. Ibid., 58.
3. Ibid., 37.
4. Ibid., 39.

5. The object label reads as follows:
 museum number: IM65359
 excavation number: ND10499
 provenance: Nimrud (SW 37)
 dimension(s) (in cm): height: 5.5; width: 7.3;
 thickness:1.0; diam. ca. 12.0
 material: ivory
 date: Neo Assyrian (ca. 800 bc)
 description: Bull facing right, head and double horns
 of another bull on hindquarters
 status: unknown.

SELECTED BIBLIOGRAPHY

Boucher, Brian, "Babylon Without Borders," *Art in America* 95 (April 2007).

"Enemy Kitchen: Artist Michael Rakowitz and the Politics of (Iraqi) Food," *Bidoun* (Winter 2007).

Fletcher, Harrell, and Michael Rakowitz, *Harrell Fletcher/Michael Rakowitz (Between Artists)*, ed. Alejandro Cesarco (New York: A.R.T. Press, 2008).

Richard, Frances, "Michael Rakowitz, Lombard–Freid Projects," *Artforum* 45, no. 8 (April 2007).

Tiven, Benjamin, "Art Matters," *The Nation*, September 19, 2007.

PEDRO REYES

BORN 1972, MEXICO CITY
LIVES AND WORKS IN MEXICO CITY

Pedro Reyes's artistic practice defies simple characterization. He blends the disciplines of architecture, visual art, and urban research into a hybrid form of social inquiry. While his investigations are founded upon an architect's understanding of space, Reyes uses artistic strategies to advocate for social agency, a philosophy that is central to his work. Reyes's interactive sculpture *Leverage* (2006–08), serves as a visual metaphor for the underlying impetus to his practice. It is an over-size seesaw with a single seat on one side, and nine on the other. He dismisses the usual associations one has of a hierarchical relationship, and imagines how an individual's single action can have "leverage" over a larger group.

Born in 1972 in Mexico City, the artist has long studied the architectural icons representing Modernism's utopian ideals that are scattered throughout the city. The artist describes Modernism as "a new classic," leaving behind what the movement "was" or might have been and instead searching for what saliency its solutions may still have in the present.[1] Modernism for Reyes is an unfinished project. He returns to the structural design of postwar architecture and the social utopias of the old political Left, but adapts them to be more sensitive to human needs. His work *Floating Pyramid* (2004) is a hollow floating structure that creates the experience of inhabiting a far-off aquatic world. It exists partly as homage to minimalist architecture of the 1960s. Originally launched only 100 feet off the coast of Puerto Rico, the aquatic space captures Reyes's appeal to spiritual, romantic, and mythic undertones often suppressed by the Modernist project.

His collaborative project *Parque Vertical* (2002–08) engages directly with one of the abandoned monuments of the past—the Insignia Tower in Tlatelolco, Mexico City. Since the 1985 earthquake in Mexico City, the building has been deserted, yet its iconic triangular shape is a distinguishing fixture in the city's skyline. Since 2002, Pedro Reyes has proposed turning the triangular building into a high-rise community garden, with multiple floors of rentable land. Completely redesigning the interior, but leaving the exterior intact, the proposal includes installing hydraulic pumps powered by solar panels throughout the building that would send water to its peak. Though the artist's proposal remains unrealized, it envisions how the lifestyles of the city's inhabitants could be transformed through a vertical park or "green skyscraper." Reyes presents *Parque Vertical* as a scale model and advertising billboard, and writes, "[w]hat really counts for me is that a work of art may become part of other people's lives."[2]

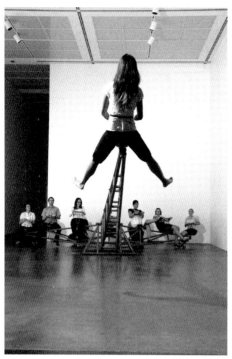

FIG. 101 (TOP): *Leverage*, 2006. Powder-coated steel structure. 60 x 270 x 472 inches (152.4 x 685.8 x 1198.9 cm). Courtesy Yvon Lambert Gallery, New York

FIG. 102 (BOTTOM): *Floating Pyramid*, 2004. Wood and Styrofoam floating structure. 144 x 192 x 192 inches (365.8 x 487.7 x 487.7 cm). Courtesy Yvon Lambert Gallery, New York

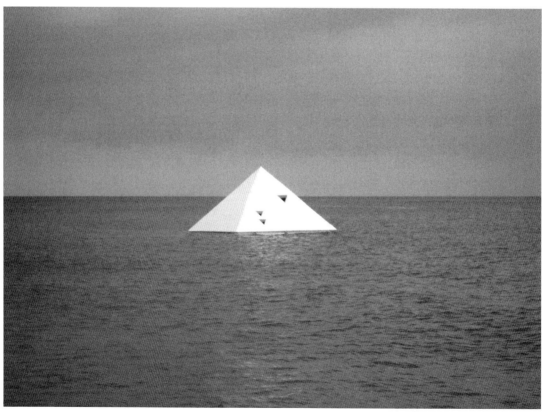

Reyes's work depends upon direct collaboration with cities' inhabitants and organizations, responding to the uniqueness of a city's history and political concerns. The artist is a realistic idealist, who recognizes the limitations of an art form—seeing that the potential visual art holds is to make micro-interventions on a local level. He is interested in adding "small stories"[3] to the world—ones that are distinct, imaginative, and open up the suppressed desires and imaginations of a city's inhabitants. In his project, *New Group Therapies* (2004), Reyes collaborated with a group of "punks" and "Goths," who meet in Tlatelolco weekly to trade music. For this project, he wanted to create a scenario where his participants could become someone else for a moment, setting aside their usual identities and everyday lives. Using simple fabricated sculptures in the shapes of guitars, a makeshift backdrop, and a karaoke sound system, he managed to create a microcosm that allowed the group to express sublimated energy, anger, and even violence through the cathartic rituals of guitar smashing and head banging.

While diverse in scope, from architectural proposals to playful scenarios, what Pedro Reyes offers are moments that breach the ordinary rituals of daily life, and suggests other ways of living. The complexity of his work connects the mythic and spiritual with principles of structural design and utility, continually recombining the diverse resources and references of Modernism to form unexpected outcomes.

JD

NOTES

1. Tatiana Cuevas, "Interview with Pedro Reyes," *Bomb Magazine* (Winter 2006).

2. Correspondence with artist, July 2009.
3. Cuevas, "Interview."

SELECTED BIBLIOGRAPHY

Cuervas, Tatiana, "Pedro Reyes," *Bomb Magazine* (Winter 2006).

Roberts, M. Downing, "Yokohama Triennale 2008: Pedro Reyes," *Tokyo Art Beat*, November 12, 2008.

Sommer, Doris, "Interview with Pedro Reyes," June 2005.

RIGO 23

BORN 1966, MADEIRA ISLAND, PORTUGAL
LIVES AND WORKS IN SAN FRANCISCO

Associated with the vibrant San Francisco mural movement of the 1990s, Rigo 23 is well known in the Bay Area for his eye-catching text pieces painted in the highly graphic style of traffic symbols. For a while, his name would change from year to year: one mural would be signed Rigo 85 while another would bear the signature Rigo 99, taking on the last two digits of the current year. However, in 2003, he settled on a permanent name by dropping the zeros, and has been Rigo 23 ever since.[1]

Though murals remain his best-known work, Rigo 23 has frequently ventured into other media, such as drawing, painting, performances, interventions, and zines—while always working in the public realm to advocate for social and political change. He addresses a range of issues, including the treatment of international workers in the new global economy, the wrongful incarceration of political prisoners, and the displacement of Native Americans in the United States. In one of his earlier works, *One Tree* (1996), he painted the words "one tree" within an oversized traffic arrow on the side of a building adjacent to a freeway entrance. The arrow points to a lone, frail-looking tree struggling to survive in a congested industrial setting, a reminder to the thousands who pass it every day of what is lost in the process of urbanization. In 2009, Rigo 23 was invited to participate in the Biennale de Lyon, where he produced two large, site-specific murals, titled *Sol* (2009) and *Soleil* (2009), installed on a building located in Lyon's city center. Designed as one-way traffic signs, the signs boldly cry SOL and SOLEIL (French for soil and sun) and point to the sky and the ground, reminding us that nature still takes precedence amidst the chaos of urban life.

The site-specific installation, *The Deeper They Bury Me, The Louder My Voice Becomes* at the New Museum, is part of a series of works that take political prisoners as their subject, portraying such figures as Leonard Peltier, Geronimo ji-Jaga, and the Angola 3. The work in the exhibition was inspired by the words of Herman Wallace, a member of the Angola 3. This was not the first time Rigo 23 had shown solidarity with this group through his work. In an earlier mural, titled *TRUTH* (2002), Rigo 23 painted this word in large letters in the United Nations Plaza in San Francisco's Civic Center to commemorate the release of Robert H. King after twenty-nine years of incarceration at the Louisiana State Penitentiary, most of which was in solitary confinement. King was a member of the Angola 3; the other two members, who have yet to be released, are Wallace and Albert Woodfox. Wallace and Woodfox began the first prison chapter of the Black Panther Party in 1971 at the Louisiana State Penitentiary, also known as Angola. King joined them when he was transferred to the prison after being falsely accused of a crime in 1972. The Angola 3 fought for prison reform from within the prison system by a variety of

FIG. 103 (LEFT): *The Deeper They Bury Me, The Louder My Voice Becomes*, 2009. Site-specific installation at the New Museum, New York. Dimensions variable. Courtesy the artist and New Museum, New York

FIG. 104 (BOTTOM): *Teko Mbarate (Struggle for Life)/ Sapukay (Cry for Help)*, 2005–2008. Mixed media. Installation view, Museum of Contemporary Art San Diego. Courtesy the artist. Photo: Pablo Mason

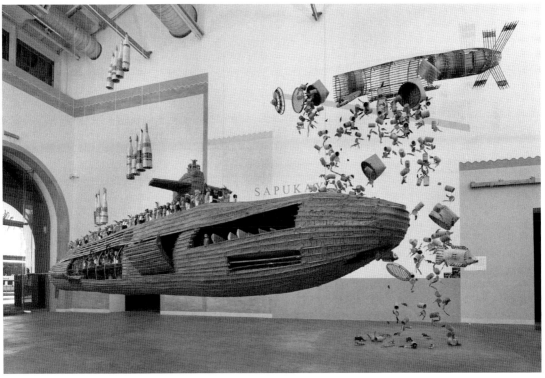

methods, such as staging hunger strikes to ensure that prisoners were handed their meals rather than having them served on the floor. The group also protected young prisoners from sexual predators, and most importantly, insisted on equal rights for all prisoners.[2]

The Deeper They Bury Me, The Louder My Voice Becomes is a sensory experience, highlighting the confinement experienced by over two million prisoners in the United States, home to the world's largest penal system. This installation allows viewers to contemplate not only the physical realities of prison confinement but also the politics that often motivate decisions made by the justice system. Wallace's words, reiterated in the title of Rigo 23's new work, have a particular resonance within the narrow walls of the New Museum's staircase exhibition space, but at the same time extend beyond the confines of the Museum to address the plight of political prisoners worldwide.

In 2005, the Museum of Contemporary Art San Diego and the Berkeley Art Museum co-organized a project called "Human/Nature: Artists Respond to a Changing Planet," that commissioned artists to make new work in response to a specific place. Artists were invited to choose from a number of natural sites, and were encouraged to make multiple visits to these locations and create work based on these encounters. Rigo 23 chose the coastal village of Cananéia and the surrounding forested areas of southeastern Brazil, where he worked closely with three local communities. Between 2005 and 2008, Rigo 23 made numerous visits to these sites. Working in collaboration with the artisans of these communities, Rigo 23 created two sculptures incorporating local traditions and materials to make a replica of a nuclear submarine and contemporary weapons of mass destruction. The works alluded to the ways in which the developed world often exploits the resources of economically disadvantaged nations to support unsustainable and often destructive ways of life.[3] Rigo 23's commitment to working with local communities allows his art—and his social advocacy work—to reach a wide audience.

JH

NOTES

1. *Rigo 23*, Volume 1, exhibition catalogue (Madeira: Centro Das Artes Casa Das Mudas, 2006).
2. See http://Angola3.org (accessed May 31, 2010).
3. http://artistsrespond.org/artists/rigo23/ (accessed May 31, 2010).

SELECTED BIBLIOGRAPHY

Beasley, Mark, Manray Hsu, and Eungie Joo, *Rigo 23*, Volume 1, exhibition catalogue (Madeira: Centro Das Artes Casa Das Mudas, 2006).

Knight, Christopher, "Biennial Arrives, and So Does the Museum." *Los Angeles Times*, October 13, 2004.

Rigo 23, "The Deeper They Bury Me, The Louder My Voice Becomes," New Museum, 2009.

Topographies, exhibition brochure (San Francisco: San Francisco Art Institute, 2004).

LARA SCHNITGER

BORN 1969, HAARLEM, NETHERLANDS
LIVES AND WORKS IN LOS ANGELES

References to pornography, fashion, motherhood, feminism, mythology, theater, and Old Master paintings are just a few of the many elements you might find in a Lara Schnitger piece. Schnitger creates her sculptural installations using domestic arts, such as sewing and quilting, to address a broad range of concerns including gender, sexuality, language, and politics.

Schnitger joins and stretches panels of fabrics over complex wooden armatures. In *Saville Row* (2007) Schnitger uses Savile Row, the famous shopping street in central London, as a departure point. *Saville Row* contrasts the artist's craftsmanship and artistry with that which is synonymous with the "bespoke" suits made for the elite on what is known as the golden mile of tailoring. The sleekness of the black fabric's abstract forms almost completely hides the wooden infrastructure and its angular joists and posts. With details like functioning buttons, the sculpture evokes, and gently pokes fun at, elegant men's fashion.

Consisting of hand-made anti-war and I Love NY t-shirts, buttons, cotton, wood, ribbon, and pins, *Rabble Rouser* (2005) looks at first glance like a bombastic protestor who is barely able to contain herself. Sometimes protruding through the sewn fabrics, the wood planks jettison the exterior skin to create supports for the decrees written and pinned on the sculpture's façade. The textiles of bumper sticker boldly cry out "MEAN PEOPLE SUCK," "save the planet kill yourself," "IF YOU WANT TO WEAR FUR STOP SHAVING," and "ANYBODY BUT BUSH"—all components of a previous sculpture titled *Gridlock* (2005). These vociferous documents are juxtaposed with buttons quietly stating "WEARING Buttons Is Not Enough" and "My karma ran over your dogma." The viewer is left to decide what such sloganeering might reveal about society, through individual expression and group dynamics.

The textile paintings *Room in my Heart for Another Cat* (2009) and *Cupidity (after Bronzino)* (2009) are examples of Schnitger's body of two-dimensional works. In contrast to the anthropomorphic sculptures, these works depict figures, mostly women, with the occasional rabbit, cat, bird, or unidentifiable creature. Constructed from lace, liquid pigment, dyed, stitched, and collaged fabrics, and wooden stretcher bars, *Room in my Heart for Another Cat* reveals two intertwined women in a relaxed, reclined embrace with four cats looking out at the viewer. Nodding toward Mannerist painting, the depictions of disquieting figures with abnormally elongated limbs bring to the foreground bizarre themes of eroticism, fetishism, and bestiality. *Cupidity (after Bronzino)*, as the title indicates, references the Florentine Mannerist painter

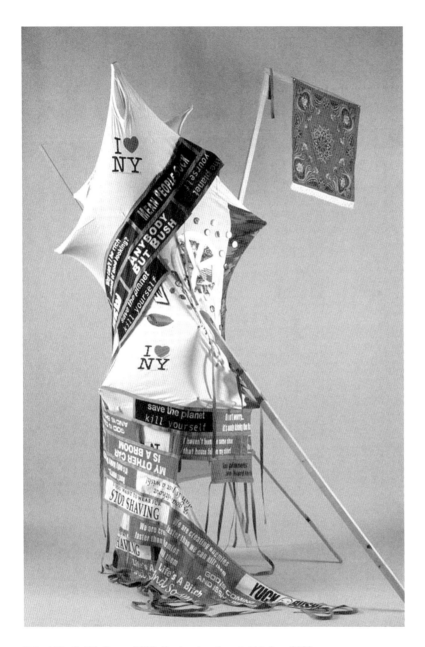

FIG. 105: *Rabble Rouser*, 2005. Handmade anti-war t-shirts from 2003,
"I Love NY" t-shirts, parts of Gridlock, buttons, cotton, wood, ribbon, and pins.
116 x 67 x 87 inches (295 x 170 x 220 cm). Courtesy the artist and
Anton Kern Gallery, New York

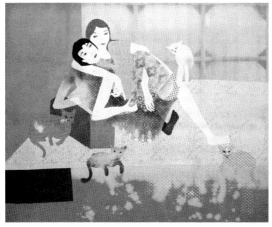

FIG. 106: *Room in my Heart for Another Cat*, 2009. Mixed media. 75 x 92 inches (190.5 x 233.7 cm). Courtesy the artist and Anton Kern Gallery, New York

FIGS 107: *Cupidity (after Bronzino)*, 2009. Mixed media. 82 x 90 inches (208.3 x 228.6 cm). Courtesy the artist and Anton Kern Gallery, New York

Agnolo Bronzino and his painting *Venus, Cupid, Folly, and Time* (1540–45). In *Cupidity (after Bronzino)*, Venus is portrayed by a washed-out woman in the same compositionally unstable pose, while Bronzino's nipple-fondling Cupid, on the verge of kissing his mother Venus, is replaced with a polka-dotted cat. Schnitger's color palette is much more subdued and washed-out than the rich hues used by the late-Renaissance painter, and the women seem more self-aware. As a result, the combination of sensuality and practicality provides a sense of equilibrium and domestic contentment.

JKII

SELECTED BIBLIOGRAPHY

Bae, James, "What Will the Community Think?" *Paper Monument* 1 (Fall 2007).

Biesenbach, Klaus and Matthew Monahan, *Fragile Kingdom: Lara Schnitger*, edited by Lara Schnitger (New York: Artimo, 2005).

Julin, Richard, "Interview by Richard Julin," in *Lara Schnitger: My Other Car is a Broom*, exhibition catalogue (Stockholm: Magasin 3 Stockholm Konsthall, 2005).

Mark, Lisa, "Forward," in *Lara Schnitger*, exhibition catalogue (New York: Anton Kern Gallery, 2005).

LISA SIGAL

BORN 1962, PHILADELPHIA
LIVES AND WORKS IN BROOKLYN, NEW YORK

Lisa Sigal is a painter. She uses the language of painting to create works that challenge the boundaries between the real and the imaginary and the preconceived notions of what constitutes being a painter. Working in mixed media with materials ranging from wallpaper to sheetrock, Tyvek, and paint, Sigal makes works that are conceptually driven, acting as narratives that tell the stories of their own "history of time, of touch, of natural erosion, and of place."[1]

Woman's Balcony (2008) is one of the many site-specific works by the artist. Located in the cavernous, military-green-painted, brick Drill Hall of the Park Street Armory in New York, Woman's Balcony is an abstract commentary on the history of women in the building. The balcony is a manifestation of the marginalized position of women in relation to the building and its use, since historically the balcony-viewing box is the only place women would have been allowed to watch the military drills that took place in the hall. Using the "architecture of the Armory to talk about the invisible code written in the structure of the building,"[2] Sigal painted many of the closed windows in cool and sometimes muted tones. A third-floor window, where there is an active women's shelter painted in orange, prompts another view of the painting and an opportunity to be within the work. Woman's Balcony is a diagram that connects the hall's history to its present.

Sigal began to address the architecture of a space in 2001 with Heap, which she painted directly on the walls of the gallery, causing the viewer to traverse the space in order to see the entirety of the painting. By altering the viewer's perception of a traditional painting, in which paint is applied to canvas and then framed, Sigal created an illusionistic space wherein the frame was in constant flux and dependent upon the viewer's physical relationship to the work. Sigal continued this investigation with Ramshackle (2003), an installation of her dismantled studio walls painted with scenes of urban landscapes propped against Artists Space's wall. But she took it even further with The Day Before Yesterday and the Day After Tomorrow (2008). The Day Before Yesterday … is completely fabricated, right down to the trompe-l'œil water stains on the delicately patterned wallpaper. This large painting depicts the remaining space of her studio, from which she was evicted, after the sheetrock walls were removed. Paying homage to the conceptual artist Daniel Buren through the usage of his signature striped fabric motif, Sigal also installed repeating red and white stripe in the stairwells of the Whitney Museum of American Art for The Day Before Yesterday … Through this intervention Sigal questions our perceptions of a given space.

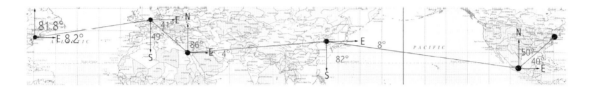

FIGS 108 + 109: *Line-up*, 2008 (detail). House paint on glass,
metal, and tape (New Museum); house paint on roof parapet
(Bari Restaurant Supply); house paint on plaster wall
(11 Prince St); vinyl mesh on brick wall (29 Prince St); house
paint on Tyvek taped in windows (295 Lafayette St); house paint
on Tyvek, compass (Eindhoven, Seoul, Cairo, and Mexico City);
map and documentation. Courtesy the artist and New Museum,
New York. Photo: Sangdom Kim

The practice of extending the work beyond the frame culminated in *Line-up* (2008). Viewed from the fifth-floor windows of the newly built New Museum, *Line-up* was a painting that drew its inspiration from the sea-foam green color of the bicycle lane outside. Similar to the subtle gesture of *On the Edge* (2006), for which Sigal painted the tarred cracks of a parking lot to match the cerulean blue façade of the lot's abandoned department store, *Line-up* consisted of a series of broad green lines painted on and in buildings neighboring the museum. From bartering drawings with store owners in order to paint on their buildings to renegotiating the placement of the line due to the potential danger of working at a precarious height, Sigal stepped outside the restrictiveness of the role of "isolated painter" to include the people most directly affected by the New Museum's location and her work. In an effort to look beyond the walls of the Museum, Sigal sent artists living in Cairo, Eindhoven, Mexico City, and Seoul a 100 foot long strip of painted green Tyvek, a compass, and directions containing the precise degree to follow to install the line in order that together the work would circumvent the globe. Shifting from the local to the global, *Line-up* continues the artist's exploration of how space is defined.

JKII

NOTES

1. Ann Landi, "Wall Power," *ARTnews* (November 2008): 151.

2. Correspondence with artist on January 13, 2009.

SELECTED BIBLIOGRAPHY

Landi, Ann, "Wall Power," *ARTnews* (November 2008): 149–153.

Ligon, Glenn, "Lisa Sigal," *ArtReview* 30 (March 2009): 89.

Princenthal, Nancy, "Lisa Sigal at Frederieke Taylor and P.S. 1," *Art in America* 96 (May 2008): 49–50.

Sigal, Lisa, ed., *Lisa Sigal*, illustrated monography with texts by Nico Israel, Gregory Volk, and Jessica Hough (New York: Some Pig Press, 2008).

TARYN SIMON

BORN 1975, NEW YORK
LIVES AND WORKS IN NEW YORK

There is a matter-of-fact quality to Taryn Simon's photographs. They trade on the notion of the photograph as a document of truth, only to upend that belief. Simon contextualizes her images with accompanying text. She claims the texts "anchor" the images, while "the photograph can dream and slip away into abstraction and form."[1] Two of her best-known projects, which have been exhibited in museums and published as books, are "The Innocents" (2003) and "An American Index of the Hidden and Unfamiliar" (2007).

"The Innocents" is a collection of portraits of forty-four men and one woman who have served time, from several years to several decades, for crimes they did not commit. Each lobbied for nearly the length of their incarceration to have the DNA evidence of their case reexamined. After their requests were approved, the DNA evidence proved their innocence and they were exonerated. The subjects were photographed in a place connected with the crime for which they were accused, often a place they had never seen or visited. One man stands alone in a tall, dry grass field near Fenway Park; another hovers amid the brown leafless branches of trees and brambles in the Blue Ridge Mountains; others are shown in a dingy hotel room, an empty bar, or standing at the edge of a river. These wrongfully accused people were often convicted based on eyewitness testimony. This was corroborated not by available DNA evidence, but by mugshots, line-ups, composite sketches, and courtroom sightings—all contexts that contribute to a sense of guilt or wrongdoing.

"An American Index of the Hidden and Unfamiliar" captures unlikely objects and places that Simon considers key to the shaping of the American story: the prop that was featured as Death Star II in *Star Wars*; the Imperial Office of the Ku Klux Klan; a decomposing corpse at the Forensic Anthropology Research Facility; a room filled with rape kits awaiting DNA analysis; the buried "City of the Pharaoh" from the movie *The Ten Commandments*; a copy of *Playboy* in Braille at the Library of Congress; and Abstract Expressionist painting hanging in the lobby of the CIA headquarters, among many other scenes. Each image is paired with a didactic, often surprising caption, since what is pictured rarely communicates the full story of the image. When "An American Index" series was shown at the Whitney Museum, Simon requested strong, direct

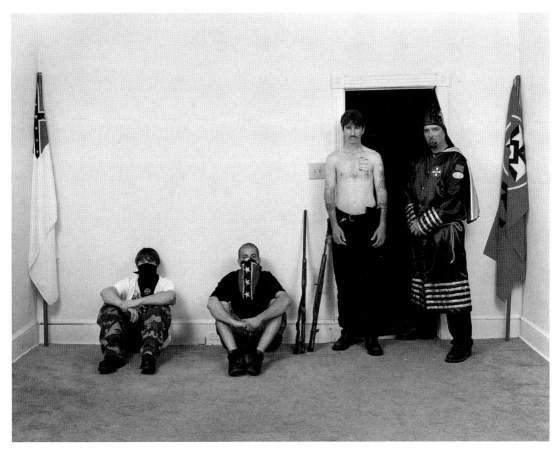

TARYN SIMON
Imperial Office of the World Knights of the Ku Klux Klan (KKK), Sharpsburg, Maryland

(L to R) Youth Director, recruiter and Kleagle (age 18); Klansman (age 19); David De Hart, Imperial Knighthawk; and the Reverend Gordon Young, Imperial Wizard preparing to visit the local mall to pass out flyers.

The World Knights of the Ku Klux Klan is a Maryland based, self-proclaimed, neo-Nazi organization committed to recruiting youths to further the KKK movement. They advocate 10 Steps to a Better America which include: 1. Stop Immigration 2. End Free Trade 3. End White Discrimination 4. Stop Interracial Marriage 5. Stop Foreign Aid 6. Stop Homosexuality 7. Stronger Law & Order 8. Support Small Business 9. Defend Gun Rights 10. Live by the 14 Words: "We must secure the existence of our race and a future for our white children." Their motto is, "Be a man, join the Klan."

FIG. 110: *Imperial Office of the World Knights of the Ku Klux Klan (KKK), Sharpsburg, Maryland*, 2007. Chromogenic color print. 37¼ x 44½ inches (94.6 x 113 cm). Image © Taryn Simon. Courtesy Steidl and Gagosian Gallery, London

FIG. 111: *FREDERICK DAYE, Alibi location, American Legion Post 310, San Diego, California, where 13 witnesses placed Daye at the time of the crime, Served 10 years of a Life sentence for Rape, Kidnapping and Vehicle Theft*, 2002. Chromogenic print. 31 x 40 inches (78.7 x 101.6 cm) and 48 x 62 inches (121.9 x 157.5 cm). Image © Taryn Simon. Courtesy Steidl/Gagosian, London.

lighting. Altering the space in this way reinvigorates the provocation of Simon's work: that a photograph can be both fiction and truth.

YO

NOTE

1. Geoffrey Batchen, "Photography is a Prostitute: Geoffrey Batchen Interviews Taryn Simon with an Introductory Essay by Nell McClister," *Museo Magazine* 8 (2007).

SELECTED BIBLIOGRAPHY

Baqué, Dominique, "Construire des identités nationales," *Art Press* 345 (2008): 98–99.

Batchen, Geoffrey, "Photography is a Prostitute: Geoffrey Batchen Interviews Taryn Simon with an Introductory Essay by Nell McClister," *Museo Magazine* 8 (2007).

—— "Taryn Simon: An American Index of the Hidden and Unfamiliar," *Aperture* 189 (2007): 82–84.

Coulson, Amanda, "Taryn Simon: Museum für Moderne Kunst," *Modern Painters* 20, no. 1 (2008): 97.

Dyer, Geoff, "Innocents Framed," *Art Review* 2, no. 6 (2004): 41–42.

Lange, Christy, "Access All Areas," *Frieze* 115 (2008).

Simon, Taryn, *The Innocents* (Brooklyn: Umbrage Editions, 2003).

Wasow, Althea, ed. and Taryn Simon, *An American Index of the Hidden and Unfamiliar* (London: Steidl, 2007).

LORNA SIMPSON

BORN 1960, BROOKLYN, NEW YORK
LIVES AND WORKS IN BROOKLYN, NEW YORK

Since the mid-1980s, Lorna Simpson has produced photographs, drawings, and videos that juxtapose the figure with text and narrative. Simpson's highly conceptual work has long dealt with conventional viewings and performances of racial and sexual politics. Departing from normative values and the status quo, Simpson reveals that culture and history are constructed and performed; gesturing towards a more complex viewing of Black subject vs. Black artist and an equally complex understanding of the self.

Simpson often isolates moments in history and recontextualizes them, as seen in *The Institute* (2007). Comprised of a 1950s promotional film for a speech and audio processing institution in Wichita, Kansas, *The Institute* is a compilation of found footage in a video format. Shown in her 2007 retrospective at the Whitney Museum of American Art, the work is projected on the wall in two distinct sections; the left side, which is divided into quadrants, features four different white actresses holding the same child—in Technicolor. They silently speak, nod, and gesture while on the right side a mock interview and a mathematical lesson are looped—in black and white. The audio corresponds to the right side, wherein Barbara, a young African American girl, answers questions spliced next to footage of the shadow of the woman interviewer, creating a further division of black-and-white imagery. The viewer is automatically thrust into the position of the invisible questioner, examining her subject while asking questions such as "What state are we in now?" and deciphering the responses.

In *Barbara and the Actresses* (2007), a series of ink, pencil, and watercolor portraits, Simpson depicts the aforementioned promotional video's characters. In Simpson's words, "I wanted the drawings to resemble the people in the film footage because they were so highly stylized. At the same time I wanted to allow working with the inks as a way to play with those stylized details."[1] Simpson's handling of the medium plays a significant role in the viewer's understanding of the work. Unlike the stylized realism in *Barbara and the Actresses*, which suggests the artist's strong relationship with photography, the drawings in *Photo Booth* (2008) are abstract ink drawings, suggestive of Simpson's predilection to experiment. The ink drawings resemble and recall the way Rorschach inkblots work. As though surrogates for unrepresented images, the inkblots are anonymous, ambiguous—stand-ins for the unknown. Simultaneously resembling and abstracted from their source, the drawings confound expectations, breaking down the hierarchy of elements in the reading; thus opening the work to new interpretations.

FIG. 112 (TOP): *Untitled (collage of six head drawings)*, 2008. Graphite and ink on paper. 11 x 8½ inches (27.9 x 21.6 cm) (each). Courtesy the artist

FIG. 113 (BOTTOM): *1957–2009 Interior Group 4*, 2009 (detail). Collage of twelve portraits. Dimensions variable. Courtesy the artist

The specific narratives of the images are left untold, but collectively the images allude to a specific time and location.

Appearing for the first time in her own work, Simpson's 2009 series, "1957–2009" reveals what Toni Morrison calls "the ability of writers to imagine what is not the self, to familiarize the strange and mystify the familiar." Using an archive of 1950s photographs, Simpson took a series of self-portraits in which she mimics the subject's attire and "pin-up" poses. Comingling her replicas with the originals, the women share a striking beauty and confidence. Yet when the original photographs were taken, the Civil Rights Act of 1964, which invalidated the Jim Crow laws in the southern US, would not be implemented for at least five years. For Simpson, the manner in which she puts together a piece parallels the complexity of the characters: "I want to avoid works that are just two-dimensional or easily read in the sense that as you're watching you think you get all the details and that's the end of the story. I prefer gaps and contradictions so that not all the viewer's questions are answered."[2] In the "gap" between the replica and original lies the mystery. Who is the woman posing several times and what is her story? Furthermore, what became of her and the subjects of her inspiration?

It would be a mistake to analyze Simpson's work simply along racial and gendered lines. Her work encompasses a much broader, conceptually challenging scope. She addresses formal issues of representation and portraiture as well as the multifarious implications of performing identity.

JS/JGKII

NOTES

1. Lorna Simpson in conversation with Glenn Ligon, *Lorna Simpson: Ink* (New York: Salon 94, 2008), 63.

2. Lorna Simpson, "Conversation with the Artist," 138.

SELECTED BIBLIOGRAPHY

Burke, Suzanne Elder, *Lorna Simpson: A Resource for Educators* (New York: American Federation of Arts, 2006).

Jones, Kellie, Thelma Golden, and Chrissie Iles, eds, *Lorna Simpson* (London: Phaidon Press Limited, 2002).

Posner, Helaine, *Lorna Simpson*, New York: American Federation of Arts and Harry N. Abrams, Inc., 2006.

JEFF SONHOUSE

BORN 1968, NEW YORK
LIVES AND WORKS IN NEW YORK

Jeff Sonhouse's portraits often depict black men in loud suits, psychedelic masks, and ostentatious jewelry. Such embellishments may recall the record covers of albums by George Clinton, Jimi Hendrix, Sly Stone, and Miles Davis.[1] Sonhouse's "composites" (as the artist refers to his work) often feature microphones, spotlights, and theatre curtains, further encouraging music or performance-related associations. However, Sonhouse is driving at something much deeper than the evocation of funk and jazz. He challenges both the genre of portraiture, by frequently obscuring the identity of his subjects, and the medium of painting, by collaging unorthodox materials onto his canvases, such as glitter, match sticks, plastic colored dots, and beads. In his work, masks are not only a signifier of performance, but allude to racial identity as a social construct that is imposed rather than voluntarily assumed.

Sonhouse's portrayal of popular or political figures has made him "more conscious of the viewer" and enabled him "to efficiently create through the formal properties of painting (line, color, composition, etc.) the friction that makes for a good work of art."[2] This is true of the painting, *The Sacrificial Goat* (2008), a painting of former Secretary of State Colin Powell flanked by former Director of the CIA George Tenet and former Deputy Secretary of State John Negroponte. The image is a still from a video of Powell addressing the UN Security Council on the invasion of Iraq.[3] Powell's face is camouflaged by a harlequin mask—like that of a court jester—which is covered by a thick layer of "rhinestones and 'reflective rays' made of an acrylic gel medium."[4] While the painting captures Powell at a critical moment during the speech—signified by the gesture of his black-gloved hand, which stabs the air as if to emphasize a point—the fact that the mask obscures our view of Powell's face also denies, according to Isolde Brielmaier, "any assurance of his stature, authority and confidence."[5] In *Untitled* (2008), a study for the aforementioned painting, Powell's face is covered by a ski mask, such as those stereotypically donned by terrorists or thieves to mask their identity. This alternate depiction suggests that Powell has taken on the identity of the very terrorists who pose a threat to American ideals of freedom and democracy.

In addition to referencing contemporary events, Sonhouse also draws from African history and culture. Such references are apparent in *The Spirit of a Hypocrite* (2008), which depicts a figure in shades of yellow, orange, and green, whose afro is made from layers of yellow-green matchsticks, and whose face is a harlequin-patterned mask. The figure's eyes, which are covered by blue-shaded glasses, are represented by cowry shells, used for centuries as currency in Africa

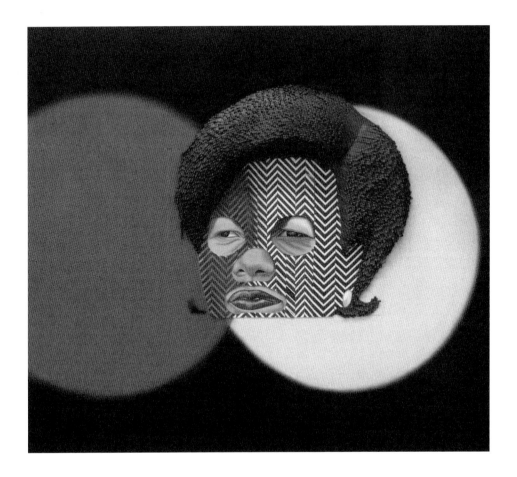

FIG. 114 (TOP): *Condoleeza Rice*, 2007.
Mixed media on medium-density fibreboard. 32 x 36 x 2 inches
(81.3 x 91.4 x 5.1 cm). Courtesy the artist

FIGS 115, 116 + 117 (BOTTOM): *Untitled*, 2008.
Watercolor on paper. 11 x 13⅜ inches (27.9 x 34 cm).
Courtesy the artist

and Asia. The mask itself recalls the use of masks in many African tribal dances. Through the use of this specific diamond patterning, Sonhouse references the joker or trickster, a fixture in black folklore. Whether represented as Esu, the trickster from the Yoruba people of Africa, or the Signifying Monkey of African American folklore, the trickster is noted for its pervasive ambiguities and inversions; its role is to change direction, to misrepresent, to jive, lie, or trick someone into doing something through misdirection.

Sonhouse's figures have been described as "Dark Dandys," and this aspect of his work is best exemplified in *Tougher Than Two Muthat%$#ers, Roger Toussaint* (2006), which portrays its black male subject standing defiantly at the center of the work in a flashy, yellow suit and apparently cool attitude. The harlequin (or trickster) mask appears here, too, on Toussaint, who, as the President of the Transit Workers Union, led an illegal strike against the Metropolitan Transit Authority in New York in 2005.[6] Although his face is concealed, Toussaint is recognizable by his facial hair and sunglasses. Mayor Bloomberg once suggested that Toussaint was thuggish.[7] It is such stereotypical identifiers of black males as "thug," "pimp," and "thief" that Sonhouse is addressing in his work. By depicting masked, black males, he brings to the forefront the conflict of black masculine identity—conceding to racial stereotypes or overcoming them—and reminds us that "identities themselves are malleable, layered and … often deceptive."[8]

CL

NOTES

1. Greg Tate, "Dark Dandys: Uppity Militants and Zombie Wolves: Unmasking the Art of Jeff Sonhouse," *Jeff Sonhouse: Pawnography*, exhibition catalogue (New York: Tilton Gallery, 2008), 42.
2. Correspondence with artist on April 7, 2009.
3. "Former Aid: Powell WMD Speech 'Lowest Point in My Life,'" CNN.com, August 23, 2005, available at http://www.cnn.com/2005/WORLD/meast/08/19/powell.un/ (accessed May 15, 2009).
4. Isolde Brielmaier, "Double-Take: Jeff Sonhouse's *Pawnography*," in *Jeff Sonhouse: Pawnography*, exhibition catalogue (New York: Tilton Gallery, 2009), 24.
5. Ibid., 24.
6. Steve Fishman, "Anger Management: Why TWU Honcho Roger Toussaint Still Blames Bloomberg—and Still Believes Striking Was the Only Possible Course," *New York Magazine*, "Intelligencer", January 1, 2006.
7. Ibid.
8. Brielmaier, "Double-Take," 23.

SELECTED BIBLIOGRAPHY

Baker, R.C., "Voice Choice," *The Village Voice*, July 1, 2005, 76.

Brielmaier, Isolde and Greg Tate, *Jeff Sonhouse: Pawnography*, exhibition catalogue (New York: Tilton Gallery, 2009).

Cotter, Holland, "Imaginings of Africa, Chained or Unchained, Dispersed or Together," *New York Times*, February 25, 2005.

"Featured NYFA Fellow Interview: Jeff Sonhouse," *NYFA Quarterly* (Winter 2005): 8–10, reproductions 10–11.

Johnson, Ken, "Art Listings," *New York Times*, June 3, 2005, E27, color reproduction E24.

Smith, Roberta, "Art Review: Where Issues of Black Identity Meet the Concerns of Every Artist," *New York Times*, November 18, 2005.

SUPERFLEX

ESTABLISHED IN 1993
BJØRNSTJERNE CHRISTIANSEN (BORN 1969),
JAKOB FENGER (BORN 1968), AND RASMUS NIELSEN (BORN 1969)
LIVE AND WORK IN COPENHAGEN AND BRAZIL

Founded and directed by Bjørnstjerne Christiansen, Jakob Fenger, and Rasmus Nielsen in 1993, SUPERFLEX has gained worldwide recognition for their projects, which use what the group describe as "counter-economic strategies." These "strategies" question systems of power by critically examining their limitations. Graduates of the Royal Academy in Copenhagen, the group's practice goes beyond photography and film to include the interdisciplinary. Their discursive practice includes, though certainly is not limited to, cartooning, graphics, manuals, performance, publications, video documentation, and even the virtual world.

SUPERFLEX has used basic structures, such as television production, to reflexively critique the medium of TV. Other projects, such as *FREE BEER* (an "open-source" beer), are a humorous way of challenging restrictive copyright issues.[1] SUPERFLEX refers to some of their work as "tools"—implying that they can be used practically or symbolically.[2] SUPERFLEX distinguishes the difference between "tools" and its other projects by stating, "[I]f we talk about a tool it will always mean that you can use it and many different things can happen with this tool that you cannot control. So when you enable others to use it things start happening."[3] Much of their work has been built on this open-ended system, where the impact of a tool is dependent on the context in which it is implemented.

The collective's tools have ranged from an instructional manual diagramming the mechanics of a bio-gas system that transforms feces to usable natural gas, to a network of studios used as sites of discussion, recording, and producing Internet TV directly, in which users are engaged in the creation and evolution of the content. A sense of humor and play balances the gravity of the issues they deal with, and they skillfully coopt corporate strategies for their own use. For example, SUPERFLEX's signature color combination is bright orange, black, and white, while titles such as "SUPERGAS" or "SUPERCHANNEL" are evidence of the collective's awareness of branding and marketing techniques. As early as 2002, SUPERFLEX questioned the elevated status of the original. Responding to global capitalism and economic disparity, SUPERFLEX dares us to imagine "a copy that became more attractive than the original—a SUPERCOPY,"[4] the title of which was silkscreened on knock off Lacoste shirts.

FIG. 118 (LEFT): *FREE BEER*, 2005–.
Dimensions variable. Courtesy SUPERFLEX

FIG. 119 (TOP RIGHT): *FREE SHOP*,
2003–. Dimensions variable.
Courtesy SUPERFLEX

FIG. 120 (RIGHT): *When the levees broke
we bought our house*, 2008. Gelatin silver
print. 47⅕ x 70⁹⁄₁₀ inches
(120 x 180 cm). Courtesy SUPERFLEX

Not all projects are to be considered tools, however, but they begin with the same approach. Similar to action research—a cycle of posing questions, gathering data, reflection, and then deciding on a course of action—the group's process engages those involved in a dialogue where inputs are looked at both individually and relationally. This collective approach has manifested in the form of a film documenting the burning of a Mercedes Benz, *Burning Car* (2009); a contract committing the signer to an "ecological and climate friendly burial in the case of death"[5] during the UN Climate Change Conference in 2007; and even the transferring of five flamingoes from Seoul Grand Park Zoo in South Korea to Odense Zoo in Denmark for the 6th Gwangju Biennial in 2006.

The group often recruit outside resources and experts to realize their projects. For the 2009 film *Flooded McDonald's*, SUPERFLEX teamed with director Tuan Andrew Nguyen, cinematographer Ha Thuc Phu Nam, sound designer Alan Hayslip, and the production company The Propeller Group. During the twenty-minute film, a replica of what may be the most famous fast-food chain in the world slowly fills with water. Presented as a wall projection, the film is not a "tool" in the same sense of the group's other works, but still reflects the collective's inquiry-based practice. For SUPERFLEX, "it is not the artist's work itself that does the job but rather the approach that made the artist arrive at the work," and through the use of the artist's identity, the collective acts as an agent for a different understanding of the individual's potential in shaping society.[6]

JKII

NOTES

1. Correspondence with Rasmus Neilsen on January 26, 2009.
2. Ibid.
3. Bjørnstjerne Christiansen in conversation with William Shaw, "Arts and Ecology." *RSA Magazine*. January 16, 2009.
4. Barbara Steiner, ed., *Tools* (Cologne: Verlag Der Büchhandlung Walther König, 2003), 138.
5. SUPERFLEX, "Ecological Burial Contract," downloadable at http://superflex.net/projects/contract/ (accessed on April 7, 2010).
6. Correspondence with Rasmus Neilsen on January 26, 2009.

SELECTED BIBLIOGRAPHY

Bradley, Will, Mika Hannula, Cristina Ricupero and SUPERFLEX, eds, *Self-organization/Counter-economic Strategies* (Berlin: Sternberg Press, 2006).

Steiner, Barbara, ed., in collaboration with SUPERDESIGN, *Tools* (Cologne: Verlag Der Büchhandlung Walther König, 2003).

SUPERFLEX, *FREE SHOP: Anything the Customer Wants to Purchase is Free* (Copenhagen: Pork Salad Press, 2009).

Starling, Simon and SUPERFLEX, *Black Out: Simon Starling and SUPERFLEX*, exhibition catalogue (Odense: Kunsthallen Brandts Klædefabrik/Museet For Fotokunst, 2010).

SARAH SZE

BORN 1969, BOSTON
LIVES AND WORKS IN NEW YORK

Sarah Sze's practice lies between the intersections of architecture, painting, and sculpture. Working primarily in installation, Sze begins each work by first "considering the nature of the space—how it is used, the circulation, the light, and the history."[1] Her formal consideration of light, color, and texture is coupled with sensitivity to materials and their various possibilities in different contexts. Her works are often assembled from innocuous, mass-produced bits of residue that are painstakingly arranged in a way that strips them of their intended utility. As early as 1998, with the exhibition "Ripe Fruit Falling" at P.S. 1 Contemporary Art Center in New York, Sze's signature sculptural aesthetic of the ephemeral has captured viewers' attention through a unique manipulation of space. In her 2006 installation *Tilting Planet*, rings of sliced Styrofoam cups intermingle with bottles and glasses of water, an unlikely balancing act that brings rocket ships and planets to mind. Associative leaps are unavoidable as one considers relational possibilities implied by the items in these impermanent constructions—water collides with a menacing micro-forest of push pins, and this tactile environment is fleshed out by razor blades, sponges, masking tape, and blades of grass. In representing the residuals of human traces in uncommon and, at times, uneasy juxtapositions, Sze engages viewers in a continual reorienting of themselves, forcing a new experience with the leftovers of everyday.

Sze's works are jubilantly open-ended, never insisting on a particular interpretation. Her experiments usher the viewer's gaze in a manner more in line with perspectival innovations of the early Italian Renaissance, rather than contemporary artists who also work with assemblage, such as Jason Rhoades. "I am interested in art that challenges and defies expectations and encourages open-mindedness and at the same time inspires the development of opinions," Sze says, adding, "I believe form and content are inextricably tangled."[2] Fusing form and content, practice and product, Sze's installations suggests a material culture investigation—a critical examination of our own exchanges in commodities and the formations of waste and obsolescence.

Navigating Sze's installations unravels a concatenation of meanings. In her 2008 piece, *Untitled (Tokyo)*, long, spindly sticks pierce sheets of paper, as if to mimic hair follicles, and culminate in a teetering heap of workaday, office-supply-store derived rubble. Her gravity-defying, grounded suspensions are characteristic of the artist's practice, allowing viewers to escape in a space that is otherworldly. Art historian Linda Norden writes of Sze's success in "orchestrating encounters that alternately catalyze recognition and confound."[3] Sze proves Maurice Merleau-

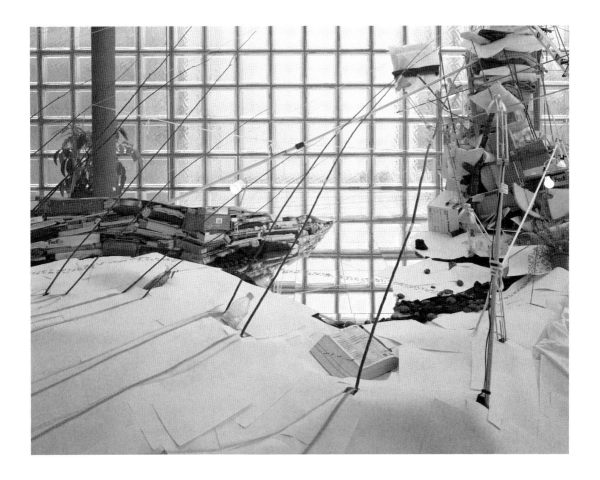

FIG. 121 (TOP): *Untitled (Tokyo)*, 2008. Mixed media. Dimensions variable. Courtesy the artist

FIGS 122 + 123 (LEFT): *Tilting Planet*, 2006. Mixed media. Dimensions variable. Courtesy the artist

Ponty's assertion that, "what each perception, even if false, verifies, is the belongingness of each experience to the same world, their equal power to manifest it, *as possibilities of the same world*."[4] Grounded and suspended, installations like *Untitled (Tokyo)* (dis)connect our experiences with our surroundings and the banality blanketing our landscapes.

Sze's careful consideration of form, content, and context was literally accessible to the public in *Corner Plot* (2006), located on the corner of 60th Street and 5th Avenue in New York's Doris C. Freedman Plaza. Instead of competing with the surrounding buildings, Sze constructed a replica of the corner of the building opposite, placed it on end as though a pyramid, and filled the interior with a variety of objects (alarm clock, ladder, lamp, microscope, orchid, socks, water bottles, etc.), eloquently offering passersby a subterranean view of a potential ecosystem that is simultaneously an interior and exterior. As the artist states, "In a lot of my work there are elements you are used to seeing every day, but then in the context or in the placement of them they have a new life."[5] Intending for the audience to look down on the street in a space that beckons attention to the skyline, the work follows the prescripts of the artist's own logic—whimsical and structural. Sze affirms succinctly that, "the artist's role is to reflect, reveal and question the complexities of what it is to be alive,"[6] while asserting the viewer's role to experience and create meanings and connections to their own lives.

JS/JKII

NOTES

1. Correspondence with artist on June 3, 2009.
2. Correspondence with artist on June 3, 2009.
3. Linda Norden, "Sarah Sze," in *Sarah Sze* (New York: Harry N. Abrams, 2007), 12.
4. Maurice Merleau-Ponty, *The Visible and the Invisible* (Evanston: Northwestern University Press, 1968), 41.
5. Wendy Goodman, "Surreal Estate: The Story Behind Artist Sarah Sze's 'Corner Plot,'" *New York Magazine* (online), April 28, 2006, available at http://nymag.com/arts/all/process/16872/ (accessed April 18, 2010).
6. Correspondence with artist on June 3, 2009.

SELECTED BIBLIOGRAPHY

Cruz, Amanda, *Sarah Sze* (Annandale-on-Hudson, NY: Center for Curatorial Studies, Bard College, 2001).

Goodman, Wendy, "Surreal Estate: The Story Behind Artist Sarah Sze's 'Corner Plot,'" *New York Magazine*, April 28, 2006, available at http://nymag.com/arts/all/process/16872/ (accessed April 18, 2010).

Grambye, Lars, *Sarah Sze* (New York: Henry N. Abrams, 2007).

Norden, Linda, *Sarah Sze* (Malmö: Malmö Konsthall, 2007).

Sans, Jerome, *Sarah Sze* (London: Thames and Hudson and Fondation Cartier pour l'art contemporain, 1999).

RIRKRIT TIRAVANIJA

BORN 1961, BUENOS AIRES
LIVES AND WORKS IN NEW YORK, BERLIN, AND CHIANG MAI, THAILAND

Human sociability is both the medium and content of Rirkrit Tiravanija's art. The physical materials of his work are significant, not for their aesthetics, but for their ability to frame or catalyze specific types of experiences. "It is not what you see that is important," he has said, "but what takes place between people."[1] This privileging of the relational over the aesthetic was manifest in his early food-based works, such as *Untitled (Free)* (1992) at 303 Gallery in New York. Tiravanija emptied the contents of the gallery's offices into its exhibition space, leveling its architectural bifurcation of administration and display, creating a unified communal space. In the middle of the gallery, he cooked and served green and red Thai curries to any visitor with an appetite. While food was ostensibly the subject of this work, its true function was to facilitate changes in the realm of the social. It created a space in which previously unacquainted members of the viewing public could gather and partake in the timeless custom of a shared meal. The work temporarily suspended the gallery's principal activity of commodity exchange and opened a site of possibility that fostered interpersonal relationships and a sense of ritual.

Creating these sites of pure potentiality has been Tiravanija's primary artistic pursuit, and none has been more ambitious than his ongoing project, the Land. Co-founded in 1998 with the Thai artist, Kamin Lertchaiprasert, the Land is an ongoing experiment in creative forms of self-sustainable living; both artists firmly insist that it not be considered "art." Situated near the remote village of Sanpatong, Thailand, its small allotment of acreage contains a pond, two rice fields, and a number of artist-designed structures built to meet the various needs of its peripatetic residents. With no electricity or running water, occupants are encouraged to contribute innovative solutions to infrastructural issues. The Danish collective SUPERFLEX, for example, implemented a bio-gas production and storage system powered by water buffalo manure that fuels the facilities' stoves and lamps. Tiravanija designed a group house structured around "the three spheres of needs," with a ground floor dedicated to communal gatherings and conversation, the second to reading and meditation, and the third to sleep.[2] Given the global circuits in which contemporary artists operate, the Land, Tiravanija says, represents "a meeting point and a rest stop from our routines."[3] Existing outside of conventional notions of property and ownership, it is a space in which artists' creativity can be applied to life's challenges without bending to the market and exhibition pressures of the art world.

FIG. 124: Stills from *JG Reads*, 2008. 16 mm film.
10 hours 6 minutes. Courtesy the artist and Gavin Brown's
Enterprise, New York

Tiravanija's awareness of the fugitive nature of such spaces motivates his recent work, *JG Reads* (2009), a ten-hour film of the celebrated New York poet John Giorno reading selections from his five-decade career. Shot on 16mm black-and-white—the same medium that immortalized him in Andy Warhol's first film, *Sleep* (1963)—Giorno appears in his famed Bowery loft, reciting his work with a spryness and vigor that belies his seventy-two years. Tiravanija screened the film on the wall of a full-sized model of the loft, creating a *mise-en-abyme*, in which poet and loft fuse into a single performer, enacting a bygone period in New York bohemia. Outside Giorno's walls, the relentless gears of gentrification have transformed his once gritty and vibrant neighborhood nearly beyond recognition. The poet in his loft serves as a bulwark against these changing tides, preserving a kernel of an artistic circle that once counted Warhol, Robert Rauschenberg, Jasper Johns, William Burroughs, Allen Ginsberg, and Emile de Antonio in its ranks. The facsimile of Giorno's loft transports the viewer to a New York that represented unfettered artistic possibility. Tiravanija's core commitment as an artist has been the creation of such times and places in a world increasingly hostile to them.

ML

NOTES

1. Hans Ulrich-Obrist, *HuO: Hans-Ulrich Obrist: Interviews* (Milan: Charta/Fondazione Pitti Immagine Discovery, October 2003).

2. Ibid.

3. Tim Griffin, *et al.*, "Remote Possibilities: A Roundtable Discussion on Land Art's Changing Terrain," *Artforum* 43, no. 10 (Summer 2005): 291.

SELECTED BIBLIOGRAPHY

Birnbaum, Daniel, "The Lay of the Land: An Experiment in Art and Community in Thailand," *Artforum* 43, no. 10 (Summer 2005): 270–74, 346.

Grassi, Francesca and Rirkrit Tiravanija, eds, *Rirkrit Tiravanija (Tomorrow Is Another Fine Day)* (Zurich: JRP Ringier; Miami: Bridge House Publishing, 2007).

Parreno, Phillipe, *et al.*, *Rirkrit Tiravanija*, exhibition catalogue (Vienna: Secession, 2002)

Ulrich-Obrist, Hans, *HuO: Hans-Ulrich Obrist: Interviews* (Milan: Charta/Fondazione Pitti Immagine Discovery, October 2003).

Wolfs, Rein, ed., *Rirkrit Tiravanija (Tomorrow Is Another Fine Day)*, exhibition catalogue (Rotterdam: Museum Boijmans van Beuningen; Paris: Musée d'Art Moderne de la Ville de Paris/ARC; and London: Serpentine Gallery, 2004).

DANH VO

BORN 1975, SAIGON, VIETNAM
LIVES AND WORKS IN BERLIN

For Danh Vo, the site of exhibition is a site to control. Here, information can be limited, contained, and cut off, thereby avoiding art as consolidation. It is precisely the lack of information that is important in navigating his work—to see things one cannot understand, and consider what is going on. Vo tests the nature of display, intentionally limiting the information accessible to the viewer to create misunderstanding. His attitude towards exhibition therefore enacts art as a process of learning for artist and viewer, in which failures are also ways of learning.

In the ongoing multiple *Untitled* (2009), Danh Vo recuperates his father's calligraphic skills to produce unique handwritten copies of the final letter of the Catholic martyr St. Jean-Théophane Vénard. The 1861 letter is Vénard's farewell to his father on the eve of his execution in Vietnam. In a way, the work is a merging of the personal and historical experiences of Vénard and Vo, and the impact of the former on the artist. While Vo's father's calligraphy is exquisite, the elder Vo does not know French and therefore does not understand the meaning of the text he is copying. Rather, his letters are pure visual copies based on a common alphabet whose convention reveals a layer of the colonial history of Vietnam. By presenting text as pure form, Vo articulates language as a site of symbolic exchange rather than communication. Vo embraces the many potential interpretations of the work, as well as the fact that some meanings will always remain unattainable or obscured for the viewer. Such circulating meanings—away from consensus—are at the core of Vo's work. The discontinuities, resonances, and impenetrabilities constitute the work itself.

In *Ngo Thi Ha* (2008), Vo resuscitates the temporary gravemarker of his paternal grandmother—a simple, white wooden cross with her name written in Roman letters, made by Vo's father. Vo explains how this functional, religious object began to inhabit the world of art:

> This cross was standing out on my balcony half a year before I could detach it from the personal life of my grandmother. And that's how a work like this starts to exist. I think it's a process of bending your own way of thinking. How can I expect people that pass by for a moment to understand? I can't expect anything from the viewer. This is just another hermetic sculpture and it's on this level of abstraction I find the quality of the work. I wish all my works would be like this—that they exist, because there is no way out.[1]

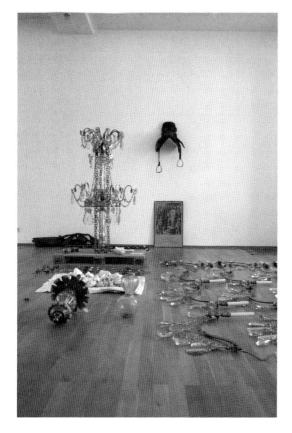

20 janvier 1861.

J.M.J

Très cher, très honoré et bien-aimé Père,

Puisque ma sentence se fait encore attendre, je veux vous adresser un nouvel adieu, qui sera probablement le dernier. Les jours de ma prison s'écoulent paisiblement. Tous ceux qui m'entourent m'honorent, un bon nombre m'aiment. Depuis le grand mandarin jusqu'au dernier soldat, tous regrettent que la loi du royaume me condamne à la mort. Je n'ai point eu à endurer de tortures, comme beaucoup de mes frères. Un léger coup de sabre séparera ma tête, comme une fleur printanière que le Maître du jardin cueille pour son plaisir. Nous sommes tous des fleurs plantées sur cette terre que Dieu cueille en son temps, un peu plus tôt, un peu plus tard. Autre est la rose empourprée, autre le lys virginal, autre l'humble violette. Tâchons tous de plaire, selon le parfum ou l'éclat qui nous sont donnés, au souverain Seigneur et Maître.

Je vous souhaite, cher Père, une longue, paisible et vertueuse vieillesse. Portez doucement la croix de cette vie, à la suite de Jésus, jusqu'au calvaire d'un heureux trépas. Père et fils se reverront au paradis. Moi, petit éphémère, je m'en vais le premier. Adieu.

Votre très dévoué et respectueux fils.

J. Théophane Vénard

m. s.

FIG. 125 (LEFT): *12:15:02, 27.05.2009*, 2009. Late nineteenth-century chandelier from the ballroom of the former Hotel Majestic, Avenue Klèber, Paris. Hosting the Headquarters of the German military government during the occupation of France in World War II; UNESCO; French Ministry of Foreign Affairs; Paris Peace Accord and the signing of the nine-point plan aimed at guaranteeing a lasting peace in Vietnam in 1973; peace negotiations on Kosovo, the Ivory Coast, and a list of other international conflicts; the future location of the first Peninsula Hotel in Europe. Installation view, Hamburger Bahnhof-Museum für Gegenwart, Berlin. Courtesy the artist

FIG. 126 (RIGHT): *Untitled*, 2009, Ink on paper, 8¼ x 11¾ inches (29.6 x 21 cm). Courtesy the artist

Some years ago, Vo saw a photograph of the signing ceremony known as the Paris Peace Accord, an event that took place at the French Ministry of Foreign Affairs, then housed at the Hotel Majestic in Paris. The event was followed by the introduction of the nine-point plan in 1973, aimed at securing an end to the war in Vietnam. The signings took place in the ballroom of the hotel, and newspaper accounts of the period often remarked on the lavish decorations of the room, the arrangement and significance of the tables and seating, as well as the clothing and style of participants. Previously, the hotel had functioned as the headquarters for the German Military Administration during the Nazi occupation of France during World War II, and later as the Ministry of Foreign Affairs, which also held peace negotiations for numerous international conflicts including Kosovo and the Ivory Coast.

In 2009, after the French government sold this building to private investors and before it was renovated into the first Peninsula Hotel in Europe, Vo acquired the three late nineteenth-century chandeliers from the ballroom. Once mute witnesses to the political history of France, these decorative fixtures now contained experiences forgotten by contemporary society. Later that year, Vo presented each of the chandeliers separately, in three different exhibition spaces. At the Kadist Foundation, Vo installed *16:32:15, 26.05.2009* (2009) in a small gallery blocking entrance to the space, the light generated by the chandelier spilling out of the doorway. At the Kunsthalle Basel, *08:03:51, 28.05.2009* (2009) hung from the center of the high, vaulted ceiling of the main space, a large gallery that allowed the chandelier a grand presence similar to its original home. Finally, at the Hamburger Bahnhof in Berlin, Vo presented *8:43, 26.05.2009* (2009), in which a chandelier remained in partial dismantlement, as if in the process of being reconstituted as part of an archeological reconstruction. The three related works bear the times and dates of their original deinstallation as their titles, a gesture that suggests the decontextualization of each object from its original use, obscuring the cultural, political, and economic meanings in which these chandeliers once participated. At the same time, Vo creates a new context for the objects, essentially offering them a new life, loaded with their experiences of the past, but also with the potential of new forms of communication and transcendence.

EJ

NOTE
1. Correspondence with artist on April 3, 2009.

SELECTED BIBLIOGRAPHY

Ault, Julie and Danh Vo, *Where the Lions Are*, exhibition catalogue (Berlin: Kunsthalle Basel, 2009).

Fassi, Luigi, "Terra Incognita: The Art of Danh Vo," *Artforum* 48, no. 6 (February 2010): 152–60.

KARA WALKER

BORN IN 1969, STOCKTON, CALIFORNIA
LIVES AND WORKS IN NEW YORK CITY

Kara Walker's is a self-reflexive practice, marked by outrageous articulations of representation that push the limits of what we can look at and question how we see. Walker pushes the image's ability to delight and disturb, enticing the viewer with a kind of beauty while challenging that same beauty with a history of violence and repression. Through her works, we come to reconsider how representations of blackness are a reflection of (art) history—a fabrication informed by fantasy, fascination, nihilism, narcissism, and pathology.

Perhaps Now is the time to
do
away with
pictures of
things
which
engage
our
pleasure
centers,
before
trying to
destroy
them

FIG. 127: *Untitled* from the series "American Primitives", 2001. Typewriting on index card, series of thirty-six plus eight framed panels, 3 x 5 inches (7.62 x 12.7 cm). Collection of Rachel and Jean-Pierre Lehmann. Courtesy the artist and Sikkema Jenkins & Co., New York

Walker's images can be cruelly flat, without physical depth, but always pointing us to the complexity of the negotiation of interpretation. She challenges us to consider "how one interacts with the work and how the work acts on you."[1] A barefoot young figure gleefully pokes the eye socket of a man's severed head. Her playful slender feet and slightly parted lips connote delight. The man's mouth is mid-scream; skin, muscle, and veins slide past the girl's hand, shoved into his soft, open wound of a neck. Precisely rendered as a negative-space silhouette, the figurative non-image in Kara Walker's *Authenticating the Artifact* (2007) powerfully suggests bodies which are gendered and racialized: white/female, black/male. But how can we interpret so much from the silhouette? Why are these representations so easily decipherable? Set amidst a collaged

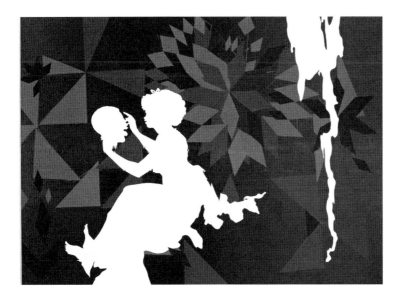

FIG. 128: *Bureau of Refugees: May 29 Richard Dick's wife beaten with a club by her employer. Richard remonstrated—in the night was taken from his house and beaten with a buggy trace nearly to death by his employer and 2 others*, 2007. Cut paper on paper. 30¾ x 20⅜ inches (78.1 x 51.8 cm). Courtesy the artist and Sikkema Jenkins & Co., New York

ground of black, gray, and brown geometric shapes reminiscent of pinwheel quilting patches, the curious girl is unaware of an ominous dripping white space behind her. Paint, blood, or entrails, the negative blob remains unsignified. As Walker asks in her essay included in this publication, "Can the performative act of cutting a figure out at least *allude* to the transient nature of the stereotypical image and can the use of narrative and figuration indicate my ambivalence about the act of making art? And is that enough if it works?"[2]

In her evocative visual essay "After the Deluge" (2007), Walker assembled images from American art history from the collections of Metropolitan Museum of Art and the Museum of Fine Arts, Boston, as well as her own earlier works in "an attempt to understand the subconscious narratives at work" in discussions of the devastation of Hurricane Katrina.[3] In her preface to the essay, Walker recalls the "hyperreal horror show" of the coverage of the "frightened and helpless populace" and the aftertaste of the information of this great social failure: "a puddle—a murky, unnavigable space that is overcrowded with intangibles: shame, remorse, vanity, morbidity, silence."[4] The juxtapositions of works that Walker offers, from a cut paper silhouette of a self-immolating girl engulfed by flames and smoke in *Burn* (1998) to a shirtless black man reclining adrift in a small row boat surrounded by sharks and bloodied waters in Winslow Homer's *The Gulf Stream* (1899); from a naked female figure walking with an enormous, grinning head in her gouache collage from the series *Middle Passages* (2004) to Joseph Mallord William Turner's *Slave Ship (Slavers Throwing Overboard the Dead and Dying, Typhoon Coming On)* (1840), remind us of the visual vocabulary in which Walker's work can best be understood. Not as a nostalgic correction of history, but as a calculated response to the history of images. As she explains, "One theme in my artwork is the idea that a Black subject in the present tense is a

container for specific pathologies from the past and is continually growing and feeding off those maladies."[5]

In *Bureau of Refugees: Mulatto hung by a grapevine near road side between Tuscaloosa and Greensboro* (2007), a mutilated figure cut from orange paper hangs inverted, her "good" leg and torso entwined in a bramble of black and green vine-like branches culminating in the profiled bust of a woman at top. The title comes from a list of "Riots and Outrages" committed by whites against free blacks in Montgomery, Alabama, in 1866, and recorded in the US national archives. Writing in blunt descriptive language, Walker describes the list as a kind of "short-form minimalist poetry" and pulls phrases such as: "Freedman and Freedwoman thrown into a well in Jefferson Co." and "July 16 Black girl beaten" and responds in the form of isolated cutouts in which the certainty of the human figure begins to wane. Part of a series called "Bureau of Refugees, Freedmen and Abandoned Lands—Records, 'Miscellaneous Papers' National Archives M809 Roll 23," the works try to "reexamine the objectivity of language and painting."[6] Playing with "repetition and isolation"[7] these works break with her confidence in the image and reveal a kind of preconscious, brutal, even self-destructive strand in Walker's studio practice at the time—a distancing from the viewer, a refusal of visual pleasure, a negation of the artist's aim for art, and a questioning of her entire engagement with so-called historical significance. "Bureau of Refugees" is part of Walker's ongoing fantasy to rescue modernism, blackness, and concepts of masculinity in painting. Deeply influenced by Ralph Ellison's *Invisible Man*, she provocatively writes, "Why is it black suffering is so valuable? The tale of Uganda's Lost Boys? The Millions displaced and dead in the Sudan? Aids in Africa? The Lower Ninth Ward? Martin Luther King's plaintive cry? Black suffering is lucrative for artists, writers and Anderson Cooper."[8]

EJ

NOTES

1. "Thelma Golden/Kara Walker: A Dialogue," in *Kara Walker: Pictures from Another Time*, edited by Annette Dixon (Ann Arbor: University of Michigan Museum of Art, 2002), pp. 43–44.

2. Kara Walker, "Manuscript for *A Proposition by Kara Walker*," p. 36 in Part I of this publication.

3. "*After the Deluge*" is a visual essay by Kara Walker based on her exhibition of the same name at the Metropolitan Museum of Art, March 21, 2006–August 6, 2006.

4. Kara Walker, *After the Deluge*, New York: Rizzoli, 2007, p. 7.

5. Ibid., p. 9.

6. Kara Walker, *Bureau of Refugees* (exhibition catalogue), Milan: Edizioni Charta, 2008, p. 3.

7. Ibid.

8. Personal correspondence with the artist, July 19, 2010.

SELECTED BIBLIOGRAPHY

Berg, Stephan, Silke Boerma, Robert Hobbs, and Eungie Joo, *Kara Walker* (Hanover: Kunstverein, 2002).

Walker, Kara, *Kara Walker: After the Deluge* (New York: Rizzoli International Publications, 2007).

NARI WARD

BORN 1963, SAINT ANDREW, JAMAICA
LIVES AND WORKS IN NEW YORK

Meaning and materials are synonymous in the art of Nari Ward. His elaborately crafted sculptures and installations give voice to the neglected objects that anonymously populate the urban environment. For Ward, the city's detritus is steeped in history and semantic potential:

> I believe that objects activate space through their physical presence as well as cultural references. Both of these states are malleable and susceptible to change over time but what that change evolves into is the subject. I chose certain materials because they are everyday objects slipping away through decay and/or neglect yet have a history that seems to prompt questions.[1]

Ward's materials convey meaning on several registers simultaneously, through a combination of their individual identities and the associations sparked by his evocative juxtapositions. Ward's strategies of retrieval and recovery place him in a lineage with modern art's many accomplished scavengers, from Kurt Schwitters to Robert Rauschenberg. David Hammons's appropriation of readymade objects to interrogate race and cultural hierarchies is an especially compelling precedent to Ward's practice. However, this mode of art-making holds additional personal significance to Ward. He has related it to the common salvaging practices in his native Jamaica, where reusing and living with found objects is an everyday occurrence.

The familiarity of Ward's materials gives his work a deceptive accessibility. Recognizing individual elements in a sculpture may lead a viewer to impute narrative or function to the whole, but his work ultimately eludes such easy cohesion:

> I am a storyteller who enjoys conjuring works which are irreconcilable. Celebration, nostalgia, repulsion, danger, abstraction, tragedy, and comedy are all performers within the vision I am creating. I build drama from the use of found and everyday objects, merging physical information (materials) with memories, thoughts, experiences and questions. The exhibition space is the place of contemplation where I attempt to visually seduce the viewer into a dialogue with their own undirected but necessary thoughts and emotions.[2]

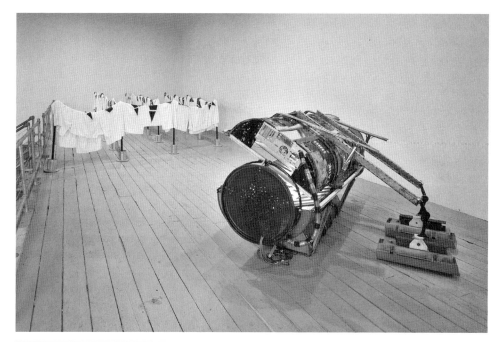

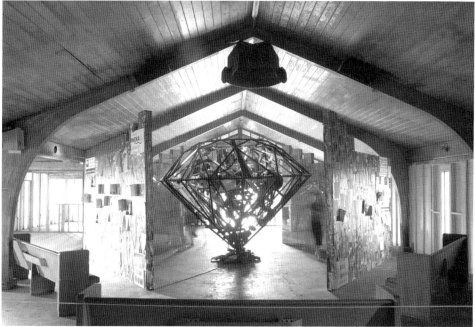

FIG. 129 (TOP): *Glory*, 2004. Oil barrels, fan, camera protective housing, UV lights, computer parts, Plexiglas, audio element: How To Teach Your Parrot English. Dimensions variable. Installation view, Whitney Biennial, 2006. Courtesy the artist and Lehmann Maupin Gallery, New York

FIG. 130 (BOTTOM): *Diamond Gym: Action Network*, 2008. Battleground Church pews, metal, exercise equipment, community bulletin board, mirrors, audio element: Marcus Garvey, Malcolm X, Martin Luther King, and Tina Turner. Dimensions variable. Installation view, Prospect 1, New Orleans. Courtesy the artist and Lehmann Maupin Gallery, New York

Glory (2004) is an example of the multifaceted drama enacted by a Ward sculpture. Oil barrels are cut and welded to form a tanning bed whose glass interior is imprinted with an opaque image of the American flag. The work summons to mind an individual with a symbol of nationalism grotesquely seared into his/her skin, while simultaneously prompting contemplation about oil's role in global politics and national identity. The varied nature of these allusions reflects the inquisitive, non-didactic role Ward sees artists playing in contemporary culture, "Artist are capable of both embracing and reframing issues of power and societal taboos. They can ask questions and make demands without the need to impose a conclusion."[3]

In his recent commissions, Ward has balanced a sensitivity to the political and cultural conditions of his host site with the indigenous qualities of his studio work. For "Prospect.1," New Orleans' inaugural biennial, he housed his installation, *Diamond Gym: Action Network* (2008), in the Lower Ninth Ward's disused Battle Ground Baptist Church. In the center of the church, he constructed a massive, floor-to-ceiling, diamond-shaped metal armature, piled high with old exercise equipment. For Ward, this structure was a sculptural transposition of his own personal history; next door to his Harlem studio is an office of Reverend Al Sharpton's National Action Network that operates in a former Diamond Gym building. The work seemed to symbolically offer New Orleans residents the tools to physically and socially rebuild their lives in the aftermath of Hurricane Katrina. Torqued mirrors etched with wavy lines surrounded the diamond, evoking the floodwaters and producing a disorienting proliferation of reflections. Ward left the opposite side of the mirrors blank, allowing them to serve as community bulletin boards. Layered fragments of music and speeches by Martin Luther King, Jr, Malcolm X, and Marcus Garvey, as well as a Buddhist incantation chanted by Tina Turner, all played from speakers positioned throughout the church, created a somber and meditative atmosphere. The work elicited a complex range of emotions. Looking back to the horrors of the past and ahead to the challenges of the future, it provided a space in which its "congregants" could both mourn and heal.

ML

NOTES

1. Nari Ward interviewed by Olu Oguibe, "Nari Ward—Generation 1.5 Artist," *Queens Museum of Art Blog*, available at http://queensmuseum.blogspot.com/2007/06/nari-ward-emigrated-from-jamaica-to.html (accessed March 10, 2010).

2. "Nari Ward," press release, Deitch Projects, 2009, available at http://www.deitch.com/artists/sub.php?artistId=21 (accessed March 13, 2009).

3. Correspondence with artist on January 1, 2009.

SELECTED BIBLIOGRAPHY

Valdez, Sarah, "Nari Ward at Deitch Projects," *Art in America* 92 (December 2004).

Vergne, Phillipe, *Ice Cream: Contemporary Art in Culture* (New York: Phaidon Press, 2007).

KEHINDE WILEY

BORN 1977, LOS ANGELES
LIVES AND WORKS IN NEW YORK

Kehinde Wiley is often viewed as the modern-day descendant of European portraitists such as Joshua Reynolds, Thomas Gainsborough, Titian, and Ingres. Using a vernacular compiled from Western and European art-historical references, Wiley recasts eighteenth- and nineteenth-century symbols of heroism, power, and wealth in his representation of young, urban black men. By deconstructing the history of portraiture, Wiley interrogates the notions of race, privilege, and class in his often larger-than-life figures. Throughout his paintings, Wiley comments on the absence of the black figure not only from art history but also from a white patriarchal society. Wiley's highly ornate, large-scale portraits blur the boundaries between traditional and contemporary modes of representation by inserting the black male body into a painting tradition that has typically relegated it to the periphery at best.

Wiley's initial portraits were based on photographs taken of young African American men approached on the streets of Harlem or Brooklyn.[1] These figurative paintings reference history while at the same time positioning the subject within the field of power. In the heroic painting, *Colonel Platoff on his Charger* (2008), a young man dressed in a red, fur-lined jacket and cargo pants steadies his horse against a colorful landscape in an allusion to the romantic portraiture of James Ward, or perhaps more specifically references Jacques-Louis David's *Napoleon on Horseback* (1801). A swirl of delicate, silver leaves flutter around the confident and regal-looking young rider. There is a noticeable corollary between Rococo ornamentation and the hip-hop industry's flare for color, ornamentation, theatrics, and excess.

Wiley tends to work in series. In his 2008 solo exhibition at the former Deitch Projects in New York, titled "Down," Wiley presented seven heroically scaled paintings inspired by historical paintings of fallen warriors and figures. The larger-than-life painting *Sleep* (2008) depicts a semi-nude reclining man. It is difficult to discern whether the man is on his deathbed or simply sleeping; this ambiguity creates a multilayered reading of the work. Wiley, however, does not conceal the obvious reference to Caravaggio's *Entombment of Christ* (1602–03); it is clear through the artist's allusion to the Renaissance artist's legendary chiaroscuro lighting.

In 2007, Wiley took his project global by including models found in urban landscapes throughout the world—in China, Mumbai, Senegal, Dakar, and Rio de Janeiro, among others—that culminated in a vast body of work called "The World Stage." Wiley began this project in China, where his models' poses were based on Chinese propaganda art from the Cultural Revolution.

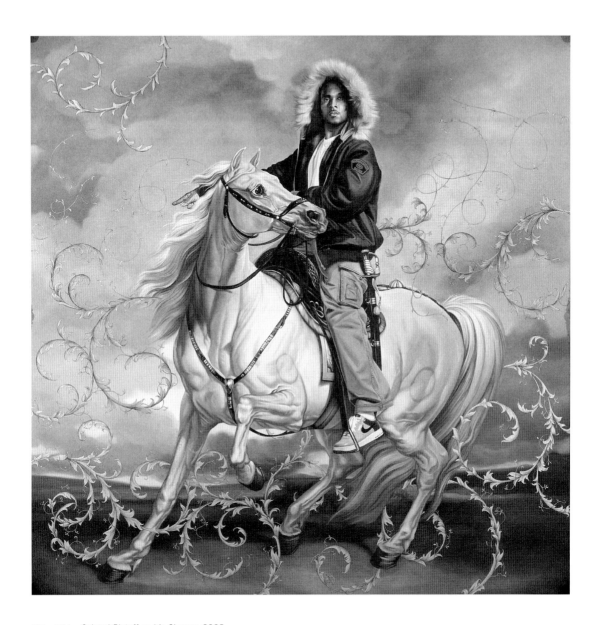

FIG. 131: *Colonel Platoff on his Charger*, 2008.
Oil on canvas. 108 x 108 inches (274.3 x 274.3 cm).
Courtesy the artist

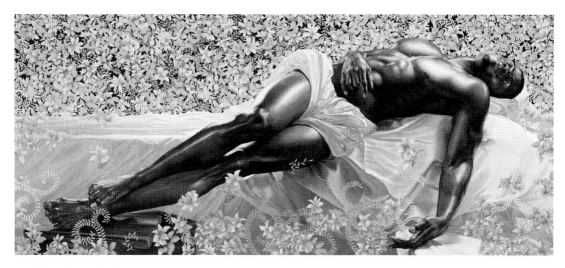

FIG. 132: *Sleep*, 2008. Oil on canvas.
132 x 300 inches (335.3 x 762 cm). Courtesy the artist

During Wiley's next visits to Senegal and Nigeria, his models imitated historical public sculptures found in Lagos and Dakar. In the painting *Dogon Couple* (2008), two nearly life-size black male teenagers are overlaid against richly floral textile motifs. The dizzying, repeated patterns are reminiscent of traditional African fabric patterns. Originally based on carved wooden figurines, *Dogon Couple* exhibits a subtle hint of homoeroticism as one man drapes his arm across the shoulders of another. The work seems to comment on both black masculinity and sexuality.

Wiley's awareness of historical exclusion is always evident throughout his work. Through his juxtaposition of "highbrow" Western and European portraiture of the eighteenth and nineteenth centuries with contemporary imagery, what emerges is an expression of the vitality and heroism of urban black men and a critique of society's modes of exclusion and control.

JH

NOTE

1. Kehinde Wiley, artist's website, 2010, available at http://www.kehindewiley.com/main.html.

SELECTED BIBLIOGRAPHY

Golden, Thelma, *The World Stage: Africa Lagos~Dakar, Kehinde Wiley*, exhibition catalogue (New York: The Studio Museum in Harlem, 2007).

Wiley, Kehinde, Brian Keith Jackson, and Krista A. Thompson, *Black Light* (New York: powerHouse Books, 2009).

Wiley, Kehinde, Brian Keith Jackson, and Reynaldo Roels, Jr., *The World Stage Brazil* (Culver City, CA: Roberts & Tilton, 2010).

HAEGUE YANG

BORN 1971 IN SEOUL
LIVES AND WORKS IN BERLIN AND SEOUL

Located in an abandoned property in Incheon, a satellite city of Seoul, Haegue Yang's *Sadong 30* (2006) resuscitates a derelict home to create a personal encounter, or a kind of journey for her audience. It was in fact her grandmother's home, hastily abandoned and then ignored for nearly a decade. After selectively cleaning the space, Yang reintroduced electricity to the property to reconnect it to the world around it, to restart it as a living space and to install small vignettes to suggest the memories still inhabiting the space. Inside, a single bulb hangs just above the floor, illuminating colorful geometric origami constructions lingering among a pile of wood, broken glass, strands of lights. In what must be the bedroom, a decaying mattress lies amid fallen wallpaper, a light on a stand, more origami objects, a covered drying rack. A fan blows a light breeze in another room, the speed of its oscillations distorted by a pulsing strobe light.

In her video *Squandering Negative Spaces* (2006) Yang discusses the house as a remnant of another time. A narrator conjectures, "Perhaps this house lived against time and development. No, perhaps it has been alone, squandering time and development because it wants to live in a different time zone, or to store time."[1] In the face of decades of rapid urban development, this neighborhood, this house, and the textured days lived here reject obsolescence, detracting from a narrative of progress in which undisciplined subjects are deported to remote systems of interaction, of being, of containment, and of knowing. Refusing the efficiency of modernity, the house "squanders all possible practical operations," secure in its own state of melancholy and disuse, while articulating a potentially radical state of "worklessness."[2] The defiance of the "workless" property communicates an incomplete or contested process of history that marks much of Yang's work.

In the sculpture *Sallim* (2009), Yang reproduced a full-scale model of her Berlin kitchen, a kind of line drawing in powder-coated steel where the absence of walls allows a visual and physical transgression of space. Inside, a heating pad with a hand-crocheted cover hangs below a rotating fan, while scent atomizers fill the air with familiar, somewhat sickening odors. Venetian blinds denote doorways, a window. A melon-size ball of dehydrated garlic sits atop a mirrored "countertop" that also reflects a mischievous blue yarn sculpture emerging from the "sink." *Sallim* (roughly translated from Korean as "running a household") considers the noncommercial space of the kitchen as a site of preparation for action and the organization of life. Indebted to works such as Martha Rosler's *Semiotics of the Kitchen* (1975) and other feminist practices of the 1960s and 1970s that insisted on the undervalued labor and potential of "women's

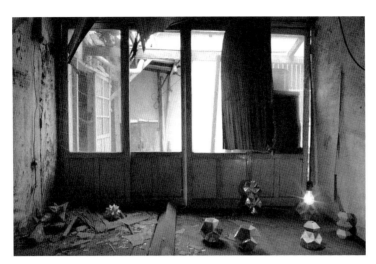

FIGS 133 + 134 (TOP): *Sadong 30*, 2006. Dimensions variable. Site-specific installation in an abandoned house in Incheon, Korea. Various light sources (hanging light bulbs, strobes, light chain), mirror, origami objects, drying rack wrapped in fabric, fan, viewing terrace, cooler filled with bottles of mineral water, chrysanthemums and garden balsams, wood bench, wall clock, glow-in-the-dark paint, wood piles, spray paint. Courtesy the artist and Galerie Barbara Wien, Berlin, Germany. Photo: Daenam Kim

FIG. 135 (BOTTOM): *Doubles and Couples—Version Turin*, 2008. Site-specific installation of five appliance objects, dimensions variable. Aluminum venetian blinds (various colors), steel frame, perforated metal plate, caster, light bulbs, cable. Boilers 20½ x 18.1 x 43⅜ inches (52 x 46 x 110 cm). Laundry machines 39³/₁₀ x 25⅗ x 41³/₁₀ inches (100 x 65 x 105 cm). Refrigerators 76⅘ x 24 x 59 inches (195 x 61 x 150 cm). Gas stoves 27⅗ x 25⅗ x 41³/₁₀ inches (70 x 65 x 105 cm). Shower rooms 68½ x 59 x 114⅖ inches (174 x 150 x 290 cm). Installation view of "50 MOONS OF SATURN," 2nd Turin Triennial, Turin, Italy, 2008. Courtesy the artist and Galerie Barbara Wien, Berlin, Germany. Photo credits: Paolo Pellion

work," *Sallim* unearths the private sphere of the kitchen as one that can unfold generously and genuinely to others. Inspired by Marguerite Duras and Yang's mother, who both cooked for and harbored political dissidents in their homes, the kitchen comes to symbolize a peaceful battlefield for struggles against sociopolitical injustice. While it is a site for a kind of social production, in *Sallim*, the kitchen remains "free from many of the things that are attributes of the ordinary concept of work in terms of social effectiveness/productivity,"[3] thereby nurturing a unique connection to the outside world, to others, and to Yang's work.

Consisting of a labyrinthine system of stacked venetian blinds flooded with natural light, *Series of Vulnerable Arrangements—Voice and Wind* (2009) evokes shadows of places and experiences not physically present. As in other installations, Yang uses manufactured venetian blinds, but here in indescribable, uncategorizable colors and patterns that exist at the edge of taste. These functional decorations for the home defy rigid concepts of design or periodization to emphasize the nonaesthetics of the private sphere, "where the self is cared for and contemplated, and can be shared in a different way."[4] The room-size installation plays off the building's light-filled architecture and features the uncapped ceiling, exposing now defunct motors, wiring, and mysterious fixtures. Six commercial fans placed around the gallery generate wind at various intervals, altering both the stability of the blinds as suspended barriers and the movement of visitors. Scent atomizers infuse the installation with subtle sensory experiences, calling upon the visitors' subjectivity as a key element in the definition of the space. Employing transparency and improvisation as metaphors for the vulnerability of space and time, Yang again pushes the possibilities of public engagement.

EJ

NOTES

This essay is adapted from two previous writings by the author: "An Encounter" in *Asymmetric Equality* and the exhibition brochure for "Condensation: Haegue Yang".

1. From Haegue Yang, *Squandering Negative Spaces* (2006), video, color, sound, twenty-nine minutes.

2. See Jean-Luc Nancy, *The Inoperative Community*, trans. Peter Connor (Minneapolis: University of Minnesota Press, 1991), 204.

3. Conversation with the artist February 6, 2009.

4. Ibid.

SELECTED BIBLIOGRAPHY

Choi, Binna, Lars Bang Larsen, and Nina Möentmann, *Community of Absence*, exhibition catalogue (Frankfurt/Main: Revolver, 2006).

Chong, Doryun, Eungie Joo, Clara Kim, Marcus Steinweg, and Haegue Yang, *Haegue Yang: Asymmetric Equality*, exhibition catalogue (Los Angeles: REDCAT, 2008).

Joo, Eungie, *Haegue Yang: Condensation*, exhibition catalogue, Korean Pavilion at the 53rd Venice Biennale (Seoul: Arts Council Korea, 2009).

YIN XIUZHEN

BORN 1963 IN BEIJING
LIVES AND WORKS IN BEIJING

Yin Xiuzhen is part of the second wave of experimental art-making in China. Through her work she explores the impact of rapid changes in government, economy, information, and movement on society. Yin has been deeply influenced by the environment in which she grew up, a time of intense ideological positions marked by the Cultural Revolution (CR). Yin explains:

> While the CR created more "hardship" and "bitterness" and "regret" for the generations before us, it left me—young [and] naïve then—with memories of "ideals," "magnificence," "collectivity" and others … We studied Mao, read Marx and Lenin, and even though we didn't really know what it was about, our spirits were charged, and a bright future was awaiting us … even with such little material wealth, we enjoyed great spiritual fulfillment and happiness. The reforms of the 1980s brought us a new life, also full of passion and ideals. Everyone has passionate feelings about the "Cultural Revolution" and the "Reconstruction," absorbing thought from other places at warp speed, catching every intellectual wave. "Presence" and "absence" intermingled, as contradictions and conflicts between isolation and openness, dictatorship and democracy became a new motivation, and as rapid changes cultivated in me an attitude of calm and quiet.[1]

In her work, Yin often incorporates used clothing as a metaphor for the "collective unconscious." She writes, "I believe that clothing is people's second skin. She [clothing] has feelings, a language, and she is connected to the times and to history."[2]

Clothing first appeared in Yin's work *Suitcase* (1995) in which she used cement to seal her own clothing from a period of over thirty years in an old leather suitcase made by her father. On the exterior, she wrote, "the clothes in the suitcase I have worn for the last thirty years, on them there is my experience, your memories, and the marks of time." The suitcase suggests departure, transience, instability. In the early 2000s, Yin began her "Portable Cities" series (2002–), sewing used clothing collected from specific cities like Shanghai, Berlin, Melbourne, Shenzhen, and Amsterdam into models of each city, adding elements of sound and light, as well as a city map, all embedded in old suitcases. These soft sculptures are at once playful and poignant, intimate re-enactments of iconic architecture and activity in which bits of clothing serve as stand-ins for local attitudes, perspectives, and emotions. According to Yin, "people in

FIG. 136 (TOP): *Portable Cities: Amsterdam + Amsterveen* (2007). Installation. Suitcases, used clothes, light, map, sound. 34⅕ x 31⁹⁄₁₀ x 10⅗ inches + 32¹⁄₁₀ x 28¹⁄₁₀ x 12⅗ (86.9 x 81 x 27 cm + 81.4 x 71.5 x 32 cm) (suitcase closed). Courtesy the artist and Beijing Commune

FIG. 137 (BOTTOM): *Flying Machine* (2008). Installation with used clothes, stainless steel, planks. 626⅘ x 480³⁄₁₀ x 139 inches (1592 x 1220 x 353 cm). Courtesy the artist and Beijing Commune

our contemporary setting have moved from residing in a static environment to become souls in a constantly shifting transience ... The suitcase becomes the life support container of modern living ... the holder of the continuous construction of a human entity."[3]

In works such as *Collective Subconscious* (2007) and *Flying Machine* (2008) Yin extends and combines vehicles with a kind of skeletal steel structure "skinned" with clothes. In *Collective Subconscious*, a minivan is elongated to begin to resemble a giant colorful caterpillar, each segment boasting assemblages of various clothing in matching hues. Entering the now anthropomorphized vehicle, the viewer is confronted with an almost cinematic experience, the light filtering through the clothing projecting various bands of color. The soft sound of a man singing a popular Chinese pop song fills the belly of the van, while small stools reminiscent of those used in public parks or markets invite visitors to linger and commune.

In *Flying Machine* a steel skeleton dissects a bare, unpainted airplane and connects it to a white sedan and a small blue tractor. Skinned in white clothing, the space that connects the machines is both mundane and futuristic, part accordion-bus, part Space Odyssey hub. From the shiny galvanized steel floor, a small spiral staircase leads to a large round portal open to the sky. With each vehicle facing a different direction, this machine is hopelessly grounded, pulled in three futile, conflicting directions of function, labor, and modernization. With experience and memory living in each article of clothing, *Flying Machine* suggests that the idiosyncrasies and ingenuities of everyday people transform the dehumanizing goals of progress into a nuanced present. The hybrid machine does not want to depart; instead, it rests comfortably as a meeting place and site for imagining the future.

EJ

NOTES

1. As cited in Eungie Joo, "Presence and Absence: Interview with Yin Xiu Zhen," in *Everyday Miracles: Four Women Artists*, edited by the Catalogue Editorial Committee of the Chinese Pavilion (Venice: 52nd International Art Exhibition/Venice Biennale, 2007), p. 64.

2. Ibid., p. 65.
3. As cited by Aimee Chang in *How Latitudes Become Forms: Art in a Global Age* (Minneapolis: Walker Art Center, 2003), 248.

SELECTED BIBLIOGRAPHY

Erickson, Britta, *On the Edge: Contemporary Chinese Artists Encounter the West*, exhibition catalogue (Hong Kong: Timezone 8 and Cantor Arts Center, 2005).

Everyday Miracles: Four Women Artists, edited by the Catalogue Editorial Committee of the Chinese Pavilion (Venice: 52nd International Art Exhibition/ Venice Biennale, 2007).

Mao, Christophe, ed., *Song Dong and Yin Xiuzhen: Chopsticks*, exhibition catalogue (New York: Chambers Fine Art, 2003).

ARTUR ŻMIJEWSKI

BORN 1966, WARSAW
LIVES AND WORKS IN WARSAW

When asked about his artistic aspirations, Artur Żmijewski is clear about his intent: "I'd like to be a partner in the political struggle."[1] Rather than staging aggressive interventions in society, Żmijewski uses a camera to document how people respond when they encounter behaviors or philosophies with which they are uncomfortable or unfamiliar. To do this, Żmijewski first establishes situations that force his subjects to confront difference, and then records the resulting tension in his videos and photographs.

His earliest videos feature individuals that cannot hide their otherness—deaf children in *Lekcja spiewu 1* (Singing Lesson 1, 2001), amputees in *Oko za Oko* (An Eye for an Eye, 1998), quadriplegics in *Na spacer* (Out for a Walk, 2001)—and requires the viewer to consider the marginalized status of the "handicapped". For Żmijewski, the physical irregularity is not the crux; rather, the conflict lies with the subsequent recognition of this disparity. The societal process of assimilation, what Żmijewski scornfully describes as "healthy people's efforts to cause the disabled to become like them," is revealed as both harmful and neglectful.[2]

But producing feelings of shame is not Żmijewski's objective; nor is he trying to inspire sympathy for his subjects. "The point isn't to mystify their condition and try to assimilate them to us," he explains, "but to acknowledge the value of what they do, to recognize the virtues of difference. The point is to really accept the fact that they're different."[3] He goes on to explain how this is one of several divisions that weaken social ties, describing a "fragmented social body divided into the hearing and the deaf, into homo- and heterosexuals, Jews and Germans, well and badly paid, well and poorly educated."[4]

With his landmark video *Repetition* (2005), Żmijewski began investigating difference that was purely subjective, rather than stemming from physical handicaps. The thirty-nine-minute-long *Repetition* is a re-enactment of psychologist Philip Zimbardo's 1971 Stanford Prison Experiment. Zimbardo asked college students to take on the roles of either prison guards and inmates for a period of two weeks. Citing the "genuine sadism" adopted by one-third of the guards, and the striking degree to which the prisoners had internalized their roles, Zimbardo terminated the experiment after six days. Żmijewski's iteration lasted just one day longer than the original, and the reconstruction demonstrates that difference is a matter of perception, and that the hierarchy of power may often come down to the random assignation of roles, which were, in this extreme example, inmate or prison guard.

FIG. 138: Stills from *Powtorzenie/Repetition*, 2005. DVD.
75 minutes. Courtesy the artist and Foksal Gallery Foundation,
Warsaw. Photo: Serge Hasenbohler

Żmijewski's next work, *Them* (2007), continued his examination of the boundaries that separate people. For this video, Żmijewski guided four Polish groups through a series of workshops with a seemingly straightforward assignment: each group would create an emblem for the political, ethnic, or religious affiliation to which they belonged. The groups, which consisted of no more than four or five people, were as follows: devout elderly Catholic women; young left-wing activists; members of the nationalist Polish Youth League; and Polish Jews. During the first session, the groups designed and painted their banners; in subsequent workshops the participants were encouraged to modify and amend one another's work. The resulting confrontation escalates quickly, as each group proceeds to alter, erase, mutilate, and finally destroy each other's project. The conclusion of *Them* is quite grim, offering few ideas on how conflicts between groups with differing beliefs might be resolved.

Throughout all these encounters—the deaf child struggling to follow her teacher's instructions, the prison guard humiliating the inmate, the socialist students cutting up the nationalists' banner—Żmijewski refuses to interfere. The minimal direction and absence of commentary is key: "There is no plan, no script—I never know where the trip will end. Many unplanned things happen, and we follow along and register them. Sometimes we lose our way, but those are the gates to virgin lands—error and straying off the path."[5]

By allowing the actions he stages to unfold naturally—"My protagonists are unpredictable and their behavior is beyond my control"[6]—Żmijewski continues to hold mirrors up to society.

ES

NOTES

1. Correspondence with artist on February 9, 2009.
2. Artur Żmijewski, interview from *If It Happened Only Once, It's As If It Never Happened* (Ostfildern, Germany: Hatje Cantz. 2005), 80.
3. Ibid.
4. Ibid.
5. Sebastian Cichocki, "The Terror of the Healthy, Artur Zmijewski Interviewed," *The Singing Lesson*, exhibition catalogue (Bytom, Poland: Galeria Kronika, 2003).
6. Ibid.

SELECTED BIBLIOGRAPHY

Belina, Slawek, "A Chat with Artur Żmijewski," *Dik Fagazine* (October 2007): 90–93.

Cichocki, Sebastian, *The Singing Lesson*, exhibition catalogue (Bytom, Poland: Galeria Kronika. 2003).

—— *If It Happened Only Once, It's As If It Never Happened* (Ostfildern, Germany: Hatje Cantz. 2005).

Kleeblatt, Norman L., "Moral Hazard: On the Art of Artur Żmijewski," *Artforum* 47, no. 8 (April 2009): 154–61.

PART III
ARTISTS' WORKS

SHAINA ANAND
Documentation of CAMP, *Wharfage*, 2009
Book publication and radio broadcast, Sharjah Biennial 2009
Courtesy the artist

EDGAR ARCENEAUX
Scorpio, 2008
Graphite, dirt, gesso, and enamel on paper
69 x 87 inches (175.3 x 221 cm)
Courtesy the artist and
Susanne Vielmetter Los Angeles Projects
Photo: Robert Wedemeyer

EDGAR ARCENEAUX
Constellation Drawings (Last Supper Room), 2008
Mixed media
Dimensions variable
Installation view, "Correlations and Isomorphisms," Susanne Vielmetter Los Angeles Projects
Courtesy the artist and Susanne Vielmetter Los Angeles Projects
Photo: Robert Wedemeyer

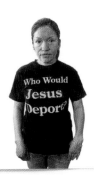

ANDREA BOWERS
Nonviolent Civil Disobedience Drawing (Elvira Arellano in Sanctuary at
Adalberto Methodist Church in Chicago as Protest against Deportation, 2007), 2007
Colored pencil on paper
30 x 22¼ inches (76.2 cm x 56.5 cm)
Hammer Museum Collection, Los Angeles
Courtesy the artist and Susanne Vielmetter Los Angeles Projects
Photo: Robert Wedermeyer

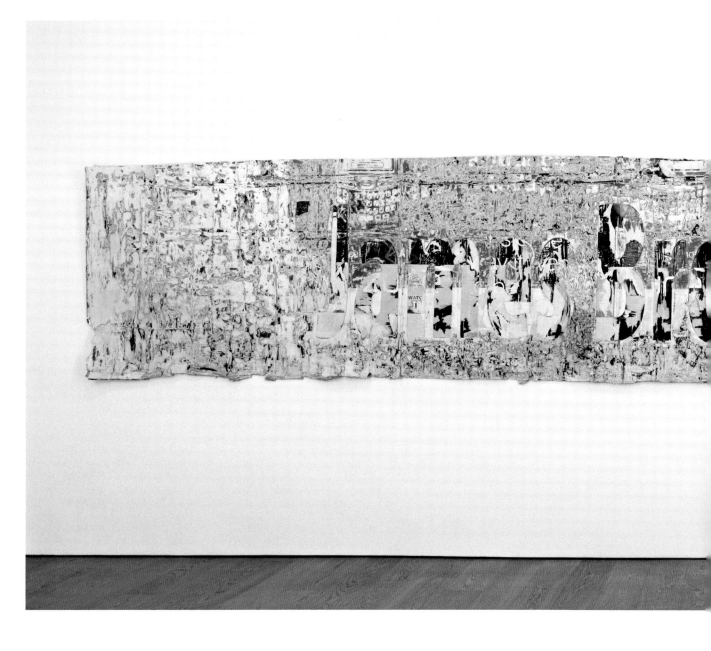

MARK BRADFORD
James Brown is Dead, 2007
Mixed media paper collage
48 x 268 inches (121.9 x 680.7 cm)
Courtesy the artist
Photo: Luciano Fileti

244

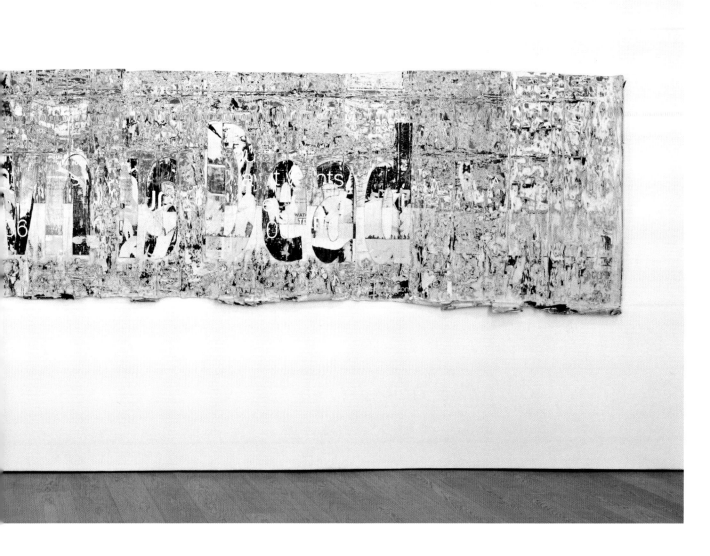

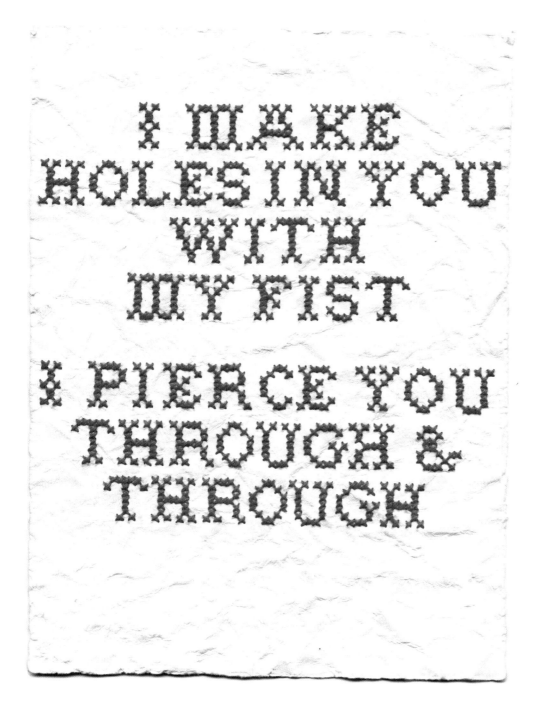

GINGER BROOKS TAKAHASHI
I Make Holes in You with My Fist I Pierce You Through & Through,
from the "Our nature is our virtue" series, 2007
Cotton thread on paper
5¾ x 7½ inches (14.6 x 19.1 cm)
Courtesy the artist

246

CENTER FOR LAND USE INTERPRETATION (CLUI)
Up River: Points of Interest on the Hudson from the Battery to Troy, 2007
Aerial photographs
Courtesy the Center for Land Use Interpretation photo archive

NIKHIL CHOPRA
Yog Raj Chitrakar: Memory Drawing IX, 2009
Documentation of performance at the New Museum and
various locations, New York City
Courtesy the artist and the New Museum, New York

248

ABRAHAM CRUZVILLEGAS
Autoconstrucción: Fragment: Handrail Ramp, 2007
Acrylic on wood and iron
36⅕ x 81½ x 5⁹⁄₁₀ inches (91.5 x 207 x 15 cm)
Courtesy the artist and kurimanzutto, Mexico City
Photo: Michel Zabé and Enrique Macías

HASAN ELAHI
Altitude v2.0, 2007
Excerpt of meals eaten in the air in 2005 and 2006
Courtesy the artist

CAO FEI
RMB CITY 4, 2007
Digital chromogenic print
47⅕ x 63 inches (120 x 160 cm)
Courtesy the artist and Vitamin Creative Space, Beijing

251

URS FISCHER
Untitled (Lamp/Bear), 2006
Cast bronze, patinated and lacquered, acrylic glass,
gas discharge lamp, and stainless steel interior framework
275⅝ x 255⅞ x 295¼ inches (700.1 x 649.9 x 749.9 cm)
Courtesy the artist and Gavin Brown's Enterprise, New York

CARLOS GARAICOA
Pérdida (Loss), 2006
Installation: rice paper lamps, wire, and stone sculptures
Dimensions variable
Courtesy the artist and Galleria Continua, San Gimignano–Beijing–Le Moulin

SHILPA GUPTA
Don't See Don't Hear Don't Speak, 2008
Photograph printed on Flex
300 x 120 inches (762 x 304.8 cm)
Courtesy the artist

DANIEL GUZMÁN
Brutal Youth, from the sculpture series "Everything is Temporary," 2008
Found furniture, found door, plastic bones, record covers, and engraved Plexiglas
83½ x 32³⁄₁₀ x 32³⁄₁₀ inches (212 x 82 x 82 cm)
Courtesy the artist and kurimanzutto, Mexico City
Photo: Michel Zabé and Enrique Macías

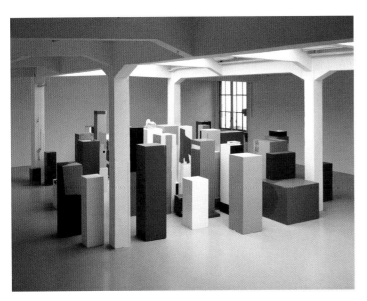

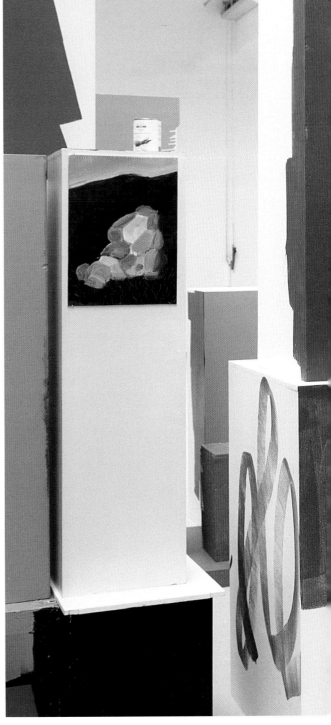

RACHEL HARRISON
Trees for the Forest, 2007
Pedestals, paint, anonymous paintings, blanket, CD-R discs, canned
pineapple, plastic wrap, bubble wrap, pink tissue, Pearl River candy, bag,
portable radio, poster, and international magazines
Dimensions variable
Installation view, Migros Museum, Zurich, 2007
Courtesy Greene Naftali Gallery, New York
Photo: A. Burger

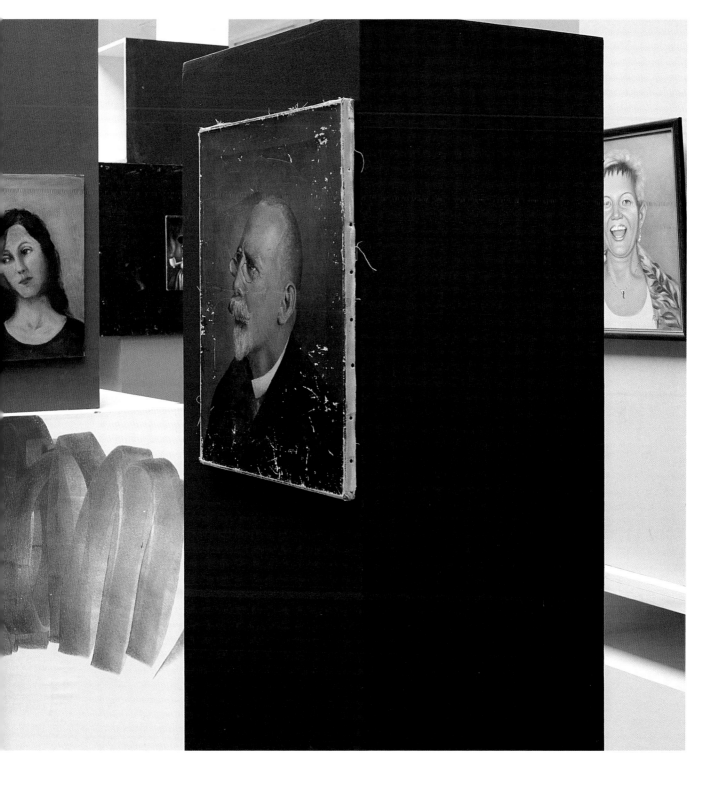

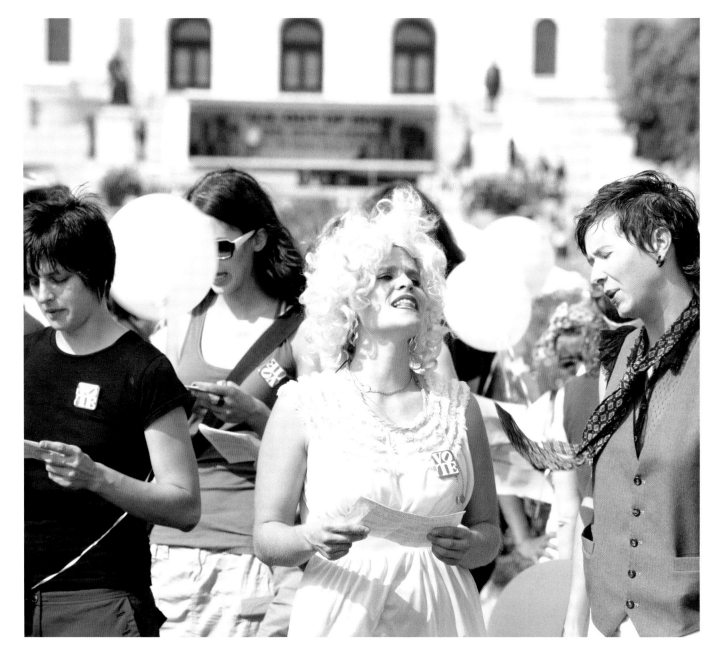

SHARON HAYES
Revolutionary Love 2: I am Your Best Fantasy, 2008
Documentation of performance, Republican National Convention, St Paul, MN
Courtesy the artist and Tanya Leighton Gallery, Berlin
Photo: Gene Pittman for the Walker Art Center, Minneapolis

SUSAN HEFUNA
Mirage, 2007
Mixed media
78⁷⁄₁₀ x 315 x 39²⁄₅ inches (200 x 800 x 100 cm)
Installation view, Sharjah Biennial 2007
Courtesy the artist

JONATHAN HERNÁNDEZ
Estado vacioso III, 2008
Forty-seven newspaper cuttings with a circular incision each
45¼ x 35¹/₁₀ inches (115 x 89 cm)
Courtesy the artist and kurimanzutto, Mexico City
Photo: Michel Zabé and Enrique Macías

LESLIE HEWITT
Make It Plain (5 of 5), 2006
60 x 84 inches (152.4 x 213.4 cm)
Digital chromogenic print
Courtesy the artist

HUANG YONG PING
Pentagon, 2007
Ceramic, soil, and plants
216½ x 216½ x 19⁷⁄₁₀ inches (550 x 550 x 50 cm)
Installation view, "C to P," Barbara Gladstone Gallery, New York
Courtesy the artist and Barbara Gladstone Gallery, New York

RUNA ISLAM
The house belongs to those who inhabit it, 2008
16 mm film with CD wild track
6:52 minutes
Image © Runa Islam
Courtesy the artist and White Cube, London
Photo: Runa Islam

RUNA ISLAM
The house belongs to those who inhabit it, 2008
Installation view, "Manifesta 7" Trento, Italy
Image © Runa Islam
Courtesy the artist and White Cube, London
Photo: Runa Islam

The telegram reads:

5571

NNNN
ZCZC PUA519 DROQ59 OAH938 TF1893
ITRM CO AASV Q29
SYDNEY 29 18 2350

JANET VENN BROWN
VIA ALBERICIO II 11/22
ROME

1710 E

SHOCKED AND SO VERY SORRY ABOUT WAEL FEELING DEEPLY FOR YOU STOP
TELEPHONE AND REVERSE CHARGES IF YOU WANT LOVE
 HELEN

COL 11/22

EMILY JACIR
Material for a film, 2004–07 (detail)
Three sound pieces, one video, texts, photos, and archival material
Courtesy the artist and Alexander and Bonin, New York

MICHAEL JOO
Bodhi Obfuscatus (Space-Baby), 2005
Mixed mediums
Dimensions variable
Installation view, 6th Gwangju Biennale 2006
Courtesy the artist and Anton Kern Gallery, New York

LAUREN KELLEY
Stills from *Big Gurl*, 2006
Single-channel video
6:55 minutes
Courtesy the artist

MARGARET KILGALLEN
Main Drag, 2001
Installation view, "East Meets West: 'Folk' and Fantasy from the Coasts,"
Institute of Contemporary Art, Philadelphia, May 12–July 29, 2001
Courtesy Institute of Contemporary Art, University of Pennsylvania, Philadelphia

267

AN-MY LÊ
Offload, LCACs and Tank, California, 2006
Archival pigment print
40 x 56½ inches (101.6 x 143.5 cm)
Courtesy Murray Guy, New York

GLENN LIGON
Stranger #22, 2006
Oilstick, acrylic, and coaldust on canvas
96 x 72 inches (243.8 x 182.9 cm)
Courtesy the artist and Regen Projects, Los Angeles

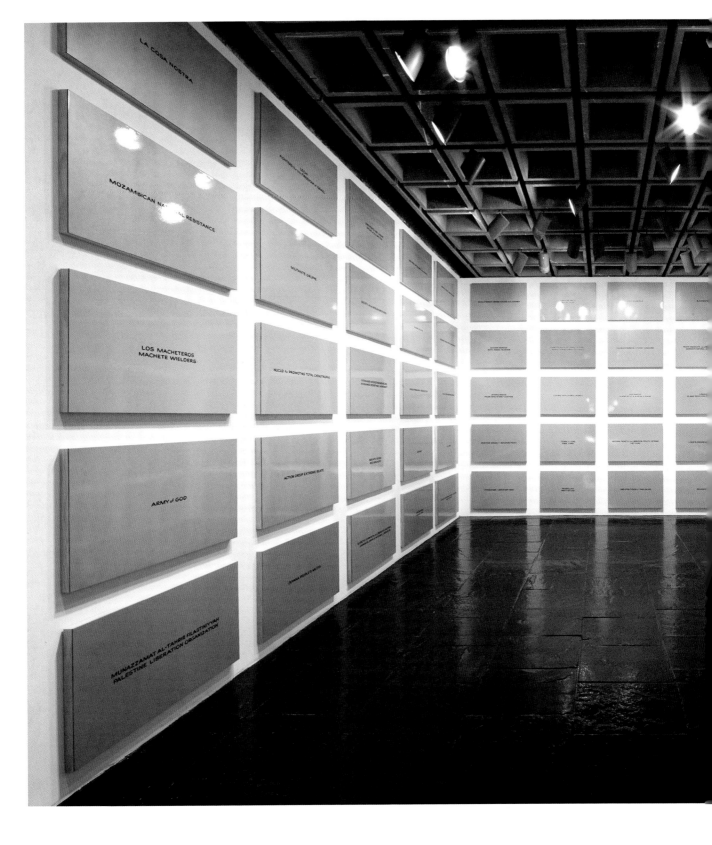

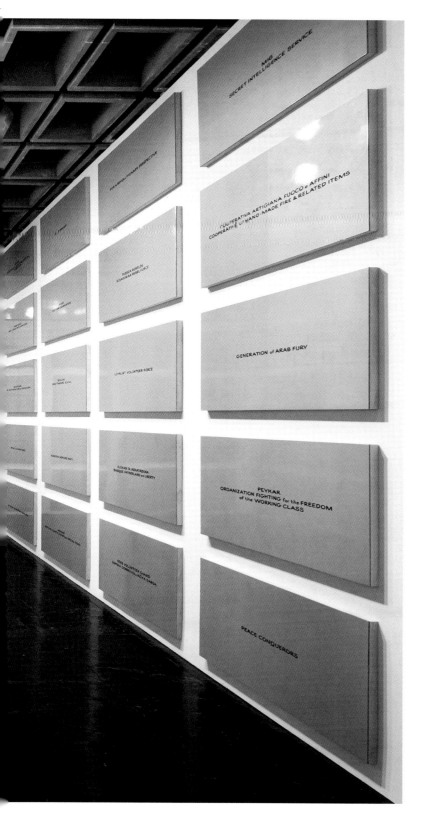

DANIEL JOSEPH MARTINEZ
"Divine Violence," 2003–
Installation, consisting of ninety-two paintings, at the
Whitney Biennial 2008 and four individual paintings
House Of Kolors: Spanish Gold, Top Coat, Candy,
automotive lacquer on panels with hand-lettered text
24 x 36 inches (61 x 91.4 cm) (each)
Installation view: Whitney Biennial 2008
Whitney Museum of American Art Collection of House
Of Kolors automotive lacquer (Spanish Gold Kandy
Koncentrate) on panel with hand-lettered text
Courtesy the artist and Simon Preston Gallery, New York

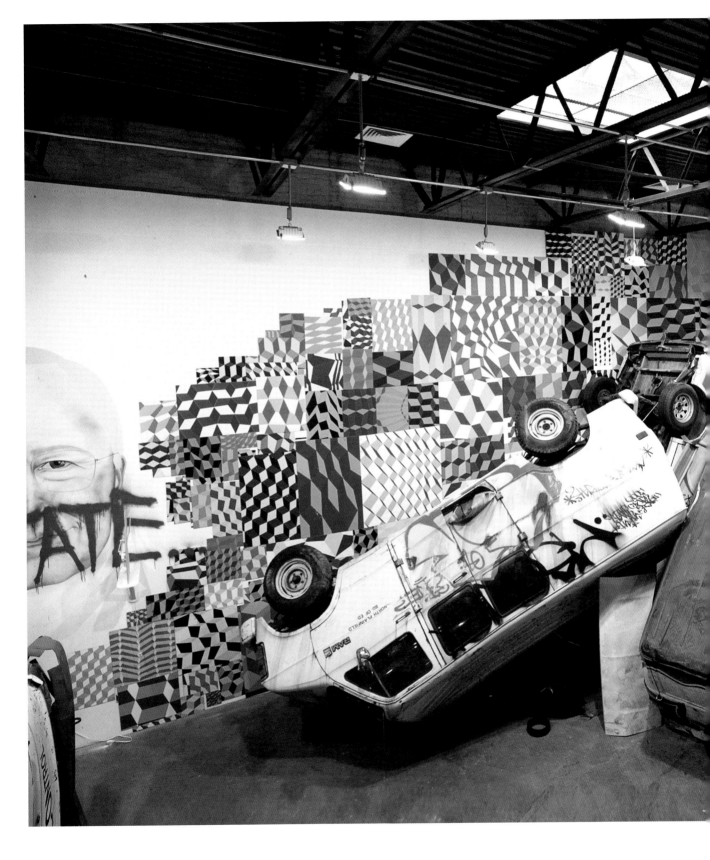

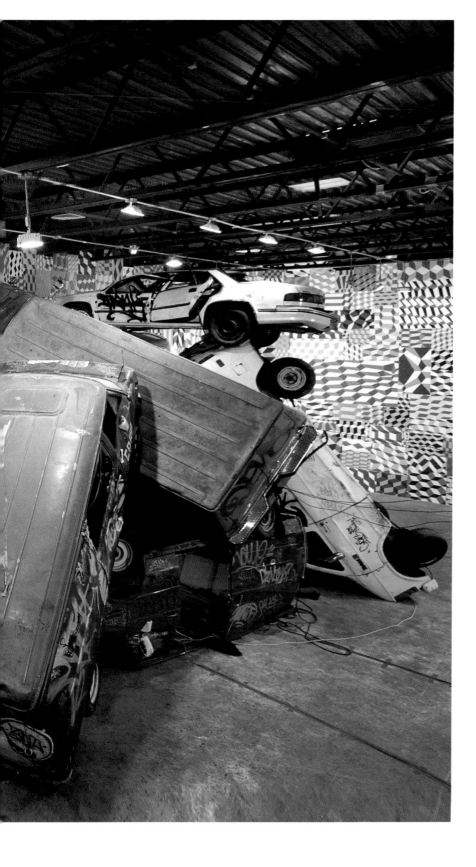

BARRY MCGEE
One More Thing, 2005
Mixed media
Dimensions variable
Installation view, Deitch Projects, New York
Courtesy the artist and
Deitch Projects, New York

DAVE MCKENZIE
I'll Be There, 2007
Performance at Adam Clayton Powell Jr State Office Building Plaza
in Harlem for Performa 07
Courtesy the artist and Performa, New York

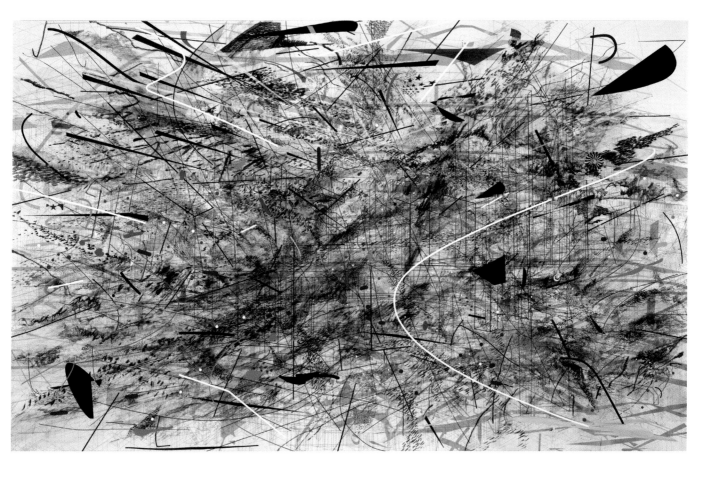

JULIE MEHRETU
Black City, 2007
Ink and acrylic on canvas
120 x 192 inches (304.8 x 487.7 cm)
Image © Julie Mehretu
Collection François Pinault
Courtesy The Project, New York
Photo: Tim Thayer

275

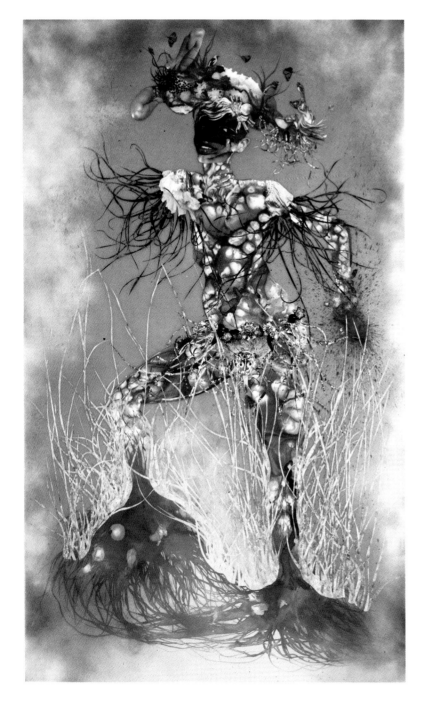

WANGECHI MUTU
Me Carry My Head on My Home on My Head, 2005
Ink, fur, acrylic, and glitter on Mylar
88¼ x 51¾ inches (224.2 x 131.4 cm)
Courtesy the artist and Sikkema Jenkins Gallery, New York

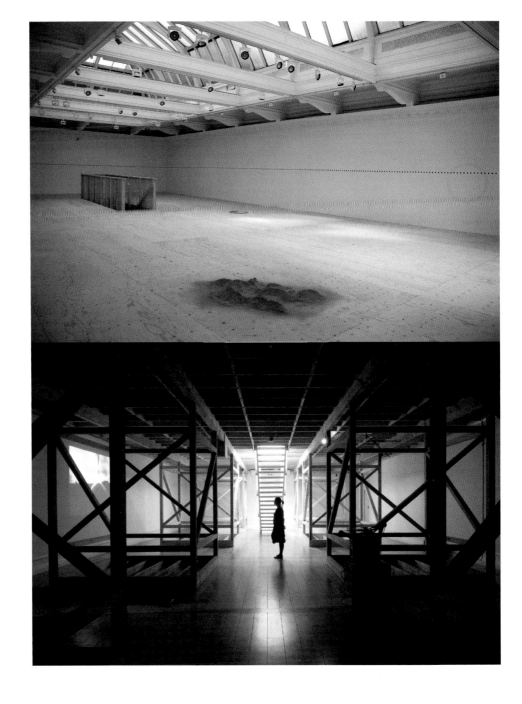

RIVANE NEUENSCHWANDER
Suspension Point, 2008
Drilled holes, dust, and wooden structure
Dimensions variable
Installation view, South London Gallery, London. Courtesy Galeria Fortes Vilaça, São Paulo;
Stephen Friedman Gallery, London; Tanya Bonakdar Gallery, New York
(Top) Photo: Rivane Neuenschwander
(Bottom) Photo: Andy Keate

NOGUCHI RIKA
The Sun #27, 2008
Chromogenic print
15⁹/₁₀ x 23⁷/₁₀ inches (40.3 x 60.3 cm)
Courtesy the artist, D'Amelio Terras, New York, and Gallery Koyanagi, Tokyo

CATHERINE OPIE
Football Landscape #1 (Fairfax vs. Marshall, Los Angeles, CA), 2007
Chromogenic print
48 x 64 inches (121.9 x 162.6 cm)
Image © Catherine Opie
Courtesy Regen Projects, Los Angeles

CLIFFORD OWENS
Photographs with an Audience, 2008 (detail)
Chromogenic print
16 x 20 inches (40.6 x 50.8 cm)
Courtesy On Stellar Rays, New York

ELIZABETH PEYTON
Susan Sontag (after H.C. Bresson's 'Susan Sontag, Paris, 1972'), 2006
Oil on medium-density fibreboard
9 x 7 inches (22.9 x 17.8 cm)
Courtesy the artist and Gavin Brown's Enterprise, New York

ANNIE POOTOOGOOK
A True Story (Cape Dorset), 2006
Pencil crayon, ink, and pencil
26 x 40 inches (66 x 101.6 cm)
Private collection
Courtesy Feheley Fine Arts, Toronto

WALID RAAD
Let's Be Honest, the Weather Helped, 1984–2007
Attributed to: Walid Raad
Image © Walid Raad
Courtesy Paula Cooper Gallery, New York

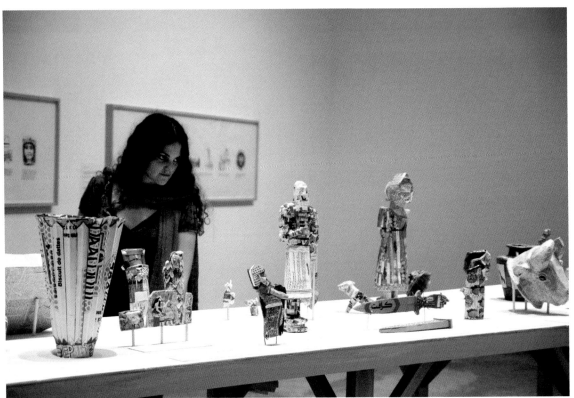

MICHAEL RAKOWITZ
*The Invisible Enemy Should Not Exist
(Recovered, Missing, Stolen Series)*, 2007

Middle Eastern packaging and newspapers, and glue
Dimensions variable
Installation view, 10th International Istanbul Biennial
Courtesy the artist and Lombard–Freid Projects,
New York

*The Invisible Enemy Should Not Exist—Skirted Male
with Beard (IM19752), Female Figure with Feet of Child
(IM19751) (Recovered, Missing, Stolen Series)*, 2007
204 x 36 x 32 inches (518.2 x 91.4 x 81.3 cm)

*The Invisible Enemy Should Not Exist—Bull Head (IM45020)
(Recovered, Missing, Stolen Series)*, 2007
8¼ x 11⅘ x 8¼ inches (21 x 30 x 21 cm)

*The Invisible Enemy Should Not Exist—Headless Male Figure
(Kh. IV 112) (Recovered, Missing, Stolen Series)*, 2007
Figure: 9⅗ x 4⁷⁄₁₀ x 2¾ inches (24.5 x 12 x 7 cm)

284

PEDRO REYES
Prototype for a human-powered passenger vehicle, 2007
Aluminium structure and mechanical parts
62 x 47 x 86 inches (157.5 x 119.4 x 218.4 cm)
Courtesy Yvon Lambert Gallery, New York

RIGO 23
Sol/Soleil, 2009–10
Site-specific mural, Lyon, France
Courtesy the artist

LARA SCHNITGER
Saville Row, 2007
Fabric, wood, and pins
131 x 78⅝ x 90½ inches
(333 x 200 x 230 cm)
Courtesy the artist and
Anton Kern Gallery, New York

LISA SIGAL
The Day Before Yesterday and The Day After Tomorrow, 2008
Paint, silk screen, joint compound, and pencil on wood panel
114 x 210 inches (289.6 x 533.4 cm)
Installation view, Whitney Biennial, 2008
Courtesy the artist
Photo: Andres Ramirez

TARYN SIMON
Sexual Assault Kits Awaiting DNA Analysis, Bode Technology Group, Inc., Springfield, Virginia

Bode Technologies is the largest private forensic DNA laboratory in the United States. It assists local, state and federal agencies in processing the large number of backlogged sexual assault evidence kits. It was recently estimated that there are as many as half a million sexual assault kits in the U.S. awaiting analysis.

A sexual assault kit, also known as a rape kit, is a sealed white box that contains physical and biological evidence collected from the victim during a medical examination. Sexual assault kits are administered by nurses to assist in identifying and prosecuting the crime's perpetrator. Forensic evidence stored in the kit can include: blood, clothing, fingernail scrapings, hair and semen.

LORNA SIMPSON
Photo Booth, 2008
Installation: fifty found photo
booth portraits and fifty ink
drawings
Dimensions variable
Courtesy the artist

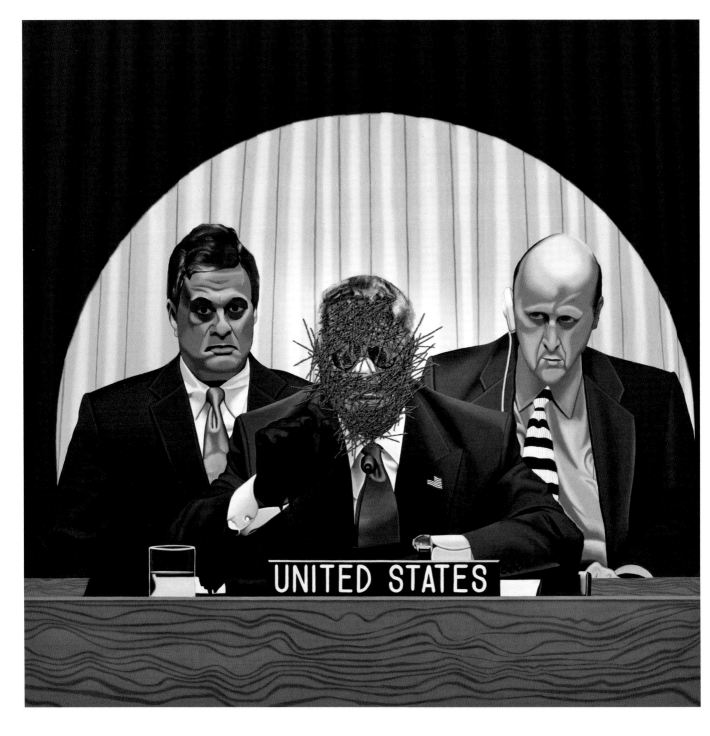

JEFF SONHOUSE
The Sacrificial Goat, 2008
Mixed media on medium-density fibreboard
48¾ x 48 inches (123.8 x 121.9 cm)
Courtesy the artist

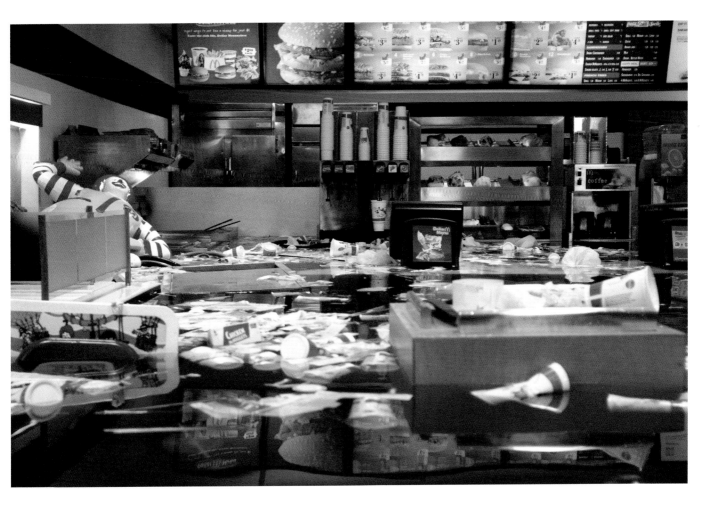

SUPERFLEX
Still from *Flooded McDonald's*, 2009
Film/Red
20 minutes
Courtesy SUPERFLEX

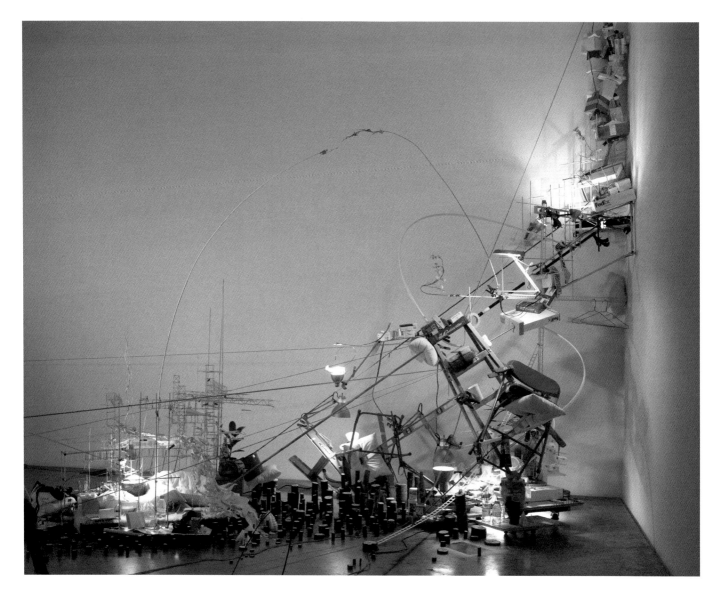

SARAH SZE
A Certain Slant, 2007
Mixed media
Dimensions variable
Courtesy the artist

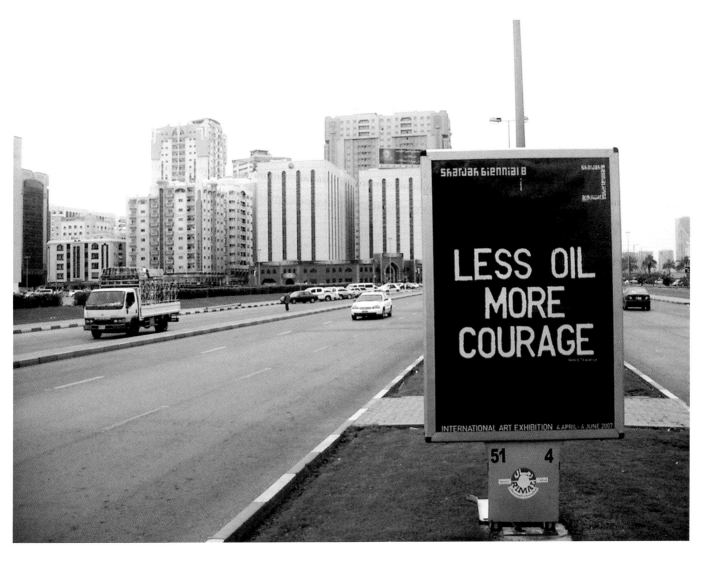

RIRKRIT TIRAVANIJA
untitled (less oil more courage), 2007
Advertisement for Sharjah Biennial 8
Courtesy the artist

DANH VO
12:15:02, 27.05.2009, 2009
Late nineteenth-century chandelier from the ballroom of
the former Hotel Majestic, Avenue Klèber, Paris
Dimensions variable
Installation view: "Where The Lions Are," Kunsthalle Basel
Courtesy of the artist

KARA WALKER
Bureau of Refugees: Mulatto hung by a grapevine near road side between
Tuscaloosa & Greensboro, 2007
Cut paper on paper
30.75 x 20.5 inches (78.1 x 52.1 cm)
Courtesy the artist and Sikkema Jenkins & Co., New York

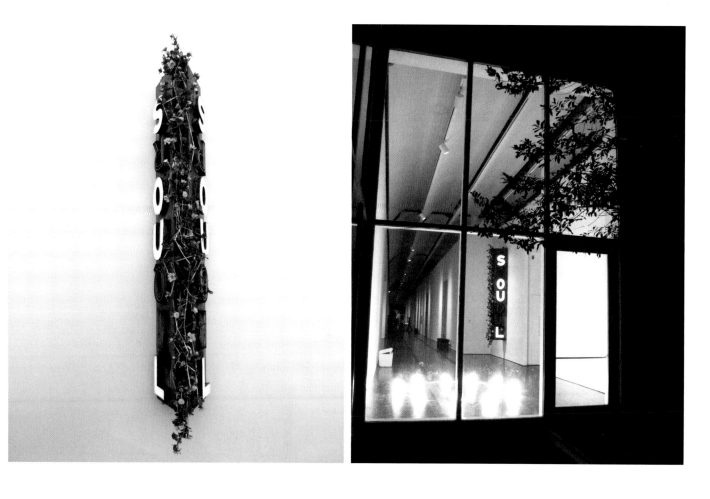

NARI WARD
LiquorsouL, 2008
Metal neon sign, wood with artificial flowers, and shoe tips
Dimensions variable
Collection of Rosa and Gilberto Sandretto
Courtesy the artist

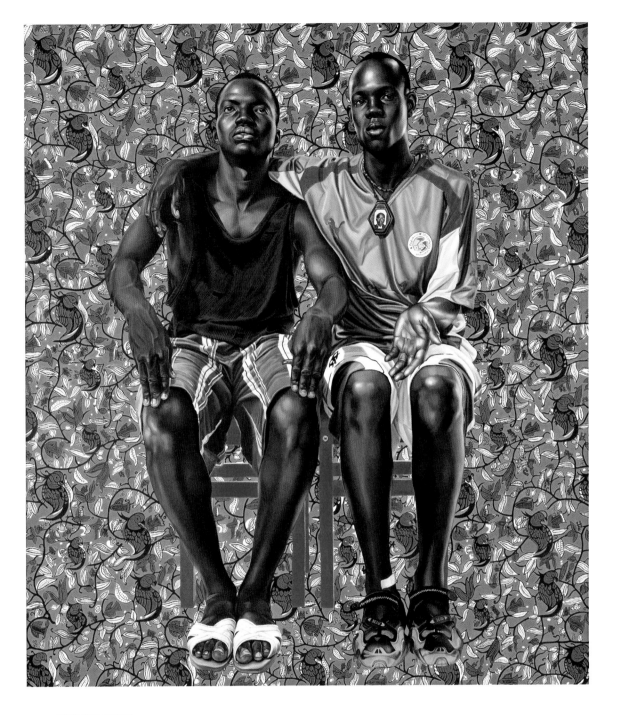

KEHINDE WILEY
Dogon Couple, 2008
Oil on canvas
96 x 84 inches (243.8 x 213.4 cm)
Courtesy the artist

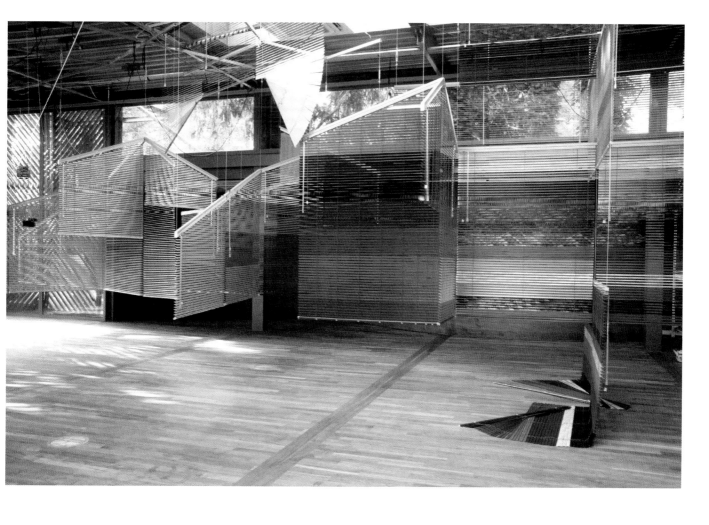

HAEGUE YANG
Series of Vulnerable Arrangements—Voice and Wind, 2009
Aluminum, Venetian blinds, industrial electric fans, scent atomizers
Dimensions variable
Installation view: "Condensation: Haegue Yang," Korean Pavillion, 53rd Venice Biennale
Courtesy the artist and Galerie Barbara Wien, Berlin, and Kukje Gallery, Seoul

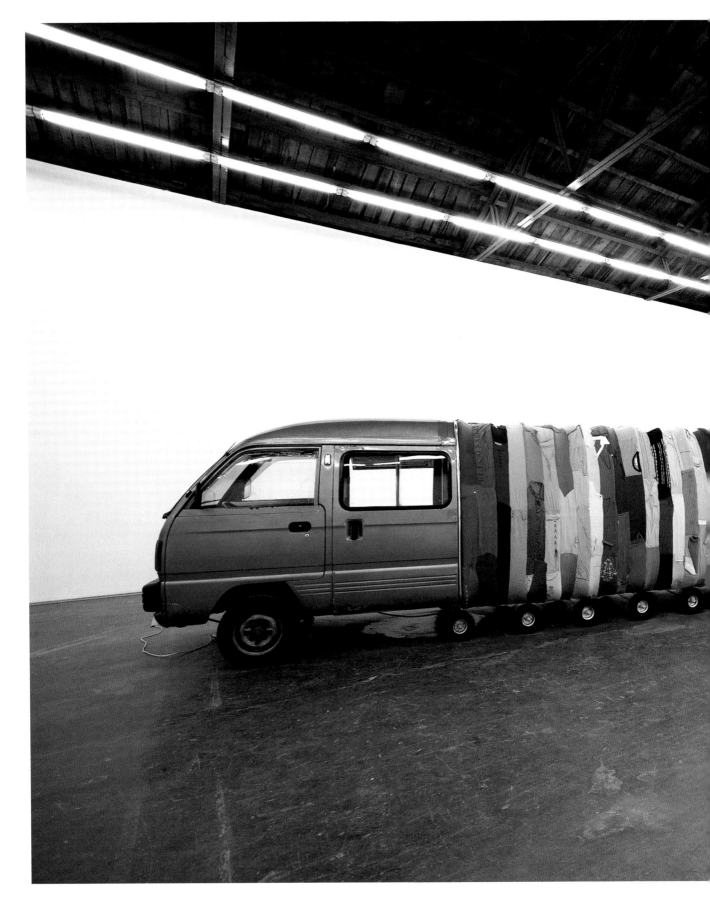

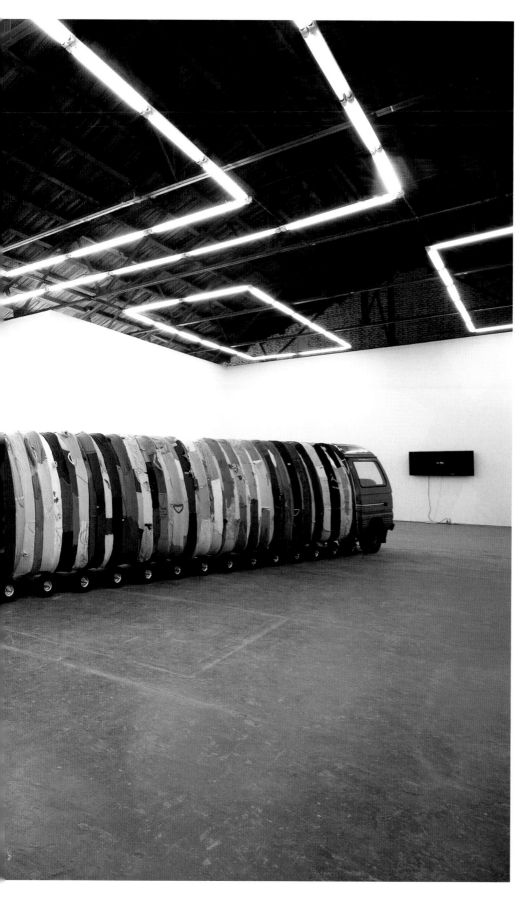

YIN XIUZHEN
Collective Subconscious,
2007
Installation with minibus,
stainless steel, used clothes,
stools, music
559 1/10 x 55 1/10 x 74 4/5 inches
(1420 x 140 x 190 cm)
Installation view, "Yin Xiuzhen
In Beijing Commune," Beijing
Commune
Courtesy the artist and Beijing
Commune

303

ARTUR ŻMIJEWSKI
Stills from *Oni/Them*, 2007
Video
27 minutes
Courtesy the artist and Foksal Gallery Foundation, Warsaw

304

PART IV
INTEGRATING CURRICULUM

INTRODUCTION

The New Museum has a strong commitment to cultivating students' critical thinking, visual literacy skills, and self-expression through innovative curricula. The following series of lessons were created in collaboration with artists and educators teaching in the Museum's Global Classroom (G:Class). G:Class is an interdisciplinary education initiative that utilizes the New Museum as a resource to enhance learning. Based on a philosophy rooted in inquiry and visual analysis, G:Class engages students and teachers to become critical thinkers and innovative investigators, and to express themselves through contemporary art. It comprises seminars for both students and teachers conducted by exhibiting artists, museum staff, and art professionals; partnerships with local high schools; and a website chronicling the exhibitions, artists, seminars, partnerships, and lessons developed since the New Museum's relocation to the Bowery in 2008. Many of the artists in this publication have established a relationship with the Museum through exhibitions, public programs, and G:Class. Additional materials and lesson plans on these artists—and many more—are located on our website: www.gclass.org.

The following curricula were designed to incorporate contemporary art into the classroom by exploring artistic practices that address each chapter's theme—"Negotiating Space/ Negotiating Self," "Activism and Democracy (Politics)," "Commodities, Exchange, Waste and Obsolescence," "Conflict: Local and Global," and "History and Historicism." Each chapter is prefaced with an introduction of the theme and the goals of the curriculum, followed by a series of lessons outlining objectives and suggested procedures. Each lesson plan is designed to use observational and interpretive activity through inquiry and extended peer discussion. Many of the lessons have an "Extending the Lesson" section, relating the thematic to specific subject areas (i.e. architecture, film, and literature). The curricula depend on a firm understanding of the "On Education" and "On Artists" sections as well as a concrete knowledge of the content in the lessons. The lessons are intended to be used sequentially but are also structured to be flexible, so they may be rearranged to create a curriculum that suits each teacher's individual needs. The aim is to foster an informed appreciation of art and culture, particularly in relation to current events; to use the familiar yet contested space of the classroom as a point of departure for discussion; and to critically investigate issues that relate to students' lives.

JENNY HAM-ROBERTS
Manager of High School Programs

JOSEPH KEEHN II
Associate Educator

NEGOTIATING SPACE / NEGOTIATING SELF

Lan Tuazon

SUBJECT AREAS: Art, Language Arts, Social Studies, History, Media Studies and Architecture

This chapter investigates how history, the law, and class structures are embedded in the physical environment and the ways they affect our social life. It is public space which bears witness to and reveals the marks of history, allowing articulations of the self to be created. In the abstract, space is the demarcation of a bound area or place. However, spaces are not natural; they are socially made and are products of political and capital values. Simple as it may seem, the demarcating line that creates spaces of difference—in and out, here and there—is essentially what formulates identity with the exclusionary definition of an "us" and "them," turning space into a social and political issue. Students will understand how to interpret social spaces as vestiges of our ideas of humanity, political values, and notions of rights. How are spaces of difference created and how does authority affect how we move through social spaces? Whose needs are expressed or represented in public and private spaces? Does public space serve our collective human needs? What are major forces that influence the development of space and how much of those forces are for capitalist productions? Finally, students will understand the relationship that democracy has to public space and will debate the central question of public space—whether it is a universal place free from politics or if it is the very sphere of politics. Included in this chapter are artists' works that articulate personal narratives, expressions, and representations of an "otherness" that challenge the reality and future of social structures and conditions.

Function and the Ins and Outs of Space

OBJECTIVES:

- Students will understand that spaces are socially constructed.
- Students will learn how to "read" a space according to its designed function and the type of "public" it serves.
- Students will learn about the importance of context in installation artworks and create a collage representing contradictory spaces.
- Students will build language skills and learn vocabulary related to spatial studies.

TIME: One session

MATERIALS: Glue, scissors, found images of places and social spaces (newspaper/magazine), paper, and pencils

ARTIST RESOURCES:

Urs Fischer: *you* (2007) (Figure 30)

Rivane Neuenschwander: *Continente-Nuvem* (Continent-Cloud) (2007) (Figure 82)

SUGGESTED PROCEDURE:

1. Read the chapter introduction and present the scope of the curriculum and its objectives. Space is an empty area demarcated by purpose or function. When we think of the word "space" we often conceive the area our own body occupies and the social and political world we inhabit. Make a list of different types of social spaces (i.e. train stations, parks, home, malls, libraries, streets, restaurants, airports, cafes, stores, museums, and plazas). Classify the listed spaces as: "in" or "out"; "private" or "public"; and "man-made" or "natural."

2. Students will consider the relationship spaces have to function and how it affects who uses them. Observe the classroom as a specific case.
 - What can students learn from the orientation of the room, chairs, and tables?
 - What are some educational needs that are designed into the room? How, for example, would it change interactions if the room or its arrangement were circular?

 Compare the classroom to a public park. A park is open to the public and must host multiple uses and variable users.

- What are some design considerations that a park must have in order to maintain safety for all?
- What kinds of acceptable activities are allowed in the park?

Relate students' responses to the curriculum theme of the social and political implications of space.

3. Discuss how spaces are limited and contained within boundaries by presenting Rivane Neuenschwander's *Continente-Nuvem* (Continent-Cloud). Have students begin by describing what they see in the installation and what they think it resembles. Consider other artworks that are placed on the ceiling, such as Michelangelo's painting in the Sistine Chapel, and ask:

- How does the placement of the installation on the ceiling affect our viewing of the work? What associations do students have to "looking up" as opposed to "looking ahead"?
- If the ceiling represents the sky and the rest of the world, how might the change in scale affect the viewer and their perception of themselves within the room?
- What space is the artist limited to with this installation? What are the parameters the artist is working within to create this environment?

4. Elaborate on the construction and containment of space by presenting Urs Fischer's *you*. Students will describe what they read about the work and compare/contrast the associations between clean white spaces and rubble groundwork.

- What type of interactions do you usually associate with this social space? What design features and qualities does the white cube of the gallery typically have and why?
- Where do we usually encounter raw spaces? Describe the experience of walking into a space that reveals a contradiction that is both inside/outside and clean/rough. Why did the artist juxtapose these two spaces together?
- Fischer has uncovered the ground to show what is beyond the boundaries of a contained space. Metaphorically speaking what does it mean to "unearth" or "uncover" something? What do you suppose Fischer is revealing about the gallery?

5. In modern art we traditionally look at form and content to understand and interpret the meaning of a work of art. In contemporary art we broaden the significance to include context as a third relative source of meaning. Define **installation art** and compare and contrast Fischer's and Neuenschwander's aforementioned artworks. Define **context** and apply the term in relation to the gallery.

- How do both artists reveal the social limits of a gallery space? Who goes to the gallery and is the gallery a public space?
- Is it possible for a space to be neutral? Explain.

6. Define **temporary autonomous zone (T.A.Z.)** and have students apply the term T.A.Z. to the artworks. Elaborate on constructed spaces by asking what it means to be in an unfamiliar environment.
 - How does an unfamiliar environment affect experience?
 - What kind of activities can the students imagine occurring in Fischer's and Neuenschwander's T.A.Z. spaces?

7. Choosing a social space such as a mall, corporate plaza, or public park, students will create a T.A.Z.—a space of contradiction. Clarify the relationship between site and context and have the students design a space that considers these two elements. Executed in collage, this project will allow students to consider how arrangement can have a profound effect on interrogating the social order of spaces. Challenge students to take Vito Acconci's position on public art—its function is to "make or break a public space."[1]

HOMEWORK:

Students will collect images of cityscapes and landscapes to complete their assignment.

EXTENDING THE LESSON IN ARCHITECTURE:

On the relationship between space and function, present and analyze *House in a Plum Grove* (1999–2000) by the architectural firm SANAA. For contemporary art related to space and collage, refer to Martha Rosler's work on the Global Classroom (G:Class) website: www.gclass.org

EXTENDING THE LESSON IN ART HISTORY:

Extend the lesson by examining artistic methodologies in earth and land art of the 1970s with works by Ana Mendieta, Robert Smithson, Walter De Maria, and James Turrell.

ASSESSMENT:

Assess students' abilities to participate and understand complex issues discussed in class and how these issues are addressed in their collage assignment. Did students understand and use new vocabulary learned in class?

ADDITIONAL RESOURCES:

For information on Vito Acconci's position on public art that its function is to "make or break a public space" refer to Acconci's essay "Public Space in a Private Time" (http://forerunner. finearts.yorku.ca/~couroux/facs3931a/acconci.pdf).

Spaces of Transition and Traces of History on the Present

OBJECTIVES:

- Students will understand how installation and site specificity can engage social and historical content within a given context.
- Students will create public art installations that inscribe narrative to a site.

TIME: One session

MATERIALS: Paper and pencils

ARTIST RESOURCES:

Carlos Garaicoa: *Untitled (La Internacional)* (2006), *Untitled (RCA Victor)* (2006) (Figure 35), and *Overlapping (Anthony Walker's Corridor)* (2006)

Lisa Sigal: *Line-up* (2008) (Figures 108 and 109)

SUGGESTED PROCEDURE:

1. Have students consider major and minor changes in their area by listing the closing/opening of a school, newly built roads and buildings, or landmark renovations. Provide examples of changes in the built environment and their impact on places and people, such as the massive infrastructure development in Penang where a built highway system, along with new apartment blocks, deeply affected the local fishing industry. Such changes effectively cut off access to the sea, and because waters were becoming polluted with waste from the developing city, the fishing community and their families' next generations were forced to work in nearby sweatshops for a living.

2. Define the term **palimpsest** as a residual trace of something that was once there. Have students read about Sigal's practice and the process it took to complete *Line-up*. Sigal gained the support and cooperation of building owners, neighborhood groups, and other artists to execute this project.
 - How does a palimpsest relate to the temporality of Sigal's gesture?
 - How permanent can the ephemeral be?
 - What impact does the work have on the surrounding businesses, residents, and neighborhoods?

3. Present Carlos Garaicoa's *Untitled (La Internacional)* and *Untitled (RCA Victor)*. Have students describe each layer of the image. What do students see in the background photograph and the pinned texts? Look at the architecture of the Havana buildings and compare them to the foreground text. Define **juxtaposition** and the effect that overlapping creates. What period are the buildings representative of?

4. Provide the context of the city of Havana and read about Garaicoa's practice and his work.
 - If space is the manifestation of history, what evidence of the past is visible on the present? How can history be inscribed or written into the present environment?
 - Consider forms of commemoration in public space. How does the subject matter of Garaicoa's work differ from what is usually represented in public?

5. The idea of the poltergeist, a disturbing spirit that takes possession of a particular space, is a metaphor for unjust repression of narratives. The idea of the poltergeist is very site-specific and functions to create a disturbance to uncover past, forgotten occurrences in history. Present Garaicoa's *Overlapping (Anthony Walker's Corridor)* (2006). Read and present the background history of Anthony Walker's beating. Ask students:
 - How does this representation of Walker's beating relate to the idea of a poltergeist?
 - Why do you think the artist chose to represent this site?

6. Define **site specificity** and have students determine if the aforementioned works are site-specific. Both Lisa Sigal and Carlos Garaicoa have chosen to represent an alternative version of history that has been abandoned.
 - How does a history of place affect our experience of the present?
 - What is the critical potential of inscribing history to a site in an installation?

7. Take the students for a neighborhood walk. Assign them the task of creating a mixed-medium, site-specific public art installation that must represent a narrative past. Have students reflect on the history of the chosen site and use official or personal histories to mark the site as specific.

HOMEWORK:

Students will continue their assignment by sketching and writing a summary of the site-specific narrative they want to represent.

EXTENDING THE LESSON IN ART:

For relevant artworks on how history is represented in place see Repo-History and Nils Norman. For examples of site specificity, investigate the controversy of the relocation of Richard Serra's *Tilted Arc* in New York City, 1981.

ASSESSMENT:

Assess students' ability to participate and analyze presented artworks.

Evaluate student projects and methods used to convey history, memory, and narrative.

ADDITIONAL RESOURCES:

Visit http://www.tourismpenang.gov.my/ for additional information on Penang

Refer to the New Museum Global Classroom website (http://www.gclass.org/da/sigal) for additional resources on Lisa Sigal's artwork.

Materials and images of Carlos Garaicoa's "Overlapping" series can be found at http://liverpoolbiennial.adatabase.org/index.php/objectui/type,vra.vrawork/id,17952 and http://www.smartprojectspace.net/artists/1651.xml.

For information on Anthony Walker refer to: "Youth Guilty of Racist Axe Murder," BBC News, November 30, 2005, available at http://news.bbc.co.uk/2/hi/uk_news/england/merseyside/4477156.stm (accessed February 22, 2010).

Class and Unequal Development: Rights versus Privileges

OBJECTIVES:

- Students will learn about the economic imbalance within the development of spaces and will apply this knowledge to debate possible solutions to public housing.

- Students will be exposed to participation-based art projects as these relate to urban revitalization.

- Students will understand how documentary projects affect our perception of social and political conditions and its relevance to the understanding of contemporary life.

TIME: One session

MATERIALS: Paper and pencils

ARTIST RESOURCES:

Center for Land Use Interpretation: *Up River: Points of Interest on the Hudson from Battery to Troy* (2007) (p. 247)

Taryn Simon: "An American Index of the Hidden and Unfamiliar" (2007)

SUGGESTED PROCEDURE:

1. Have students discuss the equality of neighborhoods. List social services and structures necessary for a functional neighborhood: schools, post office, banks, private businesses, local transportation, and cultural institutions. Do all neighborhoods have these services and structures in place? Why and why not? Make a list of conditions and factors that can affect the development, vitality, and living standards of a neighborhood.

2. Focus on tent cities and how economic conditions affect a city, state, or nation. Tent cities exist in Washington, Nevada, and Georgia, as well as Sacramento, where the fastest growing tent city in America is located as a result of the high rates of home foreclosures following the twenty-first-century economic crisis. Discuss how consensus and agreement create a sense of community. Relate this to tent city residents and how they define community values, rules of conduct, security, and communal property. Discuss federal responses to the housing crisis and if the state should furnish tent cities with infrastructure (i.e. access to water, sanitation, and security). Contextualize this possibility by defining the term **ghettoization** and ask if this would solve the problem of massive

homelessness, or if it would turn the temporary solution of tent cities into permanent ghettos.

3. Continue the discussion and debate by comparing different responses to the housing crisis, such as Florida's Take Back the Land program initiated by homeless advocate Max Rameau, who assisted homeless families in moving into and squatting foreclosed homes; and Cleveland's attempt to have the city buy foreclosed homes as extensions of public housing. Differentiate between rights and privileges.

 * Should housing be a privilege or a right?
 * How does homelessness affect personal and civil rights?
 * Do property rights impinge on our human rights?

4. How do spaces get neglected? Define and contrast the terms **redevelopment** and **urban renewal**. Present Taryn Simon's *Eminent Domain for Urban Revitalization, La Rosa Residence, Long Branch, NJ*. Have students describe what they see in the photograph. Describe the woman's facial expression and the type of house represented.

 * What kind of mood is created by the lighting?
 * What emotion is created by the woman's partial appearance in the house?
 * What associations do students have of looking into a house through a window? Are we looking in or is she looking out?

5. Define **eminent domain** and introduce the significant US Supreme Court case of *Kelo v. City of New London* (2005) where private property was seized by the government for economic yet private development. Eminent domain has historically been applied to building infrastructure, which was justified in serving the greater public by expanding and developing public needs. In the 2005 court decision, government shifted its service from public interest to private developers.

 * What should the role of government be in urban and rural development? What are the major implications of eminent domain on private ownership? What are the major implications on property rights with eminent domain?
 * Relate the above responses to interpret Simon's intention in documenting La Rosa residents. Why do you think Simon decided to place the viewer in a position of looking similar to that of an outsider or spy? Have the students explain what the artist's position is on the role that the government is playing in respect to private home ownership.

6. Contrast the former work with a presentation of Center for Land Use Interpretation (CLUI) photographs that show man-made sites of industry. CLUI has been documenting distant and unfamiliar spaces to generate both interest and understanding for how land is utilized. Refer to CLUI's *Up River: Points of Interest on the Hudson from the Battery to Troy* and show documentation of the General Motors factory at North Tarrytown and Wanton Island as a real

palimpsest of the built environment. Have students describe the landscape and respond to the effects of man-made sites. Read and share descriptions of their history.

- What is the difference between each site and its surrounding area?
- Are these sites generally known places? What do you think CLUI's intentions are for creating documents of man-made sites on the Hudson River?

7. Define **objectivity** in documentary artworks and have students consider its difference to symbolic and fictional forms of representation. Provide examples in art history by showing earlier models of documentary works by photographers Dorothea Lange, Walker Evans, and Richard Avedon. Students will create a photo documentary project of an issue relevant to their everyday lives, such as their relatives' working conditions, housing, environmental/ neighborhood changes, or social group subcultures. Students will produce a series of five photographs that relate to their chosen issue.

HOMEWORK:

Students will collect images and story clippings that relate to the issue of public space. Students will list four or five examples of the social life of a neighborhood or street by writing short, descriptive paragraphs and taking a photograph of each example.

EXTENDING THE LESSON IN SOCIAL STUDIES:

Study how the national economy affects housing and make historical connections to tent cities of the Great Depression. Present Jacob Riis's social reform photography with inner city slums and housing conditions.

ASSESSMENT:

- Assess students' ability to participate and analyze presented artworks.
- Evaluate students' documentary projects.
- Discuss the difference between advocacy and objectivity and assess students' ability to work and question these two positions.

ADDITIONAL RESOURCES:

Visit http://www.heidelberg.org for an example of neighborhood initiatives for urban renewal and art intervention.

For more information on Take Back the Land program, visit http://www.takebacktheland.org/index. cfm

Refer to http://www.oyez.org/cases/2000-2009/2004/2004_04_108 for more information on US Supreme Court case of *Kelo v. City of New London.*

For images from Taryn Simon's "An American Index of the Hidden and Unfamiliar" (2007), visit
the artist's website, www.tarynsimon.com

Information on tent cities can be found at: http://tentcity.wikidot.com/

For more information on Center for Land Use Interpretation please visit www.clui.org

Jacob Riis's photographs can be accessed at http://xroads.virginia.edu/~ma01/Davis/photography/
Images/riisphotos/slideshow1.html

Pounding the Pavement:
Sightings of Public Art and Interventions

OBJECTIVES:

- Through discussions on contemporary art and spatial issues, students will understand the critical difference between public and private space and how it affects general laws and rights.

- Students will evaluate class discussions and write a persuasive essay on the central debate about public space: is it a place free from politics or is it the very sphere of politics?

TIME: One session

ARTIST RESOURCES:

Sharon Hayes: *Everything Else Has Failed! Don't You Think It's Time for Love?* (2007)
Rikrit Tiravanija: *untitled (less oil more courage)* (2007) (p. 295)

SUGGESTED PROCEDURE:

1. Focus students' attention on the most openly public space—the street. This public property is open to all citizens, without discrimination, for general and common needs. Ask students to interpret what they regard as general and common needs. Describe the social life of the street and the types of activities, exchanges, and business occurring on the street. Define **public space** and list existing public spaces.

2. Read the following quote by Rosalind Deutsche:

 > How we define public space is intimately connected with ideas about what it means to be human, the nature of society, and the kind of political community we want. While there are sharp divisions over these ideas, on one point nearly everyone agrees: supporting things that are public promotes the survival and extensions of democratic culture.[2]

3. Based on Deutsche's comment and the availability (or lack of) public spaces, have students interpret the nature of our society.
 - What are some major consequences when a space is universally open to all?
 - What could be positive and negative qualities of this openness?
 - Discuss who would be included and excluded within the public space.

4. What are the available methods of disseminating information or the different forms of exercising free speech? Define **speaker's corner** and discuss the relationship between public space and democracy. Democratic power comes from the people and makes their collective presence known and visible in public space. Public space, synonymous with "the people," is the very space of democracy. Human rights movements have always staked their claim in public space, from the Civil Rights Movement, to gay and lesbian rights, to housing rights of the poor.

5. Present and analyze Sharon Hayes's *Everything Else Has Failed! Don't You Think It's Time for Love?* Have students respond to the private format of a love letter and the public nature of the artist's use of public speaking as a form of address.

 • Describe the context of the performance. What time of day and section of city does the performance take place? Who is the intended audience of this work?

 • How can love inform political conditions?

6. Sharon Hayes has written a fictionalized account of two lovers who were affected by the United States' occupation of Iraq. Discuss the effect of juxtaposing love and political engagement. Read an excerpt from the transcript:

 > Do you remember how you made me stop at 14th Street so you could fix your sign. You wanted to add a slogan to the back … You said you wanted to be more clear. "If everyone acted like us" it said on the front and you turned it over and wrote "there would be power in the streets." My sign said: "Together we can change the world" … which you told me was simplistic and cheesy but by the end of the day you were shouting it out at the top of your lungs as if it was the most important thing in the world to say.[3]

 • What is the narrative between the two lovers and what caused their separation?

 • Define "public art" and the inherent contradiction between the public and the private production of art. How does Hayes use this contradiction to affect the reading of the work?

 • Reread the slogans in the excerpt and have students interpret what "power in the streets" means. Do students participate in demonstrations? Why or why not?

7. Present and analyze Rikrit Tiravanija's *untitled (less oil more courage)*. Based on the location of the sign, have students determine the targeted audience for the message. Consider how this message differs from advertising and have students interpret the statement and its political significance. Tell students that the work was conceived after the artist received an invitation to Peter Cain's exhibition at Matthew Marks, a gallery in New York City. The invitation was a reproduction of Cain's notebook, containing a text that read: "More courage less oil." Tiravanija kept the invitation in his studio for years. Read the artist's statement regarding the work:

Taken in context, that message was clearly a note to himself about the dilemma of being a painter and the moral choices one faces in executing a painting … Today, in the present context, we face a different dilemma altogether. The question of courage and the thoughts facing our present condition come ironically from the turn of Peter Cain's inspired message.[4]

- What political issue is the artist responding to?
- Have students interpret the statement and its political significance. How does this message differ from advertising?
- Based on Tiravanija's anecdote, how do students interpret Tiravanija's position on the artist's role and his responsibility regarding political issues?

8. Debate whether political activities impinge on the general and common function of public space. Elaborate on the importance of this debate by asking the central question of public space and whether it is a universal place free from politics or if it is the very sphere of politics. If politics does not belong on the street, what available means do the public have in expressing their political views?

9. Have students consider the similarity in content and method between the works of Sharon Hayes and Rikrit Tiravanija. Both of these artists are occupying/hijacking public space to exercise democratic expression. Students will observe ways that messages are circulated in public space and will create an intervention such as public speaking, installing banners, or picketing in a public space that nurtures a democratic social life. This assignment can be executed through graphic design, performance, or installation.

HOMEWORK:

Observe and document areas in public that show signs of authority to deter loitering.

EXTENDING THE LESSON IN EUROPEAN HISTORY:

Present available public spaces in ancient Rome with the Nolli Maps by Piranesi.

ASSESSMENT:

Assess students' ability to participate and analyze presented artworks.

ADDITIONAL RESOURCES:

For more information on Sharon Hayes's *Everything Else Has Failed! Don't You Think It's Time for Love?* visit www.shaze.info/

LESSON 5

Leisure versus Loiter and
How the Citizen became a Customer

OBJECTIVES:

- Students will understand the type of "public" acceptable in public space.
- Students will critically analyze how naming produces class distinctions by normalizing some behavior while criminalizing others, especially in the constructed difference between leisure and loiter.
- Students will be exposed to artworks that use social relationships to create an exchange.

TIME: One session

MATERIALS: Paper and pencils

ARTIST RESOURCES:

Dave McKenzie: *I'll Be There* (2007–) (p. 274)
Pedro Reyes: *New Group Therapies* (2004)

SUGGESTED PROCEDURE:

1. Define **privatization** and provide examples. Private spaces are open only to a specified few and have particular designations of function, rules/codes of behavior, and access.
 - What are the potential consequences of privatizing spaces?
 - How do shifts from government-protected spaces to private places of business affect who is allowed to use it and how it is used?

 Have students consider the types of public spaces they have access to and those they do not.
 - In what ways are their social needs—as a group—reflected in public spaces?
 - What types of spaces and kinds of functions would they like represented in the public sphere?

2. Define **loitering** and present the historical case of *City of Chicago* v. *Morales* (1999). Anti-loitering laws illegalized persons from lingering in public spaces with no clear business or purpose. According to this law, people needed to have a justifiable purpose for being in public.
 - Who would be affected most by this law?
 - What are some major implications of this law and how would it affect public use, function, and access to the street?

321

3. Discuss how behavior is related to social space by considering unwritten, yet understood, codes of appropriate behavior.

 • Is space designed by how the public wants to use it or is it public space and the rules associated with it that socialize our behaviors and desires? What would the latter imply?

 • What is the difference between being a citizen and a customer?

4. Read the quote by Lance Freeman, Associate Professor of Urban Planning, Columbia University:

 > You have on the one hand the more romantic view of public space as a place where people can come together unfettered unrestrained, compared with the view of public space as a place of ordered, controlled recreation. Gentrification is typically associated with the latter, as a place where space is controlled and privatized, with less opportunity for random interaction.[5]

5. Define **gentrification** and have the students interpret what "controlled recreation" means. Return to the difference between citizen and customer and ask:

 • If social interactions are forms of controlled recreation and they occur in predetermined designated areas, how does it affect personal expression and individual desire?

 • Are the needs of a citizen similar to those of a customer?

6. Present Dave McKenzie's *I'll Be There*. Show students items of the project documentation and begin by asking what calendars and date books are used for.

 • How do we usually meet new people? What kinds of uncertainties and expectations are present with this planned, yet random, encounter? What does it mean that the artist wants to meet his audience?

 • What are the limitations of having this experience in a museum? How does meeting outside the exhibition space change the meeting/encounter with the artist?

 • What does it mean to experience art outside the context of a museum?

7. Dave McKenzie has often described his work as a tool for meeting new people. Define **relational aesthetics** and have students respond to the merging of art and life.

 • Does having an encounter as a form of art change our conventional perception of art? Why or why not?

 • Is there a critical potential in using social engagements, such as a party, as a form of art?

8. Have the students consider if there are spaces that exist with no function or any functions and activities for which there is no space. Present Pedro Reyes's *New Group Therapies*. What can you tell from these documentations of Pedro Reyes's project?

 • Based on the materials used, is the space permanent or temporary?

 • What type of space is created and who is it intended for?

- What associations do students have with the title *New Group Therapies*?

9. Read Pedro Reyes's interview by Tatiana Cuevas and introduce project background. Reyes constructed guitar sculptures and provided a karaoke-like setting for music enthusiasts in a market in Tlatelolco, Mexico City. For *New Group Therapies*, volunteering participants were able to perform chosen songs, culminating in the destruction of the guitar sculptures.

 - Why do you think Reyes has chosen to produce this space of controlled violence?
 - What does it mean to create new forms of ritual?
 - The division between public and private relegates some acts and expressions in the private realm. What are some consequences of this division? What potential conflicts may arise from performing private acts, like singing, in public space?

10. Pedro Reyes has activated spaces with an alternative form of engagement whether through a ritual of an action or through a specific form of encounter. Students will create a relational artwork—a **situation** that supports an activity or form of exchange, fostering a social interaction. Students may want to begin by creating a form of social intervention within that context and host/manage an interaction.

EXTENDING THE LESSON IN ART HISTORY:

Teach and introduce the concept of the dematerialization of art in 1970s Conceptual art.

ASSESSMENT:

Evaluate students' ability to understand relational forms of art and their ability to construct a social interaction.

ADDITIONAL RESOURCES:

For more information on *City of Chicago* v. *Morales* refer to http://www.firstamendmentcenter.org/faclibrary/casesummary.aspx?case=Chicago_v_Morales

For interview between Pedro Reyes by Tatiana Cuevas, visit *Bomb Magazine*'s website: http://www.bombsite.com/issues/94/articles/2779

Refer to http://plato.stanford.edu/entries/conceptual-art/ for more information on Conceptual art.

Hey You, There! Space Invaders, the Invisible Enemy

OBJECTIVES:

- Students will understand how identity determines how we are perceived in a place and how it affects how people circulate and navigate spaces.
- Students will understand how politics of inclusion and exclusion affect political issues on a national and international level.
- Students will interpret and evaluate the implications of the USA PATRIOT Act of 2001 and formulate an intelligent opinion on its effects on American civil liberties.

TIME: One session

MATERIALS: Paper and pencils

ARTIST RESOURCES:

Andrea Bowers: *Nonviolent Civil Disobedience Drawing (Elvira Arellano in Sanctuary at Adalberto Methodist Church in Chicago as Protest against Deportation, 2007)* (2007) (p. 243)
Hasan Elahi: *Tracking Transience* (2002–)

SUGGESTED PROCEDURE:

1. What are connotations of access? Is access just a matter of entering a space, a sense of belonging, or representation? The depiction of the outsider or "other" as a threatening presence, like aliens from outer space, has always been a method of uniting different groups to gather in the face of a shared enemy. The notion of "us" is negatively defined against the idea of a "them." Throughout history this excluded "other" has taken on different identities.
 - How does naming affect our perceptions of a group: for example, calling or categorizing a group of people as illegal, aliens, or terrorist?
2. Have students describe qualities of spaces that help produce the feeling of belonging. How would fear affect an individual's experience of place? Define **antagonism** and name visible signs of authority in a space, rendering it inaccessible and antagonistic. Introduce Hasan Elahi and present his project *Tracking Transience*.
 - What do you notice about this collection of images?
 - What do we usually associate with the use of aerial view photography? Who uses these tracking devices and who is being tracked?

- Discuss the function of surveillance and its relationship to the meaning of the title. Why might the artist have chosen to title it as such?

3. Read Elahi's quote: "I am intrigued by the way humans interact with [databases and other electronic forms of] information, and prefer to investigate the acceptance of technology rather than technology itself."[6]

 - Describe the airport spaces that Elahi documents. How are airports and spaces of transit different from other social spaces?

 - Transience is an impermanent or temporary moment in time. Why do you suppose the artist has chosen this in-between moment or passing of time as something worthy of documentation?

4. Discuss police profiling and whom it affects. Since September 11, 2001 many Arab and Muslim travelers have experienced what is called **airport profiling** in which individuals have testified to excessive security scrutiny: for men to remove their turbans, for women to remove their headscarves, and others altogether ejected from their flight.

 - How does the context of airport security post September 11 affect the reading of Elahi's work?

 - What are surveillance cameras used for? Interpret Elahi's quote and discuss his form of "acceptance" to surveillance technology. Why is Elahi creating a form of self-surveillance and how does his form of surveillance differ?

 - What are the stakes, if any, in producing his own form of self-surveillance?

5. Elaborate on the conditions of access seen in Andrea Bowers's *Nonviolent Civil Disobedience Drawing (Elvira Arellano in Sanctuary at Adalberto Methodist Church in Chicago as Protest against Deportation, 2007)*. Ask students what national issue is being addressed. Have students describe how the drawing is rendered.

 - Why did the artist choose to draw realistically?

 - What can students infer from the woman represented in the work? Who is she?

 - Based on the conversation of inclusion and exclusion, have students interpret the question "Who would Jesus deport?" posed by the artist.

 - How do students interpret the artist's choice of comparing the law of man and the law of God?

6. Have students discuss common perceptions of immigrants and terrorists. Discuss the USA PATRIOT Act, which was passed by President George W. Bush on October 26, a month after the tragedy of September 11, 2001. The Act, officially titled "Uniting and Strengthening America by Providing Appropriate Tools Required to Intercept and Obstruct Terrorism Act of 2001," was scheduled to expire four years after it passed, but was re-signed into law in 2006. The PATRIOT Act gave the government the right to search personal records, regulate

financial transactions of private individuals, and extended its rights to detain (at times indefinitely) and deport immigrants suspected of terrorism.

- Focus on the full title of the Act and ask how this relates to previous conversations of the notion of "us" and "them."
- How does the Act affect civil rights against illegal search and seizure and a right to privacy?
- How does this impinge on democratic values?

7. Students will write an expository paper defining the type of general public allowed in public space. Students will consider and include specific examples of how identity, sex, and class affect an individual's experience and access to social spaces. Students must research and relate this question to a national or international case, issue, or event.

HOMEWORK:

Students will create an image and text poster that illustrates ideas expressed in their paper.

ASSESSMENT:

Evaluate students' ability to participate in discussions and how they understand the complex issue of "otherness" in their paper.

ADDITIONAL RESOURCES:

The USA PATRIOT Act can be found at: http://frwebgate.access.gpo.gov/cgi-bin/getdoc. cgi?dbname=107_cong_public_laws&docid=f:publ056.107.pdf

Getting to Know You: Publicity of Private Narratives

OBJECTIVE:

- Students will discuss how private narratives of subjectivity become political positions.

TIME: One session

MATERIALS: Computer and Internet access

ARTIST RESOURCES:

Ginger Brooks Takahashi: *Julius Bootleg Print* (2007)
Susan Hefuna: *Vitrines of Afaf* (2008) (Figure 4)

SUGGESTED PROCEDURE:

1. Have students discuss where they spend time and what spaces are available/accessible to their age group. Define **dominant culture** and **dominant space**. How do these "dominants" affect marginal groups and their access for representation in social space? For example, skateboarding parks are a relatively new feature in the public space and their mere inclusion serves as a validation of the activity. What other examples of new types of social spaces exist?

2. Discuss how social groups mark their own spaces to create a sense of community and belonging. Read and interpret Henri Lefebvre's quote: "'Change life!' 'Change Society!' These precepts mean nothing without the production of an appropriate space. A lesson to be learned from the Soviet constructivists of 1920–30, and from their failure, is that new social relationships call for a new space, and vice versa."[7]

3. Discuss marginality and possible methods an individual might employ to gain new ground or visibility in dominant culture and space.

4. Present Ginger Brooks Takahashi's *Julius Bootleg Print*. Have students describe the scene depicted in the image. Describe the social space and what the male figures are doing in the print. Describe the group's relative comfort in the space and with each other.

 - Nudity is restricted in public space. What does it mean for these men to transgress this restriction together?

 - What does it mean to perform private acts in public spaces?

 - Have students respond to the outside observer looking into the space; what does his presence signify?

5. Present Susan Hefuna's *Vitrines of Afaf*. Have students describe the display and the items displayed in it. Afaf refers to the name given to women whose names are kept unknown in public, in a manner that suggests protecting them in the traditional Egyptian culture.[8] Contextualized, the display resembles a vitrine used by street vendors.

 * How does Hefuna's role differ from that of other vendors and the items that she is displaying?
 * How might the public perceive her presence?
 * What is her role in presenting unnamed women?

6. Reflect how artists invest private narratives into public space and relate to Lefebvre's position regarding the creation of new spaces to represent social relationships. Have students create a blog or Internet page that can give visibility to identity.

EXTENDING THE LESSON IN NEW MEDIA:

Present blogs that are representative of the assignment given.

ASSESSMENT:

Assess students' ability to participate and analyze presented artworks.

Evaluate students' blogs and their ability to use the personal as the political.

ADDITIONAL RESOURCES:

For images of Ginger Brooks Takahashi's *Julius Bootleg Print* (2007) refer to the Global Classroom website: www.gclass.org

Dominant Spaces and their Symbolic Destruction

OBJECTIVE:

- Students will deconstruct an image in order to understand value and icon constructions.

TIME: One session

MATERIALS: Paper and pencils

ARTIST RESOURCES:

Huang Yong Ping: *Pentagon* (2007) (p. 262) and *Colosseum* (2007) (Figure 53)
Julie Mehretu: *Black City* (2007) (p. 275)

SUGGESTED PROCEDURE:

1. Motivate students to think about representations of destruction by showing them clips from Hollywood cinema, pop media, and current and natural events (show the movie clip of the explosion in *Zabrieski Point*). What is the fascination with and the emotional effect of images of destruction? Define **catharsis**.

2. Read the statement by Boris Groys, Global Distinguished Professor of Russian and Slavic Studies at New York University, on destruction:

 > This city of eternal ephemerality has frequently been depicted in literature and staged in the cinema: this is the city we know, for instance from *Blade Runner* or *Terminator I* and *II*, where permission is constantly being given for everything to be blown up or razed to the ground, simply because people are tirelessly engaged in the endeavor to clear a space for what is expected to happen next, for future developments.[9]

 Have students summarize Groys's statement by relating the "city of eternal ephemerality" to their own experiences.

3. Present Julie Merethu's *Black City* and have students name recognizable elements in the painting. Inform the students of the scale of the painting.
 - How are the lines and textures arranged to create movement and action? Describe this movement.

4. Present two of Huang Yong Ping's works, *Pentagon* and *Colosseum*. Have students describe the two buildings and the artist's alteration of the buildings.

- Describe the material and list items usually made from this material. What scale are these items usually produced in?
- How do the material, color, and scale of the buildings, in relation to the room, affect our perception of the object?

5. Define **icon** and **iconoclasm**. Read the following quote by Boris Groys: "Iconoclasm can thus be said to function as a mechanism of historical innovation, as a means of revaluing values, through a process of constantly destroying old values and introducing new ones in their place."[10]

- How does this relate to the definitions of icon and iconoclasm?
- How has the artist chosen to "break" these images? Why has he chosen to turn the buildings into planters and what does it signify?

6. Have students make a list of icons from which they will choose one to "break" according to iconoclasm. Students will interpret Groys's quote and critically analyze their selected icon and its values by critiquing the imagery and the values they represent.

ASSESSMENT:

Based on their "image-breaking," did students articulate an understanding of the icon and its values?

ADDITIONAL RESOURCES:

A movie clip of the explosion in *Zabrieski Point* can be found at: http://www.youtube.com/watch?v=bJsW6ta4X8o&feature=related

Other Topias of Possibility:
Designing Desire for the Future Part 1

OBJECTIVE:

- Students will be presented with contemporary art and architecture and will understand how alternative social values can be used in projections of future designs.

TIME: One session

MATERIALS: Paper and pencils

ARTIST RESOURCES:

Pedro Reyes: *Parque Vertical* (2002)

Haegue Yang: *Dehors* (2006)

SUGGESTED PROCEDURES:

1. Present major issues of climate change (such as the rise in global population) and its potential effects on designs of future spaces, life, and living. It is predicted that by 2050, world population in cities will grow to ten billion. By 2015, India's slum population will reach ten million while Africa will grow to 332 million (a sum which will double every fifteen years thereafter).[11]
 - How will growing populations affect resources, environment, and health?
2. Present Haegue Yang's *Dehors*. Look at the cityscape and have students describe what they can tell about the scale of the city. Have students describe the project—its transparencies and blacked-out areas. Contrast the sprawl of low-density housing to the high-rise buildings being built. Read about Yang's practice and ask students:
 - Where are these images from, and what do they think they represent?
 - What are some potential major consequences of a newly built skyscraper?
 Consider them being "advertisements," announcing the near future of the city. Interpret the visibility of logos and articles seen through the skyscraper advertisings. Have students imagine what the erased slogans or headlines might say.
 - How would developers try to present this change?
 - What would this type of change claim to improve?
 - Do students agree or disagree with these "improvements"? Why or why not?

3. Define **urbanism** and relate it to what students envision for possible future architecture. Present and analyze Pedro Reyes's and Jorge Covarrubias's proposal *Parque Vertical*. Have students describe what information they can gather from the architectural model. Name recognizable features in the interior of the building.

 • What associations do students have with the scale used to represent the tower? Have students respond to why Reyes has chosen the model scale of a dollhouse and simplified building blocks to represent the interior.

 • What are models used for and how is this model different from other architectural models?

4. Read the following quote by Pedro Reyes in an interview with Tatiana Cuevas for *Bomb Magazine*:

 > The idea of utopian architecture alludes to a place that does not exist, or perhaps whose existence is just temporary. I think we need other topias in our bag of references—we need more topias to play with. We should talk about psychotopia, a mental place; neotopia, a new place; prototopia, almost a place; ecotopia, a sustainable place; hypnotopia, the place of our dreams; teotopia, a sacred place; infratopia, less than a place; and so on.[12]

 • Based on Reyes's quote, have students interpret the type of topia being proposed.

 • What utopian values are expressed in the proposal?

5. Refer to the "Investigating Neighborhood" lesson on the G:Class website (www.gclass.org) and read the historical background of Tlatelolco, Mexico. Present the specific context of "Icon Tower" and its proposed reconstruction as a "green skyscraper." Discuss how residents can affect, respond to, or demand changes in their neighborhood, city, or state.

 • What recourse do residents have to respond to these changes or to demand them? Discuss Reyes's strategies for creating awareness, interest, and desire for this project.

 • How does Reyes create expectation and desire among residents? What are the kinds of resistance to this type of proposal?

 • Imagine the project in practice. What are some potential gains and possible conflicts?

 • What utopian values are represented in this proposal? How does this project foster community? How would it change or redress everyday life and needs?

6. Present the notion of **unitary urbanism** to the students and have them articulate their initial responses to this idea. What are the ways in which we see the social functions being integrated in daily life? What previous works already discussed in class would be a great example of unitary urbanism? What could be the disadvantages of merging art and life? Does anyone in class disagree with the proposal for unitary urbanism? Have students explain their critique.

7. Assign students to create a painting of an image that represents an aforementioned topia. Make connections to art history and present Surrealist compositions by Giorgio de Chirico and René Magritte. Brainstorm with the students and have them use the following guidelines to enhance their painting composition.

 - Have students begin with a site (if students completed Lesson 1, encourage them to develop this work further). The notion of place will be created through an ordering or combination of different types of spaces.
 - Students will manipulate and distort scale.
 - Students will use architectural features in the composition and compose an area of the composition using pattern or texture.
 - Include a still life of two to three objects in the composition.

ASSESSMENT:

Evaluate student participation in discussions and their ability to use new vocabulary introduced in class.

Evaluate students' public proposal against larger social issues discussed in class.

ADDITIONAL RESOURCES:

Complete documentation of Haegue Yang's *Dehors* (2006) can be found at the artist's website: http://www.heikejung.de/dehors.html

For more information on Surrealism refer to the Heilbrunn Timeline of Art History: http://www.metmuseum.org/toah/hd/surr/hd_surr.htm

More information on "Icon Tower" can be found at http://bombsite.com/issues/94/articles/2779

Other Topias of Possibility:
Designing Desire for the Future Part 2

OBJECTIVE:

- Students will be presented with Thomas More's concept of utopia and artworks that reflect on the utopian desire.

TIME: One session

MATERIALS: Paper and pencils

ARTIST RESOURCES:

Edgar Arceneaux: Watts House Project (1996–) (Figure 13)
SUPERFLEX: *FREE SHOP* (2003–) (Figure 119)

SUGGESTED PROCEDURES:

1. Define Thomas More's concept of **utopia** and discuss contemporary society in relation to the concept. What are some social ills that students would redress in a utopian version of society? Brainstorm with the class and as a group, define and articulate an ideal form of society. Discuss the paradox of utopia in practice; how, for example, would such a society's relationship to authority enforce perfect harmony?

2. Provide an example of utopian society literature and read an excerpt from B.F. Skinner's *Walden Two*. The character Frazier, a founding member of the utopia Walden Two, explains how they have dispensed with the monetary system and implemented the four-hour workday:

 > Labor credits are a sort of money. But they're not coins or bills—just entries in a ledger. All goods and services are free, as you saw in the dining room this evening. Each of us pays for what he uses with twelve hundred labor credits each year—say four credits each workday … A credit system also makes it possible to evaluate a job in terms of the willingness of the members to undertake it. After all, a man isn't doing more or less than his share because of the time he puts in, it's what he's doing that counts. So we simply assign different credit values to different kinds of work, and adjust them from time to time on the basis of demand.[13]

3. Have students discuss their parents' occupations and the time it takes to earn a living (include education, training, and length of their workday). Discuss the outcomes and results of the labor credit system described in Skinner's utopia.

 * Compare and contrast our economic conditions to the form of social production described in *Walden Two*.

 * How are the problems of our monetary and work system addressed in *Walden Two*? What are some social values that are in practice in Skinner's utopia? What are the advantages and disadvantages of our labor system?

 * How would the labor credit system affect class distinctions—or the general quality of life and culture?

4. Present SUPERFLEX's *FREE SHOP*. Show FAMILY MART, Roppongi Hills, Tokyo 2003 and SELIN IZMIR FEINKOST, Bremen, Germany 2003. Read the following description of the project:

 > *FREE SHOP* takes place in an ordinary shop. Anything purchased in the shop by any given customer when *FREE SHOP* is performed is free of charge. There are no signs or other means of information communicating that merchandise, goods, services, etc. in the shop are free of charge. A customer in the shop may not realize that merchandise, goods and/or services have been purchased for free until the counter clerk gives the customer the bill for the purchase, stating the amount of 0.[14]

5. Review the term **relational aesthetics** and how this relates to the project. Have students describe the types of stores this occurs in and what the general response of the customers is when they learn that the items are free.

 * How is *FREE SHOP* different from the marketing strategy of the giveaway? How would students respond to this chance possibility of receiving free goods?

 * Why do students think the artists have chosen to reveal that the goods were free only in the end? Is it significant that the cashier follows through with a normal exchange of itemizing the goods and passing a receipt?

 * Compare and contrast *FREE SHOP* in Tokyo and in Bremen. How did customers respond to the free goods? What evidence can students gather from the images of how customers took advantage of the situation?

6. Edgar Arceneaux's Watts House Project (WHP) is a collaborative artwork in the shape of a neighborhood redevelopment. Present imagery of Simon Rodia's Watts Towers landmark. Read WHP's mission statement and discuss how Watts Towers or a landmark can affect the visibility of an area:

 > Located on 107th Street and centered around the historic Watts Towers, the
 > Watts House Project is an ongoing, collaborative artwork in the shape of an urban

redevelopment initiative. WHP expands and enhances community through exhibition spaces, artist in residence programs, educational and social programming and residential housing. Generating a physical and social infrastructure for creativity, WHP catalyzes artistic production and community pride of place, establishing partnerships that can lead to real solutions, hope, and change.[15]

7. Present Edgar Arceneaux's *Simon Rodia's Red Car* (2008). Have students describe the image and inform students that it is an edition print to raise money for the Watts House Project. Ask students:

 - How is art being used in relation to the larger community?
 - What is the similarity between Watts Towers and the role of art proposed by Arceneaux?

 Define **cultural capital** and ask students what the critical potential of art is in reshaping social and economic values.

8. Define the term **intentional communities**. Research and provide examples such as Twin Oaks or Drop City. Students will consider possible and impossible utopias and design an intentional community.

EXTENDING THE LESSON IN SOCIAL STUDIES:
Make connections to the history of Native American land rights, such as the case of Alcatraz Island and the shift of property rights with changes in eminent domain reform.

EXTENDING THE LESSON IN LITERATURE:
Read excerpts from Thomas More's *Utopia*.

EXTENDING THE LESSON IN CONTEMPORARY ART:
View and discuss works of the following artists' works related to the theme of public space and activism: Nils Norman, Krzystof Wodizcko, and Vito Acconci.

ASSESSMENT:
Evaluate students' participation in discussions and their ability to use new vocabulary introduced in class.
Evaluate students' public proposal against larger social issues discussed in class.

ADDITIONAL RESOURCES:
Refer to the SUPERFLEX website for project documentation at http://www.superflex.net/projects/freeshop/index.shtml

Please refer to the New Museum's Global Classroom website for a lesson on "After Nature: Dystopia and Detournement": http://gclass.org/lessons/plans/after-nature-dystopia-and-detournement

Refer to http://www.wattshouseproject.org/ for more information and images of the Watts House Project, as well as to research redevelopment initiative and provide context to students.

CHAPTER 1 NOTES

1 Zhanna Veyts, "Recontextualizing Public Space," *NYArts Magazine*, July/August 2004, http://www.nyartsmagazine.com/index.php?option=com_content&view=article&catid=50:julyaugust-2004&id=2012:recontextualizing-public-space-by-zhanna-veyts (accessed February 22, 2010).

2 Rosalind Deutsche, *Evictions: Art and Spatial Politics* (Cambridge: MIT Press, 1996), 269.

3 Sharon Hayes, excerpt from the transcript "Everything Else Has Failed! Don't You Think It's Time for Love?" 2007.

4 Rirkrit Tiravanija, "More Courage Less Oil," Kunsthalle Fridericianum, 2009, available at http://www.fridericianum-kassel.de/index.php?id=128&L=1 (accessed February 22, 2010).

5 Lance Freeman, quoted in Sewell Chan, "Is Gentrification Transforming the City's Public Spaces?" City Room Blog, *New York Times*, August 14, 2007, available at http://cityroom.blogs.nytimes.com/2007/08/14/is-gentrification-transforming-the-citys-public-spaces/ (accessed February 22, 2010).

6 Hasan Elahi, "Statement," artist's website, 2009, available at http://elahi.sjsu.edu/ (accessed February 22, 2010).

7 Henri Lefebvre, *The Production of Space* (Oxford: Blackwell, 1991), 59.

8 "Artists Projects: Vitrines of Afaf," Museum as Hub website, available at http://www.museumashub.org/neighborhood/townhouse-gallery/vitrines-of-afaf (accessed March 15, 2010).

9 Boris Groys, *Art Power* (Cambridge, MA: MIT Press, 2008), 109.

10 Ibid., 75.

11 Mike Davies, *Planet of Slums* (New York: Verso, 2006).

12 Pedro Reyes, quoted in Tatiana Cuevas, "Pedro Reyes," *BOMB Magazine*, Issue 94/Winter 2006, available at http://www.bombsite.com/issues/94/articles/2779 (accessed February 22, 2010).

13 B.F. Skinner, *Walden Two* (New York: Macmillan, 1948), 52.

14 SUPERFLEX, "FREE SHOP," artists' collective's website, 2009, available at http://www.superflex.net/projects/freeshop/index.shtml (accessed February 22, 2010).

15 Watts House Project, "About Us," 2010, available at http://wattshouseproject.org/wp/?page_id=2 (accessed February 22, 2010).

CHAPTER 1 BIBLIOGRAPHY

Bourriaud, Nicolas, *Relational Aesthetics* (Dijon: Le presses du réel, 2002).

Cuevas, Tatiana, "Pedro Reyes," *Bomb Magazine*, 94 (Winter 2006), available at http://www.bombsite.com/issues/94/articles/2779 (accessed February 22, 2010).

Davies, Mike, *Planet of Slums* (New York: Verso, 2006).

Deutsche, Rosalind, *Evictions: Art and Spatial Politics* (Cambridge, MA: MIT Press, 1996).

Elahi, Hasan, "Statement," artist's website, 2010, http://elahi.sjsu.edu/ (accessed February 22, 2010).

Freeman, Lance, quoted in Sewell Chan, "Is Gentrification Transforming the City's Public Spaces?" City Room Blog. *New York Times*, August 14, 2007, available at http://cityroom.blogs.nytimes.com/2007/08/14/is-gentrification-transforming-the-citys-public-spaces/ (accessed February 22, 2010).

Groys, Boris, *Art Power* (Cambridge, MA: MIT Press, 2008).

Hayes, Sharon, excerpt from the transcript "Everything Else Has Failed! Don't You Think It's Time for Love?" 2007.

Lefebvre, Henri, *The Production of Space* (Oxford: Blackwell, 1991).

Skinner, B.F., *Walden Two* (New York: Macmillan, 1948).

SUPERFLEX, "FREE SHOP," artists' collective's website, 2009, http://www.superflex.net/projects/freeshop/index.shtml (accessed February 22, 2010).

Tiravanija, Rikrit, "More Courage Less Oil," Kunsthalle Fridericianum, 2009, http://www.fridericianum-kassel.de/index.php?id=128&L=1 (accessed February 22, 2010).

Veyts, Zhanna, "Recontextualizing Public Space," *NYArts Magazine* (July/August 2004), available at http://www.nyartsmagazine.com/index.php?option=com_content&view=article&catid=50:julyaugust-2004&id=2012:recontextualizing-public-space-by-zhanna-veyts (accessed February 22, 2010).

Watts House Project, "About Us," 2010, http://wattshouseproject.org/wp/?page_id=2 (accessed February 22, 2010).

ACTIVISM AND DEMOCRACY (POLITICS)

Joseph Keehn II

SUBJECT AREAS: Art, English, Government, History, Literature, and Social Studies

Democracy is a form of government in which power is held "indirectly" by citizens in a free electoral system. It is through the "indirect" that the ideologies of democracy, a system of "rule by the governed," become blurred and ambiguous, creating exclusivity and the dichotomy us/them. With the activist, power struggles are questioned. Through their dissent, the activist is able to attain and retain freedoms and liberties, making the ideologies of democracy adaptable and amendable to new ways of thinking and governing. Activism is essential to democratic citizenship; without it, democracy would become a static system incapable of looking to the future for change. In this chapter, students will gain a deep understanding of activism and the changing strategies artists and activists have used in bearing witness to the events and issues of their time.

This chapter explores the shifts in political activism and the methods activists have used to display the convictions of their beliefs. How do past movements and events affect future activisms? Finally, students will gain an understanding of their rights as citizens and their relationship to society, government, and the rest of the world. On a larger scope, students will look at prescribing a value to an idea, a cause, or even a person, and the authorities and powers that determine the worth of that value. Prescribing a value to something can become political, and it is within this system of determining value that rights and freedoms are negotiated. The chapter concludes with artists' works that delve into the imaginary spaces of the past and present to elicit questions and speculations of future meanings of democracy, activism, and ultimately, citizenship.

Citizenship: What Does it Mean to be a "Citizen"?

OBJECTIVES:

- Students will look at what it means to be a citizen by examining American citizenship.
- Students will use the Preamble, the US Constitution, and the Bill of Rights to investigate their rights and privileges as citizens in a democracy.
- Students will learn about the activist Malcolm X and the Civil Rights Movement.
- Students will create an artwork in response to the Homeland Security Act.

TIME: Two sessions and art-making time

MATERIALS: Pencil, journal, and art-making supplies determined by students

ARTIST RESOURCES:

Hasan Elahi: *Tracking Transience* (2002–)

Jeff Sonhouse: *The Sacrificial Goat* (2008) (p. 292)

SUGGESTED PROCEDURES:

1. A week before implementing this lesson, have student keep a journal, documenting in writing, photography, audio recording, etc., all of their activities. This should be as detailed as possible (e.g. 6:40 a.m. I brushed my teeth).

2. Share with your students the definition of democracy. Ask them to expand on the definition.

 - What are the essential elements needed in order to constitute a democracy?
 - What are the ambiguities of this form of government? Who enforces this government?
 - What countries have a democratic government?

 Students will define citizenship in a democracy. What role do citizens have in a democracy?

3. Introduce students to Malcolm X and the Civil Rights Movement. Refer to *The Autobiography of Malcolm X* by Malcolm X and Alex Haley.[1] Have students respond to the following quote of Malcolm X:

 > I'm not going to sit at your table and watch you eat, with nothing on my plate, and call myself a diner. Sitting at the table doesn't make you a diner, unless you eat some of what's on that plate. Being here in America doesn't make you an American ... No I'm not an American, I'm one of the 22 million black people who are the victims of Americanism. One of the 22 million black people who are the victims of democracy,

nothing but disguised hypocrisy … I'm speaking as a victim of this American system.
And I see America through the eyes of a victim. I don't see any American dream;
I see an American nightmare.[2]

Ask students:

- What is Malcolm X bringing to our attention?
- "Sitting at the table doesn't make you a diner, unless you eat some of what's on the plate" is a metaphor. What do you think Malcolm X is referencing?
- What is he suggesting about the American democracy, when he states "No I'm not an American. I'm a victim of Americanism … victim of democracy"?
- Who is he suggesting has the power to victimize in a democracy?

4. In groups have students research the different rights and privileges in the United States' democracy. Provide students with the Preamble, the US Constitution, and the Bill of Rights as primary sources for their research. Students will share their findings with the rest of the class. Ask them:

- What rights are all citizens granted? Are there exclusions?
- Have these rights always existed? How have they changed throughout history (i.e. what amendments have been created)?
- Why were these changes made (i.e. inequality, social injustice, racism, sexism)?
- Based on this, is democracy a static form of government or one that is constantly being changed? What role does citizenship have in this system?
- Give students the definition of activism, and ask them what role an activist plays in citizenship. What makes an activist different from a witness? Refer back to Malcolm X and have students discuss activism.

5. Have students describe Jeff Sonhouse's *The Sacrificial Goat*. Ask students:

- How has Sonhouse painted this scene in order to indicate an important US political figure?
- What elements support this being a highly visible moment in US history?
- How has Sonhouse manipulated/obscured the exact identity of the figure? What is Sonhouse suggesting by this artistic choice?

Tell students that this work was inspired by the moment Colin Powell, Secretary of State during George W. Bush's presidency, gave evidence for the argument that the United Nations should wage war against Iraq. Sonhouse has commented on this work in relation to a pawn. A pawn is an instrument or a person used by another for gain or power. Sonhouse says, "The notion of the pawn really only exists because we as viewers are the ones who allow it to exist. We bring it into being… We as viewers make certain determinations and we ascribe certain labels to people and events. So who is really the pawn? Who is really doing the pawning?"[3]

By asking these questions, Sonhouse's work becomes open to variant interpretations. Have students answer Sonhouse's questions:

- "So, who is really the pawn?" Who, specifically and generically, is Sonhouse depicting as a "pawn" in *The Sacrificial Goat*? What does the title suggest about political positions?
- "Who is really doing the pawning?" Who is asserting power? As a citizen, how do you contribute to the game of pawning/power?

6. Have students read about the artist Hasan Elahi. Students will need to read about the Homeland Security Act. Ask:

- What event has shaped Elahi's artistic practice?
- What aspect of Elahi's practice is an ironic response to the FBI's investigations? In relation to the Homeland Security Act?
- How is Elahi engaging in notions of citizenship? What is he bringing to our attention about the fragility of citizens' rights?
- How is Elahi's practice similar to the activism carried out in the Civil Rights Movement? What does this suggest about the rights of citizens in the US today?

7. Using their previous week's worth of daily documentation, students will create an artwork in response to the Homeland Security Act. Students should consider methods that will ensure that their documentation is for their own eyes to see. What materials and techniques can they employ to maintain their privacy? Students should title and present their final work to the class. Students will critique each other's works by answering the following questions for each work:

- Were the materials effective in keeping the documentation private? Explain.
- How does the title contribute to the meaning of the work?

8. Collect critiques and have students discuss the relationship of this project with citizenship, activism, and democracy. Ask:

- What rights and privileges are they asserting with this project?
- How are they "pawning" or asserting their power as citizens?
- How does this reiterate the ability of change in a democracy?
- What methods can an activist use to instigate these changes?

EXTENDING THE LESSON IN LITERATURE AND FILM:

Read Philip K. Dick's *The Minority Report* (1956) and watch Steven Spielberg's *Minority Report* (2002), which was loosely based on the short story. Compare and contrast the two in terms of their questioning the existence of free will. Refer back to the artists in this lesson and discuss their practice in terms of free will.

ASSESSMENT:

Evaluate students' participation and individual artworks. Did students show an understanding of:

- how democracy changes?
- the role of the activist, as a citizen, in a democracy?
- their power as a citizen?

ADDITIONAL RESOURCES:

Homeland Security's website: www.dhs.gov

Malcolm X and Alex Haley, *The Autobiography of Malcolm X* (New York: Ballantine Books, 1992).

Preamble, US Constitution, and Bill of Rights can be accessed at The Charters of Freedom
 website: www.archives.gov/exhibits/charters/

Breaking the Nostalgic Distancing of Past Movements

OBJECTIVES:
- Students will research a movement prior to 1990 of their choosing.
- Students will present their research in an original oration paper that argues for the movement's relevancy in today's democracy.

TIME: Two sessions and presentation time

ARTIST RESOURCES:

Andrea Bowers: *The Weight of Relevance* (2007) (Figure 14)

Emily Jacir: *Material for a film* (2004–07) (Figure 57 and p. 264)

SUGGESTED PROCEDURES:

1. Have students research the AIDS movement and artist Keith Haring. For information on the artist, visit the Keith Haring Foundation at www.haring.com

2. Have students share their findings on Keith Haring and the AIDS movement. Ask them what the **movement** was about.
 - When did this movement take place and which population is largely credited for spreading the disease?
 - In what ways did Keith Haring contribute to the movement's recognition?
 - In what ways did he address the disease in his work?

3. The public's perception of the disease is often narrowly focused to marginalized groups. Discuss the common expression "It's not my problem. It's not your problem. It's their problem." What disposition does this saying express? Ask students to respond to this disposition and juxtapose it with the public's limited scope of understanding the AIDS epidemic.
 - Who marginalizes the public's perception?
 - What causes marginalization to occur?

4. In response to the silencing of those dying from AIDS, the NAMES Project Foundation began the AIDS Memorial Quilt in 1987 as an activist tool to raise awareness of the disease. The quilt acts as a poignant memorial for those who have died from the disease. For more information on the quilt, go to www.aidsquilt.org. Twenty years after the AIDS Memorial Quilt project began, Andrea Bowers created *The Weight of Relevance* (2007). Have students look at the work and ask them:

- Why would an artist create a work that uses an activist tool as a subject?
- What do you think the artist is suggesting about the AIDS epidemic?

5. Have students revisit their research on AIDS and read about Andrea Bowers. Provide students with the definitions of activism and aesthetics and ask:
 - What are the demographic shifts in those being infected with the disease?
 - What do you think is meant by "re-silencing"?
 - How does the relocation of the quilt contribute to the re-silencing of AIDS?
 - Bowers is employing "time" as a device for you to "sit with" the topic of AIDS. How does the format of video as a medium encourage viewers to "sit with" the work? Describe Bowers's aesthetics in this work.
 - How does Bowers's practice relate to activism? How does Bowers bear witness to the re-silencing of AIDS?
 - Discuss the similarities and differences between Keith Haring's and Andrea Bowers's artistic practices in terms of artist as activist.

6. Have students read about Emily Jacir. Students need to synthesize Jacir's practice using the work *Material for a film* as a case study. Ask students:
 - What materials are being collected for this work?
 - What criteria do you think Jacir is using to determine what materials are to be included? How does this inform the meaning of the work?
 - Discuss the similarities and differences between Jacir's and Bowers's practices. What is objective? What is subjective?

7. Students will research an activist movement prior to 1990. They will cite primary and secondary resources in presenting an original oration to the rest of the class. Suggest limiting the oration to ten minutes and use the following template as a guide:

 Introduction: Introduce the movement and why you believe it is still relevant today, particularly in a democracy.

 Body: Provide a history of the movement addressing the urgency for the activists involved.

 Conclusion: Bridge the movement's urgencies with contemporary times. What part(s) of the movement are or still need to be addressed today? Conclude with possible solutions to the urgencies. What is being done already that considers these issues, or what can further be expanded on?

 Have students comment on the subjectivity and objectivity of each presenter. What informs these positions? Where else do we see these positions played out?

EXTENDING THE LESSON IN FILM:

Have students watch *Munich* (2005) directed by Stephen Spielberg. Compare and contrast the film with Jacir's *Material for a film*. What are the subjective and objective elements? What does this tell us about the role of the artist and interpretation? Should there be a limit to this creative license? Why or why not?

ASSESSMENT:

Evaluate students' participation and their presentations. Did students.

- distinguish between subjectivity and objectivity?
- present on a movement prior to 1990 and argue in support of its contemporary relevancy in today's democracy?

ADDITIONAL RESOURCES:

The NAMES Project Foundation: www.aidsquilt.org

The Keith Haring Foundation: www.haring.com

Questioning Hegemony: Challenging the Status Quo

OBJECTIVES:

- Students will begin to explore who determines power and authority.
- Students will investigate devices used in perpetuating norms.
- Students will create a work that questions an accepted norm.

TIME: One session, plus research and art-making time

MATERIALS: Paper and pencils

ARTIST RESOURCES:

Lauren Kelley: *Big Gurl* (2006) (p. 266)

Michael Rakowitz: *Return* (2006) (Figure 99)

SUGGESTED PROCEDURES:

1. Introduce students to the term hegemony and provide them with its definition. Have students create a timeline of events that have drawn national attention during the students' lifetime and that have challenged US hegemonic values. The timeline should be as thorough as possible (e.g. the Rodney King beating in 1991, the death of Matthew Shepard in 1998, the attacks on the World Trade Centers in 2001, the United Nations report on Guantanamo Bay's detention camp in 2007).

2. As homework, have students individually select an event from the timeline and ask them to write a summary including groups involved, the actions taken, the reasons behind these actions, and the results of the event. Students should speculate what would have happened had the event never occurred, and they need to justify their responses with other events that were carried out for similar causes. Students need to answer the following questions in their homework:

 - What were the outcomes of the event (e.g. laws, amendments, change of public opinion)?
 - Would a similar event happen later on if this event had not occurred?

3. Introduce students to Lauren Kelley's *Big Gurl*. Tell students that Kelley uses stop-motion animation to explore stereotypes of femininity and race. Have students define stereotype. Tell students that Kelley also uses her voice in this animation to speak for a cast of black

347

dolls to address issues surrounding gender, womanhood, and the human condition.
Ask students:

- What stereotypes are emphasized in the images?
- What popular Mattel® icon is being used to act out the stereotypes? Why would Kelley use a popular icon to address such topics?
- What controversies arise when identifying with Barbie®? What does this suggest about popular culture's role in perpetuating stereotypes?

4. Provide students with the definition of norms. Ask students to compare and contrast the definition of norm and stereotype. How do they inform one another? How do they differ? Have students revisit Kelley's *Big Gurl* and ask them:

- What norms are represented?
- In what ways are these norms being carried out as stereotypes?
- What is the relationship between norms and hegemony? Who is in power?
- What is democracy's role? What actions can citizens take to challenge these stereotypes? And why is this important to democracy's values of equality?

5. Read about Michael Rakowitz. From your reading, synthesize the artist's project *Return* and share this with your students. Ask students to comment on the norms that Rakowitz is grappling with and the inequalities that he exposes in the process of creating *Return*. Document their comments on the board.

6. Introduce students to **readymades** and the **open system** approach, an organic approach to art-making that requires a continuous cycle of revision and revisiting. Using this information as a framework, students will create a work that questions an accepted norm.

 Step 1: Students will need to come to a consensus on a norm to focus on. Refer to their timeline created in the first class period. What norms were the events responding to?

 Step 2: Students will brainstorm potential objects/artifacts that have the potential to be readymades. Refer back to reading on Rakowitz for ideas.

 Step 3: Students will select a readymade to use as the departure point for the project. They will then need to brainstorm ways, materials, and a solution that connect the readymade with the norm they selected. What materials or actions can they use that will make a direct connection between the readymade and the norm in question? For example, in *paraSITE*, Rakowitz uses the exhaust duct (readymade) to heat and inflate (actions) a plastic (material) clear shelter (solution) to comment on society's masking of the homeless population (norm).

 Step 4: Students will devise a blueprint or a sketch of their proposed project including the readymade, actions, materials, solution, and norm being questioned.

Step 5: Students will implement their project in a location that will strengthen the connection between the readymade and the norm.

Step 6: After implementing the project, students should revisit their norm, readymade, and location, and consider possible changes. Are there different materials that would work more effectively? Did the location alter the norm being questioned?

Step 7: Taking into account the possible alterations to the project, students need to make necessary changes and implement the second version of their initial project.

7. Students will evaluate their project and write an analytical paper that emphasizes their experience. Students should include the norm selected and their reasons behind the selection. Have students compare their experience to the activist's role in bearing witness. In what ways are they bearing witness to the events/norm that they selected? Refer to Lesson 2, "Breaking the Nostalgic Distancing of Past Movements," for more on bearing witness.

ASSESSMENT:

Using their artwork and analytical paper, did students:

- show an understanding of informants of power and authority?
- question or challenge an accepted norm?
- provide insight on how they are bearing witness to the events/norm?

ADDITIONAL RESOURCES:

For a timeline of events from 1976 to 2009, go to "The Generational: Younger Than Jesus" exhibition on the G:Class website: www.gclass.org.

Not All Members: Pluralizing the Uniformity of Voices

OBJECTIVES:

- Students will distinguish between the individual and the collective.
- Students will discuss the tensions between different political groups.
- Students will investigate their own negotiations when participating in politics.
- Students will create an insignia as a tool to discuss the power of visual representations.

TIME: One session and art-making time

MATERIALS: Paper, pencil, and art-making supplies

ARTIST RESOURCES:

Catherine Opie: "In and Around Home" series (2005) (Figure 87) and "Football Landscapes"
 series (2007–) (Figure 86 and p. 279)
Artur Żmijewski: *Oni/Them* (2007) (p. 304)

SUGGESTED PROCEDURES:

1. Have students list the different groups that they know. This may include organizations, party affiliations, religious groups, and clubs that they may be involved in. Students will share their lists with the rest of the class.

2. Have students brainstorm what differentiates these groups from one another.
 - What "values" do these groups have?
 - Are there certain requirements that you must have to be in the group?

3. Have students define value and write its definition on the board. Next to the different groups they listed, students will write the values and requirements of the individuals participating in the groups.

4. Ask students which groups they can and cannot belong to.
 - What are the stipulations for their inclusion/exclusion?
 - What are the stipulations based on?

5. Introduce students to the works of Catherine Opie. Have students look at "In and Around Home." Ask students to describe the series of images.
 - Who/what is being portrayed here?
 - What group do you think the artist is referring to in the title?

- What are some of the differing ideologies that can exist in a neighborhood?
- What are some things that can be shared as a collective?

6. Have students read about Catherine Opie. Ask them how this writing informs their understanding of *Oliver in a Tutu* from the "In and Around Home" series.
 - What values of gay/lesbian culture are represented in *Oliver in a Tutu*?
 - In what ways are they similar to mainstream heterosexual culture?

7. Have students discuss the parallels between the constructions of lifestyles. Ask students to discuss Opie's use of photography in eliciting these questions, focusing on Opie's "Football Landscapes" series.
 - What value is being projected on high school boys in this series?
 - In what way is Opie suggesting an acceptance instead of a tolerance? Students need to make a distinction between acceptance and tolerance.
 - Why would acceptance, over tolerance, be important to society, in particular a society based on democracy?

8. Have students speculate what would happen if they were asked to interact with a group that did not share the same values as them. Use a historical event, such as the Detroit Riots, as a model to ask the following:
 - What would they expect to happen?
 - What is the basis for these conclusions?

9. Look at Artur Żmijewski's *Oni/Them*. Ask students to write three to five sentences about each still-frame of the work to tell the story of the interaction between the groups.

10. Tell students that *Oni/Them* is a film registration of four ideologically uncompromising political groups gathered together to share their respective beliefs and political convictions in the young Polish democracy. Each group was approached to create an insignia of their ideologies, and then asked to react to the other groups' creations.
 - What is Żmijewski revealing about social interactions, specifically social interactions within a democracy?
 - What attributes of a democracy fuel these interactions?

11. Have students synthesize what causes tension between social groups.
 - In what ways can these tensions be diffused?
 - What negotiations does an individual have to make in order to participate in a group?
 - Where else might an individual have to negotiate their values in a collective, in particular, as a citizen in a democracy?
 - What negotiations do citizens make when voting?
 - In addition to voting, what other forms of activism promote participation in the democratic process?

12. Have students individually create insignias for groups that they belong to. Have them share and respond to each other's insignias.

13. Ask students to think about what meanings are interpreted through signs and signifiers.

 • Are everyone's interpretations of the insignias the same?

 • What information about the group is lost or misinterpreted through the insignia?

 • How can images activate social relations?

 • How can images create participation in democracy?

ASSESSMENT:

Evaluate students' insignias and participation to determine if they were able to synthesize the reasons for group formations and articulate some of the causes for tension between different social groups.

ADDITIONAL RESOURCES:

Castle, Marjorie, and Taras, Ray, *Democracy in Poland*, 2nd ed. (Boulder, CO: Westview Press, 2002).

Catherine Opie: 1999 & In and Around Home, exhibition catalogue (Ridgefield, CT/Santa Ana, CA: Aldrich Contemporary Art Museum/Orange County Museum of Art, 2006).

For more images of Catherine Opie's series refer to Regen Projects website: www.regenprojects.com

LESSON 5

Building Citizenship:
Replacing Catharsis with Direct Involvement

OBJECTIVES:

- Students will examine different strategies of direct action used in the worldwide Civil Rights Movement from 1950 to 1980.
- Students will write a letter to their State Representative in support of or opposition to a current proposal or bill up for review in the House or Senate.

TIME: One session and research time

MATERIALS: Pen, paper, and stamped envelope

ARTIST RESOURCES:

Edgar Arceneaux: Watts House Project (1996–) (Figure 13)

Sharon Hayes: *Revolutionary Love 2: I Am Your Best Fantasy* (2008) (p. 258)

Barry McGee: *Untitled (2 bottle installation)* (2005) (Figure 71)

Lara Schnitger: *Saville Row* (2007) (p. 287) and *Rabble Rouser* (2005) (Figure 105)

SUPERFLEX: *FREE BEER* (2005–) (Figure 118)

Rirkrit Tiravanija: *untitled (less oil more courage)* (2007) (p. 295)

SUGGESTED PROCEDURES:

1. Share with your students the definition of direct action. There are two forms of direct action: nonviolent and violent. In opposition to the violent direct actions of assault, murder, sabotage, and vandalism, nonviolent direct action includes strikes, sit-ins, and graffiti. Have students brainstorm other forms of nonviolent direct action. In contrast, grassroots, electoral, diplomacy, negotiation, and arbitration do not constitute direct action. Have students justify why these actions are not direct action.

2. Pair students off and have them research different forms and methods of activism including, but not limited to, boycott, civil disobedience, community building, Craftivism, cultural jamming, demonstration, franchising, guerilla communication, Hacktivism, Internet activism, lobbying, nonviolent and violent confrontation, propaganda, and protest. Students will report to the rest of the class with:

- a definition of their assigned activism.

- examples from the Civil Rights Movement (roughly 1950s–80s) that used the activism researched. Students should include the motivations for such direct action as well as the results of the activism.

3. Give students images and excerpts on Sharon Hayes's *Revolutionary Love 2: I Am Your Best Fantasy*, SUPERFLEX's *FREE BEER*, Rirkrit Tiravanija's *untitled (less oil more courage)*, and Edgar Arceneaux's Walls House Project. Ask students to identify possible form(s) of activism employed by each of the artists. What tools, formats, and/or methods are the artists using to get a message out? Referring to the excerpts, what do you think their motivations or influences are that made them create these works? What aspects of these works address contemporary times?

4. In *Untitled (2 bottle installation)*, Barry McGee uses heavy-browed men appearing fatigued as a metaphor for the "everyday man," a.k.a. homeless in San Francisco.

 - Why do you think McGee chose the homeless to represent the "everyday man"? What do the details tell us about the "everyday man"?
 - In what ways can graffiti be used as a means of activism? Is McGee doing this? If so, how?

5. Activism is often a series of intentional actions carried out for change. Have students list actions (e.g. running, screaming, etc.) in a column. Next to the action column, have students list current events/proposals that are in the media or up for vote in the House or Senate. Categorize the events/proposals as: social, political, economical, and/or environmental. Lead the class in a discussion focusing on which actions they would use to respond to the event/proposal. Have students pick an event/proposal and implement the actions they would use to create the necessary support/change. Students should consider the pros and cons of the actions and the overall effect those actions will have in regards to the event/proposal they are intending to support/change.

6. From the list of events/proposals, have students write a formal letter to one of their State Representatives. Suggested outline of the letter:

Paragraph 1

- Who they are and the reason for their writing.
- Evidence supporting their knowledge of the event/proposal.

Paragraph 2

- Why they are concerned with the event/proposal.
- Their position on the event/proposal and possible interventions.

Paragraph 3

- Synthesize their concerns and conclude with a salutation.

EXTENDING THE LESSON IN FASHION:

The website British Style Bloggers launched a project called Fashion Activism in December 2009. The premise of the project is to be environmentally resourceful by creating fashionable layered looks in order to lower heating costs during the winter months. Have students research sustainable fabrics and materials to create innovative yet fashionable wear which would lower cooling cost during the hot summer months. Read about Lara Schnitgor and her works *Saville Row* and *Rabble Rouser*. Have students compare their sustainable wear with Schnitger's sculptures by conducting a critique, focusing on the fusion of fashion and activism. Discuss Schnitger's use of titles and instruct students to title the wear accordingly.

ASSESSMENT:

Evaluate students' definitions and research on their assigned activism and their formal letters to a State Representative.

ADDITIONAL RESOURCES:

Contact information for House of Representatives: http://www.house.gov/Welcome.shtml
Contact information for United States Senate: http://www.senate.gov/index.htm
For individual accounts of activism during the Civil Rights Movement visit *Voices of Civil Rights: Ordinary People. Extraordinary Stories*, at http://www.voicesofcivilrights.org/
Levy, Peter B., *The Civil Rights Movement* (Westport, CT: Greenwood Press, 1998).
British Style Bloggers website: http://www.britishstylebloggers.org.uk/

The Vernacular:
Ownership, Authorship, and Censorship

OBJECTIVES:

- Students will read a book once banned for its usage of a vernacular.
- Students will explore notions of ownership and authorship of language.
- Students will examine the vernacular as a consideration in policy changes.

TIME: One session and reading time

MATERIALS: Internet access and a banned book

ARTIST RESOURCES:

Glenn Ligon: *No Room (Gold #46)* (2007) (Figure 67)

Daniel Joseph Martinez: "Divine Violence" (2003–) (pp. 270–271)

SUGGESTED PROCEDURES:

1. Watch the movie trailer of *Dreaming Singapore* (2006). The trailer was banned to air for free on TV and radio in Singapore, suspected for having too much Hokkien—one of the most commonly spoken Chinese dialects in Singapore, next to the official language Chinese (Mandarin).

 - What does this suggest about government and its relationship to language, in particular **vernaculars**? Who has ownership of language?
 - Why would a government try to control the language of its citizens?

2. Look at Glenn Ligon's *No Room (Gold #46)*. The text reads "I was a nigger twenty-three years. I gave that shit up. No room for No room for advancement." The fragmented words were derived from a joke by 1970s comedian, Richard Pryor. Originally told as "I was a Negro for twenty-three years. I gave that shit up—no room for advancement." Pryor's aggressive style of comedy was new to many audiences and now has become commonplace.

 - How has Ligon **remixed** and **re-presented** the original joke?
 - What meanings are **appropriated** by this visual derivative? What new meanings are created?
 - What does the number in the title suggest about Ligon's process with this text and its meanings? Who has **authorship** of these meanings?

3. Assign students to read a book that was/has been banned or challenged due to the author's choice of using a vernacular. For a listing of books, visit the American Library Association website, www.ala.org, and search for "Banned & Challenged Books." Have students write an abstract about the book, focusing on the vernacular: its usage and their understanding of it.

4. Look at Daniel Joseph Martinez's "Divine Violence" which names "the groups in the world currently attempting to enforce politics through violence."[4] Ask students to consider the phrase "In the name of [blank]" while looking at the list. For each group, have students insert the cause (e.g. "democracy," "liberation," etc.) for the group's actions.

 • Is your understanding of the cause the same as the groups'? Explain.

 • Who ascribes the construction and interpretation of these causes?

 • What informs words and their constructed meanings?

5. Have students read about artists that use text in their work, such as Glenn Ligon, Daniel Joseph Martinez, Dave McKenzie, and Andrea Bowers. What parts of language are the artists exploring? In what ways does this parallel your exploration of democracy? What is accessibility's role in democracy and how do vernaculars contribute (either positively or negatively) to accessibility? As a class, brainstorm the possibilities of including the vernacular in policy changes. What projections on current policies would result if the vernacular was a consideration in policies' developments? Who would be affected and in what ways?

ASSESSMENT:

Evaluate the students' participation and abstracts on the banned book assigned. Did students show an understanding of the vernacular and its relationships to authorship, censorship, and ownership?

ADDITIONAL RESOURCES:

American Library Association website: www.ala.org

Trailer for *Dreaming Singapore* (2006): http://www.singaporedreaming.com/index.htm

Active Integration: Changing Political Agendas

OBJECTIVES:

- Students will learn the differences between acculturation, adaptation, assimilation, and integration when referring to politics.
- Students will be introduced to transformational politics.
- Students will have a debate surrounding a national topic with global repercussions.
- Students will brainstorm about what makes a culture sustainable.

TIME: Three sessions and research time for the debate

MATERIALS: Images of the Pentagon and the Colosseum, pencils, and paper

ARTIST RESOURCES:

Nikhil Chopra: *Death of Sir Raja III* (2005) and *Yog Raj Chitrakar visits Lal Chowk, Srinagar* (2007) (Figures 22, 23, and 24)

Huang Yong Ping: *Pentagon* (2007) (p. 262) and *Colosseum* (2007) (Figure 57)

Michael Joo: *Stripped (Instinctual)* (2005) (Figure 59)

Rigo 23: *The Deeper They Bury Me, The Louder My Voice Becomes* (2009) (Figure 103), *Sol/Soleil* (2009–10) (p. 286), and *Teko Mbarate (Struggle for Life)/Sapukay (Cry for Help)*, 2005–2008 (Figure 104)

SUGGESTED PROCEDURES:

1. Provide students with the definitions of adaptation and assimilation. Introduce Nikhil Chopra's characters Sir Raja and Yog Raj Chitrakar to the class and ask them to distinguish between the adapted and assimilated characteristics of the personas. Are the characters adapting or assimilating or both? What informs the adaptations and assimilations of the characters' developments and actions?

2. Have students look at *Pentagon* and *Colosseum* by Huang Yong Ping. Read the description of the works and introduce the terms acculturation and integration. Have students draw parallels between the work and the vocabulary thus far mentioned.

 - What can be inferred from Huang's use of structures from current and past Western civilizations made from materials found in the East?

- What correlations exist between culture and politics? Which cultures are represented in politics? Who or what determines the inclusion/exclusion?

3. Have students read about Rigo 23. Select one of his projects as a departure point in developing a debate question. A debate question works ideally as a yes/no question framed around a topic on a national level, but has global repercussions, such as "Should a nation's citizenship be determined by its borders?" Divide the class into two teams. Affirmative vs. Negative. The affirmative team will argue "yes" and the negative team will argue "no" to the question.

Suggested evidence to be used in the debate:

- Current laws and regulations pertaining to the question.
- Case studies in history as evidence for the team's position.
- Research that supports or disclaims the urgency of the team's position.

The debate will consist of the following:

Step 1: Affirmative team will present to a panel (this can consist of the teacher and other faculty members) an abstract of their position. The team should have at least three points of relevance.

Step 2: Negative team will present to the panel their abstract, including at least three points of relevance.

Step 3: Affirmative team will present their first point and supporting evidence.

Step 4: Negative team will have the opportunity to question the Affirmative team on this point.

Step 5: Negative team will respond to the Affirmative team's first point and then present their first point with evidence.

Step 6: Affirmative team will have the opportunity to question the Negative team on their point.

Step 7: Affirmative team will respond to the Negative team's first point and then present their second point with evidence.

Repeat steps for the remaining points. Throughout the debate, students should use newly acquired vocabulary and reference the selected work by Rigo 23. The last steps are for each team to conclude their arguments. These closing remarks should recap each team's points, and address which points were not thoroughly responded to by the opposing team. The panel will then ask the teams the following questions:

- What arguments make this topic contentious?
- What points of discussion were not addressed in this debate? Why?
- Both teams have valid points/arguments. Who is going to determine which points/ arguments have more value? What negotiations are going to occur?

- Consider that the Affirmative team's position becomes history. What might the future look like?
- Consider the Negative team's position and answer the same question.
- Referring back to Chopra's, Huang's, and Rigo 23's practices, what informs this hypothetical?

4. Have students read about Michael Joo. Focusing on his works *Stripped (Instinctual)* and *Bodhi Obfuscatus (Space-Baby)* (Figure 58 and p. 265), lead a class discussion on Joo's interest in context and coexistence. How do these terms relate to one another? In what ways do these works relate to these notions? How do they relate to the previous debate and aforementioned artists? What importance do they serve in forming meanings?

5. Introduce students to transformational politics and the nonprofit Co-Intelligence Institute (CII). According to CII founder Tom Atlee, co-intelligence in the broadest of sense, "involves accessing the wisdom of the whole on behalf of the whole." Atlee further explains that the organization "embraces all such ideas and methods [of co-intelligence], and explores and catalyzes their integrated application to democratic renewal, community problems, organizational transformation, national and global crises, and the creation of just, vibrant, sustainable cultures."[5] How do co-intelligence and transformational politics relate to one another?

6. Have students respond to Michael Joo's practice and Tom Atlee's concept of co-intelligence by brainstorming what they think a sustainable culture could look like. What kind of democracy would establish and sustain this community, and how?

ASSESSMENT:

Evaluate students' participation in the debate and class discussions. Did students show an understanding of the vocabulary terms? Were they able to articulate their thoughts and ideas in brainstorming a sustainable culture?

ADDITIONAL RESOURCES:

Co-Intelligence Institute website: www.co-intelligence.org

LESSON 8

Imaginary Interventions

OBJECTIVE:

- Students will show an understanding of creative license and its potentials to make change.

TIME: Two sessions with writing time

MATERIALS: Internet access, pencils, markers, and large pieces of paper

ARTIST RESOURCES:

Cao Fei: *RMB City* (2007) (p. 251)

Jonathan Hernández: "Vulnerabilia" series (2002–) and "Rongwrong" series (2005–) (Figures 47 and 48)

An-My Lê: *M-246 Semi Automatic Weapon, Khawr Al Amaya Oil Terminal, Iraq* (2007), *Target Practice, USS Peleliu* (2005) (Figure 65), and *C-17, Pegasus Ice Runway, Antarctica* (2008)

SUGGESTED PROCEDURES:

1. Before beginning the lesson, have students bring in a current event about a national or global issue from a local newspaper, blog, website, or television station.

2. Lead the class in a discussion about fiction vs. nonfiction. What does "imagined" mean? Is it fiction? Nonfiction? Is there a space for **creative license**? Have students list out in two columns some of their favorite works of literature in either fiction or nonfiction categories. Are there any works that do not fit in either category? Why do these works not fit in either category? Does a work that is rooted in historical accounts but has a fictional plot relegate it strictly to the category of fiction? How factual does a work have to be to fit into the nonfiction category?

3. Have students share their current event and the source it came from. Have students look up their current event on CNN, BBC, and a news website from the locale where the event occurred. Are the dates the same? If numbers are involved, are they the same? Have students share the possible interpretations. What are the differences in the reports? Overall, what does this tell us about the sources we reference? What biases are present?

4. Students will pick a historical fact from their activist movement researched in Lesson 3 and write a reversal of the history of the event entitled "What if …" What if that event had not happened? Or what if the outcome had taken a different path? How would history be rewritten? Students should address the subsequent events that would be affected by the change in history and how today would be different based on those changes.

5. Look at and read about the works of An-My Lê, Jonathan Hernández, and Cao Fei. Share with students the definition of **intervention**. Ask students to expand on the definition by considering these artists' practices.

 • What in An-My Lê's photographs could be read as both fiction and nonfiction? What is suggested by this interconnectedness between the simulated and the actual?

 • In Hernández's juxtapositions, what meanings are being questioned by his use of creative license?

 • By using the virtual *Second Life* and the avatar, China Tracy, how is Cao Fei blurring the boundaries between fantasy and reality?

6. Adding to their "What if …" writings, have students project the history into the future. Answer the following by using their discussions on the aforementioned artists as departure points:

 • What are the possible future interventions and consequences of the changed history?

 • What outcomes do they predict?

7. Based on their writings, students will map the multifaceted ways that creative license has been used to create policy change within democracy in the past. Refer to previous lessons for events and movements as a departure point. On another map, have students brainstorm ways in which creative license can be used on current events and possible future causes. What new understandings of democracy are embodied by these alternative ways of thinking?

ASSESSMENT:

• Evaluate students' "What if …" writings on their understanding of creative license, imagination, and intervention.

• Assess the maps to see if students understood past lessons and the potential of creative license in the future.

ADDITIONAL RESOURCES:

Cao Fei's *RMB City* website: www.rmbcity.com

Cable News Network (CNN) website: www.cnn.com

British Broadcasting Corporation (BBC) website: www.bbc.com

CHAPTER 2 NOTES

1 Malcolm X and Alex Haley, *The Autobiography of Malcolm X* (New York: Ballantine Books, 1992).

2 Scott J. Hammond, Kevin R. Hardwich, and Howard L. Lubert, eds, *Classics of American Political and Constitutional Thought: Reconstruction to the Present*, Vol. 2 (Indianapolis: Hackett, 2007), 665.

3 Isolde Brielmaier, "Double-Take: Jeff Sonhouse's *Pawnography*," essay accompanying "Pawnography" exhibition November 6–December 23, 2008, at Jack Tilton Gallery in New York.

4 Press release, "Daniel Joseph Martinez: Divine Violence" The Project, New York, 2007.

5 The Co-Intelligence Institute, "Who We Are," 2003, available at www.co-intelligence.org (accessed February 23, 2010).

CHAPTER 2 BIBLIOGRAPHY

Brielmaier, Isolde, "Double-Take: Jeff Sonhouse's *Pawnography*," essay accompanying "Pawnography" exhibition November 6–December 23, 2008 at Jack Tilton Gallery in New York.

The Co-Intelligence Institute, "Who We Are," 2003, available at www.co-intelligence.org (accessed February 23, 2010).

"Daniel Joseph Martinez: Divine Violence," press release (The Project, New York, 2007).

Hammond, Scott J., Hardwich, Kevin R. and Lubert, Howard L., eds, *Classics of American Political and Constitutional Thought: Reconstruction to the Present*, Vol. 2 (Indianapolis: Hackett, 2007).

Malcolm X and Alex Haley, *The Autobiography of Malcolm X* (New York: Ballantine Books, 1992).

COMMODITIES, EXCHANGE, WASTE AND OBSOLESCENCE

Lan Tuazon

SUBJECT AREAS: Anthropology, Art History, Literature, Urban Studies, Science, and Social Studies

The aim of these lessons is to examine art practices that utilize, critique, and/or question systems of value, specifically those involving material cultural. Through the acts of rituals, preservation, distribution, and exchange, cultural, national, and even global values are determined. Addressing the prescribed values we place on objects, actions, places, and people, this chapter examines the prejudices and biases we construct around notions of authorship and authenticity. How is value created? Who determines and upholds values? What repercussions occur when a value system is disturbed or obliterated? Students will understand the formation of value in material cultural and its cultural significance to national identity. Through systems of exchange, secondary use designs, and documentation, artists within this chapter bring awareness to our existing relationship to material cultural and provide a new way to consider the production of art.

How the Ritual and Relic Renders the (In)equality of Objects

OBJECTIVES:

- Students will understand how rituals and relics are used in art and how this affects our understanding of art and history.
- Students will curate a collection of objects that give an overview of a specific topic, narrative, or historical framing.

TIME: One session

ARTIST RESOURCES:

Dahn Vo: *Untitled* (2009) (Figure 126)

Jeremy Deller: "It Is What It Is: Conversations About Iraq" (2009)

SUGGESTED PROCEDURE:

1. Begin the class by asking what objects students have as keepsakes. Do they preserve movie tickets, presents, or letters? What is the oldest object they hold in possession? Why do they save these objects?

2. Share with students that objects give evidence to our historic past, allowing us a real and tangible hold on important and distant moments in time. On a personal level we can interpret the preservation of objects as mementos that retain sentimental value. A Greek vase is equal to that of a store-bought vase in basic function/use. Since both objects are commodities and vulnerable to certain material decay, all objects are essentially equal physically. However, the store-bought vase is seen as a mere everyday product while the preserved Greek vase acquires a surplus value and meaning. Elevating objects from their simple material and commodity status to include objects' rarity, cultural specificity, and historical significance adds distinction and differentiation on how we view the economy of objects.

3. Elaborate the discussion on objects of evidence by presenting Dahn Vo's *Untitled*. Read the contents of the letter:

 Dearest, honored and beloved Father,

 Since my sentence is yet to come, I wish to address you a new farewell, probably the last one. My days in prison are going by peacefully. Everyone around honors me, and many even love me. From the great Mandarin to the last soldier, all regret that the law

of the kingdom condemns me to the death sentence. I have not endured any tortures, like many of my brothers. A slight strike of a sword will behead me, like a spring flower picked by the garden Master for pleasure. We are all flowers growing on this earth, picked by God at some point, a little earlier for some, a little later for others. One is the crimson rose, another the virginal lily, another the humble violet. Let us all try to please the Lord and Master, with the perfume or radiance we were given.

I wish you, dear Father, a long, peaceful and virtuous old age. Bear your life cross gently, following the path of Jesus, till the calvary of a felicitous death. Father and son will meet again in heaven. I, small transient being, am to leave first. Farewell.

Your devoted and respectful son, J. Théophane Vénard

4. Define **mise-en-scène** and have students apply their understanding to the aforementioned work. Ask students what details they consider notable and why. What does it say about the figure who is writing the letter?

5. Have students summarize and interpret the narrative of the letter.
 - Who is J. Théophane Vénard?
 - What type of letter is Vénard writing to his father?
 - How would a person respond emotionally to receiving such a letter?
 - What can students tell about Vénard from the way he describes his imminent death?
 - Have students interpret the metaphor of his beheading to that of picking a flower. What does it reveal about his view on his life, his being, and finally, his death?

6. Inform the students that this copy is penned by Danh Vo's father, Phung Vo. Danh Vo will continue to make editions until the time of his father's death. Analyze Vo's work by asking the following questions:
 - In what ways does Vo's father penning the letters relate to Vénard's and his father?
 In this piece, death appears twice, first in the written account of Vénard's death, and then in learning that Vo's father will continue to make copies of the letter until his own death. What shifts in meanings does this copy have from the original?
 Define **ritual** and ask students to describe what the act of indefinitely rewriting these letters may mean. In this work, ritual is used to strengthen and make conscious the filial bond between father and son. The artist chose a real document and created a ritual where the indefinite production of the letter becomes a continual visitation to the moment of one's own death.

7. Define **relics** to students. There are also cultural relics such as fragments of the Berlin Wall or detritus of the World Trade Center; objects that are preserved as a memorial of a lost culture. Provide other examples, such as the falling of Saddam Hussein's effigy in Baghdad's Firdus Square in 2003. With frequent coverage on the news, the real destruction of the

sculpture stood for symbolic violence and victory over the fallen regime (make a connection to iconography and iconoclasm from Chapter 1, "Negotiating Space/Negotiating Self").

8. Relate the discussion of relics to a detail of Jeremy Deller's installation "It Is What It Is: Conversations About Iraq." Focus on the detail of the bombed car. Have students describe the condition of the car. Its level of destruction suggests evidence of it being bombed. Ask students:

- What effect does seeing this car have on our perception of the war?
- How does its presence make the war more real?
- What meanings are derived by seeing an object from a war in an art space?
- Is the car an artwork or an artifact?
- What factor does the historical timeframe of the war play? How recent is "too soon" to display such objects?
- Are there moral implications in treating a relic as "art" or "artifact"—something that will have monetary value? Explain.

9. Define **curation** and relate it to Jeremy Deller's role as an artist and **curator**. Students will present an idea, concept, or a specific period by curating a collection of objects and images. Students may consider grouping a collection of objects categorically according to their material, use, cultural/historical significance, or metonymically as part of a larger narrative or meaning. Refer to "Additional Resources" for examples to help students understand how artist use exhibitions as art.

ASSESSMENT:

Evaluate students according to their participation in discussions, and their ability to understand and use artistic terms presented in class, and interpret through assigned activity.

ADDITIONAL RESOURCES:

For artists' projects relevant to the activity look at:

Marcel Broodthaers, "Museum of Modern Art, Department of Eagles", available at http://www.moma.org/interactives/exhibitions/1999/muse/artist_pages/broodthaers_musee.html

Mark Dion, "Cabinets of Curiosities", available at http://edu.warhol.org/app_dion.html

Group Material, available at http://www.franklinfurnace.org/research/projects/flow/gpmat/gpmattf.html

Jeremy Deller's installation "It Is What It Is: Conversations About Iraq" visit the Global Classroom website, www.gclass.org

LESSON 2

The Hidden Economy of Art and Antiquities

OBJECTIVES:

- Students will learn how war destabilizes the preservation of cultural objects and relate it to the political engagements in the US' occupation of Iraq.

- Students will be presented with examples of how art and antiquities are acquired and their global and cultural significance to national identity.

TIME: One session

ARTIST RESOURCES:

Michael Rakowitz: *the invisible enemy should not exist* (2007–) (Figure 100 and p. 284)

SUGGESTED PROCEDURE:

1. Assign students to read the *Business Week* and *New York Times* online journal articles listed in "Additional Resources" before class. Discuss the details of the articles by asking what was the role of the United States government in the looting of the National Museum of Iraq in 2003.

2. Begin by asking students:
 - How are art and antiquities acquired?
 - How would the "priceless" value of art and artifacts affect the sale and acquisition of museum objects?

 Discuss various positions in the debate regarding museums' responsibility in maintaining, purchasing, and returning stolen goods.
 - Is it the responsibility of museums to return stolen antiquities? Why or why not?

 Relate it to students' own experience by asking if they would purchase or accept gifts that might be stolen commodities such as electronics, bikes, and personal property. What is the buyer's—or receiver's, if the commodity was a gift—role in supporting the economy of theft?

3. Present the case of *United States* v. *Schultz* (2002). Schultz was an antiques dealer in Manhattan in the 1990s and president of the National Association of Dealers in Ancient, Oriental, and Primitive Art (NADAOPA). Along with British art restorer Jonathan Tokeley-Parry, who smuggled antiquities from Egypt, Schultz falsified documents to present smuggled items as a legitimate 1920s private collection. By doing so, Parry and Schultz

attempted to evade the 1983 Act known as the National Stolen Property Act (NSPA), which states that exported antiquities need documented consent from native governments before their export and sale (without which such antiquities would be considered stolen property). Ask students:

- What rights do native governments such as Mexico, Italy, Egypt, and those in Asia have to their national treasures?

- How might today's museums look if they were to return goods that they discovered were stolen?

4. Present and analyze Michael Rakowitz's project *the invisible enemy should not exist.* Have students list and identify the objects. Ask students:

- What is the significance of the objects as a collection?

- What do students notice about the materials used in the construction of the objects? Where are the materials from? What is their everyday use?

- What do you think the artist is suggesting by using the disposable quality of packaging materials in representing Iraqi art and artifacts?

The artist has reconstructed over 100 of the 7,000 artifacts still missing from the museum to create visible evidence of lost objects. Given this information, ask students to interpret the title of the work. What or who is the invisible enemy?

5. The use of the **document** in art played a prominent role in 1970s conceptual and earthwork projects where actions, performance, and installations used the document as the final form of the artwork. Students will create art using the document as a departure point to represent absence. Art often exists on the realm of the visual, so this assignment is a poetic challenge to represent something which cannot be seen. They can conduct their own research to find a particular case study, narrative, and/or event related to the notion of erasure, obscurity, or absence.

EXTENDING THE LESSON IN ART HISTORY:

Make connections to artist Edward Kleinholz and his documents by proposing possibilities for potential artworks.

ASSESSMENT:

Evaluate students according to their participation in discussions and their ability to articulate their interpretation of the assigned activity.

ADDITIONAL RESOURCES:

Articles on the 2003 looting of the National Museum of Iraq can be found at:

http://www.businessweek.com/bwdaily/dnflash/apr2003/nf20030418_4341_db039.htm

http://www.nytimes.com/2003/04/13/world/a-nation-at-war-looting-pillagers-strip-iraqi-museum-
of-its-treasure.html?pagewanted=2

For more information on *United States* v. *Schultz* (2002), see *Culture Without Context*, Issue 10
(Spring 2002), available at http://www.mcdonald.cam.ac.uk/projects/iarc/home.htm

Commodities and Circulation and the Art of Service

OBJECTIVES:

- Students will be presented with artworks that use distribution as a primary source of meaning.
- Students will create a project that makes use of circulation in the creation and reception of art production.

TIME: One session

ARTIST RESOURCES:

Michael Rakowitz: *Return* (2006) (Figure 99)

SUGGESTED PROCEDURE:

1. Discuss the general public's accessibility to art and art ownership. The main criticism in the field of art has been the cultural divide between high art and low art, mass and elite audience. Is art accessible or exclusive? Do students collect art? Would access to art ownership affect or expand its audiences? Why or why not?

2. In this lesson students will focus on how artists use circulation as a method of distributing art to more audiences. Refer to Félix González-Torres's works as a way of introducing the notion of distribution where multiple editions of artworks were exhibited and made available for audiences to take. González-Torres also sold these works to collectors with specifications that they be reproduced for distribution to a larger public during their exhibition.

3. Extend this discussion by asking whether, if something is given away for free, it loses its value. Would students consider these free forms of art as a gift? If so, what kind of relationship is formulated between artist and audience?

4. Present the way circulation and distribution function in an art project by analyzing Michael Rakowitz's *Return.* Have students read about Rakowitz's practice and ask them:
 - What can students identify from the documentation of the work?
 - What type of space has Rakowitz simulated? What service is he supplying?
 Read an excerpted description of the work from "Additional Resources."
 - How does Rakowitz deal with the issue of circulation in his work?
 Here the art object is not distributed, but rather, Rakowitz plays the role of manager.
 - How does this change our expectations of an art project?

- How does the role of the artist change when the artist takes a managerial role in order to affect social relationships?

5. Present the assignment "Art as Gift" to students. Students will produce multiple editions of an artwork and create a gift exchange as a method of distribution.

 - Motivate students by presenting wide possibilities of distribution: add/drop works, mail art, and free multiples, such as in works by artists Adrian Piper, Bruce Nauman, and Félix González-Torres. Have students begin by identifying their target audience.
 - Where and how are they going to distribute and circulate their project?
 - How will the site of their exchange affect the form and appearance of the work?
 - How will distribution affect the form of the work?

EXTENDING THE LESSON IN ART HISTORY:

Connect the lesson to Dave McKenzie's project *While Supplies Last* (2003). For more information on McKenzie, refer to the G:Class website (www.gclass.org).

EXTENDING THE LESSON IN POLITICS:

Make connections to current social events and present the political figure Kathy Kelly and her role in importing food and medicine to Iraq in opposition to US economic sanctions.

ASSESSMENT:

Evaluate students according to:

 - their participation in discussions;
 - their ability to understand and use artistic terms presented in class;
 - their ability to interpret acquired knowledge through assigned activity.

ADDITIONAL RESOURCES:

Information on Félix González-Torres can be found at: http://www.guggenheimcollection.org/site/artist_bio_56A.html

For more information on Rakowitz's project, please visit Creative Time's website with artist interviews at: http://www.creativetime.org/programs/archive/2006/whocares/projects_rakowitz.html

For more information on Kathy Kelly, go to http://vcnv.org/speaker-bio/kathy-kelly

Exchange Rates and the Reevaluation of Ownership

OBJECTIVES:

- Students will discuss debates on intellectual property rights and their relationships to production and value.

- Students will analyze relational artworks where the act of exchange is a primary aspect of the process.

TIME: One session

ARTIST RESOURCES:

SUPERFLEX: *FREE BEER* (2005–) (Figure 118) and *When the levees broke, we bought our house* (2008) (Figure 120)

SUGGESTED PROCEDURE:

1. Motivate students by asking how many of them download files, images, music, and videos on the Internet. What is their position on file-sharing? Should people have access to Internet resources for free? Define **intellectual property** and ask: Whose rights are protected? How does it affect the larger community? How might this affect the future production of culture?

2. Expand this discussion by presenting the political implications of intellectual property rights. Should innovators profit from royalty rights? Or should it be open and made available to all for further developments? Present the stakes in this discussion by relating it to the global health crisis of HIV/AIDS. Have students investigate the intellectual property rights surrounding the further research in pharmaceutical treatment of the AIDS virus in Africa. How would they relate this to other fields in culture, technology, and science?

3. Define **Creative Commons license** and **open source**, and present SUPERFLEX's *FREE BEER*. Read the label to students:

 FREE BEER (Version 3.2) is an open source beer. FREE BEER is based on classic ale brewing traditions, but with added Guaraná for a natural energy boost. The recipe and branding elements of FREE BEER is published under a Creative Commons license (Attribution-Share Alike 2.5). This license gives anyone the permission to use the recipe or create a derivative of the recipe to brew their own FREE BEER and to use and modify the design and branding elements. Anyone is free to earn money from

FREE BEER, but they must publish the changes and results under the same license and credit our work. All design [recipe,] and branding elements are available to beer brewers … at freebeer.org.[1]

- What are students' associations to the word, "free"? How is the term being used in this project?
- What are the social and economic implications of making this product and its recipe open for production?
- What are potential negative consequences or counter arguments against open source sharing?

4. Contextualize this artwork by presenting OpenCola, a soda distributed as a marketing tool by the Toronto-based software company, OneCola, to explain free software. The cola was sold with instructions of how it was made; presenting the recipe as something that can be used, produced, and altered. SUPERFLEX's *FREE BEER* follows the same guidelines and uses the term "free" to mean that anyone can profit from the production and marketing of the beer, so long as each producer shares any new developments and changes to the recipe.

5. Teachers may choose to present an additional work, *When the levees broke, we bought our house* by SUPERFLEX. The project is available on the collective's website. Analyze the text included with the work.

- Have the students describe what they see in the photograph. What kind of house is it and where could this type of home be found?
- What is the connection between what they see in the photograph and what they read in the text?
- What is the significance of the price of the artwork?
- What is SUPERFLEX's intention in the potential sale of the artwork?

6. Return to the assignment presented in Lesson 3, which describes open source, and relate it to the Creative Commons license as a form of distribution. Have students continue producing the "Art as Gift" project and present the possibility of using the Internet as a method of distribution and circulation.

ASSESSMENT:

Evaluate students according to their participation in discussions, and their ability to understand and use artistic terms presented in class, and then interpret them through assigned activity.

ADDITIONAL RESOURCES:

For more information on OpenCola refer to http://www.colawp.com/colas/400/cola467_recipe. html

Obsolescence and the Wastebasket of History

OBJECTIVES:

- Students will be presented with photographic documentations of waste and obsolescence.
- Students will be presented with a background history of secondary use design and apply their knowledge to create a found object assemblage.

TIME: One session

ARTIST RESOURCES:

Taryn Simon: "An American Index of the Hidden and Unfamiliar" (2007).

For a focus on obsolescence use the following photographs from the series: *Cryopreservation Unit Cryonics Institute, Clinton Township*, *White Tiger (Kenny), Selective Inbreeding Turpentine Creek Wildlife Refuge*, and *Foundation Eureka Springs, Arkansas*.

For a focus on waste refer to *Michigan Nuclear Waste Encapsulation and Storage Facility Cherenkov Radiation* and *Nixon Gift Vault, Body Farm, Medical Waste*.

SUGGESTED PROCEDURE:

1. Begin the lesson by asking how waste and waste management affect the environment and in turn, what the effects are on the quality of life and health. Have students list examples of various methods of waste management: landfills, incineration, composting, and recycling. Ask them if these methods of waste management are enough to manage waste produced globally.

2. Present Greenpeace's Albatross advertisement. Have students respond to the image showing the innards of a Laysan Albatross chick filled with disposable plastic, with an ad line that reads: "how to starve to death with a full stomach."

3. Provide scientific background information on the image by explaining that there is an extreme case of waste accumulation called the Great Pacific Garbage Patch. Discovered and researched by self-trained oceanographer Charles Moore, the Garbage Patch is a waste flotsam in the Pacific Ocean measuring about twice the size of Texas. Read his quote retrieved from his TED lecture on February 2009: "Throwaway plastics take a lot space and don't biodegrade. Only we humans make waste that nature can't digest."[2]

4. Similar to Greenpeace's Albatross advertisement, Taryn Simon uses the combination of image and text to represent the "hidden and unfamiliar." The following two photographs

are documentations of obsolescence and waste. Present *An American Index of the Hidden and Unfamiliar: Michigan Nuclear Waste Encapsulation* and *Storage Facility Cherenkov Radiation*.

- Based on the image alone, can students identify what the image represents? What visual evidence are they basing the reading of the image on?
- Since Simon presents us with the "unfamiliar," have students discuss the necessity of text. Read the text that accompanies the photograph. How does text affect the reading of the image?

5. Discuss how obsolescence differs from waste. From the same series, present Taryn Simon's *White Tiger (Kenny), Selective Inbreeding, Turpentine Creek Wildlife Refuge* and *Foundation, Eureka Springs*. Have students describe what they see in the image. What can they tell about the biological condition of the tiger? Taryn Simon plays the role of an anthropologist of present-day realities, using the camera to record what we cannot see.

- How does her process of revealing the hidden contradict the ways we often perceive reality?
- How does this photograph of the hidden reality of exotic animals in zoos affect your perception of that environment/circumstance?

6. Students were presented with examples of human production, obsolete byproducts from warfare technology, and the production of waste from breeding perfect white tigers. Return to Moore's quote and your discussion on waste and possible solutions of its management. Introduce **secondary use design**, a concept that aims to design second use to all products. Waste is defined as that which has no function; therefore to eliminate waste and its management, 1970s vernacular architects, including Mike Reynolds and Shigeru Ban, attempted to design a second use to objects. Ask students to relate this concept to previous conversations and artworks.

7. Assign students to work with found objects and to invent a secondary use for the specific object chosen. Students will begin with a found object and alter its form, surface, or structure to create a secondary use to its primary functions. This assignment can be done by appropriating found objects and reusing them for different purposes, or by reinventing the object to have a new dual function altogether, such as the Bottle Brick. The beer company Heineken designed a beer bottle with the form and function of a brick. The Bottle Brick would first function as a container and then function as a building material.

EXTENDING THE LESSON IN ARCHITECTURE:
Research and present architectural examples of secondary use design from Martin Pawley's *Garbage Housing*, published by the Architectural Press, UK, in 1975.

ASSESSMENT:

Evaluate students according to their participation in discussions, and their ability to understand and use artistic terms presented in class, and then interpret them through assigned activity.

ADDITIONAL RESOURCES:

For images from Taryn Simon's "An American Index of the Hidden and Unfamiliar" (2007), visit the artist's website at www.tarynsimon.com

For more information on Charles Moore and his research on the effect of disposable plastics on the food chain, view his lecture, available at www.ted.com. Search "Charles Moore."

For more information on the Great Pacific Garbage Patch, read Donovan Hohn's essay, "Moby-Duck: Or, the synthetic wilderness of childhood" from Harper's Magazine, January 2007, available at: http://www.harpers.org/archive/2007/01/0081345

Martin Pawley, *Garbage Housing* (Oxford: Architectural Press, 1975).

Making Something out of Nothing: Waste and the Value of Artistic Labor

OBJECTIVE:

- Students will reformulate the notion of artistic authorship and authenticity by looking at the use of the found object in art history.

TIME: One session

ARTIST RESOURCES:

Mark Bradford: *Helter Skelter* (2007)

Abraham Cruzvillegas: *Autorretrato Ciego* (2007–08)

Sarah Sze: *Tilting Planet* (2006) (Figures 122 and 123)

SUGGESTED PROCEDURE:

1. Ask students:
 - How does the manner in which an object is created affect their regard of it?
 (Do they see a difference in value with things that are hand-made versus machine/mass-produced?)

 Apply their responses to art production and ask:
 - How does production affect our views on art?
 - Is the artist's hand or touch necessary in the making of an artwork?

 Compare hand-made art objects, such as paintings, to process-oriented works (e.g. Rodin's castings) and printmaking that are one step removed from the artist's touch, and artworks that are entirely commercially produced (e.g. Donald Judd).
 - How would such examples of art affect students' previous notions of artistic authenticity?

2. Discuss examples in contemporary art, such as Damien Oretega, Carol Bove, and Claire Fontaine. Frame this discussion art-historically with a brief discussion of the art object: Marcel Duchamp's **readymade**, Dadaist combinations of found object art known as **assemblage**, and Robert Rauschenberg's use of found images known as **combines**.

3. Present Bradford's *Helter Skelter*. Have students identify recognizable elements in the work.
 - What kind of images is he using?
 - Is there a common relationship from one image to another?

- Based on the scale of the work, how would *Helter Skelter* compare to a mural or a billboard?
- Which term(s)—readymade, assemblage, or combines—would most apply to Mark Bradford's work?

Provide the multifarious meanings of "helter skelter" as a chaotic order of things and events, a Beatles song, and Charles Manson's prophesy of a racial war between black and white America.

- How does the title relate to the composition and reading of the work?

4. Read the following quote by Bradford in response to constructed objects versus found objects: "It's first use, and I don't like things that are first use. I like things that are second use ... I want [things] to actually have the memories—the cultural and personal memories that are lodged in the object."[3] Have students interpret the quote and relate it to their earlier discussion.

5. Present and analyze Abraham Cruzvillegas's *Autorretrato Ciego*. Have students describe the appearance of the artwork and what type of artwork it is. Inform the students that the title, *Autorretrato Ciego*, is Spanish for a blind self-portrait. Ask students:

- How might this work serve as a self-portrait of the artist?

Explain to the students that Cruzvillegas has taken found images, painted the backs with red paint, and then presented the self-portrait with the painted side facing towards the viewer while the image sides face the wall.

- What is the difference between using a conventional canvas for painting as opposed to using a found image?
- How does it affect our perception of the work knowing there are obscured images behind the paint?
- Why do you think the artist chose to obscure the found images?

6. Have students analyze Sarah Sze's practice by looking at *Tilting Planet*. Have students synthesize their reading on Sze and compare their analyses. List the recognizable elements in the work.

- What kind of objects are these? Where might you find them?
- How are the objects arranged? How does this arrangement relate to the title, Tilting Planet? What might Sze be suggesting by her choices of arrangement and title?

Sze is informed largely by the nature of the space her installations are created within. Why would this be important to the meaning of the work? Refer to Chapter 1, "Negotiating Space/ Negotiating Self," for more lessons on this topic.

7. Compare and contrast the three works presented. How do all the artists respond to mass production? Continue and complete sculpture assignment from Lesson 5.

ASSESSMENT:

Evaluate students according to their participation in discussions, and their ability to understand and use artistic terms presented in class, and then interpret them through assigned activity.

ADDITIONAL RESOURCES:

For additional information on Mark Bradford, read his interview, "Politics, Process and Postmodernism" in *Art:21*, available at http://www.pbs.org/art21/artists/bradford/clip2.html

For more examples on found object art, refer to the New Museum's "Unmonumental" exhibition at http://www.newmuseum.org under past exhibitions.

For more information on secondary use design, read Martin Pawley's *Towards Unoriginal Architecture*, retrieved at https://kepler.njit.edu/

CHAPTER 3 NOTES

1 SUPERFLEX, "FREE BEER," artist collective's website, 2010, available at http://www.superflex.net/projects/freebeer/ (accessed February 24, 2010).

2 Charles Moore, "Capt. Charles Moore on the Seas of Plastic," TED Conference 2009, TED website, 2010, available at http://www.ted.com/talks/lang/eng/capt_charles_moore_on_the_seas_of_plastic.html (accessed February 24, 2010).

3 Mark Bradford, quoted in Ernest Hardy, "The Eye of L.A." *Los Angeles Times*, June 11, 2006, available at http://articles.latimes.com/2006/jun/11/magazine/tm-bradford24 (accessed February 24, 2010).

CHAPTER 3 BIBLIOGRAPHY

Hardy, Ernest, "The Eye of L.A.," *Los Angeles Times*, June 11, 2006, available at http://articles.latimes.com/2006/jun/11/magazine/tm-bradford24 (accessed February 24, 2010).

Moore, Charles, "Capt. Charles Moore on the Seas of Plastic," TED Conference 2009, TED website, 2010, available at http://www.ted.com/talks/lang/eng/capt_charles_moore_on_the_seas_of_plastic.html (accessed February 24, 2010).

Rakowitz, Michael, "Projects: *Return*," artist's website, 2009, available at http://michaelrakowitz.com/return-bronx-solo/ (accessed February 24, 2010).

SUPERFLEX, "FREE BEER," artist collective's website, 2010, available at http://www.superflex.net/projects/freebeer/ (accessed February 24, 2010).

CHAPTER 4

CONFLICT: LOCAL AND GLOBAL

Yvonne Olivas

SUBJECT AREAS: Philosophy, Social Studies, History, English, and Art

Conflict is something we encounter every day. Perhaps this is because conflict can vary so much in degree and connotation, simultaneously conjuring war, violence, opposition, debate, resolution, borders, sanctions, politics, and even consensus. Then there are the conflicts we experience within ourselves, with friends and family, and ethical and moral dilemmas. In perusing the newspapers, the complexity of conflict emerges—debate over finance legislation; people engaged in war over resources, identification, homelands, and religion; protests against climate policy and education; worker strikes; and control of territories and markets. If we decide to engage in and understand what is happening in the world around us, then it seems that conflict asks us to make a choice, presenting possibilities and ethical dilemmas. What is possible then? How do we choose? What once seemed clear as either right or wrong is in a tangle, the question of truth a concept superfluous and indeterminate. But we can always proceed by considering how we find ourselves connected to the world, and how this informs our assumptions and prejudices, and frames our understanding, not only of entities, people, places, phenomena, and things, but also of the role that our expectations play. If conflict can be framed in this way, it becomes clear that having any understanding of the world—or our sense of self—is a demanding and ongoing process.

In keeping with the demands of conflict, this chapter focuses on approaches to the arrangements, engagements, and entanglements of daily life. The chapter begins by looking at specific artworks to gain a better understanding of the many ways we can identify and how our subjectivity affects what we come to know.

Relating: The Role of Subjectivity, Objectivity, and Performativity

OBJECTIVES:

- Students will examine the way we approach people, concepts, and things in the world.

- Students will be introduced to subjectivity, objectivity, and performativity. These concepts are helpful in fostering a critical awareness of how we are connected to the world—how our actions and positions are affected by what we engage, decisions we make, and vice versa.

- Students will view artists' works and engage in role-playing activities as they explore these concepts.

TIME: Two sessions

ARTIST RESOURCES:

Shilpa Gupta: *Don't See Don't Hear Don't Speak* (2008) (p. 254)

Rachel Harrison: *Trees for the Forest* (2007) (pp. 256–257)

Clifford Owens: *Photographs with an Audience* (2008) (p. 280)

SUGGESTED PROCEDURES:

1. Have students look at Rachel Harrison's *Trees for the Forest*. Listed below are suggested questions to help initiate conversation about how positioning and movement in relation to this work, or even its image, affects the way it is understood. As discussion commences, introduce your students to the concepts of **subjectivity**, **objectivity**, and **performativity**. Students should come to understand that Harrison's work engages the curious viewer—one who is willing to walk around, come close, look up, crouch, and weave through the installation. You can ask your students:

 - What do you see?

 - What is the best vantage point for viewing the work? Describe what you would see from there. Is it possible to have total visual access to the work or is something always obscured? Relate your answer to the concepts of subjectivity and objectivity. Push the conversation by asking if there is a potential conflict between subjectivity and objectivity. Explain.

- What do you think the title *Trees for the Forest* means? Have you heard the phrase "forest for the trees"—what new meanings does the inversion of this phrase conjure?

- If we see in performativity the possibility of breaking with conventional ideas and values, how does *Trees for the Forest* engage this subversive possibility?

2. Have students look at *Photographs with an Audience* by Clifford Owens.

Explain to your students that *Photographs with an Audience* (see his artist practice writing) is a performance piece that includes photography, Owens, and an audience. Owens asked the audience a series of questions to which they responded by moving within the space. Directed by Owens, participants addressed the camera according to their different answers. Participation was prompted by Owens, which affected the space through continual shifts and reshapes in the audience. Discuss the following with your students:

- Owens uses photography to document his performances. This is not necessarily a common practice for performance artists. Although photography is often seen as an artifact of a performance, for Owens it becomes part of the performance—not something separate. What is it about the medium of photography that you think attracts Owens to use it in his performance practice?

- How do you think the photography affects the response of the audience in the performance? Would the dynamic of the performance be different without the presence of the camera? In other words, what expectations do you think the camera introduces for those involved (this includes Owens, the audience, and the photographer)?

- What is the artist's role in this work? What is the audience member's role in this work? Who is in charge?

3. Share Shilpa Gupta's *Don't See Don't Hear Don't Speak* with your students, but do not give them the title. Ask them:

- What do the gestures of the people in the photograph indicate?

Share with students information on Mahatma Gandhi. Gandhi was a lawyer and nonviolent activist for Indian independence from the British. He had a philosophy that became a credo for India: See no evil, hear no evil, speak no evil. He interpreted this phrase as a message about self-conduct and nonviolence, and about not perpetuating harm to others, whether through speech, action, or their tolerance.

- How does Gupta's title relate to this message? How is her message different?

- Why do you think Gupta's message might be different than Gandhi's?

- How does Gupta's work relate to visual literacy in the expanded field/ everyday life?

4. Students will brainstorm a short performance or demonstration inspired by one work discussed above. The resulting project should be performed in front of the entire class. Students should feel free to include or interact with the entire class if their project calls for it. Suggested projects based on each work:

Rachel Harrison's *Trees for the Forest*:

- Divide the class into groups of four or five students. Each group will perform scenarios based on a series of words or situations they brainstorm and write on index cards: isolation, exclusion, harmony, dominance, friendship, tall, smart, etc. The demonstration should be silent, but make use of gesture, movement, poses, and blocking—standing on a chair, sitting in a circle, turning away, and so on. The class must guess the scenario being performed. Once it is guessed, the class should try to come up with a single move for one of the performers that dramatically alters, shifts, or subverts the dominant dynamic of the scenario.

Clifford Owens's *Photographs with an Audience*:

- Have students come up with a list of four attributes for students to identify with such as:
 - Is wearing the color red?
 - Has siblings: yes or no?
 - A favorite frozen dessert flavor, pick one of three: chocolate, vanilla, strawberry.
 - Was born in the fall, spring, summer, or winter?
- Lead the class by calling out one or more of the identifiers at a time and have the students group themselves accordingly. Give the students time to see who is within their attribute group before calling out more attributes and shifting the groups around. At some point in the exercise, students should choose a group to identify with and stop moving around: for example: born in the spring and likes vanilla. This exercise should help students understand the multiple ways in which we can identify, make choices about our alliances, and also break with what seems dictated by chance—like deciding you don't have to follow the group that was born in winter even if you were.

Shilpa Gupta's *Don't See Don't Hear Don't Speak*:

- Students should think up situations they encounter in their everyday lives that call for an intervention or pose an ethical dilemma. For example: A man is walking off the bus and drops his wallet, which is stuffed with cash. It falls next to you, but no one sees this. If you return the wallet to the man, you will be late for school. What do you do? If you would like to present more examples to the class, search for "ethical dilemmas" online. Scenarios should be presented to the class followed by discussion of what individual students would choose to do and why. Variation: Students can write extended scenarios and act them out in front of the class.

ASSESSMENT:

Evaluate students' analyses of the artworks and their performances. Do they comprehend:

- subjectivity, objectivity, and performativity, and how they are different;
- that these terms can shift;
- the liberating potential of performativity?

ADDITIONAL RESOURCES:

For more research before class you can listen to a program about "Morals" by WNYC's Radiolab, available at http://www.wnyc.org/shows/radiolab/

Reflection and Noise:
Journaling Clashes and Quiet Moments

OBJECTIVES:

- Students will examine the dynamics of conflict in their lives and come up with strategies for the conflict they encounter.
- Students will reflect on the time they take for themselves and think about how best to channel frustrations, which can be the substance of internal conflict.

TIME: Two sessions and a week of journal writing

ARTIST RESOURCES:

Daniel Guzmán: *Brutal Youth*, from the sculpture series "Everything is Temporary" (2008)
　　(p. 255)
Annie Pootoogook: *Dr Phil* (2006) (Figure 2) and *A True Story* (2006) (p. 282)
Noguchi Rika: "The Sun" series (2005–) (Figure 85 and p. 278)

SUGGESTED PROCEDURES:

1.　Before beginning the lesson, assign student to keep a journal, recording arguments and conflicts, as well as the quiet reflective moments in their daily lives, for at least a week. (Students should understand that their journal is for themselves; they will share some of what they write with another student, but what they share is at their discretion.) Students should record arguments they are having with another person, an internal conflict they are dealing with, or a conflict they overheard but were affected by over the course of a week. Your students should write down when the event happened, what the problem was, and what the different perspectives of the conflict were. Finally, have students reflect on how they felt about the conflict:

- Did they change their mind about it, was the argument important or petty, and has it been resolved? If so, how?

Students should also record moments when they feel contemplative, quiet, or thoughtful—this doesn't necessarily mean happy or sad, but it does mean a moment when they are able to have their thoughts to themselves. In other words, distractions are put aside, music is off, and the phone and computer are far away. If a moment like this is difficult to come by, advise students to make an effort to create it. They should record what it is they find themselves thinking about.

- Is it a challenge to get time alone with their thoughts? Is this time respected?
- What do they enjoy or find themselves doing at these times?

Have students reflect on these moments and share their thoughts about them. Before handing in the journal, students should read through their entries and write one last entry that reflects on the two moods of the journal, or make any comments about the events they recorded in the past week.

- Did they discover anything new about themselves through this exercise?
- Did their thoughts change about anything?

They should also take note of entries they would be willing to share with another student in class.

2. Have students bring in completed journals with final reflections and comments. Divide the class into discussion pairs. Students will share a story of at least one clash and one quiet moment with their partners. In regards to the clashes, have students discuss why they think things happened the way they did and work together to imagine how things may have happened differently. Ask students to make an outline of the sequence of events; the effects of the clash; how they felt about it and why. Using the outlines, both students will brainstorm interventionist strategies so that the events would have turned out differently: for instance, listening instead of interrupting; not raising one's voice; focusing on the problem; being fair and respectful; not focusing on winning or being right; and so on. Once students have composed a list of strategies, they should write them directly onto their outlines using arrows to indicate when a strategy may have been used. Remind students that these strategies apply to all sides of the clash. In regards to the quiet moments, ask students:
- What did they do? What did they enjoy? Was it a new experience?
- What was it like to read and write about quiet moments alongside instances of conflict? Does reading affect your thoughts about your writing, and vice versa?

3. In a class discussion, have students share some of their strategies for dealing with conflict. Ask students:
- What are some common strategies?
- What do they think could be their most effective strategy and why?

Since conflict does not just arise out of our dealings with others, but also out of frustrations in our lives, the conversation might take a turn towards thinking about how we channel these frustrations.

4. Introduce students to the works of Noguchi Rika. Explain that she used a pinhole camera to take pictures for "The Sun" series. She began this series when she was asked to make photographs of a certain color, and then learned that the sun contains all of the colors. So she began to photograph the sun.[1] (You might explain to your students the simplicity of

IV : INTEGRATING CURRICULUM

the pinhole camera: a small lightproof box with a single hole that makes an inverted image directly onto film.)

5. Show Daniel Guzmán's *Brutal Youth*, from the sculpture series "Everything is Temporary," which could be seen as a makeshift altar—one that stands and perhaps worships at the threshold of teenage angst, if only to take them to create a uniquely energized defiance.

6. Present Annie Pootoogook's drawings *Dr Phil* and *A True Story*. Pootoogook chronicles the realities of her surroundings, her community, and her life in carefully outlined black shapes with blocks of solid color.

7. Regarding the artworks, ask the students to relate their journal experiences or conflict strategies to Noguchi's, Guzmán's, and Pootoogook's works.

VARIATION ON THE LESSON:

Have students make their own pinhole cameras and write about the photographs they take. Challenge students to produce images that are contemplative, and also images that register conflict.

ASSESSMENT:

Evaluate students' journaling and participation in class discussions. Were students able to relate their journaling experiences with the artists presented?

ADDITIONAL RESOURCES:

For information on pinhole cameras and how to make them, refer to http://www.pinholeday.org/support/

Engaging the Local Community

OBJECTIVES:

- Students will examine a local issue.
- Students will find creative ways of highlighting what is at stake and relevant about the local issue for a specific audience.

TIME: Two to five sessions and one to two weeks of collecting articles

ARTIST RESOURCES:

Shaina Anand: *Rustle TV* (2004) and *World Information City TV* (2005)

Nari Ward: *Diamond Gym: Action Network* (2008) (Figure 130)

SUGGESTED PROCEDURES:

1. Over the course of a week or two, bring in local newspapers and have students start cutting out or photocopying editorials and news items about a local issue. This might have to do with jobs, housing, pollution, immigration, school policy, etc. Alternatively, the issue could be one of national importance, but students should be looking for articles that discuss how the national issue is locally relevant. All students should have copies of or access to this growing archive of local issues so they may read all of the articles and keep their own log of the current issues in the community. After one or two weeks of reading and logging, break students into small groups and have each group select an issue about which they would like to research, write, and present.

2. Each individual group is responsible for charting their issue and keeping a bibliography of their sources. Students will outline and research the following:
 - the history and context of the issue;
 - the nuances of the core issues;
 - what is at stake;
 - the relevance of the issue, for whom, and why now;
 - who and what is affected by the issue and how;
 - how these parties talk about the issue—what they claim their concerns and interests are.
 These questions should be answered as fully and clearly as possible. This will enable students to come to a nuanced understanding of their issue, and confidently articulate their thoughts about it.

3. Once students are satisfied that they have a thorough grasp of their issue and its implications, they will come up with a proposal for a visual project or campaign that succinctly communicates what the group believes is important about the issue for a *specific public*. Since these are proposals, students should be as creative as possible in their outreach strategies.

4. Students will present their research and proposals to the class for feedback and critique. The research should be handed in as a typed, itemized paper with bibliography, and paired with proposals, whether as handouts or a digital presentation to the class.

5. Before students begin work on their proposals, introduce them to Nari Ward and Shaina Anand. Have them read about the artists and look at their artwork. The following questions can serve as an entry to a brainstorming session about strategies they can use for their own project proposals:

 - How did Nari Ward's *Diamond Gym: Action Network* address the local community? Give specific examples from the work.

 - How and why were Shaina Anand's *Rustle TV* and *World Information City TV* connected to the local community?

 - In the works mentioned above, Ward and Anand used methods and mediums to involve the participation of a local community. What are their methods or mediums? What do you think these achieve?

 - What do these say about the authorship of the artworks?

 - How do *Rustle TV* and *World Information City TV*, which incorporate elements of documentary video, question notions of objectivity and authority? What is the significance of this questioning?

ASSESSMENT:

- Evaluate students' ability to unpack, engage, and think critically about the local issue; how it is relevant for different groups; and how different interests can change the way it is framed.

- During the initial research and logging of issues, are students properly citing articles and relevant issues?

- In the discussion about Nari Ward and Shaina Anand, did students come to understand:
 - the means of effecting the participation of the local community?
 - how questioning objectivity and authority are relevant in (re)framing local issues to a specific audience?

- Do the student group projects and proposals demonstrate:
 - a thorough and nuanced understanding of their issue;

- research beyond the classroom archive of articles (in bibliography)?
- the relevance of their issue to a specific public and their ability to present this creatively?

ADDITIONAL RESOURCES:

For more information on *Rustle TV* and *World Information City TV*, visit ChitraKarKhana, a website founded by Shaina Anand, at www.chitrakarkhana.net

Assembly: Past and Present

OBJECTIVES:

- Students will conduct research and write a paper profiling a figure from a liberation movement of the latter half of the twentieth century.
- Students will take this research and make a collage of thoughts, ideas, and goals that were particularly galvanizing for this person.
- Students will research a current international affair that they have read or heard about in the news that they imagine would resonate with the core concerns of the figure they are profiling. Students are to imagine what the figure they chose would have to say about this present situation. These concerns will be added to the collage.
- Utilizing all of their research and their collage, students will prepare a speech concerning the current international affair in the voice of the figure they profiled and present all work to the class.

TIME: Two sessions and a month for research, collage, and writing

MATERIALS: A large and sturdy sheet of paper upon which a collage can be assembled, glue, tape, scissors, colored pencils, pens, markers, paints, etc. (if desired), magazines, newspapers, photos, textiles, maps, or any other found material that can be cut and affixed to the sheet of paper

ARTIST RESOURCES:

Wangechi Mutu: *Try dismantling the little empire inside of you* (2007) (Figure 79)
Xiuzhen Yin: *Collective Subconscious* (2007) (pp. 302–303)

SUGGESTED PROCEDURES:

1. Students will study and research influential figures from liberation movements of the latter half of the twentieth century. These are open to interpretation and inclusive of: civil rights across a spectrum of identifications, national independence, and the overthrow or dissolution of oppressive regimes; or any that may have failed in their specific goals, but whose aims still resonate.

2. Students will write a profile or biography of the figure they choose (600 words in length) and include a bibliography. The paper will contextualize how this person came to be involved or

influential to the movement, their particular role, and how they are presently regarded. It will also include a brief history of the movement and its present form or legacy.

3. Students will be preparing their own collages as they conduct their research. Introduce them to Wangechi Mutu and Xiuzhen Yin, and the concepts of **assemblage** and **collage**, and have them read the artists' practice writing so the students have background information on the artists. Show students Mutu's *Try dismantling the little empire inside of you* and Yin's *Collective Subconscious*. Ask students the following and have them take notes:

 • Describe the specific elements you see in both works. What is happening in each image?

 • How do the titles impact your understanding of the works?

 • To what historical legacy does each artwork refer?

 • What is present and what is past in each of these works? How are they understood or characterized?

 • A collaged subjectivity can be read in each work: what is their substance and character? How is Mutu's work performative?

4. On a large sheet of paper, students will begin a collage (either at home or at school) conveying their figure's relationship to their particular movement. The visual metaphors might allude to personal history, geography, friends, thoughts, actions, and so on. Remind students to look at their notes regarding the class discussion about the visual elements and strategies of Mutu's and Yin's work if they need guidance in their collage.

5. As students conduct research on their figure, they should also be paying attention to the international news for a story that they think their figure would feel is akin to the struggle they faced in their movement. Students should keep notes on their research of the current affair and maintain an annotated bibliography that will be handed in with the final written speech.

6. Students will build upon their collage with themes, facts, and other elements extrapolated from their notes and research on the current affair. This might include maps, drawing, text, or cutout images. Students should title their finished collages.

7. With the aid of their research and the visual mapping provided by their collage, students will write a 400–600-word speech about the current international affair in the voice of the figure they have profiled. Students should focus on what they think their figure would want to say and why. This speech should convey extensive knowledge of the current situation and familiarity with the context and resonating concerns of their chosen figure. The speeches can be given in front of the class and presented alongside the collages.

VARIATION ON THE LESSON:

Rather than having students focus on several different current international affairs by giving single speeches, students will engage in debates with one another, in the voice of their profile figure, about a current affair that has been assigned to everyone in the class to research.

ASSESSMENT:

Evaluate the student speeches for comprehension of the profiled figure's subjectivity and role in a given liberation movement, and the relevance of this figure in a given current-day international affair.

CHAPTER 4 NOTES

1 "Noguchi Rika," *Life on Mars*, 2009, available at
 http://blog.cmoa.org/CI08/2008/02/noguchi-rika.php
 (accessed March 3, 2010).

CHAPTER 4 BIBLIOGRAPHY

"Noguchi Rika," *Life on Mars,* 2009, available at
 http://blog.cmoa.org/CI08/2008/02/noguchi-rika.php
 (accessed March 3, 2010).

HISTORY AND HISTORICISM

Avril Sergeon and Dina Weiss

SUBJECT AREAS: English, Social Studies, History, Art, and Media Studies

History is the branch of human knowledge that deals with people, things, events, and cultural phenomena of past periods in time. As such, the discipline relies on eye-witness narrative, memory, record-keeping, and analysis. Historicism refers to the theory that history is determined by laws, not by human agency, and that contemporary social, political, and cultural phenomena are in turn governed by the past. Each period of history possesses specific underlying conditions of "truth" that constitute what is "acceptable" for the time.[1] Interpretations of the past are subject to change in response to new evidence, new questions asked of the evidence, and new perspectives gained by the passage of time. There is no single, eternal, and immutable "truth" about past events and their meaning. The unending quest of historians for understanding the past—that is, "revisionism"—is what makes history vital and meaningful.

This chapter examines how contemporary art practitioners, while purveying new ideas and processes, are linked to the past through their awareness and celebration of history and their mining of that past for inspiration. In contemporary art production, we are witnessing the deliberate use and revival of historical styles of representation; the inclusion of personal and public archival material to construct narratives in various contexts; and a direct and formal reference to earlier works of art in order to create new art. The theorist Paul Hamilton states, "Artworks and historical events....are inseparable from their moment."[2] This raises certain questions. How are contemporary artists making the past relevant? Are they providing a historicist reading? Are the artworks discussed "inseparable from their moment" or do they have future relevance? Like historian James McPherson's statement, "[h]istory is a continuing dialogue between the present and the past,"[3] artists in this chapter are in conversation with history and provide us with another interpretation for understanding where we have been and posit future possibilities of where we will be.

Facts and Fiction: A Constructed Connection

OBJECTIVES:

- Students will gain an understanding as to how history can be reinterpreted and re-presented, blurring the lines between fact and fiction.
- Students will learn how historical events and movements can influence artistic practice.
- Students will engage in a writing project to create their own narrative based on a historical event.

TIME: Two sessions

MATERIALS: Pen and paper

ARTIST RESOURCES:

Leslie Hewitt: "Make It Plain" series (2006–08) (Figure 50 and p. 261)

Walid Raad: *My neck is thinner than a hair: Engines* (2001) (Figure 97)

SUGGESTED PROCEDURES:

1. Begin lesson by engaging students in a discussion about history. Read the introduction of this curriculum to students and have them summarize history and historicism. Ask students:
 - How do we decide what are historical facts?
 - Who sifts through data and records history?
 - Is history objective?

2. Explore how **facts** and **fiction** are woven together in films and literature. For example, docudramas and memoirs are based on true stories. Have students list books and films that contain factual and fictionalized accounts. How are facts and fiction blurred within these art forms?

3. Present images from Leslie Hewitt's project "Make It Plain," a series of photographs that reference social and political history of the 1960s and 1970s. "Make It Plain" was an expression used by Malcolm X, one of the civil rights **activists** of the twentieth century.[4] This phrase was a reminder for Malcolm X to keep the focus on the audience—not on the man—and on his message of activism and change.[5] Ask students to comment on Hewitt's intention in **appropriating** this phrase to describe her art.
 - Why might an artist reference an expression from the Civil Rights Movement?

- How is she retrieving memories and mediating access to them?
- By looking at her photographs, what can we discern about the ideas and images in the contemporary narrative she has created?

4. Walid Raad is an artist who references the history of his homeland and uses available images/objects to produce art that is a commentary on radical changes and events in Lebanon.[6] Raad produces projects under the **aegis** of the Atlas Group, a foundation that is a **Conceptual art paradigm** for documenting, analyzing, and re-presenting Lebanese history.[7] Read about Raad and present his work *My neck is thinner than a hair: Engines*. Explain that this is a photographic series about car bombs detonated in Lebanon during the civil war that lasted from 1975 to 1992. The photographs and Arabic text are Raad's attempt to document, in a manner merging artistic practice with the statistical and factual, the types of cars containing bombs and the circumstances surrounding each detonation. Ask students:

- What is the artist's intention in presenting this investigative project?
- What is suggested about the artist's point of view regarding the Lebanese civil war?
- To what degree can we separate the reality of the events from the artist's imagination?
- How do these artworks compare to the way war is presented by the news media?

5. Have students focus on the similar ways Leslie Hewitt and Walid Raad refer to historical events but use their imagination and artistic practice to create another narrative. In what ways do the artists make history more vivid and relevant to a contemporary audience?

6. Have students do a writing assignment. Ask each student to select an event (no earlier than 2000) that has had major social or political impact. Have students create a narrative that departs from historical reality by including scenarios based on the students' imagination and individual perspective. The intent is to re-present the facts based on a set of "what if" questions and, in so doing, address how historical material is documented and preserved.

7. Students will share and discuss their narratives as a group. Focus on how each student has integrated the fictional and factual in their writing. How would their invented re-telling of history impact society?

EXTENDING THE LESSON IN LITERATURE:

Read *What Is the What: The Autobiography of Valentino Achak Deng* by Dave Eggers (New York: McSweeney, 2006). This book is the fictionalized 'autobiography' of a real-life refugee of the Sudanese civil war. The author assumes the voice of the refugee to describe wartime events and their aftermath in East Africa. The book is typical of Eggers's style, blending nonfictional and fictional elements into a nonfiction novel or memoir. By labeling the book a novel, Eggers says, he freed himself to re-create conversations, streamline complex relationships, add relevant detail, and manipulate time and space while maintaining the essential truthfulness of the storytelling.

EXTENDING THE LESSON IN CONTEMPORARY ART:

Mickalene Thomas is an artist who has investigated the 1970s to create her paintings and photographs. Her work references both popular culture and fine art, and has strong elements of fantasy. See her series "A-E-I-O-U and Sometimes Y" (2009).

ASSESSMENT:

- Evaluate the students' participation through the discussions and the use of new terminology.
- Review their writing assignments for comprehension on the blurring of fiction and facts as it relates to history.

ADDITIONAL RESOURCES:

Dave Eggers, *What Is the What: The Autobiography of Valentino Achak Deng* (New York: Vintage Books, 2006).

Images of "A-E-I-O-U and Sometimes Y" can be found under the "Available Works" section at: http://www.lehmannmaupin.com/#/artists/mickalene-thomas/

Cross-Fertilization: Art, Craft, and Community

OBJECTIVES:

- Students will develop an understanding of how history, in the form of traditional crafts, has influenced contemporary art.
- Students will learn how artistic practice can promote and shape community.
- Students will reflect on their own activities to develop an artwork for a chosen community.

TIME: Two sessions

MATERIALS: Computer, scanner, computer programs for designing or manipulating images, images from magazines or the Internet

ARTIST RESOURCES:

Ginger Brooks Takahashi: *an army of lovers cannot fail* (1994–) (Figure 20)

Margaret Kilgallen: *Half Past* (1999) (Figures 62 and 63) and *Main Drag* (2001) (p. 267)

Lara Schnitger: *Room in my Heart for Another Cat* (2009) (Figure 106) and *Cupidity (after Bronzino)* (2009) (Figure 107)

SUGGESTED PROCEDURES:

1. Introduce students to the concept of **cross-fertilization** and examine it in relation to **community**. Explain that a community can be a physical or cultural construct. Ask students to share the various communities in which they participate. What are the ideas, practices, and goals necessary to organizing a community and its projects? Have students compare different communities and their needs (e.g. a community with diversity versus an exclusive group of individuals with similar interests).

2. Present Ginger Brooks Takahashi's quilt project, *an army of lovers cannot fail*. What community tradition does Brooks Takahashi's work suggest? Ask students if they have heard of the quilting bee. The term applies to a group of women, and sometimes men, who work on designing and stitching a quilt as a communal project. The quilt is **embroidered** with white rabbits and women against a white background. Brooks Takahashi's design for this work is a departure from traditional colorful patterns dating back to the mid-nineteenth century.[8] Why do you think Brooks Takahashi chose one color—white particularly—instead of multiple

colors? The subtle tone change of the thread against the cloth forces viewers to look closely at the work in order to decipher the subject matter. Why do you think Brooks Takahashi made this decision with the subject matter embroidered in the work?

3. Have students take turns reading aloud the poem "The Low Road," by Marge Piercy.[9] What does the title, *an army of lovers cannot fail*, suggest about the quilt project? How does it relate to the ideas in this poem, which inspired Brooks Takahashi?

4. Brooks Takahashi hosts periodic events called "POWERSTITCH," where she invites people, often from the **queer**, **feminist** community, to come together to quilt while reading and dialoguing about gender issues, social conditions, and sexual matters, for example. Ask students how the POWERSTITCH event embodies and challenges the concept of a traditional quilting bee.

 • What does the title suggest about the overall process of the artwork?

 • What do students feel the POWERSTITCH events accomplish?

 • How does this artwork promote community, solidarity, and visibility?

5. The poem "The Low Road" has an emphasis on overcoming obstacles. How does a POWERSTITCH involving a queer, feminist community, for instance, relate to the poem? For possible insight, have students look at the collaborative project *LTTR*, an art journal which addresses the concerns of the queer, feminist community by questioning the **status quo** and, in turn, proposing solutions.[10]

6. Define **site-specific art** and discuss how an artist may experience freedom or constraints to their vision by the physical location or exhibition space. Refer to Chapter 1, Lesson 1, "Function and the Ins and Outs of Space," for more suggestions.

7. Integrate Margaret Kilgallen's *Half Past* and *Main Drag* into the discussion. Kilgallen, who passed away in 2001, was a central figure in the formation of the Mission School, also called New Folk or Urban Rustic, in San Francisco.[11] Her sources of inspiration were varied: **Folk art**; old hand-painted shop signs; nineteenth-century **typography**; South and Southeast Asian figuration and pattern; and hobo train writing, a form of **graffiti**.[12] Based on this information, ask students to analyze the line, colors, composition, and narrative content of Kilgallen's paintings.

8. Comment on the subject matter of Kilgallen's work.

 • Who is she primarily portraying?

 • How are features presented?

 • What are the people portrayed doing?

 Margaret Kilgallen believed in the need for women to be visible "in our every day landscape, working hard and doing their own thing, whether you like it or not, whether it's acceptable or not."[13] Like Brooks Takahashi, Kilgallen celebrates a community of women through

her artistic practice. Her women, while leading socially traditional lives, are portrayed as adventurous, powerful, and spirited. Have students list out the similarities of Kilgallen's and Brooks Takahashi's art and discuss how each artist forms a community based on ideas of independence and activism within different social spheres.

9 Divide the class into small groups and have students describe their activities that are organized along community lines (e.g. book clubs, music groupies, social volunteer work, and online social networks). Each group will choose a community and identify its goals. They will then work collaboratively to create a poster or logo, using images and text, to convey the role and objectives of the specific community.

10. Present and discuss the resulting projects. How well do the **iconography** and text convey their community's purpose or goals? Evaluate the potential that the artwork has to promote the students' chosen community.

EXTENDING THE LESSON IN LITERATURE:

Have students read Virginia Woolf's essay *A Room of One's Own.* Woolf was an English novelist and essayist regarded as one of the first modern woman thinkers and writers of the twentieth century. Examine the ideas in the book that may relate to today's women—of all backgrounds.

EXTENDING THE LESSON IN CONTEMPORARY ART:

Read about Lara Schnitger and her paintings *Room in my Heart for Another Cat* and *Cupidity (after Bronzino)*, which recall the legacy of 1970s American feminism as well as referencing the Mannerists of the Renaissance period. Have students write an analysis about Schnitger's works, focusing on the works' relationship to history and historicism.

ASSESSMENT:

- Evaluate students' participation through the discussions and use of new terminology.
- Evaluate the effectiveness of the iconography and text used in the project.

ADDITIONAL RESOURCES:

Ginger Brooks Takahashi, artist's website, available at http://www.brookstakahashi.com

For the poem "The Low Road" by Marge Piercy go to http://www.margepiercy.com/sampling/ The_Low_Road.htm

For more information on *LTTR* go to http://www.lttr.org/

For an online version of Virginia Woolf's *A Room of One's Own*, visit http://ebooks.adelaide.edu. au/w/woolf/virginia/w91r/index.html

Disrupting Convention: The Uncommissioned Portrait

OBJECTIVES:

- Students will learn about portrait painting and its historical role.
- Students will analyze the radical elements in the practice of two contemporary practitioners of portraiture and their sources of inspiration.

TIME: Two sessions

MATERIALS: Pens, pencils (graphite and colored), paper, canvas board or thick paper, acrylic paint, brushes, water containers, palette paper, personal photographs of family and friends, magazine/newspaper/Internet images of popular icons

ARTIST RESOURCES:

Elizabeth Peyton: refer to the G:Class website, www.gclass.org
Kehinde Wiley: *Dogon Couple* (2008) (p. 300)

SUGGESTED PROCEDURES:

1. Begin lesson by defining **convention** and showing students some notable portraits, such as Jacques Louis David's *Napoleon on Horseback* (1801). Ask students:
 - What are the elements of a portrait?
 - What functions do they think portraits served and has this changed over time? How?

2. Share with your students the history of portraiture and its historical function. As early as the fifteenth-century, portraits have been **commissioned** by celebrated individuals of certain classes, races, and statuses, resulting in the professionalization of the genre and the creation of an **aesthetic** value for portraiture.[14] According to art historian Shearer West: "Aesthetic value—the perceived quality of the of the portrait as a skillful, inventive, or beautiful work of art—has only rarely been the primary inspiration in the commissioning, display, and reception of portraits."[15] West goes on to say that a commissioned portrait was the norm. A portrait signified power, wealth, and entitlement. Why would it be important to display these attributes?

3. Share with students the writing on Elizabeth Peyton. Peyton states that she wants "to make a likeness but also to make a piece of art. I want to make something that's really magical … I don't want to copy people … [T]here's something bigger to be had in making

a painting of somebody."[16] Present Peyton's works from the G:Class website. Tell students that these portraits were not commissioned. Peyton declares of her subjects, "It's just who I'm very interested in, and identify with, and see as very hopeful in the world."[17]

- Which portraits do students recognize?
- How has the artist departed from our previous conversation for creating a portrait?
- What is the context and function of Peyton's portraits?
- Why might she identify with the people portrayed?

4. Peyton's portraits have been described as transcendental, personal, and emotional. Ask students to comment on these descriptions. Describe the subjects' poses, expressions, and moods.

 - How has Peyton conveyed a sense of her subjects' passions, inner struggles, and exceptional qualities?
 - What sense of a connection or feeling is conjured between you and the paintings?
 - What is the "something bigger" that Peyton has specified about her paintings?

 New Museum curator Laura Hoptman provides clues in her essay on Peyton: "[I]t was and is the most radical example of a particular kind of popular realism that emerged in the 1990s and reached its apex during ... the new millennium."[18] She goes on to describe them as appealing, fueling criticism from those "suspicious enough of visual pleasure to have written it out of the aesthetic conversation."[19] Ask students to comment on Hoptman's statements while looking at the portraits.

 - What are the qualities that make the work appealing and provide visual pleasure?

5. Introduce students to Kehinde Wiley and present *Dogon Couple* from the series "The World Stage: AFRICA Lagos-Dakar."[20] The series is an international project which Wiley continues his process of memorializing strangers using "his signature blend of portraiture and intense engagement with art historical imagery."[21] Like Peyton, Wiley's main body of work is not commission-based. The artist has stated, "I look for people who possess a certain type of power in the streets."[22] He often approaches strangers and invites them to sit for a portrait. Although the sitter is contemporary, Wiley frequently references historical painting and sculpture. Ask students to identify the **appropriated** signifiers of power and class that Wiley uses in the series of paintings.

 - What is the significance of the props and ornamentation in the paintings?
 - How is the artist using the signifiers of power and beauty from the past to make a statement about the contemporary black male's position in society?

6. After examining Peyton's and Wiley's portraits, have students write a paragraph expressing their views on how these artists have revisioned the portraiture genre and turned it into a

commentary on **popular culture**. How do the artists represent contemporary concerns, such as issues of class, race, gender, and social power?

7. Inform the class that Peyton and Wiley have both used photographs as references for their painting processes. Have students use the photographs they brought as a starting point to create a drawing or painting. Each artwork is to be accompanied by a label outlining specific choices, such as their inspiration, art-making process, and reasons for making the artwork. Students will present and discuss their paintings and labels and their relationships to the larger theme of history and historicism.

EXTENDING THE LESSON IN LITERATURE:

A biography, the story of a person's life and accomplishments, is a form of portraiture in words. Have students read *The Biography of Benazir Bhutto* by Omar Norman (Routledge Contemporary South Asian Series, 2010). Bhutto was the first woman elected to lead a Muslim state and served twice as Prime Minister of Pakistan. In 2008, the year following her assassination, she was named one of seven winners of the United Nations Prize in the Field of Human Rights.

EXTENDING THE LESSON IN CONTEMPORARY ART:

Have students look at the photographs of Catherine Opie, a California artist who has captured the faces and images of the Lesbian Bisexual Gay Transgender Queer (LBGTQ) community. Her intention has been to demystify that culture and provide an introduction to members of those communities. Her series "Domestic" (1995–98) are large-scale, color photographs that document lesbian families engaged in everyday household activities, in settings varying from city apartments to country homes. Repositioning these families within the iconography of the classic American home, Opie envisions a more inclusive, complex image of the contemporary family.

ASSESSMENT:

* Evaluate students' participation through the discussions and use of new terminology.
* Critique the completed portrait assignments and the relevance of their labels.

ADDITIONAL RESOURCES:

Kehinde Wiley's website, at http://www.kehindewiley.com/

Elizabeth Peyton, G:Class website, at http://www.gclass.org/tools/LiveForeverElizabethPeyton

Omar Norman, *The Biography of Benazir Bhutto* (New York: Routledge Contemporary South Asian Series, 2010).

For images of Catherine Opie's series "Domestic" (1995–98) visit Regen Projects at www.regenprojects.com

LESSON 4

Authorship and Ownership: Understanding Heritage

OBJECTIVES:

- Students will examine how artists respond to the role history and artifacts have in society; specifically, how historical information and objects are collected and documented.
- Through discussions, students will learn how new histories can be revealed; how past histories are revised; and the ways in which such practices can reshape perspectives.
- Students will conduct a debate regarding ownership claims to cultural artifacts and authorship rights for documenting history.

TIME: Two sessions

MATERIALS: Pens, pencils, and paper

ARTIST RESOURCES:

Michael Rakowitz: *the invisible enemy should not exist* (2007–) (Figure 100 and p. 284)

Dahn Vo: *Untitled, a project of the indigenous people in the Central Highlands of Vietnam* (2007–)

SUGGESTED PROCEDURES:

1. Explore how historical information and artifacts are collected and presented. Discuss students' experiences with objects from museums, historical sites, and personal collections. Examine the question of who has the right to own historical and cultural artifacts in a community.

2. Engage students in a discussion about who are the authors of history.
 - Where do historians get their information?
 - Can all written history be considered factual and accurate?
 - What role does personal bias or opinion play in documenting the official history of a community?

3. Have students choose an object in their community or home and gather information about its history by identifying the object's origin, use, and cultural significance. Have students share the collected information and the primary and secondary resources used to acquire its history. What types of primary and secondary resources were utilized?

4. Read about Dahn Vo and present his work *Untitled, a project of the indigenous people in the Central Highlands of Vietnam.*
 - Why do you think Vo is compelled to collect objects?
 - How is Vo addressing issues of personal displacement and national identity?
 - How does displacement disrupt cultural identity and ownership?

5. Have students read selected letters of the correspondence between Dahn Vo and Jay Camp concerning the eBay auctions where Vo purchased Vietnamese artifacts. Camp is a former US Military Special Forces member who collected artifacts from the Central Highlands of Vietnam.
 - What motivated military personnel to collect these artifacts?
 - Does acquiring an object through purchase or gift mean rightful ownership of that object? Explain.

6. Discuss whether political refugees continue to have rights to the cultural history and artifacts of their country of origin. Explore the ways Vo is approaching this question in his art practice. What position does he appear to present?

7. Read about Michael Rakowitz and his project *the invisible enemy should not exist*. Ask students to describe the images.
 - What are the objects made from?
 - How are the objects presented?
 - What setting does the installation of the objects suggest?

8. Explore how cultural history or national heritage can be compromised by conditions of conflict. How can a country protect and preserve its history in the midst of war, migration, and destruction? Discuss with students whether they would be concerned about preserving their cultures if confronted with wartime conditions in their own country. If so:
 - What types of information and objects of culture do they think are important to preserve?
 - How is our society committed to the preservation of our cultural history?
 - Do they think this would continue during wartime? Why?

9. Introduce students to the term repatriation and the Federal law Native American Grave Protection and Repatriation Act (NAGPRA) passed in 1990.
 > NAGPRA provides a process for museums and Federal agencies to return certain Native American cultural items—human remains, funerary objects, sacred objects, and objects of cultural patrimony—to lineal descendants, culturally affiliated Indian tribes, and Native Hawaiian organizations.[23]
 - How are Vo and Rakowitz addressing this possibility?
 - What do they think the protocol for repatriating "cultural items" would look like?

10. Conduct a debate-style discussion that addresses issues raised by the artists' practices and class discussions. The purpose of the debate is to establish the difference between two opposing viewpoints on who should own and claim authorship of historical information and artifacts. Students can take account of the following questions in preparing for the debate:
 - What types of information and objects are considered historically and culturally significant to society?
 - How do cultures gather information and form collections?
 - Who should have ownership of cultural objects?
 - How should these objects and information be presented to the public?

11. To begin the debate, separate the class in two groups and assign them a position—affirmative or negative—for a topic. For the format of the debate, refer to Chapter 2, Lesson 7 ("Active Integration: Changing Political Agendas"). Suggested debate questions:
 - Should artifacts remain with (or be returned to) their original country and people?
 - Should anyone be able to take an artifact from a country and claim ownership?

12. Have students vote on the positions that were presented most convincingly and discuss the changes in original opinions. Why did opinions change? What does this suggest about the construction of history?

EXTENDING THE LESSON IN LITERATURE:

Read selected letters from *Between Father and Son* by Nobel Laureate V.S. Naipaul (New York: Alfred A. Knopf, 1999). Through the letters of family members to each other, a story develops of a family clinging to one another against the sadness of dislocation and isolation. Although he always spoke and wrote English, Naipaul's self-imposed exile to England from his native Trinidad represented a profound cultural shift. This novel-like correspondence bears witness to the writer's transformation from an expatriate adrift to a world-renowned man of letters.

EXTENDING THE LESSON IN CONTEMPORARY ART:

Nikhil Chopra is an artist who embraces family history and cultural heritage in his practice. His semi-autobiographical performances react to and capture a particular place and moment in history, yet are distinctly situated in the "now." By layering the past onto the present, Chopra's work offers key insights into how the past influences our current situation. More information on Chopra is located on the G:class website.

ASSESSMENT:

- Evaluate students' participation in the discussions and use of new terminology.
- Examine the rigor in the debates, and assess whether students were able to make compelling arguments in their positions.

ADDITIONAL RESOURCES:

Michael Rakowitz's website, at www.michaelrakowitz.com/

V.S. Naipaul, *Between Father and Son* (New York: Alfred A. Knopf, 1999).

Place and Circumstance

OBJECTIVES:

- Students will investigate how artists respond to the sociopolitical and cultural circumstance of the place in which they have worked or lived.
- Students will analyze the community history of their own environment and the circumstances that have decided the fate of a specific location in their community.
- Through a discussion and writing activity, students will create a proposal or redesign for a site in their own community that is in need of change.

TIME: Two sessions

MATERIALS: Local map, images of selected site/building, paper, pens, pencils, tracing paper, graph paper, rulers

ARTIST RESOURCES:

Carlos Garaicoa: "Overlapping" series (2006–)

Walid Raad: "Let's Be Honest, the Weather Helped" (1984–2007) (p. 283)

Julie Mehretu: *Black City* (2005) and *Black City* (2007) (p. 275)

SUGGESTED PROCEDURES:

1. Begin by leading students in a discussion about **architecture** and architectural **environments**. Focus on how buildings and monuments can be perceived as cultural and political symbols. Explore how communities define themselves by their architectural sites.

2. Assign students to identify images and/or create a list of places in their environment that are significant—socially, politically, and historically. Have the students share specific circumstances, events, or stories about these sites. How would their neighborhood be affected by the redesign or destruction of a specific place?

3. Identify a location in the community that shows how political and societal influences can alter the architectural landscape. An example in New York City is the demolition of Pennsylvania Station in 1964, its move to Madison Square Garden in 1968, and current plans to redesign, relocate, and rename the train station in honor of a senator.[24] Have your class research the history of sites such as stadiums, abandoned factories, and municipal buildings, and consider the possibilities for **repurposing** or rebuilding.

4. In his conceptual practice, Carlos Garaicoa has responded to the influence and shifts of politics and social structures, particularly within urban landscapes, by investigating the decay of the urban environment. His practice has grown to embrace international locations and often retains a focus on architectural history, structural usage, and temporal changes. Present images from Garaicoa's photography-based series "Overlapping." Ask students to describe the images and the materials used.

 • In what ways has Garaicoa altered specific buildings?

 • What ideas can be derived from the titles and his process of layering and filling in empty spaces?

5. Explore the ways the images represent architectural renewal and/or decay. How can history be presented in architecture? Discuss why Garaicoa adds to the images and the possible meanings derived by constructing them out of threads.

 • What are the meanings underlying this addition and the use of a fragile material?

 • How are his interventions with the photographs similar to sculpture and architecture?

6. View and discuss the work of Walid Raad. Look at the Atlas Project, in particular the photographic series "Let's Be Honest, the Weather Helped." These are images of Beirut, the capital city of Lebanon. Present students with a brief history of the country during the period 1984–2007.[25] In subsequent discussions, explore what the students think the photographs are presenting. Describe the architectural environment.

 • How might the ravages be attributable to the passing of time or the fallout from the political climate?

7. Have students read and examine the following statement by Raad:

 > Like many around me in Beirut in the early 1980s, I collected bullets and shrapnel. I would run out to the streets after a night or day of shelling to remove bullets from walls, cars, and trees. I kept detailed notes of where I found every bullet by photographing the sites of my findings, and by placing colored dots over the bullet holes in my black and white photographs.[26]

 Have students discuss the meticulous documentation that informs Raad's art.

 • How important are the artist's memory and imagination to his artistic practice?

 • How does the artist convey the enormity of the circumstances that have affected his homeland?

8. Both Garaicoa and Raad explore how **ideology** and war result in events that assume a life of their own and affect the physical landscape. Assign students to write about their opinions and responses to the changes of a location/site/building in their community. Share responses and the ideas they have for repurposing this space. Ask your students to explore how altering this site would provide a new context to the place.

9. Have students develop their writings into a formal draft proposal for the selected site. They will draw or sketch out their ideas for a new site or altered space in the community. Show students examples of an architectural blueprint or community site proposal.[27] Submit the proposal statement and drawings to the local Community Planning Board.

EXTENDING THE LESSON IN LITERATURE:

Read *The Colossus of New York* by Colson Whitehead (New York: Random House, 2004). An evocation of the city that never sleeps, *The Colossus of New York* captures the city's inner and outer landscapes in a series of vignettes, meditations, and personal memories. Whitehead conveys the feelings and thoughts of longtime residents and of newcomers who dream of making it their home; of those who have conquered its challenges; and of those who struggle against its cruelties.

EXTENDING THE LESSON IN CONTEMPORARY ART:

Julie Mehretu makes large-scale, gestural paintings that convey a layering and compression of time, space, place, and art historical references. She creates new narratives using abstracted images of cities, histories, wars, and geographies. Mehretu's points of departure, in works such as *Black City* (2005) and *Black City* (2007), are architecture and the city, particularly the accelerated, compressed, densely populated, and militarized urban environments of the twenty-first century.

ASSESSMENT:

Evaluate students' participation in discussions and use of new terminology.

Review the completed projects for thoroughness, comprehension, and aesthetic decisions.

ADDITIONAL RESOURCES:

Colson Whitehead, *The Colossus of New York* (New York: Random House, 2004).

For an example of a current site proposal, see: http://www.newpennstation.org/site/action

The Confluence of History and Narrative

OBJECTIVES:

- Students will learn about artists who use history to create another means of understanding and imagining a particular period or event.
- Students will create a collage, using images and text, to provide a reading of a historically period.

TIME: Three sessions

MATERIALS: Pen, pencil, paper, photographs of students and family, historical images, contemporary images of society, scissors, glue, stencils

ARTIST RESOURCES:

Lorna Simpson: *Photo Booth* (2008) (pp. 290–291)

Glenn Ligon: *Stranger #22* (2006) (p. 269) and *Stranger #28* (2007)

Kara Walker: "Bureau of Refugees, Freedmen and Abandoned Lands-Records, 'Miscellaneous Papers' National Archives M809 Roll 23" (2007)

SUGGESTED PROCEDURES:

1. Introduce students to the term **identity**, emphasizing that it is not something fixed or possessed by an individual or group. Ask students to discuss the formation of identity as a social and psychological process mediated by the **context** of changing historical conditions.
 - How is "identity" defined in contemporary society? In what ways is it defined?
 - What determining factors have changed over time?
2. Read about Lorna Simpson and present *Photo Booth*, a work representing the artist's process of juxtaposing found images with her own drawings. In the past, Simpson has used text within her practice, providing another entry point for viewers to construct meaning. Her photographs often act as evidence of factual truth and the superimposed text prompts contemporary investigations of gender, race, and identity.[28] Ask students what they can discern about Simpson's intention in co-mingling found photographs with her abstracted drawings.
 - What is she inviting the audience to do?
 - What do the drawings represent?

 Ask students to choose a photograph or drawing and create a narrative about the image.

3. Ask students to describe the work's placement on the wall. Can they place the photographs in a specific historical period? Lorna Simpson has said, "[T]he nostalgia of how beautiful these portraits are, is one thing, but the context of the era is important with respect to what was endured at that time."[29] Have students research the context of American culture in the 1940s and share their findings.

4. Glenn Ligon's process often rests on the **appropriation** of text from past American writers by transforming their texts into paintings or sculptures. Focus on the paintings *Stranger #22* and *Stranger #28*, which are based on the seminal essay "Stranger in the Village" by James Baldwin chronicling his stay in Switzerland in the 1950s.[30] Ask students to describe the paintings. Discuss Ligon's process of using coal dust and oil sticks to stencil Baldwin's words on canvas, a process he repeats to the point of obscuring the text.[31] Ask students:
 * Why do you think the artist has made it difficult to decipher the painting?
 * What is Ligon intimating about the ability of words to communicate openly and effectively?

5. Have students read selected passages from Baldwin's essay and describe the mood of Ligon's paintings.
 * Does the art communicate similar feelings to the writing? Why or why not?
 * What is Ligon conveying about the circumstances of identity in the twenty-first century? Discuss the social and political changes that make Ligon's position in society different from that of Baldwin's in the mid-twentieth century.

6. Present images from Kara Walker's series "Bureau of Refugees, Freedmen and Abandoned Lands-Records, 'Miscellaneous Papers' National Archives M809 Roll 23." The series is named after the historical record that documented, among other things, acts against freed men and women during Reconstruction. Focus the class by looking at the images carefully and making a list of what they see, in particular Walker's use of imagery, colors, spatial arrangements, patterns, and hints of narrative. When compared to Kara Walker, Simpson and Ligon reference relatively recent periods of American history. Walker's practice references the pre-Civil War era and the aftermath of Abolition, often using the eighteenth-century medium of cut-paper **silhouettes**. Ask students:
 * How do viewers relate to the anonymity of the silhouette?
 * In what ways does the imagery create dissonance with the anonymity of the silhouette form? Arguably, her most well-known works are site-specific panoramic installations that are filled with stereotypes and caricatures. Walker's art imagines and illustrates the atrocities of slavery and the violent history of post-slavery race relations by using imagery we are often familiar with. Ask students:
 * Why are we so familiar with these images? Are they obsolete? Explain. What does this suggest about the power of images and their relationship to memory?

- What do students think Walker wants to communicate to the viewer?
- How does her use of stereotypes and caricatures subvert or support their historical intent and meaning?
- In what ways do the historical and cultural references resonate with students' knowledge of history or research of the past?

7. Referring back to the beginning of the lesson, students will create collages, imagining a narrative of an identity by appropriating images from a particular past period. Have students present their collages and lead a critique based on their comprehension of the lesson.

EXTENDING THE LESSON IN LITERATURE:

Read *The Bluest Eye* by Toni Morrison (New York: Vintage Books, 1970). The author presents the story of a poor black family living in Lorain, Ohio, in the early 1940s. The book traces the history of family members as they navigate the circumstances of their time, and documents how each family member confronts and copes with the hardships of the culture and the life he/she has been given.

EXTENDING THE LESSON IN CONTEMPORARY ART:

Adam Pendleton's conceptual practice uses language as its medium to address issues in an oblique manner. He works with language literally by combining text and image, as in the series "Black Dada" (2008), and other times figuratively by treating sculptural objects as an alphabet, such as *Ceramic Black Cubes* (2007–). Pendleton's practice demonstrates how an idea can be presented in various media and formats, and how it can also resist precise representation in works such as *Code Poem* (2009). Refer to the G:Class website for more information.

ASSESSMENT:

Evaluate students' participation in the discussions and use of new terminology.

Review students' writings and collages to assess their level of comprehension of the artworks and materials presented.

ADDITIONAL RESOURCES:

Raymond Saunders, *Black is a Color* (San Francisco: Raymond Saunders, circa 1967)

The Slavery Abolition Act of 1833, available at http://www.spiritus-temporis.com/slavery-abolition-act/

The Reconstruction Acts of 1867, available at http://www.u-s-history.com/pages/h417.html

Toni Morrison, *The Bluest Eye* (New York: Vintage Books, 1970).

Information and images for Adam Pendleton can be found at: http://www.haunchofvenison.com/en/#page=home.artists, and see the G:Class website, www.gclass.org

Re-enactments: New Insights on the Past

OBJECTIVES:

- Students will examine how historical events and sites can be re-presented through documenting and restaging.
- Students will review works by artists whose films evoke or re-create a past period or event.
- Students will explore current events and respond through group discussions and writing exercises. The goal is to delve further into the way historical situations are documented and presented.

TIME: Two sessions

MATERIALS: Pen, pencils, current magazines and newspapers

ARTIST RESOURCES:

Runa Islam: *The Restless Subject* (2008) (Figures 54 and 55)
Artur Żmijewski: *Repetition* (2005) (Figure 138)

SUGGESTED PROCEDURES:

1. Before beginning the lesson, assign students to bring in current event articles to share with the class. Students should synthesize the article and their own perspective on the event as a historical document. Concluding their writings, students must address the impact of the event on contemporary life, and how the event is relevant and important as a historical record.

2. Present and read about Runa Islam's film *The Restless Subject*. Explain to students that the conveyances in the film represented the height of technology when they were built. Students need to synthesize the film.

 - What is the time period or periods presented by the artist?
 - What are the visual clues that lead the students to their conclusions?

 Analyze the connection between the three layers of objects depicted and the artist's use of 16 mm film.

 - What perspectives of this scene does the artist layer? Which layer(s) denote an earlier time?

- How does the artist re-present that experience to current viewers of the film?
- How is this documentary-style film portraying historical periods through existing structures?

3. Runa Islam has stated: "It [film] can re-articulate time."[32] Ask the class to discuss the statement. How does the artist exhibit this statement in her practice? Examine how the artist investigates the history of technology by using the thaumatrope, an optical toy popularized in the Victorian era. What roles do nostalgia and fantasy play in the work?

4. Show stills of Artur Żmijewski's film *Repetition*. After viewing, have students write a paragraph describing what they perceive to be the focus of the action.
 - How are people interacting with each other?
 - What are the emotions expressed?
 - Do the images create empathy with any individuals or groups in the film? Explain.

 Provide students with the context for *Repetition*. Explain that the film is a re-enactment of psychologist Philip Zimbardo's research project, the Stanford Prison Experiment, conducted in 1971.[33]

 How does this information affect students' reactions to the film?

5. Discuss the outcomes of both the original research project conducted by Zimbardo and *Repetition* by Żmijewski. In both projects the role-playing became realistic and participants experienced emotional torture. In Zimbardo's experiment it had to be concluded after just six days because of the moral concerns raised by the participants' behavior.[34] In Żmijewski's film the cast decided to cease working after three days. Ask students:
 - Does the fact that it is a re-enactment change opinions about the actions of the men portrayed?
 - What is brought to our attention about the prison environment and people's reaction to being imprisoned?
 - What recent political events come to mind when discussing re-enactment? How might these events relate to Żmijewski's practice?

6. Both Islam and Żmijewski have focused a part of their artistic process on re-presenting a period in time.
 - How are their efforts in offering their perspectives on historical material for contemporary examination relevant?
 - What new insights are discovered from learning about the historical context of the subjects and comparing them to the re-enactments?

7. Have the class reorient their historical perspective by analyzing their current news event from the viewpoint of someone from the Victorian era (the period where the thaumatrope was popularized) or the 1970s (the setting for the Stanford Prison Experiment).

- How would the news event be interpreted?
- Would someone from the past view it as science fiction or a futuristic horror?

Have students consider this writing assignment as an exercise in allocating importance to cultural norms and societal perspectives when dealing with "history-worthy" events. As a class, share students' interpretive writings. Examine how history is subject to individual interpretation.

EXTENDING THE LESSON IN LITERATURE:

Read *Memoirs of Hadrian* by Marguerite Youcenar (New York: Macmillan, 2005), which is both an exploration of character and a reflection on the meaning of history. In it, Marguerite Youcenar reimagines the Emperor Hadrian's difficult boyhood, his triumphs and reversals, and finally, as emperor of Rome, his gradual reordering of a war-torn world. She exhibits imaginative insight, as a writer of the twentieth century, to guide readers through Hadrian's era.

EXTENDING THE LESSON IN CONTEMPORARY ART:

Jeremy Deller is a conceptual artist, perhaps best known for his *Battle of Orgreave* (2001). The work was a recreation of the actual *Battle of Orgreave* which occurred during the UK miners' strike in 1984. Another work, *Memory Bucket* (2003), is a documentary about Crawford, Texas— the hometown of George W Bush—and the siege in nearby Waco.

ASSESSMENT:

Evaluate students' participation through the discussions, written assignments, and use of new terminology.

ADDITIONAL RESOURCES:

Marguerite Youcenar, *Memoirs of Hadrian* (New York: Macmillan, 2005).

For more information on conceptual artist Jeremy Deller, refer to the G:Class website, at www.gclass.org

The Archive as Artistic Practice

OBJECTIVES:

- Students will learn about the archive process and its historical role.
- Students will be introduced to artists who use archiving in their artistic practice.
- Students will collaborate on an archive project for their own community.

TIME: Four sessions

MATERIALS: Pen, pencils, paper, cameras, and bookbinding materials

ARTIST RESOURCES:

Walid Raad: *The Beirut Archive/The Atlas Group* (1989–)

Rirkrit Tiravanija: *JG Reads* (2008) (Figure 124)

SUGGESTED PROCEDURES:

1. Introduce students to the concept of an archive. How is archiving a historical practice? Focus students' attention on how information is selected. Archives contain materials selected for permanent preservation on individuals, organizations, and events from an earlier period and are often regarded as a truthful record of that time. Ask students to discuss the potential for bias in an archive that may contain inaccurate or fictional information.
 - How would this compromise the archive's main function?
 - Knowing this, what can be determined about the importance of the archivist and the archival process?

2. Walid Raad's writings, videos, and photographs are created and presented using the archive format. *The Beirut Archive/The Atlas Group* (1989–) purports to be genuine histories authored by Raad and various contributing members of the Atlas Group. The Atlas Group, founded by Raad in 1989, has created archives that include fictionalized narratives to process the accounts of the Lebanese Civil War. Raad emphasizes the elements of drama and imagination over realism to portray the history of war and social strife in Lebanon.
 - Why might an artist use his imagination, such as inventing characters and documents, to present a reading of a country's history in wartime?

 In this context, examine the following statement by Raad: "The geopolitical history of contemporary Lebanon that was being written … was leaving out so much of what I

considered to be my experiences of these events … I wanted to make documents that were conscious of that."[35]

3. Rirkrit Tiravanija's practice has focused on viewer participation to activate and complete his artwork. With his film, *JG Reads* (2009), Tiravanija presents a kinetic record and performance piece with poet John Giorno at its center. The artist chose the film format to archive the career accomplishments of Giorno. Ask students:

 - What does film provide about the poet's creative life that is unavailable when only reading his words?

 The film *JG Reads* is just over ten hours in duration.

 - How might a viewer approach an archival film such as this in order to access all the information it offers?

 - If a viewer does not watch the film in its entirety, does that diminish the archive's intended function?

 - Who is the audience for an archive focusing on Giorno's life, work, and artistic community?

 Ask students to describe the setting of the film.

 - Where do they think the performance is situated?

 - Do students know anything about Giorno's Bowery neighborhood?[36] If not, share with them the history of the Bowery by visiting the New Museum's Bowery Artist Tribute website.

4. Discuss how the archivist role relates to both Raad and Tiravanija's artistic practices.

 - How important is the element of collaboration in their final projects?

 - How does their practice deviate from the traditional neutral role of the archivist?

 - What role does memory play for the artists?

5. Assign students to create an archive by conducting research on their school through interviews with current and past school community members. Solicit and review documents, photographs, and other items of historical significance to the school. Students may utilize photography, documentary writing, and drawing to record and illustrate their findings.

6. The class will meet to discuss their research findings. Have the group collate and categorize information. Divide the class into small groups and assign each an information category. The groups will organize the photographs, writings, and drawings that were collected and present their category to the class.

7. The class project's objective is to compile the research information into an archived format. This can be a book, a collection of photographs, or a video document. The archive can be created in a variety of ways, but students must discuss any necessary additions or deletions to the archive. Students will organize the materials and decide whether to print, bind, or

record for distribution. Distribute the school archive to the larger school community. Have the class examine the relevance of the information presented and assess its importance in preserving history.

EXTENDING THE LESSON IN LITERATURE:

Read *Archive Fever: A Freudian Impression* by Jacques Derrida (translated by Eric Prenowitz, University of Chicago Press, 1995). In *Archive Fever*, Jacques Derrida guides readers through, among other concepts, a deconstructive analysis of the notion of archiving. Derrida also analyzes the pervasive impact of electronic media, particularly e-mail, which threaten to transform public archives and private spaces. The philosopher argues that, although the archive is a public entity, it is also the repository of the private and personal.

EXTENDING THE LESSON IN CONTEMPORARY ART:

In discussing his artistic practice, Fred Wilson says that he is not interested in creating art objects, but in "bringing together objects that are in the world, manipulating them, working with spatial arrangements, and having things presented in the way I want to see them."[37] Wilson is perhaps best known for his interventions with museum collections where he re-contextualizes the meaning of objects in museum archives by creating new installations of familiar objects. He is assuming the role of curator/archivist to encourage the viewer to question cultural institutions' interpretation of artistic value and historical truth.

ASSESSMENT:

Evaluate students' participation in the discussions and use of new terminology.
Review the archived information and its importance to their school environment.

ADDITIONAL RESOURCES:

The Atlas Group website, at www.theatlasgroup.org/

Jacques Derrida, *Archive Fever: A Freudian Impression*, translated by Eric Prenowitz (Chicago: University of Chicago Press, 1995).

Information on Fred Wilson can be found at http://www.pbs.org/art21/artists/wilson/index.html

CHAPTER 5 NOTES

1 Michel Foucault, *The Order of Things: An Archeology of the Human Sciences* (London: Tavistock, 1970).

2 Paul Hamilton, *Historicism* (London: Routledge, 1996), 14.

3 James McPherson, "Revisionist Historians," *Perspectives*, American Historical Association, September 2003, available at http://www.historians.org/perspectives/issues/2003/0309/0309pre1.cfm (accessed March 3, 2010).

4 Alex Haley with Malcolm X, *The Autobiography of Malcolm X* (New York: Ballantine, 1964).

5 Anne S. Lewis, "Malcolm, Movement, Memory," *The Austin Chronicle*, October 1, 1999, available at www.austinchronicle.com/gyrobase/Issue/story?oid=oid (accessed February 16, 2010).

6 Edgar O'Ballance, *Civil War in Lebanon, 1975–92* (London: Palgrave, 1998).

7 Walid Ra-ad/The Atlas Group website, 2010, at http://www.theatlasgroup.org/ (accessed March 1, 2010).

8 Roderick Kiracofe and Mary E. Johnson, *The American Quilt: A History of Cloth and Comfort, 1750–1950* (New York: Clarkson N. Potter, 1993).

9 Marge Piercy, *The Moon is Always Female* (New York: Alfred A. Knopf, 1980), available at http://www.nucalc.com/ron/Piercy.html (accessed February 14, 2010)

10 *LTTR* website, 2010, at http://www.lttr.org (accessed February 14, 2010).

11 Glen Helfand, "The Mission School," *San Francisco Bay Guardian*, October 28, 2002, available at http://www.sfbg.com/36/28/art_mission_school.html (accessed February 14, 2010).

12 Eungie Joo, "Margaret," *Giant Robot* 37 (1999).

13 Susan Sollins, "Interview with the artist," *Margaret Kilgallen—In the Sweet Bye & Bye*, exhibition catalogue (Los Angeles: REDCAT Art Center, California Institute of the Arts, 2005), 126.

14 Shearer West, *Portraiture* (Oxford: Oxford University Press, 2004), 14.

15 Ibid., 44.

16 Laura Hoptman, "Interview with Elizabeth Peyton," *New Museum Paper* 5 (Fall/Winter 2008), 4.

17 Ibid.

18 Laura Hoptman *et al.*, *Live Forever: Elizabeth Peyton*, exhibition catalogue (New York: New Museum and Phaidon Press, 2008), 225.

19 Ibid.

20 See images at "Painting: Kehinde Wiley," National Portrait Gallery, 2009, available at http://www.npg.si.edu/exhibit/recognize/paintings.html (accessed March 1, 2010).

21 Thelma Golden, *The World Stage: AFRICA Lagos-Dakar Kehinde Wiley*, exhibition catalogue (New York: The Studio Museum in Harlem, 2008), 5.

22 Thelma Golden, "Kehinde Wiley: the Painter who is Doing for Hip-hop Culture what Artists Once Did for the Aristocracy," *Interview Magazine*, October 2005.

23 NAGPRA website, 2010, at http://www.nps.gov/history/nagpra/ (accessed March 1, 2010).

24 Penn Station website, 2009, at http://www.newpennstation.org/site/action (accessed February 21, 2010).

25 Edgar O'Ballance, *Civil War in Lebanon, 1975–92* (London: Palgrave, 1998).

26 "Walid Raad," The Atlas Group Archives, 2010, at http://www.sfeir-semler.com/sites/raad/startraadonly.htm (accessed March 1, 2010).

27 View the current proposal for the new Penn Station as a guide for the students to understand how a proposal may look. See Penn Station website, at http://www.newpennstation.org/site/action (accessed February 21, 2010).

28 Lorna Simpson, artist's website, 2010, at http://www.lsimpsonstudio.com/photographicworks06.html (accessed February 22, 2010).

29 Lorna Simpson, "Glenn Ligon interviews Lorna Simpson," in *Ink* (New York: Salon 94, 2008), 7.

30 James Baldwin, "Stranger in the Village," in *Notes of a Native Son* (New York: Beacon Press, 1955), 159–75.

31 Hilton Als, *Glenn Ligon: Stranger*, exhibition catalogue (New York: The Studio Museum in Harlem, 2001), 26.

32 Serena Davies, "A Cable Car Named Desire," *Daily Telegraph*, December 10, 2005, at http://www.telegraph.co.uk/culture/art/3648626/A-cable-car-named-desire.html (accessed February 23, 2010).

33 Stanford Prison Experiment website, 2009, at http://prisonexp.org/ (accessed February 23, 2010).

34 Ibid.

35 Janet A. Kaplan, "Flirtations with Evidence: The Factual and the Spurious Consort in the Works of the Atlas Group/Walid Raad," *Art in America*, October 2004.

36 Visit the New Museum Bowery Artist Tribute, at http://www.newmuseum.org/exhibitions/11/bowery_artist_tribute for more information.

37 Fred Wilson, "Memory and Beauty," *Art:21*, 2007, available at http://www.pbs.org/art21/artists/wilson/clip2.html (accessed March 24, 2010).

CHAPTER 5 BIBLIOGRAPHY

The Atlas Group. collective's website, 2010, available at www.theatlasgroup.org/ (accessed February 23, 2010).

The Atlas Group Project, *Volume 1: The Truth Will Be Known When the Last Witness is Dead* (Koln: Buchhandlung Walther König, 2008).

Baldwin, James, "Stranger in the Village," in *Notes of a Native Son* (New York: Beacon Press, 1955), 159–75.

"Bowery Artist Tribute," New Museum, 2010, available at http://www.newmuseum.org/exhibitions/11/bowery_artist_tribute (accessed February 23, 2010).

Brooks Takahashi, Ginger, *Turning Sweat Equity into Art*, New York City News Service–CUNY Graduate School of Journalism, March 23, 2009, available at http://www.nycitynewsservice.com/tag/ginger-brooks-takahashi/ (accessed February 14, 2010).

—— artist's website, 2010, available at http://www.brookstakahashi.com (accessed February 14, 2010).

Castets, Simon, "Dahn Vo Interview," 2009, available at http://.www.infochariot.blogspot.com/2008/10/plstica-dahn-vo.html (accessed February 18, 2010).

Campbell, Mary Schmidt, "African American Art in a Post-Black Era," *Women & Performance: a journal of feminist theory* 17, No. 3 (November 1, 2007): 317–30, available at http://www.informaworld.com/smpp/content~content=a787762206&db=all (accessed February 22, 2010).

Cichocki, Sebastian, "Interview with Artur Żmijewski," *ArtForum* (April 2009).

Civil Rights Act, transcript, Our Documents Initiative, 2009, available at http://www.ourdocuments.gov/doc.php?flash=true&doc=97&page=transcript (accessed March 1, 2010).

Conwell, Donna, "Context Sensitivity: The 2006 Liverpool Biennial and the Rhetoric of Place," 2010, available at http://www.latinart.com/aiview.cfm?id=362 (accessed February 21, 2010).

"Culture Shock," PBS website, 2009, available at http://www.pbs.org/wgbh/cultureshock/provocations/kara/3.html (accessed March 1, 2010).

Davies, Serena, "A Cable Car Named Desire," *Daily Telegraph*, December 10, 2005, available at http://www.telegraph.co.uk/culture/art/3648626/A-cable-car-named-desire.html (accessed February 23, 2010).

Eggers, Dave, "It Was Just Boys Walking," *Guardian*, May 26, 2007, available at http://www.valentinoachakdeng.org/essay.php (accessed March 24, 2010).

"Elizabeth Peyton," G:Class website, 2009, available at http://www.gclass.org/tools/LiveForeverElizabethPeyton (accessed February 14, 2010).

English, Darby, *How to See a Work of Art in Total Darkness* (Boston: MIT Press, 2007).

Foucault, Michel, *The Order of Things: An Archeology of the Human Sciences* (London: Tavistock Publications, 1970).

Garraghan, Gilbert J., *A Guide to Historical Method* (New York: Fordham University Press, 1948).

Gilbert, Alan, "Walid Raad," *Bomb Magazine* (Fall 2002).

Golden, Thelma, "Kehinde Wiley: The Painter who is Doing for Hip-hop Culture what Artists Once Did for the Aristocracy," *Interview Magazine* (October 2005).

—— "Post …" *Freestyle*, exhibition catalogue (New York: The Studio Museum in Harlem, 2001), 14–15.

Golden, Thelma and Hilton Als, *Glenn Ligon: Stranger*, exhibition catalogue (New York: The Studio Museum in Harlem, 2001).

Golden, Thelma, Kelly Jones, and Chrissie Iles, *Lorna Simpson*, exhibition catalogue (New York: Whitney Museum of American Art and Phaidon Press, 2002).

Golden, Thelma, Krista A. Thompson, Robert Hobbs, and Tavia Nyong'o, *The World Stage: AFRICA Lagos-Dakar Kehinde Wiley*, exhibition catalogue (New York: The Studio Museum in Harlem, 2008).

Grove, Jeffrey, *After 1968: Contemporary Artists and the Civil Rights Legacy*, exhibition catalogue (Atlanta: High Museum of Art, 2008).

Hamilton, Paul, *Historicism* (London: Routledge, 1996).

Helfand, Glen, "The Mission School," *San Francisco Bay Guardian*, October 28, 2002, available at http://www.sfbg.com/36/28/art_mission_school.html (accessed February 14, 2010).

Herbert, Martin, "Cinematic Affects: The Art of Runa Islam," *ArtForum*, January 2006, available at http://findarticles.com/p/articles/mi_m0268/is_5_44/ai_n26731931/pg_5/ (accessed February 23, 2010).

Hoptman, Laura, "Interview with Elizabeth Peyton," *New Museum Paper* 5 (Fall/Winter 2008): 4.

—— *Live Forever: Elizabeth Peyton*, exhibition catalogue (New York: New Museum and Phaidon Press, 2008), 225.

Joo, Eungie, "Margaret," *Giant Robot* 37 (1999).

Joo, Eungie, Alex Baker, and Susan Sollins, *Margaret Kilgallen—In the Sweet Bye & Bye*, exhibition catalogue (Los Angeles: REDCAT Art Center, California Institute of the Arts, 2005).

Kaplan, Janet A., "Flirtations with Evidence: The Factual and the Spurious Consort in the Works of the Atlas Group/Walid Raad," *Art in America* (October 2004).

Kiracofe, Roderick and Johnson, Mary E., *The American Quilt: A History of Cloth and Comfort, 1750-1950* (New York: Clarkson N. Potter, 1993).

Lewis, Anne S., "Malcolm, Movement, Memory," *The Austin Chronicle* 1 (October 1999), available at www.austinchronicle.com/gyrobase/Issue/story?oid=oid (accessed February 16, 2010).

Ligon, Glenn, "Interview with Lorna Simpson," in *Ink* (New York: Salon 94, 2008), 7.

Loewen, James W., *Lies My Teacher Told Me: Everything Your American History Textbook Got Wrong* (New York: Touchstone, 1996).

LTTR website, 2010, available at http://www.lttr.org (accessed February 14, 2010).

McPherson, James, "Revisionist Historians," *Perspectives*, American Historical Association, September 2003, available at http://www.historians.org/perspectives/issues/2003/0309/0309pre1.cfm (accessed March 3, 2010).

Malcolm X and Alex Haley, *The Autobiography of Malcolm X* (New York: Ballantine, 1964).

NAGPRA website, 2010, available at http://www.nps.gov/history/nagpra/ (accessed March 1, 2010).

Newman, David M., *Identities and Inequalities: Exploring the Intersections of Race, Class, Gender, & Sexuality* (Boston: McGraw Hill, 2007).

O'Ballance, Edgar, *Civil War in Lebanon, 1975–92* (London: Palgrave, 1998).

Obrist, Hans Ulrich, "Rirkrit Tiravanija," in *Interviews*, Vol. 1 (London: Charta, 2003).

"Painting: Kehinde Wiley," National Portrait Gallery, 2009, available at http://www.npg.si.edu/exhibit/recognize/paintings.html (accessed March 1, 2010).

Penn Station website, 2009, available at http://www.newpennstation.org/site/action (accessed February 21, 2010).

Piercy, Marge, *The Moon is Always Female* (New York: Alfred A. Knopf, 1980), available at http://www.nucalc.com/ron/Piercy.html (accessed February 14, 2010).

Popper, Karl, *The Poverty of Historicism* (London: Routledge, 1957).

Raad, Walid/The Atlas Group, *5B4*. February 2008, available at http://.www.5b4.blogspot.com/2008/02/atlas-group-by-walid-raad.html (accessed February 16, 2010).

—— artist's website, 2010, available at http://.www.theatlasgroup.org/aga.html (accessed March 1, 2010).

Saltzman, Lisa, *Making Memory Matter: Strategies of Remembrance in Contemporary Art* (Chicago: University of Chicago Press, 2006).

Simpson, Lorna, artist's website, 2010, available at http://www.lsimpsonstudio.com/photographicworks06.html (accessed February 22, 2010).

Smith, Esther K., Stadig, Lindsay (illustrator) and Zimmerman, David Michael, *How to Make Books: Fold, Cut and Stitch Your Way to a One-of-A-Kind Book* (New York: Purgatory Pie Press, 2007).

Smith, Lee, "Missing in Action: the Art of the Atlas Group/Walid Raad," *ArtForum* (February 2003).

Sollins, Susan, "Interview with the artist," *Margaret Kilgallen—In the Sweet Bye & Bye*, exhibition catalogue (Los Angeles: California Institute of the Arts, 2005), 126.

Spears, Dorothy, "60's Legacy, Personal Histories," *New York Times*, June 1, 2008, available at www.dorothyspears.com/assets/pdfs/art_world/artists/NYT60s060108.pdf (accessed February 16, 2010).

Stanford Prison Experiment website, 2009, available at http://www.prisonexp.org/ (accessed February 23, 2010).

Stillman, Nick, "Conversations... with Michael Rakowitz," 2010, available at http://www.nyfa.org/level3.asp?id=432&fid=4&sid=8 (accessed March 1, 2010).

Viliani, Andrea, "Pilot: Dahn Vo," available at http://www.pilotlondon.org/artists/details.php?id=31 (accessed March 1, 2010).

Walker, Kara, *Bureau of Refugees* (Milan: Edizioni Charta, 2008).

"Walid Raad," The Atlas Group Archives, 2010, available at http://www.sfeir-semler.com/sites/raad/startraadonly.htm (accessed March 1, 2010).

West, Shearer, *Portraiture* (Oxford: Oxford University Press, 2004).

Wilson, Fred, "Memory and Beauty," *Art:21*, 2007, available at http://www.pbs.org/art21/artists/wilson/clip2.html (accessed March 24, 2010).

CONTRIBUTORS

Susan E. Cahan is an art historian, educator, and curator who specializes in contemporary art and the history of museums. She is currently the Associate Dean for the Arts in Yale College. Before joining Yale, Cahan served as the Des Lee Endowed Professor in Contemporary Art at the University of Missouri–St. Louis and previously taught at Bard College and the University of California, Los Angeles. She has overseen educational programs at the New Museum of Contemporary Art and at the Museum of Modern Art in New York, and was the senior curator for Eileen and Peter Norton's art collection as well as the director of arts programs at the Peter Norton Family Foundation. Cahan has published widely on contemporary art and culture and is the co-editor of *Contemporary Art and Multicultural Education* (Routledge, 1996). She is also recipient of a 2007 Arts Writer's Grant from the Andy Warhol Foundation for the Visual Arts. Cahan earned her PhD in Art History at the Graduate Center of the City University of New York.

Travis Chamberlain joined the New Museum in August 2007 as the Public Programs Coordinator, overseeing the production of public performances, concerts, and exhibition-related discussions. He coordinates approximately 150 programs annually for the Museum and curates two performance series: "New Museum Presents" and "RE:NEW RE:PLAY." Prior to joining the New Museum, Mr Chamberlain was the Artistic Director of Galapagos Art Space in Brooklyn from 2004 to 2007.

Lauren Cornell, Executive Director of Rhizome, an affiliate of the New Museum, oversees and develops Rhizome's programs, all of which serve to promote and contextualize art engaged with technology. Cornell is also Adjunct Curator at the New Museum, where she organizes exhibitions and the monthly "New Silent" public programs series. Previously, Cornell worked as an independent curator and writer in London and New York. From 2002 to 2004 Cornell served as Executive Director of Ocularis, an organization dedicated to avant-garde cinema, video, and new media. Cornell's writing has been published in a range of international publications, and she has organized events or exhibitions at venues including the Kitchen, Foxy Production, Participant Inc, and the Institute of Contemporary Art in London.

Sarah Demeuse has worked as freelance educator and curatorial research volunteer at the New Museum since 2007. She writes for *(H)Art International* and recently completed her MA at the Bard College Center for Curatorial Studies.

Jenna Dublin is a gallery educator in the New Museum's Education Department. She received a BFA from the Cooper Union in 2008, with a concentration in photography and cultural studies.

Özge Ersoy is an independent curator. She recently completed her master's degree at the Center for Curatorial Studies at Bard College, New York. She holds a BA in International Relations from Bogaziçi University, Istanbul and Binghamton University, New York.

Chitra Ganesh was born and raised in Brooklyn, New York, where she currently lives and works. Her drawing, installation, text-based work, and collaborations seek to excavate and circulate buried narratives typically excluded from official canons of history, literature, and art. Ganesh graduated from Brown University magna cum laude with a BA in Comparative Literature and Art Semiotics in 1996. In 2001 she attended the Skowhegan School of Painting and Sculpture, and received her MFA from Columbia University in 2002.

Ganesh's work has been exhibited at PS1/MOMA, Brooklyn Museum, the Queens Museum of Art, the Asia Society, Bronx Museum of Art, White Columns, Momenta Art, and Apex Art in New York. International venues include the Fondazione Sandretto, MOCA Shanghai, Montehermoso Center in Spain, ZKM, and the Saatchi Museum in London. Her work has been featured in *ArtSlant*, *ArtKrush*, *New York Times*, *Flash Art*, *Art Asia Pacific*, and *Time Out New York*. She has worked as an educator in New York City since 1996.

Benjamin Godsill is a Curatorial Associate at the New Museum where he curated "*Urban China*: Informal Cities," a multifaceted exploration and physical manifestation of the groundbreaking magazine *Urban China*, and Agatha Snow's installation *Master Bait Me*. Previously he worked as an independent curator in New York and Los Angeles. He has written for various publications including *Vice Magazine*, *XLR8R*, and *The Blow-Up*. Benjamin holds a BA degree from Pitzer College (Claremont, CA) and an MA from the New School (New York, NY). He was a Helena Rubenstein Curatorial Fellow in the Whitney Museum of American Art's Independent Study Program in 2005/06.

Jenny Ham-Roberts is former Manager of High School Programs at the New Museum, as well as an interdisciplinary artist and independent curator. Previously, she managed several youth programs including the National Science Foundation and 21 Century grants at South Bronx Overall Economic Development Corp (SoBRO). She received her BFA from Simon Fraser University and an MFA from Hunter College. Her work has been exhibited in Vancouver, New York, Berlin, and the Netherlands.

Eungie Joo is the Keith Haring Director and Curator of Education and Public Programs at the New Museum, where she spearheads the innovative Museum as Hub initiative. Joo came to the New Museum from the Gallery at REDCAT in Los Angeles, where she was Director and Curator from 2003 to 2007. Joo is currently a Visiting Curator at Bard Center for Curatorial Studies. She is a board member of the William H. Johnson Foundation; is on the advisory committees to Independent Curators International and Side Street Projects; and has contributed to numerous contemporary art publications. In 2006 she was the recipient of the Walter Hopps Award for Curatorial Achievement. Joo was commissioner of the Korean Pavilion at the 53rd Venice Biennale where she presented "Condensation: Haegue Yang." She completed a doctorate in Ethnic Studies at the University of California at Berkeley in 2002 and a BA in Africana Studies from Vassar College in 1991.

Joseph Keehn II joined the New Museum in 2008 as Associate Educator, coordinating the Global Classroom (G:Class). He holds an MA in Museum Studies and a BFA in Studio Art and Art History. He has worked at several cultural institutions, including Brooklyn Museum and Japan Society, as well as university museums, such as Spencer Art Museum and Mulvane Art Museum, developing curriculum and implementing high school programs. In November 2010, Keehn became Curator of Public Programs at the Salina Art Center, Salina, Kansas.

Martha Kirszenbaum is a former research assistant at the New Museum, where she has worked on the exhibitions "The Generational: Younger Than Jesus," Jeremy Deller's "Conversations About Iraq," "Emory Douglas: Black Panther" and "Brion Gysin: The Dreamachine". She graduated from Sciences-Po in Paris and Columbia University in New York.

Zoya Kocur is former Associate Curator of Education at the New Museum of Contemporary Art. She is an adjunct professor in the Department of Art and Art Professions at New York University. She is co-editor of the volume *Contemporary Art and Multicultural Education* with Susan Cahan (1996), and co-editor, with Simon Leung, of *Theory in Contemporary Art Since 1985*, published by Blackwell (2005). Her latest anthology is called *Global Visual Cultures: Representation, Place, Power* (Oxford: Blackwell, 2010).

Matthew Levy was the 2008/09 Institute of Fine Arts/New Museum Fellow. His publications include catalogue essays for the National Gallery of Canada and Barbara Mathes Gallery, as well as articles for *New York Arts Magazine* and *… might be good.* He is presently completing his doctoral dissertation, "Abstract Painting after the Minimalist Critiques, 1965–1975."

Cathleen Lewis is an artist, and former Manager of High School Programs at the New Museum. Lewis's museum experience includes Curatorial Assistant at the Detroit Institute of Arts and Head of Youth and Community Programs at the Whitney Museum of American Art, where she managed the Youth Insights Program. Lewis completed her MFA at the School of Visual Arts in 1993, Skowhegan School of Painting in 1993, and the Whitney Independent Study Program in 1994. Lewis is currently Manager of School, Youth and Family Programs at the Museum of Art and Design, New York.

Amy Mackie is a Curatorial Associate at the New Museum where she curated *The Deeper You Bury Me, The Louder My Voice Becomes*, a site-specific installation by Rigo 23, *C.L.U.E. (color location ultimate experience)*, a project by A.L. Steiner and robbinschilds, and co-curated Jeremy Deller's "It Is What It Is: Conversations about Iraq." She has organized exhibitions or worked on projects with a number of mid-career and emerging artists including Ana Prvacki, Andrea Geyer, Mariam Ghani, and the New York-based collectives LTTR and Ridykeulous. She is the recipient of a 2009 Artslink Grant.

Yvonne Olivas is a teacher and writer informed by practices that break with the hum of the everyday. Since finishing her MA at the School of the Art Institute of Chicago she moved to New York, where she has worked and written for *Art in America*, thefanzine.com, and the New Museum. In 2008, she received an MFA in writing from the School of Visual Arts, where she also teaches art history.

Cristina (Cris) Scorza is the Manager of Tours and Family Programs at the New Museum where she manages the Docent program, develops tour materials, and supports Professional Development for Teachers. In her experience working with families and children, she has worked at the Brooklyn Children's Museum and the Museum of Modern Art. She received a BFA from the National School of Visual Arts in Mexico, a BA in Arts Administration and Art History from Baruch College, CUNY, and an MA in Leadership in Museum Education from Bank Street College of Education.

Avril Sergeon is an Educator at the New Museum, facilitating the Group Tours Program, Community Outreach, and creating lessons for the G:Class website. Previous work experience includes commercial art galleries and the Metropolitan Museum of Art. She has also curated exhibitions of emerging artists for organizations such as GENART. Avril is currently working towards a graduate degree in Arts Administration at New York University.

Brian Sholis is a freelance writer and editor living in New York. He is the co-editor of *Younger Than Jesus: The Reader* (New Museum/Steidl, 2009) and *The Uncertain States of America Reader* (Sternberg Press, 2006). His reviews of exhibitions and essays on artists have appeared in *Artforum*, where he was Artforum.com Editor at Large, *Aperture*, *Parkett*, and numerous other publications and exhibition catalogues. His reviews of books have appeared in *Bookforum*, *The Village Voice*, *The Virginia Quarterly Review*, *The Brooklyn Rail*, *Frieze*, and elsewhere. He has taught at New York University, been a visiting critic at more than a dozen art institutions in the United States, and he is currently pursuing a PhD in American History at the Graduate Center of the City University of New York.

Ethan Swan is Education Associate of the New Museum, where he organizes the "Get Weird" music series, manages the Bowery Artist Tribute, and envisions and executes exhibition-related audio guides. His art and music writing can be found in the following publications: *ANP Quarterly*, *Vice Magazine*, and *Kingsboro Press*.

Jordana Swan is a graduate of Hunter College, where she studied art history and economics. She has participated in the Guggenheim's Learning Through Art program, mentored middle school girls at Oasis for Girls in San Francisco, and taught drawing and painting workshops in Richmond, Indiana.

Lan Tuazon studied at the Cooper Union in 1999, received an MFA from Yale University in 2002, and finished a residency at the Whitney Independent Study Program in 2003. She has exhibited internationally at the Künstlerhaus Stuttgart in Germany, Floating IP in Manchester and the Lowry Museum in Salford, UK, and with the Ise Cultural Foundation, Artist Space, Canada Gallery, Sculpture Center, and Apex Art in New York. She has been a visiting artist professor at the Cooper Union and at Yale University. Tuazon, originally from the Pacific Islands, currently lives and works in New York.

Kara Walker is among the most complex and prolific artists of her generation. Using drawing, painting, colored-light projections, writing, shadow puppetry, film, and video, Walker confounds the historical narrative, depicting scenes haunted by sexuality, violence, and subjugation. She has exhibited at Musée d'Art Moderne de la Ville de Paris, the Walker Art Center, the Solomon R. Guggenheim Museum, and the Whitney Museum of American Art. A 1997 recipient of the John D. and Catherine T. MacArthur Foundation Achievement Award, Walker was the United States representative to the 2002 São Paolo Bienal in Brazil. Walker teaches at the School of the Arts at Columbia University.

Omar Wasow is a PhD candidate in African American Studies and Government at Harvard. His research focuses on race and politics, particularly in relation to education and crime. In addition, Wasow is the co-founder and strategic advisor to BlackPlanet.com, a social network he helped grow to over three million users a month. Omar also works to demystify technology through regular TV and radio segments. In 2003, he helped found a K–8 charter school in Brooklyn. He is a recipient of the NSF Graduate Research Fellowship and the Aspen Institute's Henry Crown Fellowship.

Dina Weiss is an artist and educator who worked with G:Class at the New Museum, and currently part-time faculty at Parsons School of Design. Prior positions have included Education Coordinator for the Drawing Center and Dia Art Foundation, both in New York City. Weiss holds an MFA from Parsons School of Design and a BS in Studio Art from New York University.

Ethan Zuckerman, an early partner in the Web company Tripod and a co-founder of the nonprofit organization GeekCorps, is a senior researcher at the Berkman Center for Internet and Society at Harvard University. He is co-founder and board chairman of Global Voices, a group of bloggers located around the world who are bridging cultural and linguistic differences through their weblogs.

ISBN 978-0-415-96085-4

EDUCATION/ART

For over a decade, *Contemporary Art and Multicultural Education* has served as the guide to multicultural art education, connecting everyday experience, social critique, and creative expression with classroom learning. The much-anticipated *Rethinking Contemporary Art and Multicultural Education* continues to provide an accessible and practical tool for teachers, while offering new art, essays, and content to account for transitions and changes in both the fields of art and education. A beautifully-illustrated collaboration of over one hundred artists, writers, curators, and educators from in and around the contemporary art world, this volume offers thoughtful and innovative materials that challenge the normative practices of arts education and traditional art history. *Rethinking Contemporary Art and Multicultural Education* builds upon the pedagogy of the original to present new possibilities and modes of understanding art, culture, and their relationships to students and ourselves.

This fully revised second edition provides new theoretical and practical resources for educators and students everywhere, including:

- Educators' perspectives on contemporary art, multicultural education, and teaching in today's classroom
- Full-color reproductions and writings on over 50 contemporary artists and their works, plus an additional 150 black-and-white images throughout
- Lesson plans for using art to explore topical issues such as activism and democracy, conflict: local and global, and history and historicism
- A companion website offering over 250 color reproductions of artwork from the book, a glossary of terms, and links to the New Museum and G: Class websites— www.routledge.com/textbooks/9780415960854

Cover image: Nikhil Chopra, installation view, "Yog Raj Chitrakar: Memory Drawing IX," 2009, New Museum, New York. Courtesy the artist and New Museum, New York. Photo: Matthew C. Wilson.

**NEW
235 BOWERY
NEW YORK NY
10002 USA
MUSEUM**

Routledge
Taylor & Francis Group
www.routledge.com/education